Likeness

Fronti nulla fides.

JUVENAL, *Sat*. II. 8

LIKENESS ❧ A Conceptual History of Ancient Portraiture ❧

By James D. Breckenridge

❧ Northwestern University Press ❧ ❧ ❧

Evanston ❧ 1968

James D. Breckenridge is Professor of Art
at Northwestern University, Evanston, Illinois

THANKS ARE DUE the following publishers for permission to quote the passages indicated:

P. 210: Reprinted by permission of the publishers from P. V. Pistorius, *Plotinus and Neoplatonism*. Cambridge, England: Bowes & Bowes, 1952.

Pp. 56–57: Reprinted by permission of the publishers from John A. Wilson, *The Culture of Ancient Egypt*. Chicago: The University of Chicago Press, 1960.

Pp. 209–10: Reprinted by permission of the publishers from Plotinus, *The Enneads*, translated by Stephen MacKenna, revised by B. S. Page. London: Faber and Faber Ltd., 1956.

Pp. 95–98: Reprinted by permission of the publishers and The Loeb Classical Library from W. H. S. Jones, translator, Pausanias, *Description of Greece*, Volume IV, Book X. Cambridge, Mass.: Harvard University Press.

P. 147: Reprinted by permission of the publishers and The Loeb Classical Library from H. Rackham, translator, Pliny, *Natural History*, Volume IX, Book XXXV. Cambridge, Mass.: Harvard University Press.

P. 257: Reprinted by permission of the publishers and the author, H. P. L'Orange, from *Acta Congressus Madvigiani Hafniae MDMLIV*. Vol. III: *The Classical Pattern of Modern Western Civilization: Portraiture*. Copenhagen: Ejnar Munksgaard, 1957.

Contents

v

List of Illustrations

Asterisks denote date of original, of which the illustrated sculpture is a copy.

96. Augustus. Rome, late first century B.C.
97. Tiberius. Rome, first century A.D.*
98. Tiberius. Rome, first century A.D.
99. Deified Claudius. Rome, first century A.D.*
100. L. Domitius Ahenobarbus. Greece, early first century A.D.
101. Julia. Rome, first century A.D.*
102. Julia (?). Rome, first century A.D.*
103. Head. Rome, first century A.D.
104. Nero. Rome, first century A.D.*
105. Vitellius. Rome, *circa* 69 A.D.
106. Vespasian. Rome, first century A.D.*
107. Head. Rome, late first century A.D.
108. Valerian. Asia Minor, *circa* 255 A.D.
109. Gallienus. Asia Minor, *circa* 255 A.D.
110. Gallienus. Rome, mid-third century A.D.*
111. Gallienus. Rome, 260–70 A.D.*
112. Gallienus. Rome, 260–70 A.D.*
113. Hadrian. Rome, second century A.D.*
114. Hadrian. Egypt (?), early second century A.D.
115. Antinous. Rome, second century A.D.*
116. Marcus Aurelius as *pontifex maximus*. Rome, second century A.D.
117. Commodus. Rome, second century A.D.*
118. Alexander Severus. Rome, third century A.D.*
119. Maximinus Thrax. Rome, third century A.D.*
120. Head. Egypt, third century A.D.
121. Gordian III. Rome, third century A.D.*
122. Philip I. Rome, third century A.D.*
123. Trajan Decius. Rome, third century A.D.*
124. Trebonianus Gallus. Rome, third century A.D.*
125. Military leader. Rome, later third century A.D.
126. Diocletian (?). Rome, late third century A.D.
127. Tetrarchs. Egypt (?), *circa* 300 A.D.
128. Constantius I Chlorus (?). Rome, *circa* 300 A.D.
129. Head. Early fourth century A.D.
130. Constantine I. Rome, *circa* 315 A.D.
131. Constantia. Greece, *circa* 315 A.D.
132. Dogmatius. Rome, *circa* 325 A.D.
133. Constantine I. Rome, *circa* 325 A.D.
134. Constantine I (?). Rome, *circa* 335 A.D.

THE COURTESY of the following individuals and institutions has been extended in granting permission to reproduce illustrations of works of art as indicated:

The Baltimore Museum of Art: Figures 6, 8, 9.

Baltimore, The Walters Art Gallery: Figures 31, 85.

Berlin, Staatliche Museen: Figures 28, 29, 110.

Boston, Museum of Fine Arts: Figures 2, 16, 45, 88.

The Brooklyn Museum: Figures 32, 33, 86, 92.

The Art Institute of Chicago: Figures 103, 131.

Chicago, Field Museum of Natural History: Figures 7, 10, 11, 12, 27.

Chicago, Oriental Institute, University of Chicago: Figure 34.

Copenhagen, Ny Carlsberg Glyptotek: Figures 30, 44, 50, 55, 56, 57, 59, 61, 66, 77, 87, 93, 94, 100, 101, 105, 106, 108, 109, 111, 124, 125, 126, 128, 136.

Florence, Fratelli Alinari S.A.: Figures 48, 52, 53, 54, 63, 64, 68, 73, 75, 76, 78, 79, 80, 81, 82, 84, 96, 97, 99, 107, 112, 113, 115, 116, 117, 119, 121, 122, 123, 133, 134.

Kansas City, Nelson Gallery–Atkins Museum of Fine Arts: Figures 22, 37, 38, 120.

London, Trustees of the British Museum: Figures 1, 5, 13, 14, 20, 23, 25, 26, 35, 36, 40, 41, 46, 47, 49, 67, 69, 70, 71, 72, 95, 102, 114.

Munich, Prof. Dr. H. W. Müller: Figure 89.

Munich, Staatliche Antikensammlungen: Figure 43.

New York, The Metropolitan Museum of Art: Figures 3, 4, 18, 19, 21, 39.

Oslo, Nasjonalgalleriet: Figure 62.

Paris, Archives Photographiques: Figures 17, 24, 83, 91.

Paris, Photographie Giraudon: Figures 64, 98, 129, 135.

Providence, Museum of the Rhode Island School of Design: Figures 74, 90.

Rome, Deutsches Archäologisches Institut: Figure 51.

Rome, Fototeca Unione: Figures 42, 58, 118, 127, 130, 132, 137.

Vienna, Kunsthistorisches Museum: Figures 15, 60, 138, 139, 140.

Worcester Art Museum: Figure 104.

Preface

WHILE CONCEIVED as a free-standing unit, this book also constitutes the first part of a general survey of the history of the portrait as an art form. As such, it may claim the elementary virtue of novelty, since to the best of our knowledge no systematic attempt at such a survey exists. More to the point, it is to be hoped that the vantage of such a survey may afford some useful insights into both the history of a rather special form of artistic expression and the history of art in general.

Such advantages may in some small way compensate for the inevitable deficiencies of the survey as a mode of scholarship. A former colleague, who had spent over a decade rewriting and refining his doctoral dissertation into ever more intricate intellectual convolutions, used to remark how much easier and more relaxing it would be to write a general survey of his field. As others tried to do then, we can assure him now that the difference in ease is illusory; what exists is merely a difference in kind. Matters of technical difficulty aside, there is an infinite difference psychologically between making oneself master of a limited field of special knowledge, free of all possibility of challenge because no one else has bothered to acquire the same quantity of facts, and compiling a survey, which must inevitably rely on secondary sources, and in which on virtually every detail there will always be at least one expert better informed than the surveyor.

We are fully aware of the risks undertaken here; but we feel that the challenge justified these risks. We have always attempted to base our statements on the best available data, but in some cases we have adopted solutions that certainly represent minority viewpoints within their respective fields of specialization. In such cases we felt that the special point of view provided by our own study as a whole contributed to the adoption of one solution as against its competitor.

Certainly the absence of any general survey of the art of portraiture—the lack, even, of any agreed definition of what a portrait was, at any given time—has militated against adequate consideration of the role of the portrait as an art form in those cultures in which it has flourished. This has been especially true of the periods covered by the present volume. The few general books on the portrait, aside from one or two highly theoretical essays, have begun their serious discussion of the topic with the Renaissance, all but ignoring the enormous stretch of history whose remains had in fact a profound influence on the development of art—and of portraiture—in the Renaissance itself.

This is not to say that there has been no general awareness of the existence of ancient portraits; quite to the contrary, both popular and scholarly interest in certain phases—especially the highly realistic Egyptian and republican Roman phases—of ancient portraiture has been sustained and intense for many generations. Only rarely, however, has this interest led to the pursuit of problems beyond those of subject identification.

Studies of portraiture in the ancient world have thus been largely specialized, and restricted to specific areas and eras: Egypt, Greece, and Rome, for the most part, since it was there that the largest quantity of ancient portraits was created. While the Egyptians conveniently provided identifying inscriptions—in itself a fact of some significance—the portraits of Greece and Rome come down to us less often incontrovertibly identified, so that a great deal of effort has been expended over the years on problems of identification and what might be termed iconography.

Important as it is to have correct identifications of as many portraits as possible, there is no question but that too exclusive a concentration on this aspect of the problem has created a situation in which the wood has been ignored for the trees. The very important questions of the origins, technical procedures, and interrelationships of these schools of portraiture remain unresolved.

The arrangement of a survey of (more-or-less) identified Greek portraits according to the dates of their subjects has, for example, the result of creating a visually incoherent product. For our own purposes, "Famous Faces" are important for the chronological clues they can offer, but not primarily in their own right. We have tried to focus our attention instead on the broader problems of stylistic and what we call "conceptual" developments, most of which transcend the limits of portraiture as a special form.

Likeness

One of the most obvious conclusions to emerge from our study is the complete erroneousness of the cliché that the form of a portrait is apt to be conditioned as much by its subject as by its artist. Quite the contrary is true. Throughout history the portrait obeys—at the same time that it can in certain cases help to determine—the general laws of stylistic development shown in all aspects of the art creations of a given region and period.

What is meant by ''a conceptual history of portraiture'' should become sufficiently evident in the course of this book to obviate the necessity, at this point, for a narrow definition. The premise underlying the study is, then, that the art of a society—including its portraits, if any—is to be understood as one product of the general cultural and intellectual environment, not as an autonomous and insulated series of activities and phenomena devoid of connection with life. As a corollary, the investigation of art as a cultural product should offer certain information and insights not available when it is seen only in isolation.

In the case of the portrait, we are dealing with a very special art form, one particularly dependent on the subject relationship for its very possibility of existence. Thus it would appear particularly suitable to a contextual study of the sort attempted here.

It will be our contention, then, that the incidence of portraiture, an art form far from universal in human culture, can be taken as one index of certain characteristics of the society which produces it. For some cultures, like that of republican Rome, we have a good deal of information linking the art form with its context, although even here gaps exist in our knowledge. In others, such as Mochican Peru, we have virtually nothing but the objects themselves as testimony to a cultural situation about which we are nevertheless justified in drawing certain minimal inferences.

We shall hope to demonstrate, then, that the portrait—however we may choose to define the term—is an art form whose occurrence has significance for our understanding of both the development of art and the history of civilization itself. The common concerns which produce likenesses of specific individuals at various moments in the history of mankind—as well as the common or disparate qualities of those likenesses themselves—are what justify our attempt to approach the subject of the portrait as a general theme rather than as a series of isolated phenomena.

In this first volume, our method leads us, after a rather protracted introductory development, to focus attention on certain pivotal moments in the history of portraiture, in which major shifts in the approach to the meaning of the portrait evidently took place. It should be clear, on the other hand, that these moments occur in the course of what is, once the essential process has been initiated, a continuum.

This mode of organization, although applicable to the initial part of our larger study, will not necessarily be followed in succeeding ones. Tentative explorations have suggested that somewhat different structures may seem more appropriate to later periods than those surveyed here, which is another reason for dividing our project into separate books. The present work has thus been limited to the earliest manifestations of the portrait and to its forerunners, culminating in the moment when, at the close of the antique era, one major phase of development in art had been concluded and another was already under way. Whatever the variations in method of exposition, the same fundamental approach to the study of the portrait as an art form in its social context will, it is hoped, prove useful in the examination of medieval and later portraiture in succeeding volumes.

Although the ideas which inform this study took root some years ago, the basic research for it was begun under a grant from the American Council of Learned Societies in 1959–60; work has continued since that time, and special acknowledgement should be made of the subventions of time and money furnished by Northwestern University.

A great many individuals and institutions have been instructive and helpful far beyond the call of duty. While we hope that most will find their direct aid acknowledged in the notes, we should single out here a few whose aid has been especially significant at one point or another: initially, Dr. Gertrude Rosenthal and the late Professor Ludwig Edelstein, and, in the course of our work, Dr. Vagn Poulsen and Professor H. P. L'Orange. Dr. Poulsen, in placing the unique resources of the Ny Carlsberg Glyptotek at our disposal, made a contribution comparable only to that of Professor Ernst Gombrich, who gave us the freedom of the Warburg Institute when we were beginning our research.

Obtaining exactly the right photographs of exactly the right works of art is the unattainable dream of every student of the history of art; if we have reached any approximation of this ideal, it is only because of the aid of innumerable generous individuals, again in particular Dr. Poulsen, and also Dr. Bernard V. Bothmer of the Brooklyn Museum and, through him, Professor Dr. H. W. Müller, Director of the Aegyptische Staatssammlung in Munich. In the final stages, it would have been impossible to complete the set of illustrations without the efficient aid of Mr. Ernest Nash's Fototeca Unione in Rome.

To all these scholars, named and unnamed, as well as to the other directors and curators of museums, libraries, and collections who have opened their files to us, we can only express the assurance that whatever merit this work may have is due to their aid.

<div align="right">JAMES D. BRECKENRIDGE</div>

Evanston, 1968

Chapter I ❧ What

Is a Portrait?

WHAT IS A PORTRAIT? While no literate person fails to form at least a mental image in response to this question, the answers to it are almost as numerous as the answerers.

As long as everyone seems to have at least a general idea of the subject under discussion, the better part of valor might urge us to avoid defining the word at the start, plunging instead *in medias res* with examination of examples from which perhaps a more precise definition may eventually be distilled. Yet even this course is fraught with problems, as the next chapter will show.[1] So many widely different kinds of things have been termed ''portraits'' at one time or another that some definition of terms will be required before we can begin to study the evidence.

An example of our difficulty is offered by a recent assertion that ''everyone agrees that a portrait is a representation in an artistic medium that closely resembles a specific human model.''[2] In this brief sentence virtually every phrase is open to dispute. Leaving to one side the problem of how we define ''representation,'' what is meant by the words ''artistic medium''? If it is intended to restrict the application of the word ''portrait'' to intentional works of art, well and good (except in certain schools of criticism); but if the words imply that certain materials and techniques are alone admissible, then it is doubtful that the statement could be sustained.

Once again, how are we to interpret such words as "closely"? "resembles"? "specific human model"? This definition offers no means of discriminating between, for example, one of Thomas Eakins' likenesses of his friends—in which the "like-ness" is very great indeed—and one of his painfully accurate studies of the nude model; yet in this distinction lies the very nature of the portrait as an art form in its own right.

Equally untouched by this definition is the problem of interpreting works in which identifiable likenesses of specific individuals are introduced as onlookers, accessories, or participants into scenes to which their identity is irrelevant. Perhaps most familiar are some of the frescoes of Renaissance Florence,[3] such as Benozzo Gozzoli's "Journey of the Magi," or a number by Ghirlandaio. There is a fundamental difference between the use of highly specific likenesses in works of this sort and the introduction of identifiable spectators into a painting of a present event, such as Rembrandt's "The Anatomy Lesson of Dr. Tulp."

A truly useful definition of the portrait demands greater precision than this statement offers.

This need for precision has been met best by Bernhard Schweitzer, through a series of statements rather than a single dictum. For him the essentials of the "true" portrait are as follows:

1) It must represent a definite person, either living or of the past, with his distinctive human traits. 2) The person must be represented in such a manner that under no circumstances can his identity be confused with that of someone else. 3) As a work of art, a portrait must render the personality, i.e., the inner individuality, of the person represented in his outer form.[4]

These are useful criteria, even though some areas remain open to subjective interpretation and despite the fact that we shall find it necessary to augment them as our investigation proceeds. Certainly the point made in (1), that a definite and specific person must be the subject of the work of art, is indispensable; not only does it solve the problem posed by Gozzoli and Ghirlandaio—and Eakins as well, in one sense at least—but it also establishes that an image of a specific person meant to represent a class or type of individuals cannot be considered a portrait in the sense described. The precision of identification required by (2) would also seem self-evident; even in cases where we can no longer establish the identification by physical comparison with the original—and these cases are inevitably the large majority—it should be clear that no confusion existed at the time the work was made. On the other hand, it is certainly true that in many periods the establishment of physical resemblance per se was not considered the primary means of achieving this unquestioned relationship.

The point becomes clearer when these criteria are applied to a specific work of art: the portrait of Pericles best known from the inscribed herm in the British Museum (Figure 1). Is this what Schweitzer would consider a "true" portrait?

Nearly all commentators agree that the strongest impression to be gained from this work is not that of a particular individual but of a generic hero figure, an idealized "type" of the soldier-politicians who dominated the administration of Athens after the Persian Wars. How far does the sculptured image measure up, then, to Schweitzer's requirements?

As regards (1), whether or not the likeness was posthumous, it seems most definitely to have been intended to represent only this one specific person. In terms of (2), the possibility of confusion is eliminated if by no other means than the inscription; but since other, uninscribed likenesses of Pericles can be identified by their physical resemblance to this work, it is evident that this latter aspect of the portrait was also brought to a reasonably specific state. If we can find fault with this likeness as a fully developed example of "true" portraiture, it must be on the grounds of Schweitzer's third criterion, the question of how far the image renders the "inner individuality" of its subject.

Here, of course, we are forced onto subjective ground. Can we ever know how closely this image corresponded to either the appearance or the nature of Pericles? Almost certainly not, in terms of actual comparison. It is useful to compare our reactions to this artistic likeness with the account of Pericles given by the great contemporary historian, Thucydides.[5] It has struck many commentators that these text passages have a great deal in common with the sculptured portrait, since they present a list of ideal virtues so depersonalized as to offer no grasp of what an actual man could have been like. No effort at physical description, no seasoning of humanizing anecdotes, softens the rigid schema of perfection. It is obvious that both artist and historian were operating in an environment where information on such individual traits was not considered useful; phenomena were to be represented instead in terms of types and generalizations. In portraiture just as in all forms of the visual arts, and in other modes of expression as well, concentration must be on the typical as the truly significant, not on the unique and individual. What matters is what the members of a group have in common, not what differentiates them one from another. To this degree the portrait of Pericles would not fit Schweitzer's definition of the "true" portrait.

Yet we cannot deny to works of this sort any link with the term. What the recurrent use of the modifier "true" suggests is that the requirements specified by Schweitzer constitute a more rigorous test than is always used in judging the portrait as a work of art. For a somewhat looser, yet still serviceable definition of

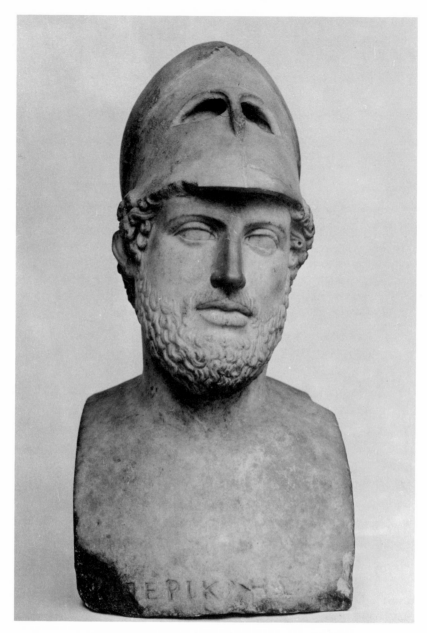

FIGURE 1 The portrait of Pericles by the sculptor Cresilas, famous in antiquity, and one of the sights of the Acropolis. Made in Athens in the high classic period after the middle of the fifth century B.C., it conforms to the idealizing tendencies current at that time. This herm is generally considered the best surviving copy.

The British Museum

the class of works with which we are concerned, we may well turn back to Richard Delbrück: A portrait is "the representation, intended to be like, of a definite individual" [6]—understanding that great emphasis must be placed on the word "individual."

We must deal, then, with several levels of imagery, all related to the representation of the specific individual but embodying different approaches to the manner of such representation. Schweitzer's "true" portrait is only the latest and highest manifestation of this concern for the individualized in art.

If we may use, for the moment, the broader classification provided by Delbrück, we will find that we have to deal with a large quantity of works of art, from a vast geographic and chronological range, which nevertheless is susceptible of arrangement into a fairly limited number of groups. The fact is, as we shall show in more detail in the following chapter, that most surviving portraits from prehistoric societies, and the majority of those from any early civilization, relate —insofar as function can be identified—to funerary practices.

Taking Delbrück's terms, we may find "representations of definite individuals" occurring far back into the dawn of time and also within the compass of recorded history, as in Egypt; yet it will be our contention that none of these works—and virtually no funerary images anywhere—reaches the level of "true" portraiture. The reason is explained most simply by Panofsky: "An Egyptian tomb statue, intended to be occupied by its soul, is not what a Greek or Roman statue is. It is not a representation (*mimesis*) of a living being—body plus soul, the former animated by the latter—but a reconstruction of the body alone, waiting for animation." [7]

Only when the subject is shown "for his own sake" can we really speak of the portrait—which concerns itself with the whole of the person—and of a work of art, not a work of magic. All the earlier forms of imagery of the individual are also instruments of magic: magic for the protection of the living, magic for the sustenance of the departed, and often both at once. While we are dealing with a slightly different problem than what the aesthetician had in mind, it is well to remember Collingwood's insistence that the primary function of magic is fundamentally nonaesthetic; such works may on occasion become art as well, but the primary demand of the society requiring them is for "practical" function, not aesthetic effect. [8]

When the portrait appears in its most highly developed form, as described by Schweitzer, it will have emerged from a background in which the image or effigy has been used for magical purposes; but only when those magical functions fade from public awareness does the "true" portrait so emerge.

As an art form, the portrait even in the broadest sense is far from being of universal occurrence; when it is found, it relates to periods, by and large, when all the arts attempt the more or less naturalistic portrayal of the world. The attitude toward portraiture, in other words, relates to the general attitude of a given period toward representation, and the highest moments of achievement in the art of portraiture have occurred at times when the tendency of artists was toward a highly specific naturalism in all aspects of representation.

As a phenomenon of naturalism, the relation of the making of portraits to the taking of casts and other exact records of physical appearance needs to be considered. That such casts of the face and other parts of the body were taken in the ancient world we know from scattered Egyptian remains as well as from direct observation of Roman republican portraiture. This varied evidence has all too often led critics to consider that the ultimate objective of the naturalistic artist— and especially the portraitist—lies in just this sort of direct copying of phenomena, a technique which stands as a more or less exact prototype of the process of photography.

The fact is, of course, that the cast or mask has never served as an end in itself for artistic creation. It is a tool which an artist, interested in naturalistic representation, may employ, as he would a sketch of any other sort. It has been demonstrated that the much-quoted passage in Pliny about Lysistratus, brother of Lysippus, having been the first Greek sculptor to make casts of his models, must be understood in this way rather than as testimony to his having used such casts directly in finished sculpture.[9]

It is also true that the cast is not so realistic a medium of recording appearances as the uninitiated assume. A death mask can be taken, it is true, without disturbing the subject; but what it records is the processes of dissolution already under way:

The bony structure becomes more apparent. The form of the forepart of the skull grows very pronounced. Temples and cheeks fall in, cheek- and jawbones strongly protrude. . . . The closed eyes sink deep into the orbits because the moisture in the tissues supporting the eyeballs and the tone in the eye-muscles disappear. The bridge of the nose grows very pronounced; its tip falls in. The naso-labial furrows become deeper, the folds grow limp. The mouth hangs loosely down with drooping corners and is often drawn awry; the lips are sunken, especially the upper one, so that the distance between nose and lips is unnaturally lengthened. . . . Every detail, every little line and wrinkle is smoothed away; death masks hardly ever show anything of the so-called "verism" generally attributed to them.[10]

These problems in relating the death mask to the living appearance of the subject are equaled by the difficulties involved in taking a mask from the living model (Figure 2). Bodily apertures must be plugged and breathing provided for, and

in a variety of ways areas will be created in the cast which will necessarily require reworking. In addition, the taking of a life mask can only be accomplished when the subject is in repose throughout the hardening process, so that the flesh on whatever part of the body is being cast will sag and be distorted.

It is scarcely surprising, then, that no works of art survive in which the untreated cast has been reproduced without some modification by an artist. For a

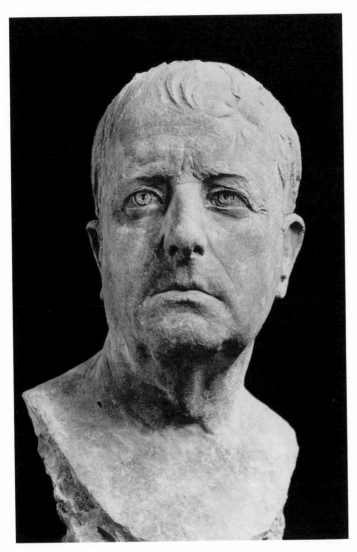

FIGURE 2 A portrait of a Roman in terra cotta, evidently made directly from a life mask of the subject. While it is understood that casts were used extensively in the creation of Roman funerary portraits, this example is unique in its employment of a cast from the live model.
Boston, Museum of Fine Arts, Gift by Contribution

certain group of works from the period of the Roman republic, the amount of such reworking is quite minimal, and many traces of the mask impression remain evident; but what is significant is that these represent the least satisfactory of all the portraits from that high moment of "Roman verism" and they undoubtedly represent the most economical, least exalted form of commemoration in their own time.

This question of the mask raises a further point, that when we speak of the portrait we almost invariably think of the face; yet the Greeks, who played so important a part in the creation of the first "true" portraits, always conceived of a portrait as requiring representation of the full body, not the face alone, or the head or bust. The bust portrait was in fact a Roman invention. Yet before and after the Greeks, all our evidence would indicate that, for most purposes that required portraiture, the head and face were considered by early peoples the essential elements, the only indispensable means, for establishing individual identity.

Seen in this view, the Greeks appear unique in their demand that the individual could not be adequately portrayed unless he was shown in his full stature. Equally unique would seem to have been the Greek insistence on placing the core of the personality elsewhere than in the head. They seem almost perverse in this refusal to acknowledge that the head, the evident site of all the localized senses, deserved special emphasis when indicating the seat of consciousness.[11]

The criterion of the "true" portrait, then, is in no sense merely literal accuracy or fidelity to optical appearances; on the contrary, the creation of a successful portrait, as of any successful work of art, will call for some manipulation of visual appearances on the part of the artist. As Gombrich has so convincingly demonstrated, "All art originates in the human mind, in our reactions to the world rather than in the visible world itself. . . ."[12] Directly to our point, he continues:

The correct portrait, like the useful image, is an end product on a long road through schema and correction. It is not a faithful record of a visual experience, but the faithful construction of a relational model. Neither the subjectivity of vision nor the sway of conventions need lead us to deny that such a model can be constructed to any required degree of accuracy. What is decisive here is clearly the word "required." The form of a representation cannot be divorced from its purpose and the requirements of the society in which the given visual language gains currency.[13]

Parts of this statement come close to paraphrasing the formulation of Collingwood:

The true definition of representative art is not that the artifact resembles an original. . . . but that the feeling evoked by the artifact resembles the feeling evoked by the

original. . . . When a portrait is said to be like the sitter, what is meant is that the spectator, when he looks at the portrait, "feels as if" he were in the sitter's presence. This is what the representative artist as such is aiming at. He knows how he wants to make his audience feel, and he constructs his artifact in such a way that it will make them feel like that. Up to a point, this is done by representing the object literally; but beyond that point it is done by skillful departure from literal representation. The skill in question, like any other form of skill, is a matter of devising means to a given end, and is acquired empirically, by observing how certain artifacts affect certain audiences, and thus through experience (which may in part be other people's experience communicated by instruction) becoming able to produce in one's audience the kind of effect one wants to produce.[14]

It is for these reasons that the portrait of any given period will naturally conform not only to the techniques but to the style and conceptual attitudes of all the arts of the time. The level of naturalism will depend, then, on the degree to which the practice of naturalistic representation is common in that society. But whether portraits will occur at all in a given society compels us to consider another, extra-artistic factor. This is the significance placed by a given society on its individual members. While obviously no society completely ignores the importance of its unitary components, it is self-evident that in some societies, at all stages of cultural development, the individual holds greater importance than in others.

Even beyond this, many societies make distinctions between those who belong within the group and those who do not—the distinction the Greeks made between their own people and the "barbarians." Long before the Greeks, the Egyptians "made a distinction between 'men' on the one hand, and Libyans or Africans, on the other. The word 'men' in that sense meant Egyptians; otherwise it meant 'humans' in distinction to the gods, or 'humans' in distinction to animals. In other words, the Egyptians were 'people'; foreigners were not."[15]

Egyptian artists were careful to distinguish between foreign physical types in portraying, for example, captives and slaves; but this is a distinction of types, not of individual specimens (Figures 3 and 4). The very care exercised in depicting racial types is therefore little or not at all different from the accuracy shown in the delineation of species of plants and animals in the same scenes, a matter at which Egyptian artists show great skill. The distinctions between races of mankind were felt to be neither more nor less significant than those between, for example, the lotus and the papyrus plants in the swamps of the Nile.

The Greeks, too, preserved their use of the term "barbarian," which always had a subhuman connotation, long after they had enjoyed sufficient contact with other races and peoples to have destroyed any rational justification for such a generic differentiation. Yet the persistence of comparable attitudes can scarcely

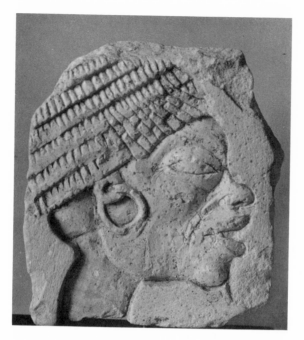

FIGURE 3 The head of a Negro, carved in limestone on a sculptor's trial piece, found in the work-shops of the abandoned Eighteenth Dynasty city of Tell el-Amarna. While the racial characteristics of the physical type are brought out unmistakably, no sense of individuality is bestowed on the representation.

New York, *Metropolitan Museum of Art, Rogers Fund*

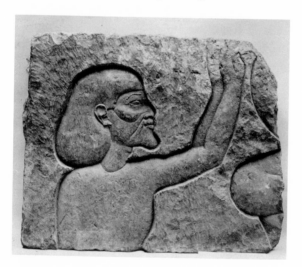

FIGURE 4 A fragment of a finished relief, showing the head of an Asiatic, probably a prisoner. The distinctive features of the racial type are clearly indicated, but no portrait intention is evident.

New York, *Metropolitan Museum of Art, Rogers Fund*

be surprising in a generation which has seen both the concentration camps and ovens of Nazi Germany and the police dogs of Birmingham. Curiously revealing in this regard are comments on the attitude toward the lower classes held by a man who stands as one of the founders of modern thought:

> It seems hardly to have occurred to Freud that one might identify with oppressed and struggling animals. . . . Freud's attitude towards the lower classes of human society was actually not very different. Wherever servants, nurses, porters, and so forth, appear in his writings, they are viewed as dubious rather undifferentiated beings, scarcely credited with personality. . . . In all this, he is the nineteenth-century bourgeois gentleman, for whom the lower classes are not really people, scarcely seen as individuals, and not respected.[16]

The point has sometimes been made that the development of Greek art toward the more careful distinction of individual traits, toward naturalism in short, and hence toward fully individualized portraiture, was facilitated by the exercise Greek artists received in portraying barbarians and subhumans (such as the ever popular centaurs) in such works as the great temple friezes of the mid-fifth century B.C. "La bellezza fu tipica, sole il brutto potè essere individuale."[17] Thus it is asserted that the depiction of such figures, working counter to the high level of idealization employed in the portrayal not only of gods but of Greeks (i.e., human beings), was at the root of fourth-century naturalism.

A closer look at the works of art cited tends to weaken the force of this argument. The fact is that Greek artists throughout the archaic and classical periods continued to depict barbarians, not to mention monsters, with just as much disregard to specifics as they did their Greek heroes, i.e., they depicted them as types. In this regard they were considerably less conscientious than their Egyptian forerunners. Virtually all barbarians, for example, are shown wearing trousers, though in actuality this was the garb of only certain Iranian tribes; all foreign rulers are shown wearing one type of crown, and so forth.[18] Thus, far from representing a tendency away from idealism, these portrayals of non-Greeks are the other face of the same coin. The grimacing centaurs of the Parthenon metopes, bald pates and all, are as much idealizations as the serenely unruffled heroes who so nonchalantly overcome them.

Idealization, as Socrates himself points out, is not a question solely of making beautiful things perfect in their beauty. *Any* attitude or emotion or species may—in his terms *should*—be idealized.[19] It might even be held that ugliness and violence are necessary contrasts to beauty and calm, if the serenity of the human—the Greek—ideal is to be fully apprehended. Without the ugly we cannot know how beautiful the human ideal truly is. Just as fifth-century artists worked out a canon of beauty for the human figure, deformations and characteristics of

age were studied for the same purposes of generalization, although not for embodiment in a canon.

The wider political horizons of the fourth century must have compelled at least a few Greek intellectuals to recognize the essential identity of mankind as a whole; this awareness was then achieved, it would seem, for the first time in history. It was Aristotle's pupil, Alexander the Great, himself a "barbarian," who put this new viewpoint into practice in the administration of his universal monarchy.[20] The opposition of the Greek man-in-the-street to his universalist policies is too well known to require extended comment.

The thesis of the present work is that the presence of a favorable intellectual atmosphere was necessary before the "true" portrait, the individualized likeness in its most fully developed sense, could be created. At just what moment this ultimate step in conceptualization was taken remains to be discussed. What cannot be denied is that it was in Greece that, for the first time, the concept emerged of the portrait as a work of art portraying the single individual *for his own sake*. No longer is the portrait made to serve as a magical reproduction or double, or as a charm against the spirit world. "The step from the 'prospective' to the 'retrospective,' from the magic manipulation of the future to the imaginative commemoration of the past, was taken, like so many steps in the development of our civilization, in Greece."[21]

The portrait thus enters human time. The funerary image as created by earlier—and by many later—cultures was not conceived of as existing in a temporal situation related to human life. There may be a sense of the future involved in the religious concepts underlying these works, but this is a wholly different dimension from that familiar to the living. This temporal otherness is present, in point of fact, even in most nonfunerary art of preclassical societies.[22]

The "true" portrait, on the other hand, is freed from the magical concern with future action and instead portrays the individual as an integrated, living human being: as he was in his own time. The portrait records his living experiences, it may probe his thoughts and his personality, all because human time has assumed a significance it could not have so long as the image was concerned with magical action instead of actual representation.

As a work of art, the portrait in this highest sense can come into existence only when society's conception of the worth and importance of individuals has reached an advanced level; but it is also necessary for the individual to be conceived of as existing within the time span of history and for this existence to be regarded as meaningful. The "true" portrait, therefore, is not only a work of art but a consciously conceived document of history.

Chapter II ❧ The Prehistory of Portraiture

THE OBVIOUS POINT at which to begin a historical survey is at the beginning. Placing one's finger on the earliest portrait, however, is no simpler than arriving at a clear-cut definition of the portrait—obviously for interrelated reasons. An examination of the evidence, however, cannot help but improve our understanding of the meaning of the form and thus help bring us closer to answers to both questions.

The earliest date claimed with some currency for the appearance of a portrait likeness is about 5000 B.C. In the prepottery strata of the excavations at Jericho, seven skulls were found buried under the floor of a single room; each of these skulls had been modeled over with clay and fitted with "eyes" of shell (in one instance, cowries; in all the others, flat shells in two leaves separated by vertical rather than horizontal slits), to simulate the appearance of a fully formed human head. (Figure 5). The excavators have recorded their sensation of being in the presence of true portraits of specific individual persons.[1]

Remarkable as this find is, it has close analogies to works produced in present-day societies which have remained at or near a Neolithic stage of development. The excavators of the Jericho skulls cite as comparative examples the modeling of heads over skulls among the tribes of the Sepik River area of New Guinea (Figure 6); other instances are found elsewhere in Melanesia, as in the

Torres Straits area of New Britain and in the New Hebrides and the Solomon
Islands.

There is of course no documentary evidence from Jericho of the purpose for
which these skulls were prepared in this way and buried in such a location. On
the basis of comparison with what we know of present-day practices of similar

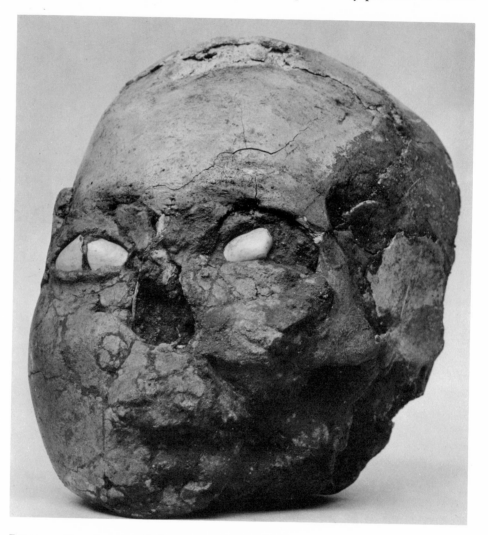

FIGURE 5 One of seven skulls found buried beneath the floor of a room in Neolithic Jericho, at a
level dated to about 5000 B.C. On the face of each skull, clay has been modeled into the semblance
of a human face, with shell eyes inserted to increase the sense of reality. While the magical function
of such burials is not in doubt, there remains some question as to just who is "represented" by such
a head.

The British Museum

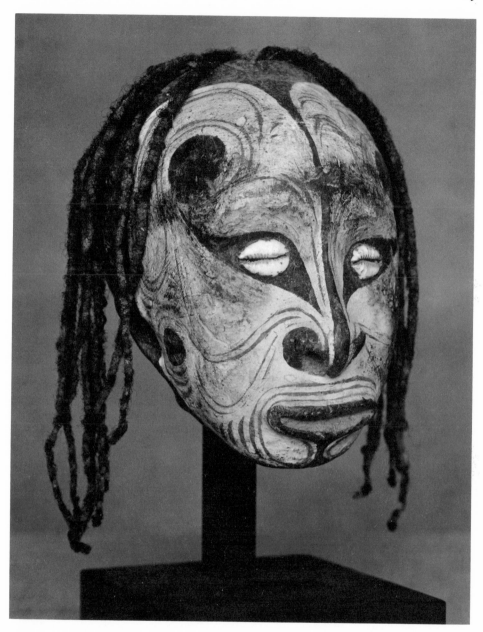

FIGURE 6 A comparatively recent example of modeling a face on a skull, illustrating the persistence of this Neolithic practice. This skull, from the Sepik River area of New Guinea, has cowrie-shell eyes, strands of hair, and plastered face; the paint on the face might duplicate the facial markings of the deceased.

The Baltimore Museum of Art, Wurtzburger Collection

type, however, it is possible to suggest hypothetical reasons for the usages in-
volved. In addition, it will become evident that this treatment of the skulls of the
dead must be understood as only one special facet of a far more widespread
religious practice—that of preserving skulls in a variety of ways—which seems to
date back to the very dawn of humanity itself.

The Cult of the Skulls

Melanesia provides numerous instances of special reverence being shown to
skulls of the dead; in addition to the modeled skulls cited above, there are many
more where no effort was made to duplicate the integuments of living flesh. The
same Sepik River tribesmen who prepare some skulls with modeled features also
preserve others unadorned (Figure 7). No evidence has been presented to explain
this difference in treatment.

Skulls preserved in such societies can be derived, broadly speaking, from
two sources which would seem to the outsider psychologically antithetical:
honored members of the community itself and enemies. In the latter case, the
skulls were obtained in battle or by head-hunting. This antithesis aside, there is
one obvious difference in the way in which the remains would be handled, since
in the first case the whole corpse would be present in the village at the moment
of death, while in the second the body would customarily (although not in-
variably) be left where it fell, with only the head brought home for preservation.
Nevertheless, it is impossible to discover any trace of fundamental difference in
treatment of the two kinds of remains; on the contrary, it would appear that
substantially the same religious motivations underly both kinds of preservation and
the cult in general.

Skulls of members of the home tribe were usually obtained by the process
known as secondary burial. At Anyeitum in the New Hebrides, for example, the
body of an important chief would be buried up to the neck, with the head above
ground. The grave would be watched by female mourners, and when the head
had decomposed, it was deposited in a cave. Elsewhere, and more commonly,
complete burial would be followed by exhumation; then the skull, with or with-
out other bones, would be preserved either in caves or in the houses of the living.
It is possible to argue, as a matter of fact, that the practice of inhumation itself
originated as a device for desiccating the flesh from the skeleton prior to ultimate
disposal above ground, inside or close to the habitations of the survivors. In the
Malay Archipelago, after the funeral feast, the skull of the deceased was washed
and placed in a basket inside the house of his family, where offerings were placed

before it. After a suitable time, the skull was taken out of the house and deposited in a cave. In the Trobriand Islands, after exhumation, the bones were smoked over a slow fire, were then placed in a basket in the house of the deceased, and once again were ultimately transferred to a cave.[2]

In the still more undeveloped regions of Australia, burial was often omitted, and, instead, parts of the body were eaten by the mourners. "This cannibalistic feast is said to be a symbol of respect and regret for the dead, but over and above this it was doubtless for the purpose of imbibing their qualities."[3] Among some of the tribes of the Adelaide Plain the skull was preserved and used as a drinking vessel, a practice to be encountered elsewhere.

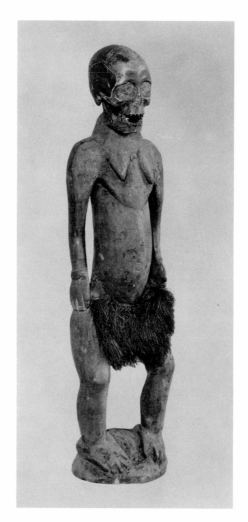

FIGURE 7 The variety of ways in which skulls may be used in funerary cults is illustrated by this specimen, also from the Sepik River, in which an undecorated skull has been fixed to a carved effigy of a female figure.
Chicago, Field Museum of Natural History

On the Asiatic mainland, within recent times, the skull cult has been found not only in Assam and Burma but in India and Tibet as well. In India the preservation and use (as cups) of skulls of honored Brahmans was primarily a practice among tantric sects, and it would appear that comparable Lamaist customs in Tibet are interrelated.[4] While some of the tantrists were still practicing cannibals at the end of the past century, the Tibetan usages appear to have replaced an earlier skull cult related to ancestor worship; and this in turn suggests connections with shamanistic cults of central Asia.

Among the Yukaghir, skulls of dead shamans were preserved and venerated, but primarily for a type of divination based on the apparent heaviness or lightness of the relic.[5] Here we find ourselves on the edge of the marshy subject of necromancy, which we need not attempt to survey; suffice it to recall the mummified head of Mimir, used for divination by Odin in the Volüspá poem, and the singing head of Orpheus.[6]

All these practices for dealing with the honored dead reflect in varying degrees the evidently rather vague beliefs about the afterlife held by these societies, all of which differ in degree but not in kind. On the one hand, there is grief at the departure of a loved one, who is paid honors—even including cannibalism—before receding slowly from the vicinity of the living. On the other hand, even with the closest of relatives, there is always the element of fear, the suspicion that the dead are resentful of their condition and may seek revenge on the survivors.

The relation of these practices to the custom of head-hunting, which is equally prevalent, is thus not so difficult to perceive. The fundamental belief is that the spirit of the dead may be made to serve the living, especially in an apotropaic function, provided the proper observances are kept. The way in which such survival of the dead is imagined, furthermore, is not so highly personalized that the survivors feel either that the late members of their own group will inevitably be benevolent or that defeated enemies will be hostile; through the practice of the correct ritual, the attitude of the dead can be controlled in either case.

It is worth noting that all these practices assume without question the capital importance of the skull, i.e., the head, as the focal point of whatever powers the individual may have. Whereas the far subtler Greeks argued at great length as to the location of the components of the spirit within different parts of the body, primitive man evidently decided empirically that appearances could not be deceiving and that the part of the body which was the seat of the localized senses must be the most important part of the whole.

The general similarity between these broadly scattered customs relating to the preservation of skulls certainly suggests the purpose for which the seven skulls

of Jericho were modeled and buried in the Neolithic period. Still other prehistoric finds enable us to perceive traces of a cult of skulls far earlier even than the foundation of urban life at Jericho.

Dating from the end of the Mesolithic period, about 10,000 B.C., there are caches of skulls requiring interpretation as having ceremonial character. The most famous of these finds, which may actually be from the early Neolithic, is the one made at Ofnet, near Nördlingen in Bavaria. Here two piles or nests of skulls were found embedded in red ochre, one pile containing twenty-seven skulls, the other only six. Examination showed that all heads had been severed from their bodies; several show evidence of blows from stone axes. The piles were not made all at once, as the progressive crushing of the bottom skulls indicated, but accumulated gradually; but all were placed to face the West. Comprising members of both the brachycephalic and dolichocephalic types, the group included twenty skulls of children (all skulls ornamented with snail shells), nine of women (decorated with necklaces of deer teeth), and four of adult males. There were indications that fires had been lit nearby.[7]

Although the disproportion of women and children to men has led to the suggestion that these were victims of a single attack, the evidence that the skulls had accumulated gradually would seem to controvert this. On the other hand, the disparate cephalic types might indicate that these were trophies of raids by the dedicators of the shrine. The honors paid the skulls would not negate this assumption, since such measures would be used in propitiation of any deceased, friend or foe alike. On the other hand, the evidence of axe blows on the skulls does not prove that the subjects met violent deaths; some peoples are known to believe that the spirit must be released from the skull *after* death by just such a blow. In New Caledonia, in recent times, the skulls of especially revered persons were collected in piles just like the ones at Ofnet and became the object of pilgrimage.[8]

Other instances of finds relating to the skull cult from Mesolithic times include a single skull found near Lierheim and the curious memorial in the grotto of Trou-Violet at Montardit, consisting of a fragment of a skull from which the flesh had been peeled away, together with a few small bones and a number of pebbles arranged in the form of a human body.

From the Upper Palaeolithic, perhaps 25,000 B.C., a number of total burials have been discovered, but, in addition, a large number of isolated skeletal parts, particularly skulls. In a number of cases there is evidence of ritual practices in connection with these burials, the most notable of which is the find at the Grotte du Placard in Charente. Here to the left of the cave entrance was found a single female skull, complete with its lower jaw, and surrounded by a quantity of shell ornaments. Within the cave, however, there were discovered some nine skull

fragments as well as a lower jaw, a humerus, and a femur, at varying levels from the Magdalenian to the late Solutrean. Close study of the skull fragments has demonstrated that they were not accidentally broken but were deliberately shaped into cups; traces of ochre were found inside one of them. Comparable skull cups have been found in Upper Palaeolithic deposits from Spain to Moravia, and there can be little doubt that they were religious utensils of some sort.[9]

Some of the finds from this epoch, including some skeletal remains at the dwelling level at the Grotte du Placard, have been taken to demonstrate cannibalistic practices; but this cannot be proved, and the indications must be regarded as ambiguous. Further finds, however, certainly prove that fragments of human skeletons were preserved as amulets; teeth, incised and pierced for suspension, as well as a fragment of a lower jaw pierced and reddened with ochre, must have been worn for magicoreligious reasons, just as the skull cups were evidently more than just practical utensils (although the suggestion has been made that the skull did form the first practical water-holding vessel in ages before the invention of pottery, and where bark was not available).

The Upper Palaeolithic is the time of the emergence of *Homo sapiens*; but the cult of skulls is traceable to even earlier periods. In the Mousterian, perhaps 100,000 B.C., Neanderthal man seems to have been preserving skulls for ritual purposes. The most notable case is that from the cave of Monte Circeo, on the Tyrrhenian coast, where a Neanderthal skull was discovered within a circle of stones, surrounded by the bones of a wide variety of animals; two fractured metacarpals of an ox and a deer were placed beneath the cranium. The skull had been shattered on its right side, and at its base the *foramen magnum* connecting the brain with the spinal cord had been enlarged, a practice necessary to extracting the brain.[10] Once again the discoverers saw proof of cannibalism in this evidence, but the same attack on the *foramen magnum* is made by modern tribesmen intent merely on removing the brain mass at the time of secondary burial.

Suggestive of attitudes toward the dead in this era is the find at La Ferrassie, where a decapitated male corpse was found below a rock shelter, the body bound in a fashion resembling that used to restrain the corpse from troubling the living among some modern peoples; a woman and four children buried nearby were left intact and unbound.

Thought to be roughly contemporary with the Mousterian finds of Europe are the human remains of the Ngandoeng terraces of the Solo River in eastern Java, where skulls appear to have been hacked open (suggesting a cannibal feast to some) and subsequently used as bowls.

From the Mousterian, too, come a number of finds of animal skulls placed in shrinelike assemblages. Whether connected with the hunt or totemic in character

(or both), these seem most frequently to contain remains of bears, as at Drachen-loch in Switzerland and at Petershöhle near Nürnberg.

Nor have we reached the farthest chronological limit to which the cult of skulls can be traced. For some time investigators have speculated that the fact that a large proportion of the finds of earliest humanoid remains consists of skull and jaw fragments cannot be attributed to pure chance or entirely to the somewhat greater resistance of these bony parts to decay by comparison with the rest of the skeleton. The most famous of all these finds, those of "Peking Man," *Sinan-thropus pekinensis*, from Dragon-Bone Hill near Choukoutien, which have been dated as early as 500,000 B.C., now number fragments of the skulls of at least fourteen individuals, together with teeth and pieces of jaws belonging to more than forty; yet only a handful of bones from other parts of the human skeleton have been found. The skulls show the usual evidence of damage attendant on extraction of the brains, as well as the polish of handling, so that they must have been preserved and used in one way or another before being finally discarded.[11]

The human fragments at Choukoutien were found scattered among large quantities of animal bones; this and the other evidence has led once more to the attribution of ritual cannibalism to Peking Man. On the whole, however, all this evidence remains ambiguous, since secondary burial or other decomposition processes could also result in the same indications, i.e., decapitation and en-largement of the *foramen magnum*. The increasingly dominant view of students of early man is to consider cannibalism a relatively late and metaphysical development, not a truly "primitive" custom.[12]

It remains clear, in any case, that the very earliest traces of what might con-ceivably be called religious belief involve some form of the cult of skulls: the special preservation of the head of the deceased, whether a relative, a victim, or both. Not only does the practice of preserving skulls appear to have persisted through half a million years of human history, but it has disappeared only within a matter of decades from the present day—if it does not still survive in remote regions of New Guinea or South America.

Combinations of ritual cannibalism and the skull cult are reported of a wide variety of peoples, the earliest literary reference being that of Herodotus (IV. 23), to the Issedoni, a people evidently located in Central Asia, who were said to serve the flesh of the deceased mixed with that of slaughtered sheep at the funeral banquet; the skull of the honored parent was later stripped and mounted with gold, to be brought out year after year at memorial festivals.

Especially common are stories of such mounting of the skull and of its use as a drinking cup.[13] We have already cited the presence of the skull cult in Lamaist Tibet and tantrist India; in more conventional Buddhism the bowl which Amitabha

holds as a receptacle for the nectar of immortality comes also to be represented as a human skull. Elsewhere, a skull excavated at Pompeii in 1875 was mounted with precious metals and inscribed in Greek, ''Drink and you shall live for many years.''

Most early references to the use of skulls as cups describe them as battle trophies. This is true of Herodotus' report of the Scythians, Livy's of the Celtic Beii, who invaded Italy in the third century B.C., and Plutarch's rather general one of the Teutons of Northern Europe. Paulus Diaconus tells a famous story of the Lombard use of the skull of the defeated chief of the Gepids in the sixth century A.D., while the Bulgars mounted in silver the cranium of the Byzantine Emperor Nicephorus I after defeating him in 811, and the Pechenegs used gold for that of the Russian chief Sviatoslav in 972. All these references seem to relate to peoples migrating out of Central Asia; Chinese annals report from the opposite margin of the same area similar practices of the Huns and other Turkish tribes. Elsewhere, Spanish explorers reported similar practices among a few of the Central and South American Indian tribes; modern visitors to the same areas have found it surviving there. We have already cited the occurrence of a skull cult in Australia.

Existing over better than 99 per cent of all human history, the skull cult could scarcely be expected to have remained absolutely immutable in beliefs and practices from beginning to end. Little as we can know with certainty of the customs of our Palaeolithic forerunners, it would appear that some changes did take place in these beliefs during their period of activity and that still other shifts occurred during more recent Mesolithic and Neolithic times. These modifications in practice may well reflect changing attitudes toward the nature of the afterlife, as well as a changing relation between the living and the dead.

Already in the obscure dawn of mankind there was enough of a sense of the significance of the departed to bring their survivors to take special measures with the skulls, extracting the brains—whether or not for cannibalistic purposes—and perhaps using the skulls as receptacles thereafter. There is no sign of any particularized concept of the afterlife from which the dead might play, in spirit form, a continuing part in the existence of the living. In the Mousterian period, on the other hand, the practice of burial seems to have been introduced, as well as the placing of remains, including those of animals, in special cult locations and arrangements. These new customs, together with the binding of the corpse, suggest that a concept of the survival of the individual spirit had entered the framework of religious belief, however vaguely defined might have been the distinction between human and animal spirits.

With the appearance of *Homo sapiens* after the last glaciation, we can discern virtually all the practices of the skull cult known to recorded history and to

modern anthropology: skull cups, orientation of remains, sacrifices to the dead, and apotropaic usages, all intimating the existence of fairly concrete beliefs about the survival of the spirit in the afterlife. The Neolithic practice of burying skulls under or near inhabited quarters, as at Jericho, is almost certainly an indication of a fully developed doctrine of spiritual protection, whether by former friends and relatives or vanquished enemies.

The modeling of a face on the skull, then, is only the final stage of a long development toward the practice of magical means of reviving the dead for the benefit of the living: from the ochre coating of the Neanderthalers (and the painted skulls of Australian bushmen, Figure 8) toward some attempt actually to duplicate the appearance of an individual in life. Something similar exists in the practice of preserving or imitating the skin of the head, as found in parts of Africa (Figure 9), among the Maori of New Zealand (Figure 12), and notoriously with the Jivaro in South America.

While the links in this long chain of development are tenuous to say the least, the general course is clear enough; but any connection with the purposes of portraiture has become more and more remote. In the first place, when it comes to

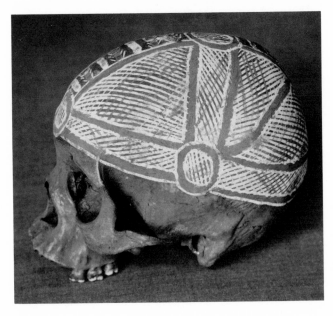

FIGURE 8 A skull from Arnhem Land, Australia, painted, but with no other accretions or decoration. This treatment of the skull is recorded in Palaeolithic levels from various parts of the world.
Baltimore Museum of Art, Wurtzburger Collection

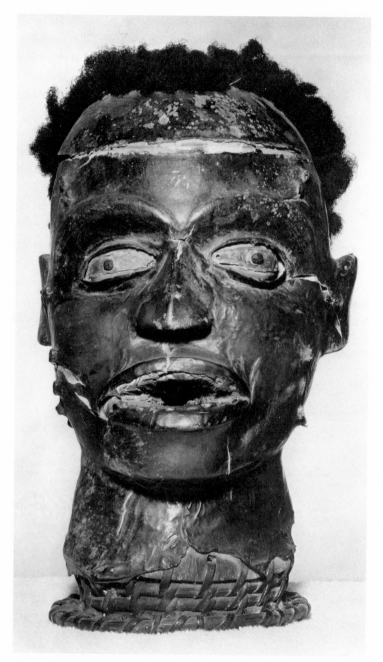

FIGURE 9 A mask from the Ekoi tribe of Southern Nigeria, covered with skin (which may or may not be antelope) and prepared with hair and shell eyes to duplicate the appearance of a human being.

Baltimore Museum of Art, Wurtzburger Collection

the modeled skulls, we have no way of knowing what the faces were intended to resemble; the time which would have to pass between death, decomposition, and reconstruction would limit inspiration to that supplied by memory, supposing the intent were to reproduce the features of the particular deceased. The real question is whether any such intent could have been entertained at all. Nothing we know of Neolithic art suggests that it would. (Objective examination of the Jericho heads tends in any case to weaken the impression of any serious degree of realism. The faces are actually quite generalized. Of course the excavators were startled by them at first sight, but that initial impression need not govern all subsequent reactions.)

Second, the conceptual basis of such practices is quite the opposite of that which underlies portraiture as we know it. The interest does not lie in the subject but in the beneficiary, the survivor who receives protection from the spirit represented by, or housed in, the relic.

The use of the term ''relic'' serves as a clue to the understanding of the use of these skulls. Aside from the use of an occasional skull as a *memento mori*, as with St. Jerome, the medieval Christian church, for example, had a strong belief in the efficacy of contact with the physical remains of holy persons, as well as objects to which power had been imparted by contact with sacred personages and events— the instruments of the Passion most conspicuously. Just one example might be cited: the skull of St. Sebastian, preserved in the church at Ebersberg in Bavaria, which is not only revered by the faithful but used as a utensil; on the saint's name day, January 20th, consecrated wine is poured from the skull to be drunk as a cure for any disease. This skull is ordinarily protected by a silver bust of the saint. The point is significant: the church has a use for representations of its sacred persons and objects, as well as for relics proper—and no confusion exists between the two.

The relics preserved by the cult of skulls were magical charms to help the living. We cannot legitimately consider them as ''representations'' or ''likenesses'' of the deceased. Even when a vestige of naturalistic physical appearance was imparted to such relics, as in the skulls from Jericho or New Guinea, this was done only for the purpose of enhancing their efficacy, by making them look more like living humans in general. The intention was not to recreate the appearance of a particular dead man for his sake.

Just as, in the medieval Church, relics and icons existed side by side, we can find in Neolithic societies effigies intended to represent the dead. It is from these, rather than from the preserved skulls and heads, that we gain an idea of what, at this stage of cultural and religious development, a representation of an individual was apt to look like.

Funerary Images

In New Guinea, the same Sepik River tribesmen who modeled faces on some of the skulls of the dead also prepared figures to receive the souls of the departed; but these images bear no sort of resemblance, in the naturalistic sense, to the human form. On New Ireland, where the skull cult does not seem to have gained currency, funeral posts were carved which depict, not the physical appearance of the deceased, but the mask which he wore on ceremonial occasions; this was of course a unique design which did serve to indicate his identity (Figure 10). Similarly, on New Zealand, the Maori tribesmen are said to have identified individuals by the patterns of their facial tattoos without any indication of the underlying features (Figures 11 and 12).[14]

In Central America there are records of images of dead kings, although we have no detailed descriptions of their appearance. Under certain special circumstances, as when a traveler died far from home or when warriors were killed in battle, effigies might be made for their funeral services; in the latter case, one figure might serve as collective representation.[15] This fact alone would indicate that physical naturalism was not considered a requirement for such figures.

A little farther north, in Southern California, the Diegueño made, for festivals of the dead, effigies of eagle feathers, matting, and cloth which were intended as receptacles for the spirits of the dead. The face was supposed to bear a likeness to the departed, but descriptive details indicate that this must have been of a very limited nature. The mouth was painted red outside and black within, the teeth were of pearl, and the eyes were made of abalone shell with black-wax pupils. For its journey to the spirit world the ghost was supplied with food and drink in two small vessels hung in a net round the neck. The completed image was thought to be occupied immediately by the spirit of the dead, and at the end of the festival it was burned, together with a variety of offerings, in order to free the soul for its journey.

Still farther north, the Indians of the Northwest Coast occasionally made posts as representations of the dead, but almost invariably these seem to have been made only for those lost at sea or in any case away from home. In some cases such images might contain the ashes of cremation returned from the spot of death.

In all these examples the question of accuracy of physical resemblance between effigy and original remains at best conjectural, although surviving material from the Northwest Coast gives some indication that the representation was no more naturalistic than that of, say, New Ireland. It is clear, however, that the effigy was always carefully identified in one way or another with the individual whom it was to serve. The function of these effigies, however, should not be

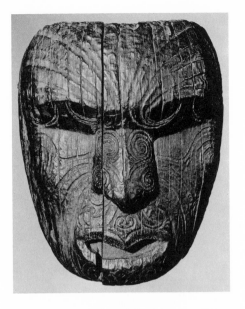

FIGURE 10 A funerary monument from New Ireland representing not the deceased man's appearance, but the mask which was worn by him on ceremonial occasions.

Chicago, Field Museum of Natural History

understood as commemorative; they might best be compared with lightning rods—conductors directing the powerful energies of the spirits of the dead away from the community of the living, impelling them safely into the other world, whence they could not imperil the survivors.

There is one other area of the New World where examples have been found of a kind of portrait image which is perhaps the most startlingly individualized of

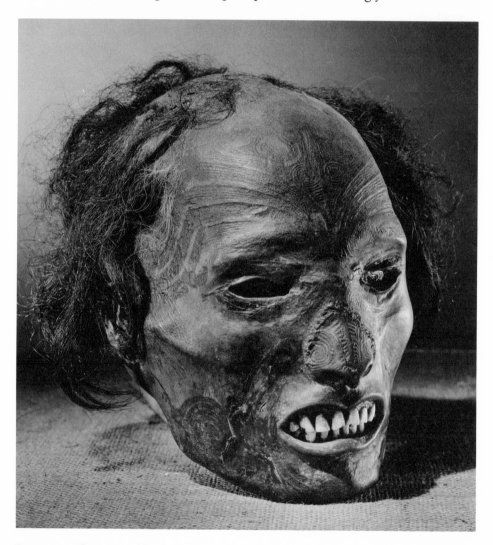

FIGURE 12 The preserved head of a Maori tribesman, illustrating the nature of the tattooing which was applied to the male features. The preservation of the head itself seems significant among this Polynesian people.
Chicago, Field Museum of Natural History

all the protoportraits to be found in primitive art: the Mochica portrait jars of the early Chimu culture, which flourished along the northern coast of Peru from about 500 to 800 A.D. (Figure 13). Here we must study the image in total isolation, with no certain knowledge of its function and little enough of its cultural environment. Only the amazingly lifelike appearance of the finest of these pottery faces conveys the sense that we must be dealing with some kind of portraiture.

This may well be so, but we must reserve decision. The pots may perhaps have been modeled for funerary purposes, to hold the ashes of the dead, as were some of the wood carvings from British Columbia. In this event, they would constitute the most extreme development of the tendency of this kind of funerary magic to reach a degree of naturalism in the interests of maximum efficacy. On the other hand, many of the jars verge on caricature, as in the representations of grotesques and of the malformed and diseased; even among ''normal'' examples the number which really conveys the kind of startling immediacy which characterizes the group as a whole as ''portrait jars'' is quite small. We may well be dealing, in fact, with an advanced level of idealization of character types rather than with individualized characterizations. Finally, since molds were used in the production of these jars and a certain number of duplicates have been recorded, the direct image-to-subject relation implied by the use of the term ''portraiture'' in connection with funerary practices must be suspect.

The suggestion has been made that the portrait likenesses found among these jars were based on the appearance of certain chieftains and were then reproduced for the use of their subjects. This possibility would indicate circumstances not unlike those under which Egyptian portraiture was produced, in which the image of the Pharaoh tended to condition the representation of his courtiers; in any case, it becomes extremely improbable that the funerary function of these jars, if any, was related to deliberately realistic portrayal of the deceased.[16]

A final and supreme example of funerary effigies of realistic type is found in Nigeria, where a group of amazingly naturalistic bronze—or rather brass—heads was produced at Ife some time before the arrival of Europeans in the fifteenth century (Figure 14). Even though it is no longer believed that these heads were made under the influence of Europeans, we cannot assume that they were produced in absolute isolation from the influence of societies already acquainted with the fully developed realistic portrait.

The suspicion that the original inspiration for this group of especially convincing (although none the less strongly idealized) likenesses came from outside this region is supported by the probability that the technique of *cire-perdue* casting itself was an importation at this time.[17] The very earliest of these brasses

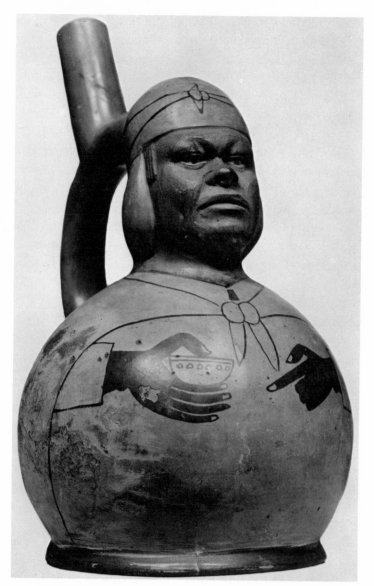

FIGURE 13 "Portrait jars," like this one, made by the Mochica culture of Peru between about 500 and 800 A.D., represent a startling incursion of convincingly naturalistic portraiture into the work of a prehistoric culture not otherwise known for attention to realism of representation. The deliberate contrast between the highly particularized head and the extremely stylized body is a conscious device which succeeds in heightening the sense of conviction of the likeness. On the other hand, the jars were produced in molds, and hence duplicated, so that specific reference to particular individuals in any conceivable use of them seems unlikely.
The British Museum

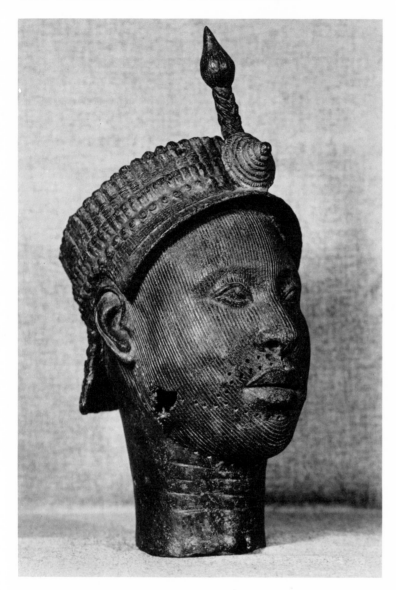

FIGURE 14 The brass portrait heads from Ife, in Nigeria, represent the farthest development of
the art of realistic portraiture known in Africa. They date from before the earliest contacts with
European explorers, but the extremely brief flowering of the art at its technical and naturalistic
height suggests, none the less, that it was the product of an intrusion into the Yoruba culture.
The British Museum

are apparently the most sophisticated in technique; the later ones show thickness of metal, crudeness of execution, and loss of naturalism in portrayal—especially at Benin, where the craft was transplanted from Ife. There is evidence that these metal heads were created to reproduce in more durable form effigies made originally in more fugitive materials, not unlike those of the festivals of the dead of the Diegueño Indians. That there was a long tradition of terra-cotta sculpture in Nigeria onto which the new metal-casting craft could be grafted cannot be in doubt; but it would not be safe to judge the potentialities for realistic representation of genuinely primitive art from the standpoint of what was achieved for a few generations at Ife—however brilliant the products may be as works of art.

All the material related to portraiture discussed so far—and, while not exhaustive, the survey may fairly claim to be representative of all the material currently available from prehistoric and preliterate societies—relates, as far as we have any way of knowing, in one way or another to the disposition of the dead by the living.

1. At the dawn of mankind, and throughout the Palaeolithic era, preservation of parts of the body, and particularly the skull, was associated with the honoring of the departed and perhaps with the aim of obtaining benefits from a continuation of the relationship begun in life, or at least magical control over the spirits of the dead for the benefit of the living.

2. In Neolithic societies, at Jericho just as among tribes of recent times, skulls were used to protect the living through the magic power of the spirit world and came to be decorated, painted, or modeled to increase the efficacy of performance of this crucial function.

3. Finally, in funerary effigies, receptacles were provided for the spirits of the dead, to avoid their impingement on the living. Although such effigies may have existed far earlier in prehistory, their customary fashioning from impermanent materials would give them no chance for survival, even where they would not have been destroyed in the normal course of events after the completion of the ritual.

Closely allied to the funerary effigy, rather than to the skull employed as a relic for its magical benefits, is the mummy, the preserved body used as a housing for the spirit. The concept underlying mummification differs from that which motivated the making of the effigies, since the latter were most commonly used merely as temporary housing for the spirits en route to their final destination. The mummy—and the effigies which ultimately developed from the mummy cult, at least in Egypt—was conceived as a permanent receptacle for the spirit of the dead. It may therefore be assumed that its use enters the picture only at a

time when the dead are no longer feared but are either valued, for the protection they might offer, or regarded as psychically neutral. In any event, the basic motivation in attempting to gain for them permanence of physical state would be the hope that similar help would be received in turn, each generation caring for its predecessor. The action of creating the mummy, then, while still partaking of magical significance, is not so directly self-serving as the production of one of the earlier types of relic or effigy; the creator does not expect immediate benefits from his creation.

Mummification seems to have arisen as a practice in areas where natural desiccation was apt to occur in any case, generally in arid regions widely separated geographically. Desiccation was taken advantage of by the Basket-Maker Indians of Arizona and elsewhere in the American Southwest as well as in Mexico; mummification proper was practiced by early societies living on the arid coast of Peru.

However, the most elaborate development of the processes of mummification, as of the funerary portrait, took place in Egypt, as man emerged from the shadows into the light of recorded history.

Egypt: The Old Kingdom

The funerary statue can be considered the pre-eminent figurative type produced by the artists of the emerging Old Kingdom, and it is noteworthy that this form developed side by side with the elaboration of the technique of mummification. The increase in production of effigies, in fact, seems to have been the direct corollary of the growing emphasis in Egypt on physical preservation of the material shell of the individual human being. Portrait-like statues, in other words, had their origin as alternate abodes for the spirit—the *ka*—of the deceased, while the very concept of the *ka* was evolving concurrently with the development of the funerary statue itself. Such statues were also employed as objects of the elaborate mortuary ritual, carried out in funeral chapels, in those increasingly frequent cases in which the body was buried in a chamber inaccessible to celebrants; these ritual ceremonials were necessary to assure continued life beyond the grave.

It may be that a root of the funerary-statue concept may be traced in an occasional elaboration of the treatment of the mummy itself, which seems indeed like an extension of the Neolithic custom of decorating the plastered skulls:

In two graves of the Sixth Dynasty, Professor Junker found the corpse covered first with a fine linen cloth to protect the mouth, ears and nose from a layer of stucco-plaster which was then applied and modelled according to the form of the body. The head was so accurately followed that in one case the fallen-in nose and twisted mouth could be clearly

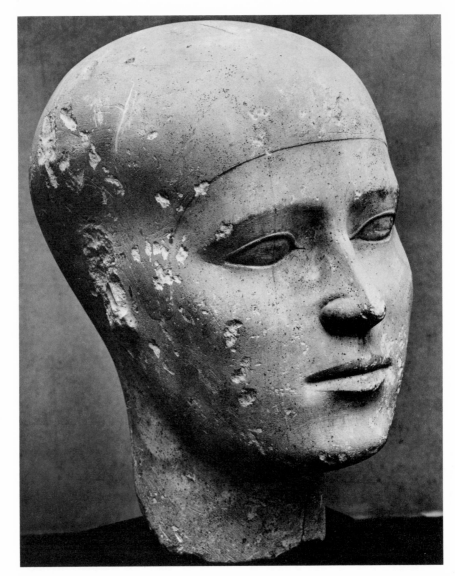

FIGURE 15 Detached "reserve" heads, like this one, found in a group of tombs from Old Kingdom
Egypt, dated *ca.* 2600 B.C., are believed to have been intended as substitutes in case of damage to the
mummy itself; they occur only where no funerary statues are found. Although vivid by comparison
with normal Egyptian sculpture, the likenesses are strongly generalized, and it has been suggested
that they represent the head already wrapped in cloth for burial. All the tombs in which these heads
have been discovered were made for members of the family of Khufu, Pharaoh of the Great Pyramid;
thus it is possible that they are due to some special circumstance, such as an intrusion from a variant
culture.

Vienna, Kunsthistorisches Museum

seen. In two other instances only the head was covered with plaster, and on the linen
enveloping the head of Idew II the face was painted.[18]

This practice appears to explain the curious provision of "substitute" or so-
called "reserve" heads in certain tombs of the reign of Sneferu, the predecessor of
Khufu in the Fourth Dynasty. These life-sized heads, artistically among the finest
products of the sculptors of the Old Kingdom (Figure 15), have been found only
in tombs where no statues or statue chambers have been located. Instead, these
heads were placed in the burial chamber itself, evidently as substitutes in the case
of damage to the mummy.[19] Although they are sometimes held up as examples of
highly developed Egyptian realism, objective examination reveals that they are
not truly specific in their treatment of physical detail; in fact they are quite
strongly simplified and idealized. It has been suggested, significantly, that what
they duplicate is the appearance of the *wrapped* head of the mummy, modeled in
plaster, just as in the cases from the Sixth Dynasty, cited above.[20]

Far more striking in its naturalism is the famous bust of Ankh-haf, in the
Boston Museum of Fine Arts (Figure 16). Yet this figure is apparently unique in
its degree of specificity: it is not at all typical of the run of tomb statues of its
period, being approached only by a handful of other images from the Old King-
dom, among them the seated scribe, Kay, now in the Louvre (Figure 17), and
the famous Ka-aper, whose sobriquet, "Sheik-el-Beled," was received when the
native workmen at the dig exclaimed at its "speaking likeness" to the chief of
their own village.

It is dangerous to put too much emphasis on the individuality and realism
of these images; it is perhaps noteworthy that their lifelike qualities are usually
most appreciated by those who are not Egyptologists. Specialists tend to be more
cautious about acknowledging the degree of specificity actually present in the
image. Their attitude is expressed by Engelbach:

> The statue of the well-known Sheykh el-Balad seems to radiate personality, but in
> the absence of another portrait of this noble we are unable to say whether the expression
> obtained by the artist was fortuitous or not. The eyes are inlaid and appear to have come,
> so to speak, from stock, and the mouth differs very little from those of other Old King-
> dom statues. Furthermore, if analogy counts for anything, the statue was most probably
> gessoed and painted and when new it must have been far less expressive than it is now.[21]

The words, "in the absence of another portrait," are especially significant; for
in some cases several images of the same subject have been found, and they tend
to vary widely in appearance. This is true of Kay, the Louvre Scribe, whose com-
panion statue is quite different and far less convincingly realistic; the same thing
can be observed in the several statues of Mitry, an official of the Fifth Dynasty, in

the Metropolitan Museum (Figures 18 and 19) or those of Khnumbaf in Boston.[22] The irreconcilability of various likenesses of the same person is clearest of all in the royal portraiture. In the triads of Mycerinus, for example, where the Pharaoh is grouped with Hathor and a nome deity, the three profiles in each group are identical; but, from group to group, no two likenesses of the Pharaoh himself are identical.

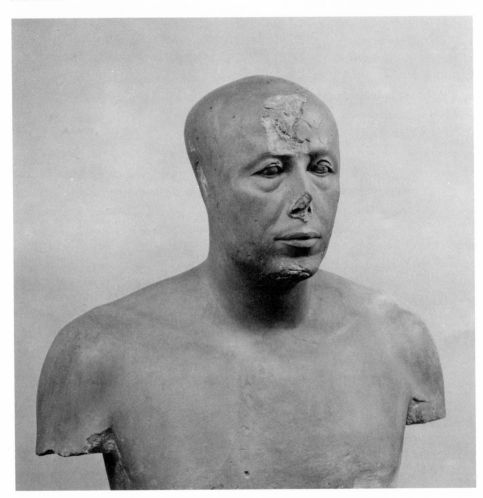

FIGURE 16 This bust of Ankh-haf, prince and vizier of the Fourth Dynasty, has been said to come "as close to realism as the idealistic conventions of the Egyptian style permit." Made of limestone coated with plaster and painted, it was probably not made as a tomb statue at all but represents, like the "reserve heads," a special situation within Old Kingdom portraiture.
Boston, Museum of Fine Arts

FIGURE 17 Kay, the "Louvre Scribe," is an Old Kingdom tomb figure which stands as an out-
standing example of lifelike naturalism. Yet other statues of the same official, found in the same
tomb, show neither the liveliness nor even the exact features of this representation.
Musée du Louvre

This variation among likenesses of the same individual is not to be explained
in terms of varying levels of competence among the artists producing them, for
variation of this kind is far too prevalent at all periods of Egyptian art to be
explained in this way. Above all, if the obtaining of an absolutely faithful likeness

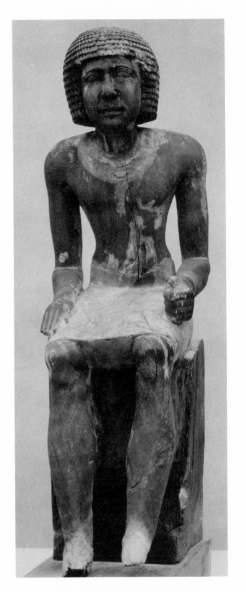

FIGURE 18 The portrait of Mitry, an important
official of the Fifth Dynasty, extends the repre-
sentational techniques of the servant statue to
the execution of a funerary image.
*New York, Metropolitan Museum of Art, Rogers
Fund*

FIGURE 19 Another portrait of Mitry, fol-
lowing the same pictorial conventions, without
establishing any convincing sense of looking
like Mitry himself or even the other portraits
of him.
*New York, Metropolitan Museum of Art, Rogers
Fund*

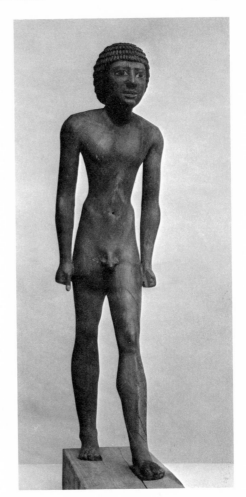

FIGURE 20 A typical "servant statue," placed in an Old Kingdom tomb for the use of the departed in the next world, shows none of the effort to obtain an individual likeness apparent in some effigies of the honored dead. On the other hand, it employs most of the same conventions used to delineate the features on the funerary portraits themselves.
The British Museum

had been a prime desideratum among patrons, the less competent artists would not have been used by those who could afford better, and we would expect to find the levels of accuracy stratified generally according to the luxury of the tomb as a whole. Instead, the degree of naturalism varies quite independently of the lavishness of the burial as a whole and can in fact be ascertained most clearly because it does fluctuate within single burials.

This extreme variation in approach to the likeness appears to be explained rather by the fact that, although the catching of an accurate physical likeness was obviously within the capabilities of the best of these early Egyptian artists—who were not only highly competent craftsmen but artists whose interests were directed toward and closely attuned to the careful observation and rendering of

natural appearances—such accuracy was not actually required for the purpose to which the statues were to be put. It was, in fact, virtually irrelevant. We may recall Gombrich's words: "The correct portrait . . . can be constructed to any required degree of accuracy." [23] Physical resemblance was not the essential aim of the Egyptian funerary statue.

These portraits were meant to be identified with their subjects, but this identification was accomplished, not by physical resemblance—although the artist could be motivated to make them "like"—but by the inscription, which included the subject's name. Once named, the portraits were securely identified as long as the inscription remained unchanged; if it were altered or defaced, then, no matter what the appearance of the image, its identity as a portrait was immediately altered. The fact that none of these works was made to be seen by the eye of man may have had a bearing on this: "The statues . . . were usually to be hidden away from the eyes of men in special shrines or tomb chambers. Their function was the utilitarian one of acting like the god-sticks of Polynesia as the repository of supernatural force." [24]

What comes through to us from the most lifelike of these funerary portraits, it might be said, is the individuality of the sitter but not his personality, his humanity. A distinct and specific human being may be depicted, but his likeness is anything but revelatory of his inner self. Because these images were for use in the future, they could not record the past or portray the present: "They tell us nothing of an inner human life of fears, hopes and suffering; but there is revealed the serene optimism of an assured eternity." [25]

The magical character of these statues is indicated by the way in which they were employed. In the tomb chapel, where the funerary statue was placed, it received the same rites from the priests as the actual mummy would have, had it been accessible. The smoke of incense enveloped the statue, and food offerings were placed before it. Ritual practices actually began in the sculptor's workshop, where the initial ceremony, called the "Opening of the Mouth," was performed to bring the object to "life."

It is easy to see, then, why the sculptor was called "he who makes to live," and why bringing a funerary portrait into effectuality was considered an act of creation—a rebirth or renewal of life itself. Once dedicated in this way, the statue served as a substitute for the body of the deceased in every way, just as, in the temples of the gods, the images received the devotions due to their prototypes.

Although the earliest available text of the ceremony of the "Opening of the Mouth" dates only from the Nineteenth Dynasty, its elements are clearly traceable as far back as the Old Kingdom and have their origin in the ancient formulae

which were designed in the first place to reconstitute and revivify the mummy itself, through the restoration of its *ba* and *ka*. In its earliest forms the ceremony as preserved seems to have been performed on the funerary statue, with the sacrifice of an ox, lustrations of various kinds, and a variety of other operations. In the Eighteenth Dynasty the ceremony had come to be applied to the mummy; but by that time the whole rite had been amalgamated with the rituals of Osiris, and the making of funerary statues was in something of a decline.[26]

In this context, the question of Egyptian belief about the nature of the soul, of both the living person and the dead one, becomes significant. The Egyptians conceived of two aspects of what we would term the "spirit" or the "soul": the *ba* and the *ka*. The *ba* comes closest to our concept of the individual soul or ghost, continuing life after death. But for the Egyptians this life of the soul was not continuous. There was a real discontinuity at the moment of death. After death the body had to be revivified, that is, have its *ba* reinjected into it.

As Breasted has pointed out, although among no people ancient or modern has the idea of life beyond the grave held so prominent a place as among the Egyptians, the belief in the immortal and imperishable soul cannot be attributed to them. The purpose of their mortuary ritual was to reconstitute and resuscitate the deceased after the dissolution by magico-mechanical processes and ceremonies external to him, to enable him to continue his existence in the hereafter.[27]

The *ba* was represented pictorially in the form of a human-headed bird, while the *ka*, the vital force or creative power, was portrayed by two raised arms with outspread hands, the *orans* position of prayer virtually universal in early religious practice. The *ka*, unlike the *ba*, began its effective existence only at the death of the body, as a guide for the departed in the afterlife. Only the Pharaoh, who was, after all, a god rather than a mere human, held communion with his own *ka* during his lifetime.

In the earliest period of Egyptian history, neither of these aspects of the soul was considered a necessary attribute of all human beings. In the Old Kingdom not even nobles had *ba*'s. Since the *ba* was originally an attribute of divinity, it could not belong to mortals but only to the god-king. Pharaohs and nobles both possessed *ka*'s, but, as we have seen, the relation to the *ka* during life was tenuous at best. It has been suggested that some Old Kingdom nomenclature implies that a noble's *ka* was actually his Pharaoh or some other god; and this is perhaps another way of saying that a man's fortune was not dependent so much upon his own efforts or abilities as upon the favor of superior divinity.[28] Only in the Middle and New kingdoms did the *ka* become a possession of commoners as well as their rulers, and at that time it began also to take on a more impersonal character. It was then

understood as the vital principle of life, born with each individual, sustaining him throughout life, and proceeding with him into the next world.

The circumstances of Egyptian life during the Old Kingdom did in fact encourage a degree of individual initiative, in a situation still sufficiently open to offer the prospect of advancement through effort directed along the proper lines. It has even been suggested that an excess of individual ambition played a part in the eventual fragmentation and disintegration of the central power of the Old Kingdom itself. Books of advice and counsel such as the "Instruction of Ptah-hotep" remind us of familiar latter-day manuals like "Poor Richard's Almanac." Yet this individualism never existed, in principle, outside the framework of the Pharaoh's own divine power.

It was the royal power, real or illusory, which formed the true focal point of existence, both in this world and the next. As a god, Pharaoh was assured of eternal life; the noble was not so assured. The latter's best chance of immortality, then, lay in his having the closest possible relations with his god-king.

If he could be buried close to the royal *mastaba* or pyramid, if his titles as carved on his tomb clearly stated his service to the pharaoh, and if the inscriptions of his tomb expressed his dependence upon royal pleasure, he might then be needed as an agent in that continued rule which the deceased pharaoh would enjoy in another realm. . . . In the earliest dynasties, only those were sure of eternal life after death who carried within them the germ of divinity—king and queen, prince and princess—and . . . the noble class apparently depended upon royal need of their services in order to gain such eternal life. . . . As to the lower grades of society—merchants, artisans, peasants, serfs, and slaves . . . probably they, like the nobles, depended upon their immediate overlords.[29]

These considerations have an obvious bearing on our evaluation of the reflections of individuality to be found in the art of Egypt, whether of the Old Kingdom or later. The Old Kingdom is the age when the individual Egyptian had widest scope for self-expression, and this fact seems relevant to the wide variety of expression to be found in the tomb sculpture, as in the other arts of the period. Taken as a group, the portraits of the Old Kingdom are the most individualized and naturalistic of any major period of Egyptian history; yet this character is established on the basis of a comparatively small number of surviving works.

This was an age of discovery and invention, when virtually all the principles underlying Egyptian civilization were discovered—and stereotyped. As Schäfer remarked, the individual observations in Egyptian art are isolated and remain without consequence; accidents are weeded out by natural selection. The more Egyptian art develops, the less frequent are variations from the type.[30] "We must remember that the ancient Egyptians desired the representation which best served the purposes of eternal life and that this necessarily had a great deal of the static and idealized."[31]

Egypt: The Middle Kingdom

The centralized power of the Old Kingdom dissolved into feudalism. After the obscure years of the Sixth Dynasty, during which the process of disintegration was accelerated, there followed more than a century of sheer anarchy in the Nile Valley. The sense of the realizable potential of the individual human being, which had been discernible under the Old Kingdom rulers, evidently had gradually eroded the central government's cohesion; the interregnum, subsumed under the designations of the Seventh through the Tenth dynasties, saw what might have been "democracy" dissolve into nothing better than chaos. The seeds of egalitarianism were present during this period, but they failed to bear a healthy fruit.

One of the Pharaohs of the Herakleopolitan dynasties that struggled for a share of power during this interregnum has left a set of instructions for his son, Meri-ka-Re, which reflect the comparatively open attitudes of this time of troubles: "Advance thy great men, so that they may carry out thy laws. . . . Great is a great man when his great men are great; valiant is the king possessed of courtiers; august is he who is rich in his nobles." Here is the antithesis of the attitude of the age of the mastabas: instead of the nobles drawing all virtue from the king, the ruler draws his from them! "Do not distinguish the son of a (noble) man from a poor man, (but) take to thyself a man because of the work of his hands."[32]

This almost democratic spirit was not, however, the confident, assured individualism expressed in Old Kingdom texts and visible in its art; insecurity and pessimism were natural concomitants of the precarious circumstances under which life was carried on from day to day under the Herakleopolitans. It is from this period that one of the most remarkable of all Egyptian literary texts derives, the "Dialogue of a World-Weary Man with His Ba," or soul.[33] In this unusual record of a personal religious experience, the contemporary temptation to elect suicide in the face of loss of faith in divine (Pharaonic) power and social disintegration is explored and, evidently, rejected. This text must be understood in terms of the changing beliefs in concepts of the afterlife which reached full maturity under the Middle Kingdom. From the Old Kingdom's emphasis on material survival of the body we pass to a more spiritualized conception of the next world—from the cult of Re to that of Osiris, which spread from its early home in the Delta throughout Middle Kingdom Egypt. This cult, which had a natural effect on funerary practices, replaced the earlier belief in the material presence of the deceased in his tomb with a concept of an afterlife of the spirit, not the body, in the realm of the god.

Attention was still paid to the preparation and preservation of the corpse, but the portrait statue as a repository and cult object lost its former importance.

In consequence, images of nonroyal personages become infrequent in the Middle Kingdom; any attention to preserving the likeness of the deceased is confined to the mummy mask. At the court, however, where the cult of Re in any case retained its importance in the state ritual and where the pharaonic image was used as a cult statue as well as a repository for the divine royal spirit, portrait statues retained their old popularity. Yet even here the effect of changing belief is evident, for the magical significance of the portrait image as a likeness is diminished. The actual portraiture produced under these circumstances comes closest to a mature definition of that art—the likeness "for its own sake"—of anything in Egyptian history (Figure 21).

The characteristics of Middle Kingdom portraiture have been remarked many times:

> The heads that wear the Middle Kingdom crowns lie uneasy; . . . the expression is almost brutal, or severe; at the most sympathetic, it is sad and introspective. The artist seems to be less concerned with delineating majesty or divinity than with *conveying an official mood*; less with imprisoning godhead in stone than with releasing human characterisation.[34]

> The sculptures of this time sought to bring out this emphasis on conscientious character and moved from a delineation of majesty and force to a portrayal of concern for obligations. Such careworn portraits of the pharaohs of the Middle Kingdom are well known.[35]

These harrowed portrait images find a striking parallel in the literature of the same age. The classical text for this analogy is the Instruction of King Amenemhet I, who was in fact ultimately the victim of a palace conspiracy:

> Hold thyself apart from those subordinate to (thee), lest that should happen to whose terrors no attention has been given. Approach them not in thy loneliness. Fill not thy heart with a brother, nor know a friend. Create not for thyself intimates—there is no fulfillment thereby. Even when thou sleepest, guard thy heart thyself, because no man has adherents on the day of distress.[36]

Not only is this disillusioned attitude very different from that shown in the Herakleopolitan ruler's Instruction to Meri-ka-Re; it is still further from the Old Kingdom conception of the Pharaoh as a sublime divinity far beyond the reach of ordinary humankind. Amen-emhet is, at least for the moment, a fallible man himself, fully aware of the perils which beset his humanity on every side.

The air of haggard watchfulness worn by the images of the Twelfth Dynasty Pharaohs certainly confers a strong sense of individuality at the same time that the magical function of the image is patently diminished. "With [the portraits of

FIGURE 21 This head of King Senusret III, a Middle Kingdom Pharaoh who ruled Egypt about 1800
B.C., is in red quartzite, which seems to have stimulated the sculptor's sensitive portrayal of a mood
of melancholy quite different from the harsh bitterness expressed by portraits made further south
in the Nile Valley about the same time.
New York, Metropolitan Museum of Art, Gift of Edward S. Harkness

Amen-emhet III], in fact, we may fairly claim that the Egyptian sculptor transcends the concept of statuary as a repository of superhuman force, and achieves instead an embodiment of human personality."[37] It was his subjects that the Pharaoh wished to impress with his sleepless vigilance; these images were made for the eyes of men, not for unwatching eternity, and herein we see the reason for our own apprehension of a new dimension in Egyptian portraiture.

Yet the question remains: Just how individualized in actuality were these works? Do they really give us an objectified view of the appearance—and the character—of their subjects, or are they rather "conveying an official mood"?

The very fact that this apparent realism of treatment is evident only in the portraits of the Pharaohs of the time is an indication that the nature of the individual subject himself is not the artist's concern. Only the Pharaoh is represented in the guise of a thought-laden personality—and the Pharaoh is, even in this era, ultimately not a mere man, but a god (Figure 22). May it not be true, then, that "The apparent realism of these royal heads is thus actually a different expression of the idealized ruler"?[38]

Despite the time-bound character of the depiction of the Pharaoh's visage, the direction taken by art in the Middle Kingdom, seen as a whole, is not toward, but away from, the naturalism of the Old Kingdom. Soft, easily carved limestone —not to mention wood, valued in the Old Kingdom because of its scarcity in the Nile Valley, and hence in no way considered inferior to stone as a substance— was no longer used for important images. Instead, hard stones were employed which would take a high, antinaturalistic polish, and the total impression of the sculpture produced conveys very strongly the sense of the blockiness of the material employed in its natural state.

Difference in scale, furthermore, is now strongly emphasized. Statues of Pharaohs tend to be colossal in size, towering over the images of lesser beings. This may be understood as an aspect of the effort of Middle Kingdom rulers to re-establish the central power, the dominance of the pharaonic court, which had vanished during the interregnum.

We saw that in the Old Kingdom the pyramids of the nobles ceased to cluster around the royal pyramid and became independently located out in the provinces. A similar observation may be made about the Middle Kingdom. At the beginning of the Twelfth Dynasty the tombs of the nobles were relatively large and their inscriptions were dated, not only in the reign of the pharaoh, but also in the reign of the local prince. As the dynasty went on, the nobles' statements became more modest, their tombs became smaller and less assured, whereas the royal tombs became larger and more dominating.[39]

By sleepless efficiency the pharaoh had stolen back from his people the prize of individualism which they had wrested out of chaos.[40]

FIGURE 22 In this portrait of the Middle Kingdom Pharaoh Sesostris III, dating from the mid-nineteenth century B.C., more of the majesty of the Egyptian conception of royal power is in evidence, yet the dynastic mood of worried concern still dominates the image.
Kansas City, Nelson Gallery–Atkins Museum of Fine Arts

Another of those useful texts of instruction, from the reign of Amen-emhet III, supposedly written by a chief royal treasurer, supplies evidence for the new attitude:

> Worship King (Amen-emhet III), living forever, within your bodies and associate with his majesty in your hearts. He is Perception which is in (men's) hearts, and his eyes search out every body. He is (the sun-god) Re, by whose beams one sees; he is one who illumines the Two Lands more than the sun disc. . . . The King is a *ka*, and his mouth is increase. He who is to be is his creation, for he is (the god) Khnum of all bodies, the be-getter who creates the people. . . . He is (the goddess) Sekhmet against him who trans-gresses his command, and he whom he hates will bear woes.[41]

The omnipotence of the Pharaoh had been recaptured and successfully reasserted by the rulers of the Twelfth Dynasty. The royal power would never again face the individualist challenge of the first interregnum, although far worse political trials lay ahead. The portraits of these Pharaohs were deliberately conceived instruments for the assertion of overwhelming might. Insofar as they were expressions of temporal rather than supernatural power, they did in fact approach nearest to the "true" portrait in its nonmagical sense. But even exponents of their "modern" character are obliged to concede that it is all but impossible to distinguish the weary Middle Kingdom faces one from another on the basis of individualized physical characteristics. Models were in fact carried over from reign to reign, and, as would ever be the case in Egypt, the power-conferring name inscribed on any given statue might be altered to make an image functionally operative for a succeeding ruler.[42]

The true nature of the portrait image in Egypt, not just in the Middle Kingdom but at any period, must be demonstrated by the whole of the evidence. If there was a process of development carrying over from one period to the next, it could be expected to manifest in the later works the revealed implications of preceding ones. Insofar as this assumption has any validity, the art of the New Kingdom serves only to reinforce our evaluation of Middle Kingdom portraiture: that it remains always and essentially idealized in concept.

Egypt: The New Kingdom

The psychological state in which Egypt emerged from the Second Inter-mediate Period was far different from that prevailing at the end of the first. Then centralization had been a product of the forces which had restored the pharaonic power; now centralization was the necessary weapon by which the occupying Hyksos were resisted and ultimately expelled. Thus the break between the

New and Middle Kingdom traditions was far less sharp than the one that occurred between the First Intermediate Period and the Old Kingdom. The second interregnum, with the country in the grip of foreign invaders, was, if anything, more, rather than less, traumatic; yet when unity was restored under native rule, there was a natural tendency to take up exactly at the point where the Middle Kingdom left off, in art as in political theory.

The early part of the Eighteenth Dynasty, the phase during which the Egyptian Empire was built (*ca.* 1550–1375 B.C.), also saw the development of an artistic style which is considered classic for Egyptian art. As the term itself implies, this classic style embodied the most characteristic ideational forms of the art of Egypt's past, in the most thoroughly generalizing stylistic system yet achieved in that country.

The character of portrait statuary was inevitably affected by new mortuary practices. The acceptance of the Osirian doctrine of the immortality of the spirit, already influential in changing the character of funerary art during the Middle Kingdom, became fully ascendant. Although tomb effigies were still made, and indeed were now larger than ever before, their magical significance was almost completely ignored. They were now seen as memorials, not vehicles, for the dead; just as the tombs themselves were now open to visitors, the statues were placed out in the open where they could be viewed. In the same way, the pictorial decorations of the tomb walls (now more often painted than carved in relief) lost their former significance as magical predictions of the future existence of the departed in the afterlife and became biographical documents, recording the achievements of the occupant of the tomb in the life he had relinquished.

Although there appears this new interest in biography of a sort, the individuality of ordinary people can scarcely be said to have been stressed; more than ever, the subject's personality merged in that of the monarch, so that the likenesses of persons living in any single reign all tend to have a family resemblance that is based on the features of their Pharaoh.[43] Even among the rulers themselves, any sense of individual difference was not strong enough to overcome the age-old timelessness which pervades even historical documents:

> The almost omnipotent rulers of Egypt were satisfied, in contrast with the tyrants of all ages, to let their individuality merge with the impersonal portrait of the ideal ruler. Even in the accounts of royal achievements which we should classify as historical texts, we find, to our exasperation, that everything that is singular and historical is treated as of little account.[44]

The tendency to take the appearance of the Pharaoh as the ideal type for all mankind (mankind being, of course, composed exclusively of the inhabitants of the Nile Valley[45]) was not even overturned by the great "naturalistic revolution"

of the Amarna period; quite the contrary, the art of this time is perhaps the most clear-cut exemplification of the character of Egyptian idealization.

For a variety of reasons, the Amarna period is the pivotal moment for any investigation of the art of the New Kingdom, including one centered on portraiture. From the earliest part of the Eighteenth Dynasty, the royal imagery—and the portrayal of persons of lesser importance, for that matter—has a highly idealized character (Figure 23). The sudden shift in physical types portrayed during the reign of Amen-hotep IV (who changed his name to Akh-en-Aton)—not to mention the evident interest in accurate portrayal of specific physical forms in other branches of pictorial subject matter—gives, on the other hand, every indication of a new interest in nature and its faithful reproduction on the part of Egyptian artists and their patrons (Figure 24). While the extremes of the artististic style practiced during this brief episode seem to have disappeared with their chief patron's death, the course of Egyptian art in subsequent reigns reflects some impact of the innovations of Amarna.

While this change toward artistic naturalism in the time of Akh-en-Aton has long been regarded as sufficiently radical in relation to what preceded it to justify the adjective ''revolutionary,'' scholars recently have tended to emphasize that the seeds of this naturalism, like those of Aton-worship, were present in Egypt for at least half a century before gaining official sponsorship and that both this special art form and this new system of religious belief can best be understood within the total context of existing Egyptian practices and not as a wholly radical set of unanticipated innovations.

The characteristic form of the sun-god Aton, for example, is that of a disk with arms extended, and this can already be found in works made under the reign of Amen-hotep II, (ca. 1448–1412 B.C.); the name and special cult of Aton were widely current under this Pharaoh's successor, Thut-mose IV (1412–1402). In the visual arts in general, this reign of Thut-mose IV marks the point at which a new and comparatively more naturalistic outlook becomes clearly apparent, although here, too, the seeds of the tendency were beginning to germinate a reign or two before.[46]

During the actual reign of Amen-hotep IV/Akh-en-Aton, when all these various tendencies converged, a two-phased development is believed to have taken place. The extremes of radicalism, in art as well as religious doctrine, are most evident at the outset of the reign, while in later years they clearly become more and more moderated.[47] The interesting suggestion has in fact been made that the almost caricatural naturalism, approaching a seemingly inept crudity, which is to be seen in the art of Akh-en-Aton's first years of power, may be the simple consequence of his being at the time only coregent with his father, Amen-hotep

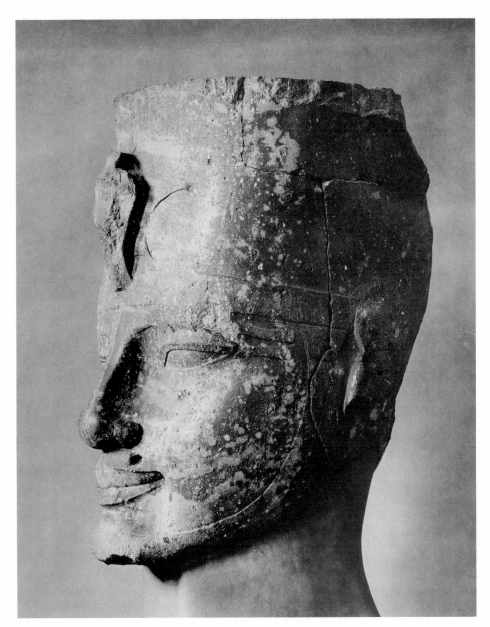

FIGURE 23 A colossal head of the New Kingdom Pharaoh Amen-hotep III, father of the famous
Akh-en-Aton, created in accordance with a long-established set of conventions: long, narrow face,
curving jaw, and highly geometricized organization of the total form. There is little doubt, however,
that these conventions serve to indicate some distinctive physical traits of the royal dynasty, as
idealized by the official court artists.
The British Museum

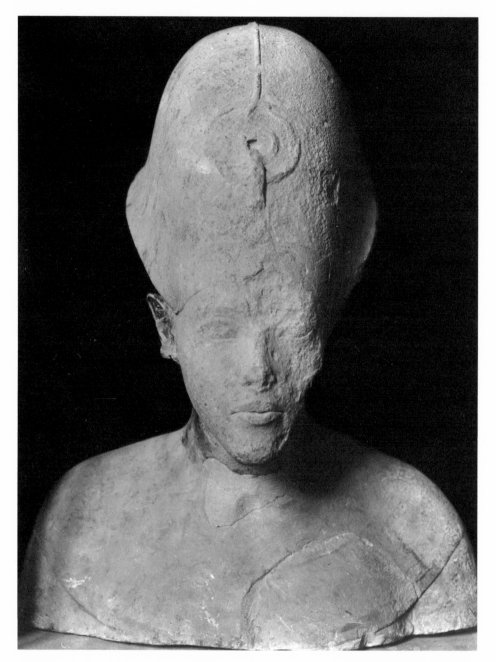

FIGURE 24 This weathered likeness of Akh-en-Aton (Amen-hotep IV) reveals a family resemblance
to even the most highly conventionalized images of his father, as well as an exaggeration of the
distinctive physical features which seem to have been characteristic of this ruler of the second quarter
of the fourteenth century B.C.

Musée du Louvre

III, who would naturally have had at his disposal the most highly trained artists—those who were also the most thoroughly indoctrinated in the traditional conventions—leaving only the younger, more daring, but less polished craftsmen for the service of the junior ruler and his revolution.[48] The chief difficulty with this thesis is that there is considerable disagreement as to the length of this coregency, since the date of Amen-hotep III's death in relation to his son's accession is uncertain. If, as is quite possible, the coregency lasted no more than a year or two, the argument loses its force. All in all, it may be safer to regard the phenomenon of the early extremes of style under Akh-en-Aton as, like the first violent surge of religious propaganda for Aton, a reaching for ultimates which was inevitably moderated by compromise after the first shock had been achieved.

While broader consideration of the Aton cult lies far beyond the scope of this study, certain of its implications have a close bearing on our particular problem. One of these is the cult's position on the status of the Pharaoh within the total structure of the state and its religion. Wilson's statement is most persuasive:

> The most important question at issue was whether the pharaoh, as a god, was a free and responsible agent, whose divine word was the law of the land, or whether he was the chief interpreter of the gods to Egypt, so that his official word derived from the oracular guidance by gods whose function was to direct the nation and the empire. The older theory had made the pharaoh the state; that theory had been limited but had not been abrogated by the Re revolution at the beginning of the Fifth Dynasty. The newer theory, arising out of the religious cleansing of the state after the Hyksos impiety and out of the emotional insecurity at the beginning of the Empire, was that the gods ruled the state by "divine command," giving their direction through dreams or oracular responses, and that the pharaoh was merely the channel through which that guidance came. The tremendous rise of Amon and his priesthood, as a product of the success of empire, had placed these two theories in opposition, and, whatever the line-up of factions may have been, the function of pharaoh as ruler was a crucial question.[49]

Thus it is possible to see the Amarna episode as more reaction than revolution, as the last attempt to assert the pre-eminence of pharaonic power against the encroachment of the great priestly bureaucracies. This reaction, however, was not intended as a mere return to past systems of belief, any more than its art was a simple revival of outmoded styles and iconographies; the reaction involved the creation of a virtually new system of thought. The new art has been described as strongly "non-Egyptian," with its sloping lines and flowing surfaces and the idealization of temporal rather than eternal aspects of existence. In literature, too, a new colloquialization is remarked which gives a more lively and immediate effect than the stereotyped conventions of established literary forms.[50] Just how large a part foreign influence played in this shift of viewpoint remains highly debatable, especially since the evidence is so meager. As far as portraiture is

concerned, there is even less evidence than elsewhere that anything other than purely native traditions and practices were involved.

It is a mistake to draw too close analogies between the Amarna faith and later monotheistic systems.

The most important observation about Amarna religion is that there were two gods central to the faith, and not one. Akh-en-Aton and his family worshipped the Aton, and everybody else worshipped Akh-en-Aton *as a god*. In addition to his formal names and titles, the pharaoh was referred to as "the good god," and he asserted that he was the physical son of the Aton. The abundant scenes in the Amarna tombs show him serving the living sun-disk, while all of his courtiers bow in adoration to him. Their prayers were not addressed to the Aton, but directly to Akh-en-Aton. The courtier Eye, who was later to become pharaoh, asked Akh-en-Aton for mortuary benefits: "Mayest thou grant to me a good old age as thy favorite; mayest thou grant to me a goodly burial by the command of thy *ka* in my house. . . . May (I) hear thy sweet voice in the sanctuary when thou performest that which pleases thy father, the living Aton." Another noble did pray to the Aton, but prayed only on behalf of Akh-en-Aton, with his petition for himself addressed to the pharaoh. . . . This is a stated acknowledgement of the centrality of the pharaoh in the worship of the Aton and of the dependence of the noble upon his god-king.

Akh-en-Aton himself in his famous hymn to the Aton asserted that this was his personal god. The hymn is entitled "the worship of the Aton . . . by the King Akh-en-Aton and the Queen Nefert-iti," and the pharaoh says explicitly: "Thou art in my heart, and there is no other that knows thee except thy son (Akh-en-Aton), whom thou hast initiated into thy plans and into thy power." It must be emphasized that the Aton faith had no penetration below the level of the royal family as an effective religious expression; it was

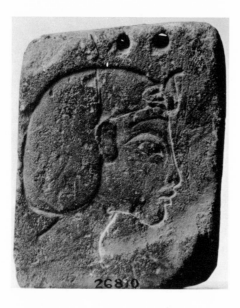

FIGURE 25 This sketch of the profile of a Pharaoh—most probably Akh-en-Aton himself —comes from Amarna, the city of Aton. It is part of an enormous and important find from a sculptor's workshop, which has revealed the studies through which the finished works, with their new kind of idealization, were evolved. *The British Museum*

stated to be the exclusive faith of the god-king and his divine family, and the god-king welcomed and encouraged his subjects' worship of his divine being as the source of all the benefits which they might desire.[51]

The dependence upon the central figure of the Pharaoh, which of course is far from new in Egyptian culture, is paralleled in the art of Amarna (Figure 25). Not only are all members of the royal family so closely similar in appearance that more than just the accident of physical resemblance must be involved (Smith speaks of "this stylization of the appearance of members of a family who seem to have borne a resemblance to one another but are also difficult to distinguish individually because of the persistence of a type created to portray the king and queen"[52]), but the same stereotypes—long neck, long jaw, long narrow face, protuberant cranium—were employed in depicting other members of the court who must have been unrelated in any close way to the royal family and hence not apt to have shared so invariably the highly idiosyncratic physical features of Akh-en-Aton and his relatives (Figures 26 and 27).

The remarkable physical appearance of the Pharaoh and his queen has been remarked upon time and again; it is entirely possible that the very distinctiveness of their physiques in comparison with those of "normal" Egyptians may have played a part in motivating artists to shift to a less predetermined, more naturalistic and empirical approach to the depiction of visual appearances. None the less, it must be acknowledged that much more than simple naturalism is involved in what happens to Egyptian art at this pregnant moment.

The most strongly caricatural depictions of Akh-en-Aton, those farthest from the norms of Egyptian conventional styles, are to be found in the colossal images which were made for the temple of Aton at Thebes; these are presumed to date from his coregency, or in any case from early in his reign.

Where the Akenaten colossi are unusual is that they show the king as a vital terrestrial ruler in the costume of the living. . . . If in making such colossi, Akenaten was challenging comparison with the Osiride pillars in the temples of his forefathers, we may assume perhaps that he has chosen to represent himself as assimilated to his god, Aten, a supposition which is supported by the inscription of the names of the Aten on all the pectorals and ornaments in place of his own name which would be the more normal practice. This attempt to represent the ruler as imbued with the divinity of the Aten, may help to explain the extraordinary expressionist distortion of form in these sculptures, unparalleled in any art of the Ancient World. The long face, hanging jaw, gaunt collar bones, prominent hips and spindle-shanks of the King have all been exaggerated to such an extent as to lose their natural significance and to take on a new superhuman symbolism—a stigmata. Not only is the colossal Aten-king larger than life, but different too: and as he differs from all other gods, so does the representation differ also; even his sex is indeterminate. We should see in these early, perhaps almost pathological manifestations of the Amarna

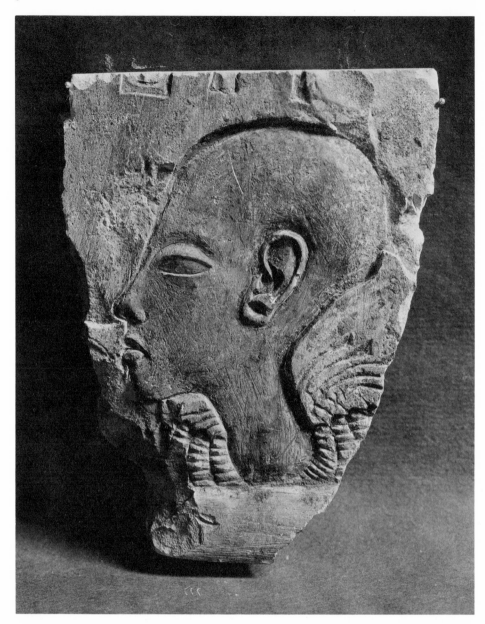

FIGURE 26 Another sketch from Amarna. Though it does not represent a member of the royal
family, it offers the same set of distinctive physical features seen in likenesses of the Pharaoh, his
queen, and their children. It would appear that even in this brief period of revolutionary ideology,
the likenesses of the divine rulers of Egypt conditioned those of their subjects.
The British Museum

religious art, an expressive mannerism which changes from its first excesses to something less revolutionary. It would be rash to assume from these colossi, which can only have been as strange to the orthodox Egyptian as they are to us, that Akenaten was himself physically abnormal, or that he should have expressed his new religion in the old iconography.[53]

These figures, bizarre as they appear even in comparison with the exceptional art of Amarna, offer a clue to the apparent naturalism embodied in all of that art, both in its approach to the depiction of the individual phenomenon and in its interest in the intimate, almost genre-like details of the day-to-day life of the royal family. This art was not portraying mere anecdote or physical accident but

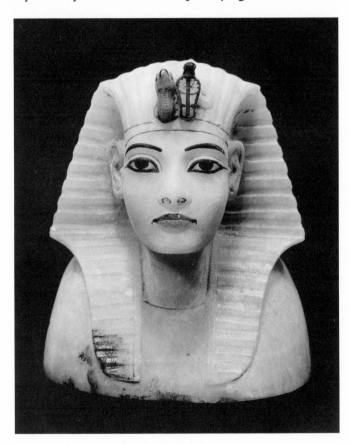

FIGURE 27 The alabaster lid of the chest made to hold the viscera of the Pharaoh Tut-ankh-Amen, successor of Akh-en-Aton, is strongly generalized, but nevertheless betrays the continuing family resemblance within this highly inbred royal court.
Cairo Museum

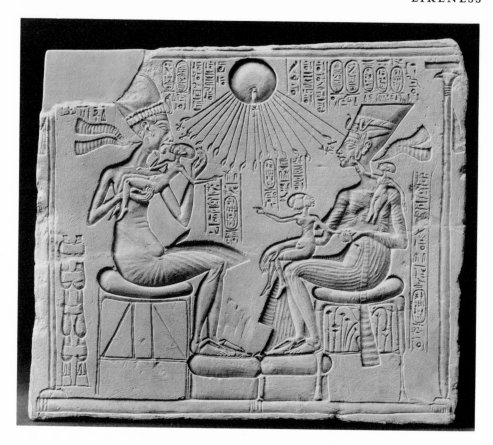

FIGURE 28 Recurrent portrayals of the Pharaoh and his family in "domestic" scenes, unprecedented in earlier Egyptian art, suggest that an effort was being made by Akh-en-Aton to replace the old religious iconography with a new one, projected toward the sun-disk Aton through the intermediary power of the Pharaoh as earthly representative.
Berlin, Staatliche Museen, Aegyptische Abteilung

a new kind of religious symbolism. The new religion rejected the enormous iconographical apparatus of the traditional cults and hence needed to fill a gap which had been opened in the repertory of popular imagery (Figure 28).

The disappearance of the old gods and priesthoods was accompanied by the loss of many of the outward symbols of funerary beliefs. Pictorially, the Sun Disk of the Aten with its rays provided a meagre substitute, and the old representations were largely replaced by the great set-pieces of the royal family which we know from the tombs at Amarna.[54]

The swing to naturalism at Amarna, then, was not truly an overthrow of either the conceptual or the stylistic norms of traditional Egyptian art. The

instinct for formalization was unchanged; only the material which underwent formalization was new. The foundations of Egyptian art were unshaken by what happened at Amarna.

The new approach to the subject in the art of Amarna had, however, a consequence of a different sort. It has been noted that, with the shift of attention from the timeless to the temporal, a new sense of action and tension enters Egyptian art. From this, however, it was all too easy to slip over into exaggeration, in the effort to achieve the desired effect of portraying an actual event taking place in real time and space. From this to a depiction of the grotesque was then but a slight step, and thence to caricature was but one more. As a result, some of the little sketches found at Amarna have the look of deliberate parody of the royal appearance. Here is, in fact, an unexpected consequence of the ideology of the Aton cult: the Pharaoh is actually seen as an accessible mortal. The revolution designed to rescue his godly attributes resulted, in the event, in the sacrifice of the mystery which had of old enshrouded the personality of the divine ruler.

The relation between the esthetic naturalism of the artists of Amarna and the concern of the theologians of the Aton cult with *ma'at*, or "truth," has often been suggested: "The candor of family life, the naturalism in art, the open equity of the sun-disk, and the colloquial coloring of the texts were all aspects of this new emphasis on *ma'at*." [55] The ethical connotations of the word, which at times must be translated as "justice," lend coloring to its use in describing the character of art under Akh-en-Aton. But it is important to avoid anachronism in relating the Egyptian concept of "truth" to the question of what an artist depicts and how he does it.

Certainly the use of direct observation of nature by Amarna artists was of a very special sort, and limited in degree. We have already observed that, in the portrayal of individuals, likenesses were evidently conditioned by the physical appearance, not of the subject, but of the Pharaoh he served. We have, furthermore, archaeological evidence which gives direct insight into the procedures used by these artists. In the ruins of Akh-en-Aton's city (in modern Egypt, Tell el-Amarna)—a city built and abandoned within a single generation—excavators found the remains of a sculptor's studio complete with tools, models, trial pieces, and all the paraphernalia of the craft. Among the finds were a group of "masks" showing an unparalleled combination of realism and liveliness (Figure 29). [56] The only comparable convincing likenesses from the ancient world are the portraits of late republican Rome, with which these Egyptian masks are, in fact, frequently compared.

The first and most obvious point to be observed about these masks, however, is the fact that—unlike the Roman portraits—they are not finished products of the

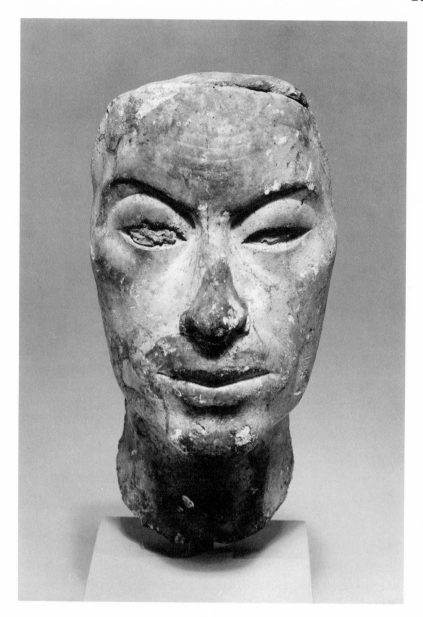

FIGURE 29 Materials found in the abandoned sculptor's studio at Amarna supply evidence for the
procedures used in the creation of official portraits, as highly realistic masks were reworked into
idealizations which conformed with official types. This mask represents an intermediate stage of
such a process, since it is neither taken directly from the model nor yet quite ready for public and
official display.

Berlin, Staatliche Museen, Aegyptische Abteilung

studio. They are, instead, part of the studio equipment, just one element in the process employed in developing the final and "official" portraits of the individual subjects. Röder has even been able to classify them, some as direct casts from the model, some as intermediate and transitional studies, and all of them as steps in the process of arriving at the acceptably idealized final likenesses. Thus direct impressions of the features of the subject—always a possibility at times when realism is a component of the dominant esthetic approach—are found to have been merely tools in the production of "true" portraits, even at the moment when the Egyptian artist came closest to direct naturalism in his work.

These masks, moreover, raise a further question. To what extent did Egyptian artists of any time use direct casts from the face—life masks or death masks? This is a problem that involves the wider question of the Egyptian artist's whole relation to "reality" itself.

A true death mask has in fact been preserved from the Old Kingdom, found not among the "reserve" heads, but in the funerary temple of King Tety of the Sixth Dynasty.[57] Along with the usual traces which betray such a cast, this mask bears the marks of having been tooled after casting to remove the traces of contact with facial hair, to rework the area of the eyes, and so forth. There are no such indications of tooling on the Amarna masks, which is further evidence that few of them are true direct casts from the subject but are rather reproductions of various stages in the evolution of the finished public images. The conclusion to be drawn from this and other evidence about the way in which Egyptian portraiture was created in any era is summed up by Aldred: "It was customary for the king's chief sculptor to make a master-portrait which served as a model for the greater part of the reign. In fashioning this model, casts from life might be used to assist in achieving a likeness, but were never of course substituted for the work of the sculptor's own hand."[58]

With the death of Akh-en-Aton the whole system of thought and belief which he had espoused rapidly crumbled, and with it, to all appearances, the tendencies in art which were so intimately related to the Aton cult. His widow, Nefert-iti, seems to have held to his faith; it was her half-brother Tut-ankh-Aton who succeeded to the throne, but he was unable, or unwilling, to fight for the god. The change of his name to Tut-ankh-Amen signified the end of the Amarna revolution, as do the enormous reparations he paid to the temple of Amen to indicate his full submission to the power of that god—and to the power of the priesthood. If Akh-en-Aton had made the last attempt to win autonomy for the Pharaoh from the priestly and bureaucratic oligarchy, Tut-ankh-Amen's surrender confirmed the fact that personal rule could no longer prevail in Egypt, given the nature of the state organization and ideology as it had then evolved.

The suppression of the individuality of Pharaoh himself, implicit in this surrender to the bureaucracy, is revealed in the impersonality of the images and the records of the Pharaohs of the Nineteenth Dynasty, who succeeded to the throne after the confusion of the post-Amarna years. This is the period that offers those extreme instances of the submergence of individual achievement which Frankfort found so revealing, such as Ramses III's direct transcript of a list of Asiatic conquests exactly as recorded by Ramses II—who had had it copied from a monument of Thut-mose III! [59] Concomitant with this was a positive decline in any sort of strongly held power, reflected in a variety of ways. There are disclaimers of responsibility for the events of his time in the testament of Ramses III; and it is noteworthy that, by the end of the Twentieth Dynasty, a High Priest of Amen could have himself represented in sculpture on the same heroic scale as the Pharaoh. [60]

A sense of awareness of the situation was not absent. Indicative is the new use of a formula which is the equivalent of our term "Renaissance": "Year 2 of the Repeating of Births of [Seti I]" is an example of a formula which is common in datings of this period. A sense of glories which had vanished—and a faint hope of recapturing at least a bit of that grandeur whose relics surrounded them— was understandably prevalent among Egyptians through the long twilight of their greatness.

Just as Egyptian art was never quite the same after the Amarna episode, the Egyptian state suffered permanent changes in its texture in these latter years.

The discipline which the state had demanded, first to eject the Hyksos and then to extend and maintain the Empire, had killed the old, easygoing tolerance and pragmatism, with their acceptance of individual voluntarism. The individual had become strictly circumscribed by determinism for the advantage of the group, dogmatically for the service of the gods who ruled the land, including the pharaoh, but practically for the ruling oligarchy. As the highest nobility grew more powerful, the lower nobility, the middle class, and the masses became poorer and less powerful. Theology then advised them that this was their predestined fate and that they must submit to it with quietude, in the hope of a reward in paradise. The concept of Fate and Fortune as controlling deities was first visible in the Amarna period, when the Aton was praised as "he who made the god Fate and brought into being the goddess Fortune," and when Akh-en-Aton was called "the god Fate, who gives life." A later hymn praising Amon as the creator-god, says: "Fate and Fortune are with him for everybody." In scenes of the judgment of the dead, the god Fate may stand beside the scales in which a man's heart is weighed, with the goddesses Fortune and Birth-Destiny in close attendance, to prevent any eccentric individualism. [61]

The sense of personal inadequacy inherent in this attitude had its natural concomitant in a growing sense of sin. This was not, as it had been in the Book

of the Dead, a matter of ritual error but a question of moral error and spiritual failure, to which mankind was now considered inclined by nature and from which the individual could be saved only through divine intervention. The attitude permeates the texts of the period:

Come to me, O Re-Harakhti, that thou mayest look after me! Thou art he who does, and there is no one who acts without thee, unless it be that thou actest with him. . . . Do not punish me for my many sins, for I am one who does not know himself, I am a man without sense. I spend the day following after my own mouth, like a cow after grass. . . . Come to me, . . . thou who protectest millions and rescuest hundreds of thousands, the protector of the one who cries out to him! [62]

God is (always) in his success, whereas man is in his failure. One thing is that which men say, another is that which the god does. [63]

The crepuscular decline of Egyptian power was interrupted once or twice when twilight was mistaken for false dawn—when, in the absence of foreign intruders, some sense of renewed but illusory strength was briefly felt. Most notable were the Twenty-fifth (Kushite) and Twenty-sixth (Saite) dynasties, interrupted by eight years of Assyrian occupation between 671 and 663 B.C. During this period of the eighth and seventh centuries B.C. a self-conscious revivalism was part of the artists' stock-in-trade and was reflected in an archaism which has sometimes led to wide disagreements among modern scholars in dating their works (Figure 30).

For the most part, the artists avoided the Empire and went back to the Old and Middle Kingdoms for their inspiration, back to the ages when the Egyptian spirit had been most vigorous and most native. At its best this copying was remarkably successful, so that it is often difficult to distinguish a statue of the Twenty-Fifth or early Twenty-Sixth Dynasty from a statue of the Sixth or Twelfth Dynasty. For some reason, the earlier stages of this renaissance were more effective, with a successful capture of form and vitality. When, however, the movement settled down to mere slavish copying, any attempt at creative recapture was lost, and the work became dull and lifeless. [64]

Curiously, this process of stereotyping took place within each of these two dynasties; whereas formerly it was thought that the contrast lay between a livelier Kushite art and a more uniform, though sophisticated Saite style, the accumulation of evidence shows that each dynasty saw a similar process at work. [65] The artists of both could on occasion produce portraits which bear comparison with the work of the Old or the Middle Kingdom. In particular, Theban sculpture of the early Saite period offers numerous—yet curiously isolated—examples of the great talent always latent in Egyptian artists for this art form (Figure 31). It is noteworthy that the exceptional portraits which constitute the principal fame of Saite art, in particular, are almost always portraits of nobles and even commoners.

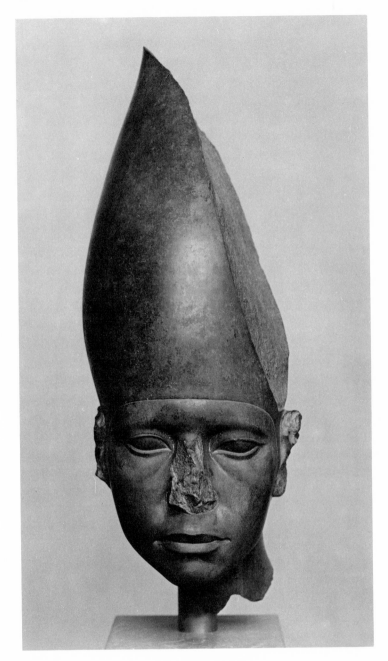

Figure 30 Long accepted as a contemporary portrait of the Middle Kingdom Pharaoh Amen-em-
het III, this splendid head is now generally regarded as a product of the Late period, when sculptors
demonstrated enormous facility at imitating much earlier styles.
Copenhagen, Ny Carlsberg Glyptotek

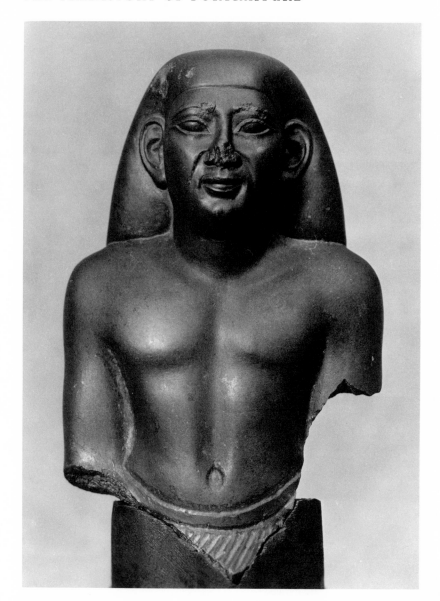

FIGURE 31 An aspect of the revivalism of the Late period in Egypt was the return of a taste for portraits with serious pretensions to naturalism. This portrait, probably from the early Twenty-sixth Dynasty (about the middle of the seventh century B.C.), represents so distinctive a physical type that it is assumed to portray an official of Libyan ancestry; none the less, he is portrayed as an individual rather than as an example of a type (as in Figures 3 and 4).

Baltimore, Walters Art Gallery

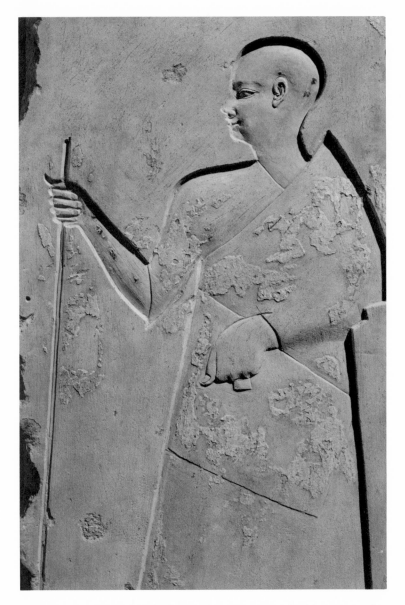

FIGURE 32 The doorjamb of a temple portraying, on both its inner and outer sides, the Royal Secretary, Tha-aset-imu, an official of the Thirtieth Dynasty, which, in the middle of the fourth century B.C., represented a brief period of Egyptian autonomy between eras of Persian rule. The inner side of the jamb, on which the carving was left undecorated, reveals the great sensitivity with which the sculptor could portray the subtleties of the human form within the conventions—as of eye and ear—normative to Egyptian art.
The Brooklyn Museum

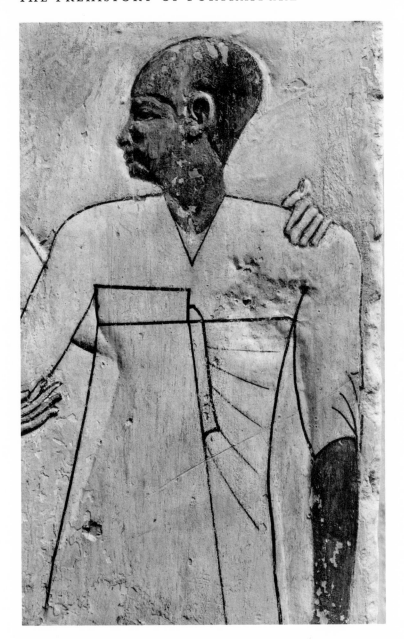

FIGURE 33 The outer face of the doorjamb of the tomb of Tha-aset-imu also portrays the Royal
Secretary; but in this case the relief has been "finished," with a covering of gesso and the applica-
tion of paint. While this is the way in which the sculpture was intended to be seen, the subtleties of
the original relief (visible on the inner face) have been almost totally obscured.
The Brooklyn Museum

The royal portraits are consistently more idealized, less realistic, and totally uninteresting.[66]

Our knowledge of the art of these late dynasties has been confused by errors of attribution and of dating; for example, the famous "Green Head" in the Berlin Museum (Figure 89, Chapter IV) was long attributed to the Saite period, where it represented a startling and anomalous example of meticulous surface realism; its more recent placing in late Ptolemaic times, contemporary with Roman republican portraiture, restores a more coherent character to the art of both periods.[67]

Seen in an objective light, neither Kushite nor Saite portraiture departs in any significant way from the standards of traditional Egyptian imagery, although it does rise to a level of quality comparable with all but the finest of earlier art (Figures 32 and 33). Its limitations are those of all true Egyptian portraiture: It cannot reach the fullest expression of individual human personality for its own sake.

In reviewing the course of development of the portrayal of the human image over the millennia-long history of Egyptian art, we have seen that this art form did not remain within one simple and absolutely undifferentiated *stasis*. Change and progress did take place, so that absolute generalizations about the character of Egyptian ideation must be treated with great caution. On the other hand, the very stability of Egyptian institutions made for certain kinds of normalization, and it cannot be gainsaid that, given the long period of time involved, Egyptian art did change far less than that of any other ancient, much less modern, civilization.

What processes did take place were those relating to the narrowing-down of possibilities, a steady movement from multiplicity toward uniformity of expression.

The Egyptians were a rich people, set apart from outside peril. For them the election by the gods meant the privileges of civilized life, including a tolerance of minor divergences within the system. Further, their special election was in their mythology a part of the original creation, so that effort or incentive toward change, what we call "progress," was out of the question. The only thing necessary was to get back again to original principles whenever the system went out of adjustment, that is, to restore the *ma'at* of the beginning.

This will explain why the only really creative period was at the beginning of Egyptian history, at the end of the predynastic and in the early dynastic. When the culture was formative, the Egyptians were trying to discover what it might be that the gods had given them. One might say that they were trying to write their mythology. So the earliest dynasties showed the most exacting technology, the closest approach to a philosophy of being. By the time that the culture was formed—by the Fourth Dynasty—the governing mythology was known, and further experimentation or change was proscribed. The system had been set for eternity.[68]

Even within each major phase of Egyptian history something of this narrowing-down of possibilities may be discerned. In art an identical progression from the specific to the generalized is to be found during the Old and the Middle kingdoms, and again under the Empire (with new complications, induced in part, perhaps, by foreign intrusions), and once again in the Late period. Each time that the Egyptians emerged into a period of comparative stability, we discover that their artists proceeded methodically, through the selection of forms, toward the establishment of a standardized mode of expression that would suit their particular set of circumstances. Initially they would draw, on each occasion, not only upon the art of previous epochs, but also on their own observations of nature itself; but the desired end was always the refining of a particular stabilized formal expression that would best serve the needs of their society at its special moment in time.

Such a procedure will, at a certain point, interest itself in the observation and recording of individual phenomena, including the portrait subject; but it will never make of these phenomena a subject in itself. It will always be merely a step in the process of idealization which is the ultimate aim of this art, as it is of the culture for which it existed.

Whether, therefore, the function of the portrait image is purely magical—in the perpetuation of the *ka* into eternity—or more strictly political and temporal—in the assertion of royal omnipotence or the identification of a subject with the divine source of power—the individual as a subject is not its object. Egyptian art did, because of the nature of its procedures, come close to an understanding of the art of portraiture; but Egyptian culture never gave it reason to develop this understanding into an actual art form.

Mesopotamia

A survey of the evidence of portraiture in the other great cultural region of the pre-Hellenic world reveals less need for detailed exposition. The surviving works themselves, whether from the earliest levels of Sumer (Figure 34), the later dynasties of Lagash or Ur (Figures 35, 36, 37), the period of the Babylonian Empire (Figures 38 and 39), or the later Assyrian domination (Figure 40), show a far less consequential interest in either individualization or naturalism than the art of ancient Egypt.

The root of the difference in approach may be said to lie in the difference in function of works of art in the two lands:

All Mesopotamian statuary was intended for temples; the human form was translated into stone for the express purpose of confronting the god. The statue was an active force;

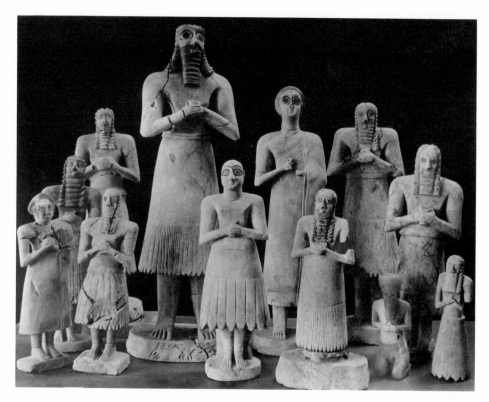

FIGURE 34 A group of ten stone sculptures found buried in the floor of a shrine at Tell Asmar in
Mesopotamia, from the early third millennium B.C. Two represent the deities of the sanctuary; the
others are their votaries. The gods are distinguished by inscriptions, by their large size, and, above
all, by their enormous eyes; but insofar as the general treatment of features or the approach to rep-
resentation is concerned, no significant differences are evident. In fact, all the images share the same
general physical characteristics in the same highly stylized form.
Oriental Institute, University of Chicago

it was believed to possess a life of its own. Gudea, the ruler of Lagash in the later period
(twenty-first century B.C.), erected a statue which was called "It offers prayers."
Another was entitled "To my king (the city god Ningirsu) whose temple I have built;
let life be my reward." Here the statue is, as it were, charged with a message; first it
names the recipient of the petition, then the request itself.[69]

The statue, in other words, was not a double of the donor, as in Egypt, but an
essentially external agent of his will.

While the religious beliefs of Mesopotamia, taken either sequentially or in
contemporaneous cross-section, are probably more difficult to penetrate through
the available evidence than those of any other major ancient civilization,[70] it

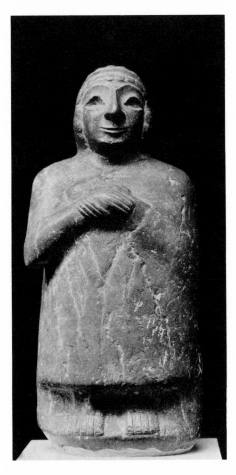

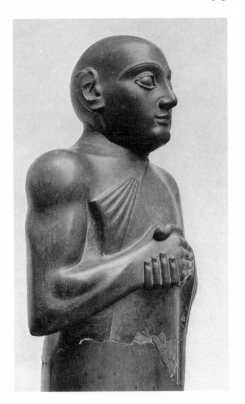

FIGURE 36 Gudea, who ruled Lagash at the close of the third millennium B.C., left an enormous number of portraits of himself as votary of the deities who, in Mesopotamian belief, actually held power over the city.
The British Museum

FIGURE 35 The portrait in Mesopotamian art serves almost invariably as a votive figure, conveying the prayers of the donor to the deity in whose shrine it is placed. There is little impulse to offer any serious degree of descriptive naturalism in the likeness in such a case. Two portraits from Lagash, some 700 years apart in date, demonstrate the continuity of this tradition from one epoch and one ruling nationality to another in this troubled land. The first, shown here, dates from the middle of the third millennium before Christ and represents a member of the ruling non-Semitic class in control at that time.
The British Museum

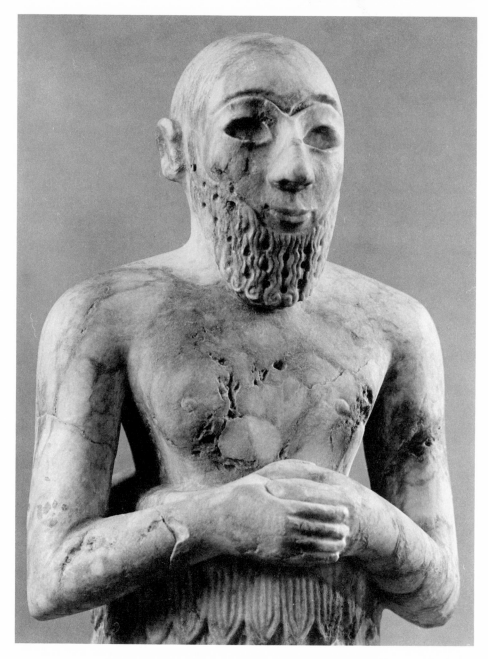

FIGURE 37 The universality of the Mesopotamian conventions of representation are confirmed by
this image of a nobleman from Mari, also from the middle of the third millennium B.C. and differing
only in technical details from the portraiture from Lagash (Figure 35).
Kansas City, Nelson Gallery–Atkins Museum of Fine Arts

may be stated with some degree of confidence that during virtually all of their recorded history the Mesopotamians did not share the Egyptians' ultimate optimism about the continuity of existence. The confidence of Egypt, sheltered by geographical circumstance, can of course be understood as relating to the belief in the secure provisioning of earthly life by the Nile, within a stably structured society, followed by a continuation of the same circumstances in the next world. Although the elaborate royal tombs of the lower levels of Ur are evidence for an active belief in bodily survival after death and for ritual service involving sacrifice during the earliest period of Mesopotamian civilization presently recoverable, there are no indications that such practices survived the end of that cultural phase; the cult of the dead never appears to have become established on any scale in Mesopotamia.

During the rest of Mesopotamian history, so far as we can tell, the next world was never regarded as the assured place of comfort depicted in Egyptian myth and art. At best it was a vague House of Darkness, a shadowland in which the souls of the dead slowly withered away. For the Mesopotamians, only this life was certain—a thought which gave them little joy. All, from the mightiest to the most humble, were, according to political theory, merely servants of the gods. The ruler himself was simply the chief representative of the gods, who were the true proprietors of the earth; he was, if anything, more burdened with ceremonial obligations than the ordinary run of mankind. In such circumstances, the scope for individual achievement which the Egyptians had enjoyed, however briefly, could never be realized in the land of the two rivers.

A fundamental contrast of outlook can be distinguished between the peoples of Mesopotamia and those of Egypt. There is an anxiety in the Mesopotamians, ever at the mercy of their capricious rivers, whose very floods came at the wrong time of year and brought no rich soil deposits to remedy the depletion of the existing acreage, but merely clogged the irrigation canals; moreover, the Mesopotamians were unshielded by nature from the ravages of migrant barbarian tribes which time and again overturned the fragile structure of their civilization. Contrast with this the serene security of the Egyptians, sheltered by geography and nourished by the splendidly dependable floods of the Nile.

Parallelisms can, of course, be discerned between the two major cultures of the ancient Near East. The Mesopotamians had, in particular, a spiritual concept apparently equivalent to the Egyptian *ka*, so important in relation to individualization. This was the *lamassu*, a term which apparently ''personifies in the guise of an external manifestation those essential aspects of individuality which comprise an assemblage of distinct and specific corporeal features'':[71] the visible individuality of the person. The word is sometimes used to refer to a likeness in sculptural

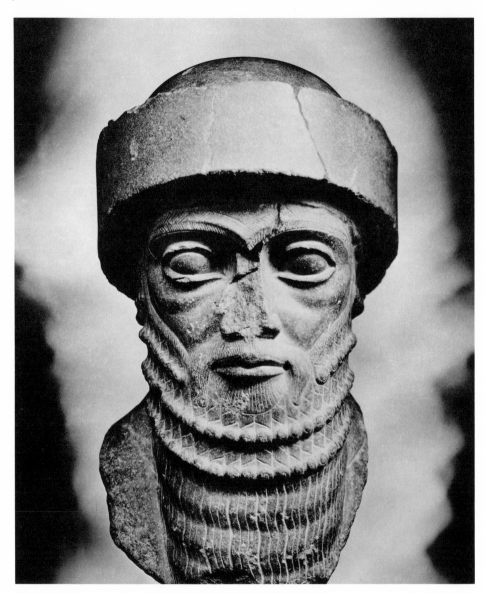

FIGURE 38 Continuity of Mesopotamian beliefs and practices is further indicated by the portraiture of Hammurabi, king of Babylon in the first half of the eighteenth century B.C. A new medium, basalt or diorite, and somewhat more delicate techniques are in use, but the fundamental conventions and functions governing the image are unchanged.

Kansas City, Nelson Gallery–Atkins Museum of Fine Arts

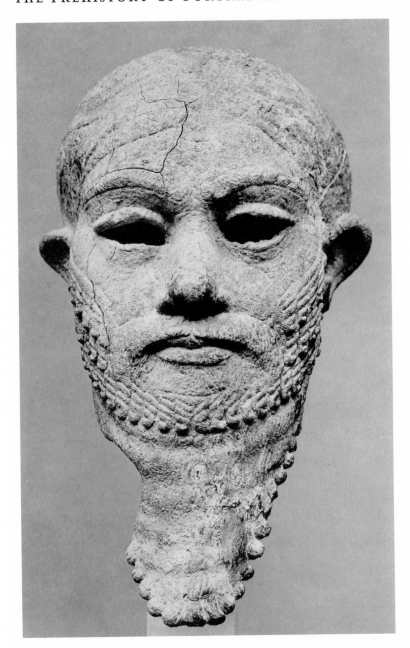

FIGURE 39 A new medium, cast bronze, and a new provenance, the Azerbaijan plateau north and
east of Mesopotamia proper, distinguish this head, created late in the second millennium B.C.; yet
it clearly belongs to the sequence of portraits characteristic of Mesopotamia for the previous two
thousand years.
New York, Metropolitan Museum of Art, Fletcher Fund

form, so that it does seem to relate to the general concept of what can be meaningfully represented of a person by artistic means.

Examination of images of specific individuals, however, reveals the limitations of this concept. The effigies seen in Figures 35 and 36, made as devotional offerings, as spokesmen for their donors, give evidence of no serious concern for

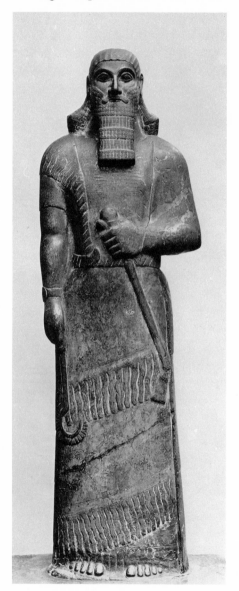

FIGURE 40 Although the physical likenesses clearly indicate a new racial type, the portraits of the Assyrian kings, like this one of Assurnasirpal II, who ruled from Nimrud during the ninth century B.C., nevertheless conform to the general characteristics of the Mesopotamian ruler portraits established by the very first royal dynasties.
The British Museum

accuracy of portrayal. Whatever the charm of their execution, as in the ubiquitous dedications of Gudea (Figure 36), they nevertheless conform to the highly conventionalized standards of all Mesopotamian sculpture of whatever period; in addition, as a consequence of their function, they tend to be assimilated to the conventions of the representation of the deity being honored.

This is a trait to be found in all periods of Mesopotamian culture (and it is, of course, far from unknown in Egypt). The very early group of figures found at Tell Asmar, for example, includes both donors and deities, and it is all but impossible to distinguish one from the other except by attributes; facial likeness is the least reliable index (Figure 34). In the Assyrian period, some two millennia later, the identity of likeness between the king and his patron deity is virtually axiomatic. In the later period there is some evidence that the likeness of the king was taken as the basis for the double image: An inscription on the bronze reliefs mounted on the gate of the New Year's Chapel at Assur states that "the figure of Assur going to battle against Tiamat is that of Sennacherib."[72] Even so, we are scarcely enabled to consider these as literal portrait likenesses even in the sense of comparable ruler-deity images of Egypt, such as the triads of Mycerinus.

The *lamassu* was only one component of the "personality" as distinguished in Mesopotamian texts; perhaps the most significant of all these aspects of the human spirit was that called *simtu*—the immutable "share" of existence allotted to each individual from the instant of creation.[73] Such determinism, which may be understood as one facet of the theocratic Mesopotamian social and political structure, inevitably denied any importance to the individual human being; and just as this would affect the representation of such individuals as sought memorialization, so it precluded the development of a significant funerary cult.

Our conclusion about Mesopotamian portraiture, then, must be that it lacked the degree of concern for the individuality or uniqueness of the subject found in the most significant periods of Egyptian history. Instead, the individual is portrayed only as donor of a votive offering and is thus evaluated in relation to the object of that offering; he can be of no interest to the artist in and of himself.

This type of dedicatory portrait, in which the likeness of the donor is assimilated to the likeness of the recipient (or vice versa), is not, however, without a degree of importance in relation to developments in the art in later cultures. This form of image does represent one viable alternative to the Egyptian funerary portrait-as-double; while also essentially a work of "magic," the Mesopotamian image has different magical functions to perform for its donor—emissary functions, regarded as no less important in many societies.

We have seen that Egyptian religious beliefs seem to have grown without any noticeable break out of the Neolithic cults of the Nile, just as funerary

portraiture in the Old Kingdom appears as a logical outgrowth of predynastic practices relating to the preparation of the mummy. In Mesopotamia, the rising water table has erased the lowest strata of physical evidence; but on the basis of what we do know, it can be stated that the religion of this area has far less in the way of evident affinity with systems of belief known to exist among other prehistoric cultures.[74] Under the circumstances, it is not surprising that Mesopotamian art developed along different paths from that of Egypt.

In the event, neither the Egyptian nor the Mesopotamian concept of the portrait was without consequence. When the Greeks came in time to concern themselves with the representation of the human individual, they were in contact with late but intact survivals of both civilizations and can be seen to have drawn upon both artistic traditions before arriving at their own, truly original, solutions.

Chapter III ✿ The

Portrait in Greek Art

ALTHOUGH PLINY'S CHARMING STORY of the potter's daughter tracing the outline of her lover's shadow on the wall implies that the desire for, and an ability to achieve, faithful likenesses was present virtually from the dawn of Greek art,[1] our material evidence, not to mention a critical evaluation of the sum of the literary material, serves to bear out what we know of the subject in general: that portraiture in Greece was a late development. It has even been contended that there was an active resistance to the idea of realistic portraiture among the Greeks for many generations, despite the fact that, through their contacts with Egypt, they were certainly exposed to the concept of effigies of individual persons as early as the archaic period.

Unlike the Egyptians, the Greeks of the preclassical and classical periods seem to have lacked the predisposition to rely on direct observation and representation of visual appearances of the sort responsible for the near approach to realistic portraiture so early in Egyptian history. If considered as any sort of continuum, Greek art seems always to have obeyed a strong impulse to generalize, to idealize: to draw conclusions from the evidence rather than to present it directly to the viewer.

It is for this reason that, although it will be our contention that the beginnings of fully fledged portraiture can be credited to later Greek culture, the

portrait does not play a part in the history of Greek art in the periods for which it is now most famous: the sixth and fifth centuries B.C. This book cannot even epitomize the broad history of Greek art; its concern is essentially, in this chapter, with one special manifestation of mature Greek civilization.

The Archaic Period: Funerary and Dedicatory Effigies

Portraiture in the pre-Greek Minoan period is remarkable in the same sense that the barking of the dog was significant to Holmes: It is not there at all, even in the broadest context of our preliminary definition. The first trace of any sort of recording of individual appearances comes from the shaft graves of the alien invaders who ruled Mycenae. Masks pressed from thin sheet gold were found over the faces of some of the bodies in these graves.[2] There is no essential disparity between such masks and the other funerary articles we have observed at late Neolithic and Bronze Age levels everywhere; they fall somewhere between the modeled skulls, found not only at Jericho but now in Neolithic Ionia, and the routine Egyptian mummy masks. Their value as likenesses, in any case, is negligible, and it is obvious that a realistic intent to record appearance for its own sake was quite absent from their creation.[3]

This type of funerary portrait remains rare, however, in Greek history. When the presentation of the human individual, whether or not with the intent of creating true portraiture, begins to play a significant part in Greek art, it is rather in relation to the dedicatory or offertory portrait as we saw it in Mesopotamia.

The first such images appear, significantly, during the orientalizing period of the sixth century B.C., and priority should probably be given to the seated statues of the Branchidae, the hereditary priests of Apollo, which were placed along the approach to his great sanctuary at Didyma in Ionia (Figure 41). While the sadly battered condition of these figures would make it impossible to judge their function on formal grounds, the preservation of an inscription on one statue reveals what that function was. It reads, "I am Chares, son of Kleisis, ruler of Teichioussa. The statue is the property of Apollo."[4] There is no indication of funerary cult here; this appears to be a purely votive dedication, just like the images of himself that Gudea of Lagash offered to his city god. It would appear that, like the Mesopotamian offerings, these statues were thought of as having a separate existence from their models, acting as agents rather than doubles of their donors. This similarity in concept is paralleled by the stylistic similarity of the figures of the Branchidae to the Mesopotamian ones, with their rounded forms and soft,

curving contours, so different from the sharp, blocky forms of the Egyptian tradition, which was influencing Greek sculpture at the same time.

Also in the category of votive offerings are the curious sixth-century clay masks found at Sparta, a few of which have a realistic flavor bordering on caricature; as the excavators put it, "They are realistic studies of the human face,

FIGURE 41 Statue inscribed "I am Chares," hereditary priest of Apollo's shrine at Didyma in Ionia—one of a large number of seated statues placed before the shrine early in the sixth century B.C. While the features are totally obliterated, the rounded boulder-like form of the statues is an indication of their ultimate derivation, in style as much as in concept, from the votive figures of ancient Mesopotamian rulers, such as Gudea.
The British Museum

exaggerated but essentially based on nature.''[5] While the particular group of masks showing these traits of realism are to be dated after 550 B.C., the group of Branchidae is now dated to the first quarter of the same century, some two generations earlier.[6]

What was to become the largest category of images referring to specific persons and originating from the archaic period, although made for a different purpose than the preceding works, belong none the less to the same general category of dedicatory offerings. These are the statues erected by victorious athletes in commemoration of their own triumphs; most were placed at Olympia, but examples could be found at many other sites, including the native towns of the victors.[7]

The practice of dedicating such statues was, like the other surviving offertory images, a development of the sixth century. Pausanias states, ''The first athletes to have their statues dedicated at Olympia were Praxidemas of Aegina, victorious at boxing at the 59th Festival (544 B.C.), and Rexibius the Opuntian, the successful pancratiast at the 61st Festival (536 B.C.). These statues . . . are made of wood.''[8] The mention of an apparently still earlier figure of this type at Olympia, that of Eutelidas, victor in the 38th Olympiad (628 B.C.),[9] has occasioned some controversy as to the validity of the statement just cited; but this need not have been a slip on the author's part, since it was evidently not uncommon for these commemorations to be made some time later, even long after the event.

On the other hand, there is some evidence in Pausanias that the practice had begun in Greece a little earlier than mid-century. His description of the dedication at Phigalia of Arrhachion, a victor some time before the 54th Olympiad (564 B.C.), gives us an accurate picture of the appearance of such works: ''It is archaic, especially in its posture. The feet are close together, and the arms hang down by the side as far as the hips.''[10] This would be a good description of any of the class of sixth-century statues now known as *kouroi*, ''youths,'' some of which were doubtless made for just this purpose, although most seem to have been funerary dedications. An early example, which shows clearly the degree of individualization possessed—or rather not possessed—by such works, is the pair of statues of Cleobis and Biton, inscribed as the work of Polymedes of Argos, found at Delphi, and dated by Miss Richter contemporaneously with the earliest of the figures of the Branchidae.[11]

The difficulty of recognizing different individuals in such dedications so baffled men of later centuries, when realistic portraiture had become normal, that they invented an *ex post facto* explanation to account for the very lack of individualization:

It was not customary to make effigies of human beings unless they deserved lasting commemoration for some distinguished reason, in the first case victory in the sacred contests and particularly those at Olympia, where it was the custom to dedicate statues of all who had won a competition; these statues, in the case of those who had been victorious there three times, were modelled as exact personal likenesses of the winners—what are called *iconicae*, portrait statues.[12]

This explanation to the contrary (and attempts are still made occasionally to rationalize it), the surviving works of art make it clear that, throughout the period in question, no intention existed to "represent" specific individuals, except in the dedicatory sense. Such realistic portrait likenesses as existed at Olympia in Pliny's or Pausanias' time originated at a far later date than the archaic period.

At the end of the sixth century, however, a shift in attitude toward the image of the individual begins to be evident. To the best of our knowledge, the new viewpoint is present in society long before stylistic character—or visual naturalism—was noticeably affected. "I rather believe," says Pliny, "that the first portrait statues officially erected at Athens were those of the tyrannicides Harmodius and Aristogiton. This happened in the same year as that in which the Kings were also driven out at Rome (510 B.C.)."[13] The author refers, of course, to the original bronze group by Antenor (which was in fact erected some twenty years later than Pliny states[14]), shortly to be carried off by the Persians when they captured Athens in 480. Although Antenor's group finally returned home after Alexander's conquest of the East, we cannot be sure of its appearance, for the group of the Tyrannicides, which was the basis for the numerous existing copies of later date, was apparently the replacement supplied by Critius and Nesiotes and erected in the market in 477 B.C. (Figure 42).[15]

The group honoring the tyrannicides, however dubious the merit of their cause really may have been (they assassinated Hipparchus, brother of the tyrant Hippias, in 514, not in the name of liberty but over considerably more sordid business affairs), does indeed mark a new stage in the history of the portrait in Greece. It is the first time, to our certain knowledge, that likenesses were set up not by the individuals portrayed—whether athletes or religious votaries (and athletes were of course votaries in the critical sense)—but by the community as a way of honoring the achievements of special heroes.

Although even Antenor's first group was made long after the death of the tyrannicides, something like individualization would have been possible in the likenesses had it been desired; but we have every evidence that such was not the case. Instead, even the later pair of figures appears to have been conceived in terms of the most idealized athlete statues of the time. More dramatic poses and

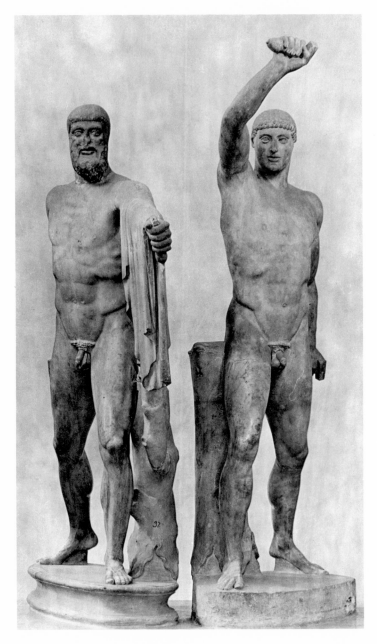

FIGURE 42 Although Pliny records that the first portrait statues officially erected at Athens were
those of the tyrannicides, Harmodius and Aristogiton, the extant copies of this portrait group—all
drastically restored like this pair—seem to reproduce a second set created in the 470's B.C., some
thirty years after their death.
Naples, Museo Nazionale

open stances offer foresights of developments to come in fifth-century sculpture, but they represent no advance toward individualized representation. Insofar as the evidence of copies can be used, V. Poulsen has observed that the two heroes might as well be brothers, the only distinction in their appearance being made by Aristogiton's beard.[16] The artist was simply not concerned with the appearance the two men had in life; his object was rather to portray their heroic virtue as expressed in their "noble deed." A man was not to be represented for the sake of his human nature but for his superhuman achievements.

These statues, then, are still linked to the athletes' dedications, insofar as any representational intent was present; but they also share this character with much later Greek portraiture. As Schefold has put it, "Die Bildnisstatuen wurden seltener den Dargestellten selbst, meist einer Gottheit geweiht Das Individuelle interessierte soweit, als in ihm etwas Allgemeingültige, Neues sichtbar wurde, als es für die Gemeinschaft, den Staat etwas bedeutete, als es im Mund der Menschen zur 'Sage' geformt, also mythisch wurde."[17]

The Fifth Century: The Hero

This heroizing—this translation of man into myth—is the key to all portraiture of the fifth century B.C. Every likeness from this period for which we have adequate documentation exhibits this heroic, superhuman character rather than a personal, realistic interest in the appearance of the individual human subject.

Athletes' dedications naturally continued to be produced throughout the period; Critius and Nesiotes themselves are recorded as creators of a statue for Epicharinus which Pausanias saw on the Acropolis and which appears to have been such a work.[18] Closely related to the public dedications were the more private ones that were placed in the palaestra of every Greek city. As artists during the fifth century increased their mastery of naturalistic representation, these statues approached a degree of realism which could well be taken by later ages as portraiture but which nevertheless was not based on the direct portrayal of the donor-model.

In the course of events, these athlete statues tended to fall into a set of stereotypes of idealized youth, natural enough under the circumstances, which made them as a class less and less likely to offer examples of portrait-like depiction. More significant for the ultimate development of the art of portraiture was the offshoot of athlete statuary, heralded by the Tyrannicide group: the considerable number of hero monuments erected to the victors in the struggle for the freedom

of Athens and of all Greece, the two wars with Persia. In the years following the
battle of Salamis (480 B.C.) and conceivably even during the interlude after
Marathon (490 B.C.), a number of official monuments were ordered to commemo-
rate these victories. On these memorials, according to our sources, recognizable
portraits of the principal leaders on both sides were to be found. In the painting
of the battle of Marathon in the Stoa Poikile, made by Panaenus (brother of
Phidias) and Micon, were depicted such leaders as Miltiades, Callimachus, and
Cynegirus,[19] as well as specific members of the lower ranks—if the story that the
likeness of Aeschylus was recognizable among the private soldiers is to be
credited.[20]

There is a certain contradiction of the concept of naturalistic intent in the
story, recounted by Aeschines, that Miltiades was refused permission to have his
name inscribed on the picture in order to identify his likeness.[21] The state re-
mained as jealous as ever of excessive glorification of individual citizens. But the
question then arises: Just how recognizable were these likenesses in the original
painting, before subsequent generations invested them with a haze of myth?
Since the painting was executed some thirty years after the battle, not only men
like Callimachus, who had been killed in the action, but many survivors would no
longer have been available to sit for a likeness, even had the artists been inclined to
work in that way.

A review of the literary evidence shows that virtually all discussion of portrait
likenesses in the highly realistic sense in works like this stems from writers of the
Roman period and may be suspected as a projection of attitudes of that date toward
the art of the portrait, rather than those of the fifth century B.C. Thus the story
that Phidias included a self-portrait, as well as a likeness of Pericles, on his Shield
of the Athena Parthenos has been condemned as a Ciceronian fable;[22] although
many of the copies of the shield, such as the Strangford Shield in the British
Museum, show a strongly individualized bald-headed man lifting a stone to hurl
at the Amazons, the very contrast between this highly specific head and the wholly
generalized ones on all other figures of the relief (the supposed Pericles face is
actually hidden) raises the suspicion that the "portrait" is a later intrusion.[23]
Nothing in the surviving and securely dated art of the mid-fifth century permits
us to regard any of the hero images recorded in the literature of the time as
portrait likenesses in the later sense of the word.[24]

This must have held equally true of the great dedication of spoils from the
Persian Wars which was made at Delphi. In this statue group, ascribed to Phidias by
Pausanias,[25] the only contemporary represented seems to have been Miltiades;
the other figures were gods or mythical heroes: Athena and Apollo, Erechtheus
and Cecrops. Miltiades was obviously assimilated to the great figures of Athens'

mythical past; and if the ascription to Phidias is to be taken seriously, this work, too, must have been created long after the event.

It has been suggested, however, that in the decade or two following the victory at Plataea (479 B.C.) there did appear something approaching individualized portraiture.[26] This thesis is a corollary of the generally accepted view that the decades immediately following the Persian Wars saw a phase of Greek art characterized by dramatically active compositions and rapidly advancing naturalism of depiction; this phase was partially reversed, more or less single-handedly, by Phidias, who formulated the high classic style of the Parthenon with its static and idealized forms.

The earliest surviving specimen of realistic portraiture, according to this theory, would be the likeness of Aristogiton in the second Tyrannicide group, the one by Critius and Nesiotes. We have a fairly good copy of this head in the Vatican;[27] our difficulty lies in the wide variety of reactions to it, from Miss Richter's, that it stands "among the first individualized Greek portrait statues,"[28] to the finding of another writer that, aside from its beard, it is not noticeably different from its companion.[29] Except for an expression of forcefulness, which sets it apart from most late archaic heads, it is difficult indeed to see how this image can be described as "individualized" by comparison with others which are more closely contemporaneous; nor should we expect this to be the case, since we are, once again, dealing with a long-posthumous likeness.

The keystone of the argument for a post-Plataean "true portrait," however, is the truly remarkable image of Themistocles discovered at Ostia in the 1930's, a work which certainly has a number of stylistic resemblances to such works as the Olympia pediment and metope sculptures and yet conveys a powerful sense of individual personality (Figure 58).[30] On the other hand, few scholars would deny that it also betrays elements of later style—certainly traits of the fourth century B.C., and possibly others of still later date. The question, then, is whether the traits which tend to make the work seem most individualized, such as the thrust of the head and the forcefulness of the expression, are among these later accretions or are part of the original formulation. According to those who hold the former point of view, the work is probably a pastiche, a thorough reworking of an earlier model in terms of the more highly emotionalized aesthetic of the third quarter of the fourth century.[31] Comparable works from that time would include the head in Copenhagen which has been identified with Philip of Macedon; this exhibits a number of similarities, in the handling of its coiffure, its expression, and the thrust of its neck, to the Themistocles herm (Figure 59).[32] Other examples of fourth-century reworking of earlier types to invest received likenesses with greater emotion are the familiar "archaic" blind Homer—of which the best

example is in Munich—where, again, the expression of pathos contradicts the traits of fifth-century "strong style,"[33] and perhaps the portrait identified as either Pausanias or Leonidas of Sparta, which has stylistic traits in the manner of Polyclitus but whose far later date is betrayed by a comparison with its existing fifth-century model.[34]

This controversy is not within sight of reconciliation. Since decisions must be based not only on copies of widely varying quality but perhaps also on copies of adaptations, it is understandable that one student's conception of the characteristics of the early classical period's style of portraiture will continue to differ from another's. For our present purpose we may state that we have adequate evidence from literary sources that, in the period between 480 and 450 B.C., a number of heroic portraits of the leaders of Greek resistance against the Persians were produced but that a strong degree of individualization sought or achieved in these works cannot be surely demonstrated. There are even indications that individualization was actively discouraged; we have already noted the city-states' objections to having the heroes identified in the pictures of battles, including Marathon.

The inclusion of representations, however specific, in these memorials did in any case create a significant precedent for the Greeks: The idea of honoring the great men of the *polis* by statues was now accepted. It was on this precedent that the well-known portrait of Pericles was placed on the Acropolis, in all likelihood posthumously (Figure 1).[35] The familiar image, typified by the herm in the British Museum,[36] is generally accepted as faithfully reproducing the work of the sculptor Cresilas, identified in the sources. It is a fascinating blend of the classic type of the general, forceful and strong, with that of the thinker, the poet or philosopher, as they were established by the middle of the fifth century. As a portrait, however, it is naturalistic only by comparison with earlier *strategos* types (Figure 43);[37] this likeness of Pericles cannot be regarded as anything but a manifestation of a type, the most spiritualized of all the examples of the military portrait from this period. It offers little more in the way of specific information about the appearance of its subject than does the famous passage of description in Thucydides,[38] which is devoted to an enumeration of noble traits of character better suited to an unworldly ideal of perfection than to the actual very practical politician—wise and noble though he was—whom Thucydides elsewhere reveals in more circumstantial detail.

Not only military and political leaders were commemorated; other types of heroes—even poets—could be honored with portrait statues, although always, so far as we can tell, posthumously. The prototype of the sentimentalized "archaic" blind Homer was probably first created at this time. More securely datable to the classic period is another imaginary likeness of an early poet, the

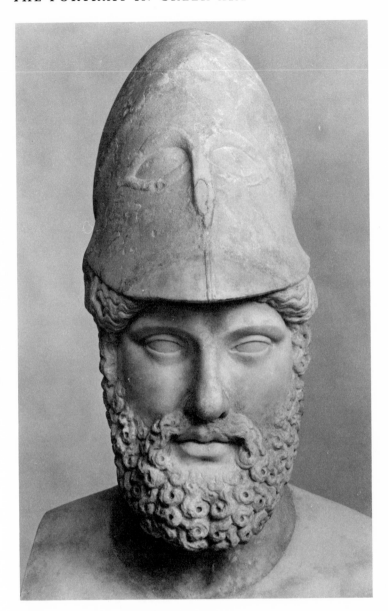

FIGURE 43 In the absence of any clue to identification, this copy of a head of a Greek military chieftain offers no certainty as to whether a specific portrait was intended or merely the representation of a type; it is in fact a type which could occasionally be used to refer to a specific person. It relates to the likenesses known to have been made of the generals who achieved fame in the Persian Wars, a period when the literal depiction of individuals—what we would call the "true portrait" —was still out of the question in Greek art.

Munich, Staatliche Antikensammlungen

full-length statue of Anacreon, now in Copenhagen (Figure 44).[39] This has been accepted as a good copy of the statue Pausanias saw on the Acropolis, placed there beside a portrait of Anacreon's friend, Pericles' father Xanthippus, presumably by Pericles' order.[40] Both these posthumous works suggest recreations—evocations of the spirit rather than the substance of their subjects, not literal transcriptions of visible appearance—although the question of whether the ecstatic stance of Anacreon suggests intoxication by more than just the spirits of the Muse

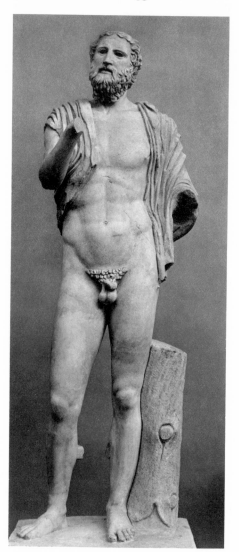

FIGURE 44 This Roman statue copies a portrait of Anacreon, most probably the one placed on the Acropolis of Athens during the reign of Pericles. While depicting a specific poet, the statue is more a portrayal of the state of poetic ecstasy than the literal transcription of the appearance of one particular individual. The heroic nudity first became conventional for athletes' dedications.

Copenhagen, Ny Carlsberg Glyptotek

may be considered irrelevant. If, as has been suggested,[41] these two works may be attributed to the hand of Phidias, we have a valuable pair of documents to compare with the image of Pericles by Cresilas and can gain a still better idea of what, at the height of the classical period in Athens, was considered significant in portraying an individual. These works, formally, represent a logical development from the idealizing method of portrayal evident in such securely placed likenesses as that of Aristogiton; an intervening reaction strong enough to have produced such works as the Ostia Themistocles is at least conceivable, but it is difficult to understand how it could have taken place without leaving at least a trace of its passing on subsequent works such as these.

The most that can be said with full certainty is that the classical period, while not averse to the creation of images of specific persons, required these images to be sufficiently idealized to bring out the superhuman qualities which alone merited the commemoration. This period may have developed new subtleties in the realization of the blend of qualities requisite to true greatness in human affairs. But, while basing its creations on observed reality, it raised its representations to the level of the ideal, allowing no reference to the accidentals of individual appearance or idiosyncratic character to intrude.

The Turn of the Century: Soldiers and Satraps

The end of the fifth century marks a significant turning point in the history of Greece. With the defeat of Athens in the Peloponnesian War, certain possibilities of cultural as well as political growth were eliminated in the Greek world. In the arts of the time we may sense a change of atmosphere as well, and a shift to conditions more favorable to what we may consider the "true" portrait. Above all, there is a growing interest in the individual phenomenon, paralleling an intellectual concern with and appreciation of the importance of the human individual for his own sake.

So far as the arts are concerned, it may be suggested that the weakening of Athenian hegemony was partly responsible for the admission of such new interests as these. It appears possible that the stimulus for a new growth of concern for the individualized likeness originated, not from the mainland at all, but from the East: Ionia may have been the source of realistic portraiture in Greek art.

The evidence, particularly for a background to this development, is unfortunately meager and tenuous. From the archaic period we have only the featureless statues of the Branchidae to compare with the legendary reputation of an artist such as Theodorus of Samos, who "cast a statue of himself in bronze.

Besides its remarkable celebrity as a likeness, it is famous for its very minute workmanship. . . .''[42] Again, there is the tale of the unfortunate poet Hipponax, "who certainly lived in the 60th Olympiad [540–537 B.C.] . . ." and who "was conspicuous for his ill-favored countenance, which incited the sculptors [Boupalus and Athenis, of Chios] in wanton jest to display his portrait to the ridicule of their assembled friends."[43]

Archaeological evidence which would allow us to judge the actual fidelity to nature of works such as these—as against their quality as caricature—has yet to be uncovered; our earliest significant evidence from the eastern part of the Greek world dates only from the postclassical period, and it is work in miniature, on coins and gems. It may nevertheless be significant that the first coins to bear something like portrait images were in fact struck in Ionia, by the Persian satraps marginally involved in the Peloponnesian War.

Persian coins had long carried the picture of the head of the Great King on one face, with the Zoroastrian fire altar presented on the reverse; but such emblems cannot be considered seriously as realistic likenesses of the individual rulers. They are rather representations of the king's divine power, an essentially supramundane guarantee of the worth of the coin, no different from the profile of Athena used on the staters of Athens: "C'est bien le Roi qui est représenté, mais l'art du portrait n'y trouve guère son compte, si l'on songe surtout que l'artifice dés barbes et des perruques offrait à la foule admirative une image uniforme et immuable."[44] It has proved impossible to distinguish between issues of different reigns purely on the basis of the royal images on the coins, so little are they differentiated.

The striking of silver tetradrachms bearing their own images, instead of that of the Great King, by Tissaphernes in 411 and by Pharnabazus in 410 B.C.,[45] certainly represents a major conceptual step: the symbol of divine authority, which these satraps were defying, was replaced by a symbol of mortal power. The question remains whether the artists who carved these coin dies were capable of producing likenesses as revolutionary as the implications of the types themselves.

Even allowing for the fact that the magnification of the slightest accidental touch of the graver, working on this minute scale, can be seriously misleading, little in the way of individualization can be claimed for these coin types. We can distinguish them from those of the Persian King, or from one another, by details of costume, coiffure, and other attributes, but not by the physical details of the likenesses. There is no assurance that, in imagery as in politics, the rebellious satraps had progressed much farther than the restless Greek commanders of the Greco-Persian Wars. Only when a much later rebel satrap, Orontes, followed the

same example as late as 358 B.C., striking in both gold and silver,[46] is it possible to speak of any significant degree of portrait character in the coin images; and by this time, of course, the idea of the portrait as we understand it was well established throughout the Greek world.

It is in the context of the earlier satrapal coin types that we may consider the vivid profile carved on a gem by Dexamenos, now in the Boston Museum of Fine Arts (Figure 45).[47] The signature on the gem presumably identifies this work as that of a recorded Chian artist, who may therefore be linked with the putative Ionian "realist movement" of the late fifth century. That it is the product of a realistic tendency cannot be questioned, but the degree to which it betrays serious interest in the delineation of a specific individual and his personality may be challenged; it still appears to have, within the limits of its scale, a degree of idealization clinging to it. In any event, a fifth-century date for this work is by no means a certainty, and it can as easily be dated after 400 B.C., as far as comparable stylistic material and the evidence of the sources indicate.[48]

When we can turn at last to an Ionian portrait on a large scale, it is conspicuously useless for proving anything decisive about the nature of the supposed realism of the region's artists. The work in question is another satrapal portrait, the presumed image of Mausolus from his tomb at Halicarnassus, which was probably executed after the subject's death in 363 B.C. (Figure 46).[49] The figure from the tomb, heroic in scale and generalized in treatment, shows almost no sense of individualization whatever—a fact which probably accounts for the persistent doubts as to whether this is really the intended portrait of Mausolus at all. Actually, its transcendental nature is shared by most Greek funerary images, its intention being to convey the heroic stature of the deceased, not his mundane idiosyncrasies. In this case, the form of the subject seems indeed to have been assimilated to the image of divinity itself.

In mainland Greece, the victors in the wars against Athens made their dedications at Delphi, just as an earlier generation of warriors had done after the defeat of the Persians. Now, however, mortals occupied far more of the stage, as Pausanias' catalogue makes clear:

Opposite there are offerings of the Lacedaemonians from the spoils of the Athenians: The Dioscuri, Zeus, Apollo, Artemis, and beside these Poseidon, Lysander, son of Aristocritus, represented as being crowned by Poseidon, Agias, soothsayer to Lysander on the occasion of his victory, and Hermon, who steered his flag-ship. This statue of Hermon was not unaturally made by Theocosmus of Megara, who had been enrolled as a citizen of that city. The Dioscuri were made by Antiphanes of Argos; the soothsayer by Pison, from Calaureia, in the territory of Troezen; the Artemis, Poseidon and also Lysander by Dameas; and Apollo and Zeus by Athenodorus. The last two artists were Arcadians from Cleitor.

FIGURE 45 A carved gem of the late fifth century B.C., signed "Dexamenos," presumably the work of an artist of that name known to have worked at Chios in Ionia. The degree of naturalism is comparatively high for the period, but it may be questioned to what degree it represents either the development of fully naturalistic portraiture or the existence of a putative Ionian school of naturalism in advance of developments in mainland Greece. Actual height ¾ inch.
Boston, Museum of Fine Arts, Francis Bartlett Donation

Behind the offerings enumerated are statues of those who, whether Spartans or Spartan allies, assisted Lysander at Aegospotami. They are these:—Aracus of Lacedaemon, Erianthes a Boeotian . . . above Mimas, whence came Astycrates, Cephisocles, Hermophantus and Hicesius of Chios; Timarchus and Diagoras of Rhodes; Theodamus of Cnidus; Cimmerius of Ephesus and Aeantides of Miletus. These were made by Tisander, but the next were made by Alypus of Sicyon, namely:—Theopompus the Myndian, Cleomedes of Samos, the two Euboeans Aristoclus of Carystus and Autonomus of Eretria, Aristophantus of Corinth, Apollodorus of Troezen, and Dion from Epidaurus in Argolis.

FIGURE 46 This statue of the Ionian satrap Mausolus, preserved in the ruins of the tomb his wife built for him at Halicarnassus, must date from the middle of the fourth century B.C. It testifies to the degree to which Greek funerary portraiture continued to conform to the standards of idealization, even heroization, with which it had begun. Mausolus appears here more as god than man.
The British Museum

Next to these came the Achaean Axionicus from Pellene, Theares of Hermion, Pyrrhias the Phocian, Comon of Megara, Agasimenes of Sicyon, Telycrates the Leucadian, Pythodotus of Corinth and Euantides the Ambraciot; last come the Lacedaemonians Epicydidas and Eteonicus. These, they say, are works of Patrocles and Canachus.[50]

This passage has been quoted at length, not only to convey the complexity of such a monument and the number of sculptures—and sculptors—involved in its production, but also to show how it contrasted with the monument to Marathon, with its statues that "represent Athena, Apollo, and Miltiades, one of the generals."[51] In addition, the range of origins of the sculptors concerned gives no clue to any regional specialization in portraiture. It is notable that the same artist, Dameas, an Arcadian, was responsible for two of the divinities as well as the portrait of the Spartan chief—apparently the key central grouping of the whole rather motley composition.

Certainly the conclusion of the Peloponnesian War saw the existence of a new attitude toward the portrayal of contemporary heroes, if only in the extent to which they were included in official monuments. This change is evident in Athens once Spartan power had begun to decline in the 390's. The first man to be honored at Athens by a dedication at public expense since the Tyrannicides, according to Demosthenes, was Conon, the admiral who had, with the help of the Persians, broken the Spartan naval power at Cnidus in 394.[52] Demosthenes, in a later speech, made a great point of the fact that none of the leaders of the earlier Persian Wars—Themistocles, Miltiades, or their peers—had been so honored but had found sufficient glory in the knowledge that they had been selected for leadership by the free vote of their fellow citizens.[53] This, of course, does not quite agree with the other story of Miltiades' request to be identified in the painting of Marathon, however well or badly it may tally with the sources in other respects. Conon was later joined in honor by his son Timotheus, victor over Corcyra in 376,[54] and from this time on the practice of making official dedications of statues of public heroes, erected in public locations (usually accompanied by other honors, such as the conferring of certain legal immunities, the right to maintenance in the Prytaneum at public expense, and the like) became a common means of recognition for outstanding public service.

These records give us no clue to the actual appearance of such portraits of the early fourth century, but a few other texts do give some indication of what artists were beginning to find interesting in their subjects, and they suggest that a new approach to the portrayal of the individual was becoming current. Whereas it is said of Cresilas, the portraitist of Pericles, that "nobiles viros nobiliores fecit,"[55] we learn that Demetrius of Alopece, who must have been active just before and after the turn of the century, was "less concerned about the beauty

than the truth of his work." [56] Lucian underlines the difference by stating that Demetrius "makes men, not gods." [57]

As portrayed by ancient writers, this Demetrius sounds more like a caricaturist than a naturalistic realist. His statue of Pellichus, as described by Lucian, "pot-bellied, bald on the forehead, half bared by the hang of his cloak, with some of the hairs of his beard wind-blown and his veins prominent," seems worthy of Daumier.[58] That the early phase of a naturalistic movement may tend to go in the direction of exaggeration of distinctive traits is scarcely unexpected; it has been seen at Amarna in Egypt, for example. In any event, in view of the uncertainty of Demetrius' chronological position, it is difficult to know whether he portrayed living models or posthumous legends. His subjects all seem to have lived during the third quarter of the fifth century, while his own activity seems to have fallen inside the fourth, although it may have begun earlier.

His recorded works are of Simon, an Athenian cavalry officer mentioned in Aristophanes' *Knights*, which was produced in 424; Pellichus, father of the admiral Aristeus, who commanded the fleet of Corinth in 434; and Lysimache, the aged priestess of Athena.[59] Only in the last case has a suggested identification with an existing work—known in several copies—been offered (Figure 47), and even here the evidence is far from conclusive.[60] On the other hand, epigraphic evidence of the name of this sculptor—if it is the same Demetrius—has been found on the Acropolis, dating apparently from as late as *ca.* 360 B.C.; two other inscriptions, dated to the late fifth century, which may mention his name are so heavily interpolated, and so unspecific as to the occupation of a man named Demetrius, as to be of doubtful value to the problem.[61]

On the more likely assumption that Demetrius' chief period of activity lay within the fourth century, an attempt has been made to assemble a group of works, related in style to the presumed head of "Lysimache," which form a coherent body of work suggestive of the reported style and interests of Demetrius of Alopece.[62] It seems significant that all these works, as well as the lost ones mentioned in our sources, portray elderly people—those past the prime of physical beauty. Such subjects display more of the effects of experience and are hence of greater interest to the portraitist who is just beginning to master his craft and needs to find his way by using the most obvious and striking signs of individuality.

While any such reconstruction of the *oeuvre* of an artist like Demetrius of Alopece must remain wholly tentative, it is possible to conclude that he does represent a new, comparatively anticlassical (i.e., anti-idealizing) tendency in Athenian art. As regards the degree of objective realism in his new approach, it is well to bear in mind the cautionary words of Hekler: "One thing seems certain, and that is, that the assertions of the ancient writers as to the relentless

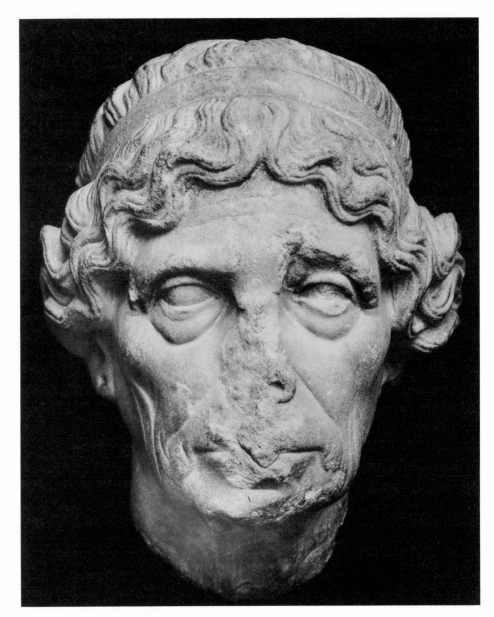

FIGURE 47 Portraits of women are rare from the Greek world; this apparent exception records the somewhat generalized features of an elderly lady and follows the style of the second quarter of the fourth century B.C. It has been identified with the portrait of Lysimache, priestess of Athena—and possibly the original of Lysistrata—known to have been made by Demetrius of Alopece, a specialist in images of elderly persons. If this is correct, the portrait was almost certainly posthumous—as its ideal of clear-sighted old age does nothing to contradict.

The British Museum

realism of Demetrius were greatly exaggerated. No one can overstep the limits of his time.''[63]

The Fourth Century: The Thinker

If the beginning of the fourth century—a time of change in so many aspects of Greek life—ushers in a new attitude toward the portrayal of the individual, this change is manifest not only in an increase in the number of military and political leaders honored by portraits but also by an interest in creating such memorials to eminent figures in other fields of activity. Of particular interest is the series of likenesses of intellectuals—writers, poets, and philosophers—which appears to have originated during this period.

Such works would not have been official dedications at this time, when the state (as in Athens) was still quite sparing in its willingness to confer such honors. It would be only natural to expect, however, that the grudging award of a dedication to a hero like Conon was the reflection of a far more common *private* practice. It seems to be particularly significant, therefore, that the one such private dedication recorded for this period is a portrait of Plato, ordered from the sculptor Silanion by a former student of the Academy, a Persian named Mithridates, and placed within the grounds of the Academy itself.[64]

The only Persian of that name appearing in the records is a satrap at Cius in the Propontis, who died in 363 B.C.[65] If this is the same person—and we have no reason to question that it is—then a practical terminal date for the commissioning of the portrait is available; and in that case, the fact that Plato himself died as late as 347 would make it reasonable to assume that the likeness in question was, for once, demonstrably not posthumous.[66]

We have just one established portrait type of Plato (Figure 48), known in over twenty copies, and identified by an inscribed herm in Berlin.[67] It is the likeness of a grim-looking personage, whose massive cranium is covered with hair lying flat to the shape of the skull, framing a scowling brow above an almost sneering mouth. Although the scholars of two generations ago, when this likeness was first securely established, were reluctant to accept so forbidding a representation as that of the great philosopher, the fact is that the portrait conforms well with written descriptions, which almost always mention Plato's grave and unsmiling mien.[68]

The portrait is indeed more of a mask than a revelation of character; as F. Poulsen put it, ''The portrait is extraordinarily abstract and typical, there is no trace of intellectual comprehension, and likeness to the individual is limited to a

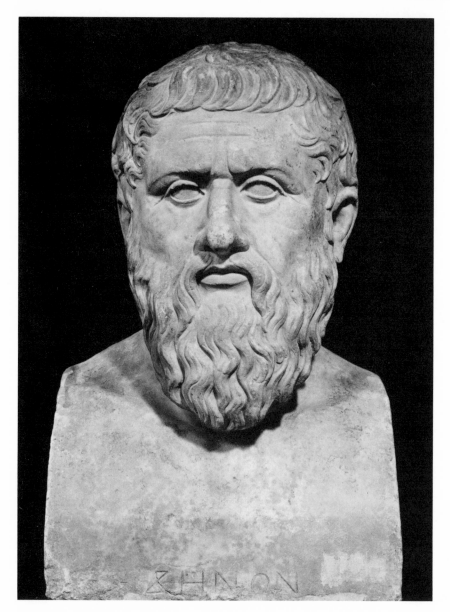

FIGURE 48 The likeness of Plato exemplified by this incorrectly inscribed copy is probably the earliest of extant Greek portraits which could have been made directly from its living subject. It was probably the image placed in the Grove of the Academy at the order of a former student, who died within Plato's lifetime. While agreeing with the recorded description of the philosopher, the portrait lacks any sense of the warmth or intellectuality one would expect in a representation of such a man—a lack fully characteristic of the first phase of naturalistic portraiture.
Vatican Museum, Sala delle Muse

few such traits as the breadth of the forehead and the cut of the beard."[69] A portrait like this, in other words, did not attempt to portray the inner life of its subject; on the framework of an idealized head, the modifying traits of the particular individual were applied, without any effort to suggest what went on behind the façade. It is possible, in fact, to relate this way of portraying the individual to that deliberate use of contrast between exterior appearance and interior content which was a fundamental premise of early fourth-century intellectual expression, such as Plato's own.[70]

It is instructive, in this context, to compare the description of another of Silanion's recorded portraits:

> Silanion cast a metal figure of Apollodorus, who was himself a modeller, and indeed one of quite unrivalled devotion to the art and a severe critic of his own work, who often broke his statues in pieces after he had finished them, his intense passion for his art making him unable to be satisfied, and consequently he was given the surname of the Madman— this quality he [Silanion] brought out in his statue, the Madman, which reproduced in bronze *not a human being but anger personified.*[71]

The only other portrait by Silanion that is mentioned in the sources is one of the poetess Corinna, an older contemporary of Pindar;[72] such an image must necessarily fall within the category of imaginary reconstructions rather than likenesses based on the record of actual appearance.

It seems clear that it would not have been the practice of an artist like Silanion to concentrate his attention on portraying the individual characteristics of his subjects; he would use these, rather, to modify the features of a generalized type, with which the individual could then be identified. Creative procedures of just this sort appear to underlie the surviving portrait type of Plato, making it all the more probable that this is indeed the recorded work of Silanion which we have before us.

Although the records do not mention the existence of a likeness of Socrates within the precincts of the Academy at this time, it is all but unthinkable that a portrait of Plato should have been placed there without one of his master as well. The existence of a portrait type of Socrates which relates to that of Plato in general stylistic and conceptual terms, although apparently slightly earlier, fits our demands very well (Figure 49). Known in seven examples,[73] this type conforms all too well to the caricatural descriptions of Socrates found in the writings of his friends, such as Xenophon's catalogue of broad, flat face, flat-set eyes, protruding nostrils in flat snub nose, and thick rubbery lips,[74] or Plato's assertion (through the person of Alcibiades) that "he is likest to the Silenus-figures that sit in the statuaries' shops; . . . and I further suggest that he resembles the satyr Marsyas."[75] The portrait type under examination does indeed suggest Myron's Marsyas in

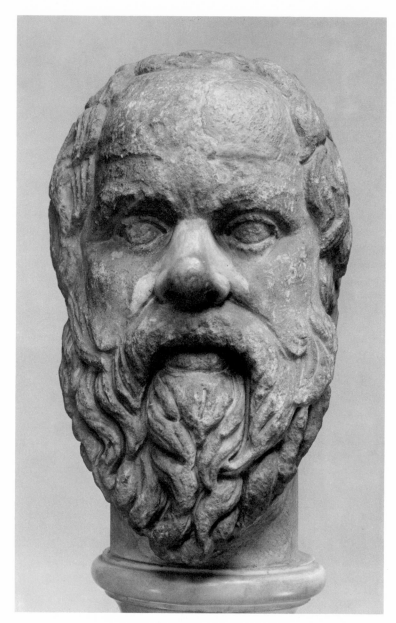

FIGURE 49 It is assumed that a portrait of Socrates had been set up in the precincts of the Academy by the time the statue of Plato was dedicated. This—evidently the earliest portrait type of Socrates —conforms to the somewhat satirical description of the subject's ugly features and shares with the Plato image a lack of any sense of intellectual presence. The portrait is a mask which hides rather than reveals the action of the mind.

The British Museum

many of its traits; certainly it is easier to discern in these works the humor which was an important component of Socrates' charm than the wisdom which was his most essential property.

This very trait, the absence of any serious indication of the character of the subject, which is indicated merely in terms of superficial physical idiosyncrasies, helps to link this portrait with Silanion's Plato in conceptual approach. In style, too, there is a degree of correspondence which places both works in the same general phase of development within the period: the conformity of the features to the over-all globular shape of the head and their flatness and lack of plasticity; the lack of interest in differentiating textures, as between flesh, hair, and beard; even details such as the arrangement of locks of hair, the framing of the mouth by mustache and beard, and the articulation of the ears, all sustain a comparison which, while not suggesting prototypes by the same hand, indicate that we are dealing with products of the same artistic milieu.[76]

If a portrait of Socrates was produced in Athens during the first half of the fourth century, it must have been done on private initiative, and it is most likely that it would have been made for the Academy, which was founded in 387, a dozen years after Socrates' death. In all likelihood, this portrait was created a decade or so before that of Plato—an assumption the differences between copies of the two prototypes seem to bear out. Despite this gap in time, both likenesses belong to the same general stage of development of Attic style and particularly to the same phase in the evolution of an approach to the problem of representing the individual person—a phase in which the individual image is still strongly conditioned by the concept of the type. The process of idealization, reflected in the words of Socrates to the artists in Xenophon's *Memorabilia*, was still dominant in the creative procedure, although far more attention than formerly was being paid to nature's accidents.

Around these likenesses of Plato and Socrates it is possible to group a wider circle of stylistically related portraits, all of which seem to have originated during the same period, that is, about 380–360 B.C. The portrait of the rheotrician Lysias, who died in 380, is especially similar to the Socrates in such points as the construction of the head as a whole, the proportions of the face, the forming of the hair and beard, and the lack of interest in differentiation of surfaces and textures.[77] The portrait of Thucydides, who died early in the century, has many of the same traits and the same rather generalized features.[78] A similar broad skull, squared forehead, and even more idealized facial features are evident in the copies of another portrait type of the same stylistic phase which has recently been tentatively identified with the philosopher Democritus (Figure 50) and which is also found linked in a double herm with a comparable likeness which might be of Heraclitus.[79]

FIGURE 50 This image, once identified with Sophocles, but more probably a portrait of Democritus, is a product of the same early phase of Greek portraiture as the likenesses of Plato and Socrates. It shares many stylistic features with the portrait of Plato and betrays much the same tendency to mask any sense of the subject's intellectual activity.
Copenhagen, Ny Carlsberg Glyptotek

The "Democritus" portrait is of particular interest because it has been regarded from time to time as an additional—and the earliest—portrait of Sophocles. The only basis for such an identification lies in the strong family resemblance between the features of this portrait and that of the head of the familiar standing statue of Sophocles in the Lateran, as we know it in its unrestored state, thanks to a cast preserved in the Villa Medici (Figure 51).[80] This resemblance, which was the basis for the original identification of "Democritus" with Sophocles,[81] may be accounted for, not by the possibility that both portraits refer to the same individual, but, far more probably, by the derivation of both images from the same general time and place of origin.

Such a proposal, of course, does violence to the conventional assumption that the Lateran Sophcoles (Figure 52) reproduces the statue placed in the Theater of Dionysus by Lycurgus in the 330's[82]—an assumption which has not gone unchallenged before now.[83] While the Lateran statue does, in its present state, fit adequately our rather ill-defined picture of Athenian style in the waning years of the fourth century, we are faced with the difficulty that the statue was drastically restored, a century ago, by a sculptor who based his reconstruction on a still later work, the figure of Aeschines in Naples (Figure 53), whose original must date from after 300 B.C.![84]

Except for the cast of the head, we have no accurate picture of the unrestored Sophocles figure, although we do know that it was in sadly battered condition when found. All the lower part of the figure, including not only the base but the feet and the scrinium, is totally new, and the entire figure must have been heavily reworked, to judge by what has been done to the head. The drapery conforms to a general type of cloaked figure which was popular throughout the Hellenistic period, and the Lateran statue in its present condition so closely resembles that of the Aeschines in its drapery style as to offer no useful information for discriminating chronologically between them. A recently published statuette, reproducing this figure of Sophocles in a general way, shows a drapery style somewhat simpler and softer—handled in terms of masses rather than lines— as well as a base lacking the scrinium, as expected;[85] but such variations are apt to increase in works of greatly reduced scale such as this, so that it is not too safe to base conclusions on their evidence.[86]

What is left as a basis for stylistic judgment, then, is merely the cast of the head of Sophocles; and this, as we have observed, seems to conform more obviously to the style of the first half of the fourth century than to that of the second. While the shapes of the hair, beard, and mustache are built out from the head more prominently than on most of the works just described, the height and shape of the forehead, the shape of the mouth and its relation to the mustache, the

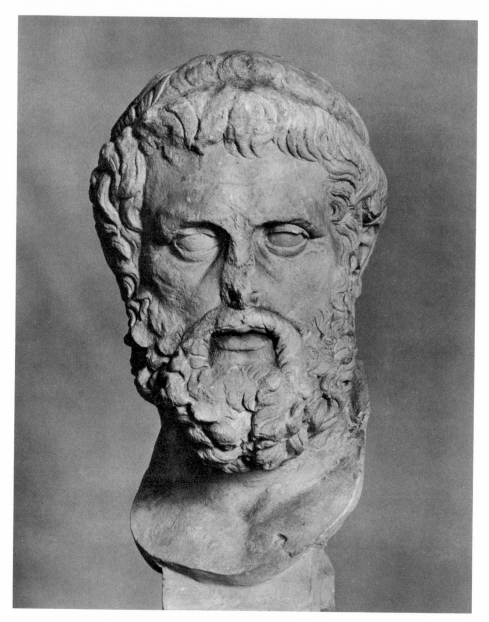

FIGURE 51 Also related to the first stage of Greek realistic portraiture is this head, known from the cast which preserves the original appearance of the portrait of Sophocles in the Lateran (Figure 52). Although the hair is more fully modeled and the features are more strongly idealized, the conceptualization of the likeness as well as the treatment of surface details places the work early in the evolution of the individualized portrait in Greece.
Rome, Villa Medici

FIGURE 52 In the course of its drastic nineteenth-century restoration, the statue of Sophocles was furnished with a number of attributes—such as the scrinium (the scroll-carrier on the pedestal)— for which there is no evidence in the original fragments or in comparable figures. Beyond this, the entire surface of the sculpture was totally reworked by the restorer to conform to his own ideas of finish.

Rome, Palazzo Lateranense

FIGURE 53 The model for the restoration of the Lateran statue of Sophocles was in fact this portrait
of Aeschines, whose original was made in the early third century—much later than any possible
dating of the Sophocles. A great deal of the difficulty that modern critics encounter in relating the
Sophocles to the development of fourth-century portraiture evidently derives from the inconsis-
tencies introduced by the nineteenth-century restoration.

Naples, Museo Nazionale

general organization of the relation of physical details of the features, the surface treatment, and, above all, the level of idealization involved, all link this work to the Athenian portraits of the period with which we are concerned here.[87] Even more than it does the portraiture of the time, this head resembles a type of "old man" portrayed on innumerable grave reliefs of the first half of the century; and while the chronology of these reliefs is a vexed subject, we do know two things about them which can bear on our problem. In the first place, they were stylistically and conceptually highly conservative, lagging far behind advances evident in other forms of sculpture; and in the second, their erection was forbidden under Demetrius Phalereus, so that their creation has a reasonable terminal date of 315 B.C. at the latest.[88]

At the middle of the fourth century, Athens—and all of Greece, for that matter—entered a new time of trial, with the rising Macedonian power challenging the autonomy of the city-states more seriously than anything had since the Persian invasions over a century earlier. This time, Greek resistance was less successful, and, ultimately, a new world came into being. It should not surprise us that a hiatus in the creation of works of art of the sort we are discussing seems to exist during this time of troubles.

On the morrow of Chaeronea, in 338, when the Athenians at last acknowledged the futility of resisting Macedonian pressure, Lycurgus was appointed *tamias* (financial administrator of the city)—an office he held for a dozen years. During this period, as virtual dictator of the defeated city, he set about systematically to restore the domestic well-being, confidence, and pride of his fellow citizens, working within the new political framework. His policy found expression in, among other things, a large number of public works projects, including the completion of the Theater of Dionysus on the slope of the Acropolis. In general it was his object to revive in the men of Athens an awareness of their heritage of greatness, and to this end he held up the great men of their past as examples for emulation. As one aspect of this effort, a number of portrait statues were erected in public sites, the first systematic effort at such commemoration by the Athenian state, properly speaking.

Themistocles and Miltiades were honored with statues in the Theater of Dionysus;[89] in addition, and perhaps more pertinently, there were placed within that hemicycle bronze statues of the three greatest dramatists of the classical period, Sophocles, Euripides, and Aeschylus.[90] At this same time, in all probability, a statue of Socrates was ordered from Lysippus, the most eminent portraitist of the age, and placed in the Pompeum[91]—the first public honor paid to the great philosopher.

FIGURE 54 The likeness of Socrates was evidently "revised" in later generations, as the earlier image was found unsatisfactory because of its lack of expressiveness. This type, apparently corresponding to a portrait erected in Athens in the 330's, is far more intellectualized than the earlier one from the Academy.

Rome, Museo Nazionale

With this last commission is generally identified a portrait type of Socrates which compares reasonably well with what we are able to reconstruct of the style of Lysippus (Figure 54).[92] This image differs radically from the earlier "Silenus type," for it shows a longer, narrower face, a high, squared forehead, heavier masses of hair and beard treated in a strongly plastic way, and, above all, a significant change of expression, from the wry smile of the earlier, mocking image to a wholly serious, almost pessimistic demeanor suggestive of an awareness of the full implications of the life and teachings of the man himself rather than a superficial seizing of his bantering mode of exposition. Here we face a totally new approach to the concept of what a portrait should reveal about its subject, a concept paralleled in the other works datable to the Lycurgan domination of Athens.

The conventional assumption that the Lateran statue of Sophocles reproduces the likeness made for the Theater of Dionysus has confused numerous attempts to assemble a group of three portraits of the great tragedians which could be identified with the Lycurgan triad. Once the Lateran portrait is eliminated from consideration, however, it is possible to find three images of the dramatists sufficiently similar stylistically to one another (as well as to the Lysippan Socrates) to fit the requirements of the Lycurgan set.

We must emphasize the neglected fact that, not only in the case of Socrates, but in that of Sophocles and Euripides as well (and of a few more subjects of less immediate significance to our problem), more than one portrait type of a historical personage has come down to us in a clearly defined recension.[93] Each of these men lived well within the period when Greek sculpture had a fully developed naturalistic style, so that the creation of fully accurate likenesses was within the capabilities of the artists of the time; yet later generations apparently felt at liberty to revise their received images so drastically that the basic physical type, shape of skull, and total physiognomy could be so wholly altered, as in the case of Socrates or Euripides, that it is possible for a diligent and perceptive scholar even to reject the identification of one of the major portrait types with its subject.

Such a degree of license is more understandable in the case of earlier personages, such as Homer, where no recorded likenesses could have been handed down from their lifetimes; but it is noteworthy that even in these cases the periods at which major revisions in the likenesses were made seem to coincide with those for the portraits of the great intellectuals of the fifth century. Not only must the fact of these revisions be recognized, but it appears almost equally significant that the most active period for such revising of the images of the great ancestors was just the time of the Lycurgan domination.

The key to the Lycurgan group of tragedians seems to be the type of portrait of Sophocles exemplified by the head in the Farnese Collection in Naples (although better-preserved examples are found in other collections—Figure 55).[94]

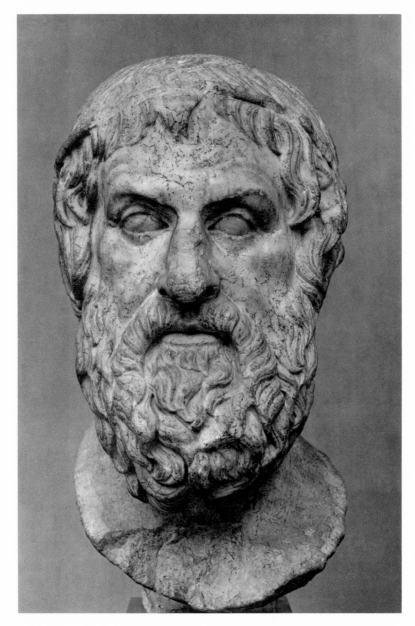

FIGURE 55 In the decade of the 330's, portraits of the three greatest tragedians were set up in the newly completed Theater of Dionysus in Athens. The portrait type of Sophocles which corresponds most closely in style and characterization to the art of this period is the second sure version, the so-called "Farnese" type. It seems probable, therefore, that this, rather than the original of the Lateran statue, reproduces the revised likeness of the great dramatist created for Lycurgus' theater. *Copenhagen, Ny Carlsberg Glyptotek*

The head itself is longer in proportion than that of the Lateran portrait (as in the case of the "revised" Socrates), while the face is narrow and the expression solemn. The hair, thin on top, becomes full at the sides and back of the head, and the beard and mustache are long and full.

This type has been found paired in a double herm with the likeness customarily accepted as that of Aeschylus (Figure 56),[95] which, though less expressive, has a great deal in common stylistically as well as psychologically with the Farnese Sophocles. Closer in the depth of its expression—approaching anger—is the portrait of the third member of the group, the Euripides of the "Rieti" type,[96] which has the same long oval face, thicker locks of hair, and soft flesh treatment seen in the other two (Figure 57). In these three portraits, and only in these three, the stylistic traits coincide closely enough to suggest a common point of origin (although not necessarily a common hand); and there is adequate evidence for locating this point in Athens about the middle of the second half of the fourth century B.C.—the time of the Lycurgan dedications.[97]

As we have already indicated, other portraits of great leaders of Athens' past seem to have undergone a similar "modernization" in this period, although most of the ones we can identify show less sophistication of treatment than the ones just cited. The later traits which betray the pastiche character of the Themistocles from Ostia (Figure 58) are probably best located in this milieu, and it would appear that the portrait of Miltiades which we have is from the same revision;[98] but whether or not these two types have any connection with the Theater statues must remain an open question. We have already cited other examples of fourth-century archaisticism associated with these military portraits, suggesting a general type of leader image current in the early Macedonian period: not only the revised Leonidas of Sparta, but also the likeness, which may have been post-humous, of Philip of Macedon (Figure 59).[99] In these cases of revision the style of the prototype, as well as what this historically conscious age knew of earlier art in general, conditioned the revised likeness. However, the new images have in common an added quality of emotionalism: the deliberately invoked sense of the character and the significance—why not say the personality?—of their subjects, in strong contrast to the detachment and impersonality of the fifth-century likenesses that have survived in unaltered condition.

The portraits we have discussed constitute only one facet of the evidence which shows that, by the third quarter of the fourth century B.C., Greek art had become oriented to the naturalistic representation of visual appearances—within the limits imposed by the essential Greek predisposition to generalize from any evidence. The means for this sort of representation had been at hand for some

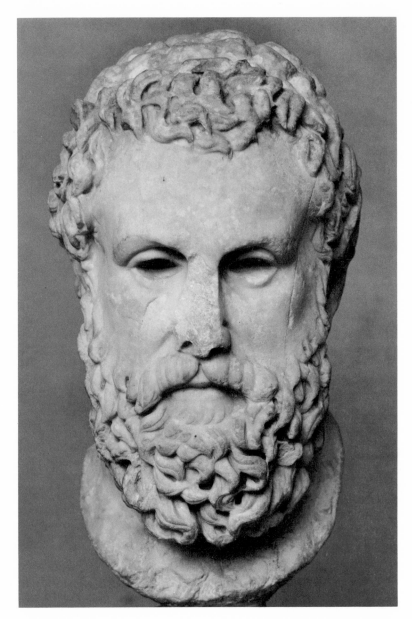

FIGURE 56 The only established portrait type of Aeschylus is so strongly idealized that no sense of immediacy is present; this is not surprising, since he was the oldest of the three dramatists and lived long before the Greek portrait had progressed beyond the stage of heroization. In style the image compares closely with that of the ''Farnese'' type of Sophocles, which is postulated as the portrait created for Lycurgus.

Copenhagen, Ny Carlsberg Glyptotek

FIGURE 57 The third great tragedian, Euripides, was closest in time to the period of Lycurgus. No earlier portrait type of him is known than that established by the Rieti herm in Copenhagen—a figure which best matches the likenesses of Aeschylus and Sophocles shown here and hence probably reproduces the final figure from the set in the Theater of Dionysus.

Copenhagen, Ny Carlsberg Glyptotek

FIGURE 58 This herm of Themistocles, found in the excavation of Ostia, has stimulated great con-
troversy, for it combines traits of fifth- and fourth-century imagery in such a way that the dating of
its original depends upon each viewer's judgment of the balance of these elements. A number of
features, such as the thrust of the head and the intensity of expression, compare with those of the
strategos in Figure 59, suggesting that the Themistocles in its extant form is a product of the same
retrospective moment in the last years of Greek political autonomy.
Ostia, Museo

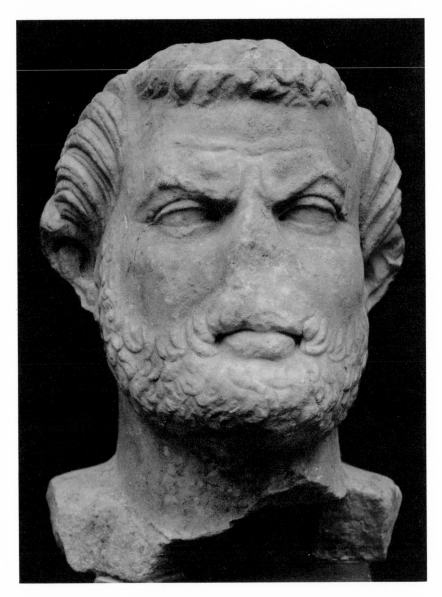

FIGURE 59 This portrait of a ruler has many characteristics relating to the conventions of the fifth-century *strategos* image seen in Figures 1 and 43, but it is imbued with a force of personality unknown in the earlier period. The complex new phase of Greek art which began about the middle of the fourth century saw a deliberate retrospection, as part of a conscious effort to draw upon the roots of tradition; this image seems to belong to just this phase, and the combination of traits and circumstances surrounding it has led to the intriguing suggestion that the original was a portrait of Philip II of Macedon, father of Alexander the Great.
Copenhagen, Ny Carlsberg Glyptotek

generations; only the gradual evolution of attitudes and concepts had led the artists to this kind of explicit portrayal of physical reality. As Webster has put it, "What has often been called a development towards realism may equally well be called a change in the kind of opinions in which the audience is interested." [100]

Not only the visual arts, but all forms of creative expression had been tending in this same direction from the beginning of the century, a direction comprehended by Aristotle's dictum that Sophocles drew men as they ought to be, Euripides as they were. [101] It was Aristotle's pupil, Theophrastus, following models supplied in the Fourth Book of the *Nicomachaean Ethics*, who brought this development to one kind of conclusion in his book of *Characters*, published in 319. The characters described are not, of course, individuals so much as personality types; but it is significant that, unlike fifth-century literary types, who were classed according to occupation—generals, politicians, courtesans, athletes, and so on—these are now labeled by traits of personality. It was Theophrastus' friend Menander who made this new apperception the basis for the creation of the New Comedy, in which the Greek drama, using Theophrastus' methodology, reached a new level of naturalism.

Under the circumstances, it seems especially appropriate that the highest point of development of portraiture in Greece has been recognized in the generally accepted [102] likeness of Aristotle himself (Figure 60); Pfuhl called it "the first portrait of an individual in the strongly realistic sense of the word." [103] In this image we do find a new sense of immediate contact with a powerful and exciting personality—a sense of contact missing, despite their brooding power, in the Lycurgan dramatists, for example. A comparison of this Aristotle image with the portrait of Plato is instructive. The likeness of the older man is wholly external, an assessment of the visible surface of its subject; that of the younger philosopher uses the external physical traits consciously to evoke the internal life of the man.

It is our thesis that the difference in approach to the portrayal of these two individuals may relate to the enormous shift in Greek thought which took place as the result of their work, from Plato's idealism to Aristotle's empiricism. A consideration of their respective attitudes toward the relation of the physical and the spiritual aspects of the individual human being should be relevant to our problem.

Plato's *Phaedo* is of course an extreme statement of its author's belief in the primacy of the realm of Ideas; this is inevitable, since the purpose of the dialogue is to set forth Socrates' (or Plato's) consolatory doctrine of the immortality of the soul, expressed as he awaited execution. None the less, it is a fair statement of the wider Platonic rejection of the significance of the physical world in favor of

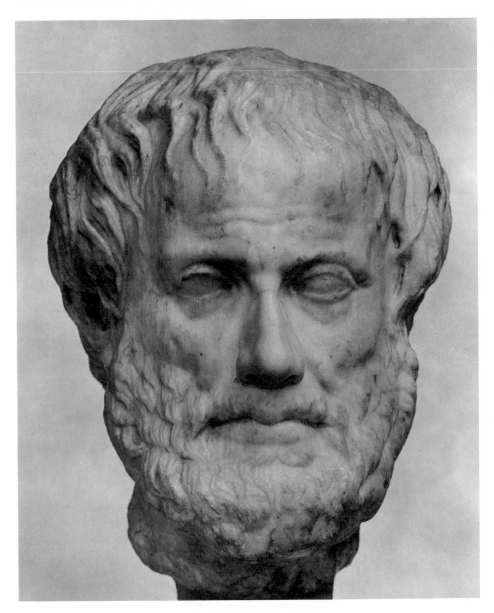

FIGURE 60 With this likeness of Aristotle the art of portraiture can be said to reach maturity for the first time in history. Total conviction as to physical accuracy of the portrayal combines with a sense of the spiritual state of the subject to produce a kind of image hitherto unknown: the portrayal of the whole person in the full vividness of life itself.

Vienna, Kunsthistorisches Museum

the sphere of Ideas. Reality does not lie in anything apprehensible by the human senses but only in what the mind can perceive through pure intellection. Thus Socrates concludes:

"When the soul and the body are united, then nature orders the soul to rule and govern, and the body to obey and serve. Now which of these two functions is like to the divine? and which to the mortal? Does not the divine appear to you to be that which is formed to govern and command, and the mortal to be that which is by its nature subject and servant?"

"True," answers Cebes.

"And which does the soul resemble?"

"The soul resembles the divine, and the body the mortal—there can be no doubt of that, Socrates."

"Then reflect, Cebes: of all which has been said is not this the conclusion?—that the soul is in the very likeness of the divine, and immortal, and rational, and uniform, and indissoluble, and unchangeable; and that the body is in the very likeness of the human, and mortal, and irrational, and multiform, and dissoluble, and changeable." [104]

The world of the senses, moreover, is inimical to that of the spirit, clouding the intellect and soiling the soul. From Plato's point of view, as expounded here and elsewhere in the dialogues, the physically apprehensible aspects of man are not merely irrelevant to an understanding of his essential character; they are antithetical to it. Plato's rejection of body and matter has a long legacy in the thought of the West, and all of his heirs mistrust the notion that any truth can be discerned through simple observation of the natural world.

Aristotle, on the other hand, came to insist that the only way in which we can apprehend the immaterial (to which he conceded due importance) is through its impact on the material world of the senses.

There seems to be no case in which the soul can act or be acted upon without involving the body; e.g., anger, courage, appetite, and sensation generally. Thinking seems the most probable exception; but if this too proves to be a form of imagination or to be impossible without imagination, it too requires a body as a condition of its existence. . . . It therefore seems that all the affections of soul involve a body—passion, gentleness, fear, pity, courage, joy, loving, and hating; in all these there is a concurrent affection of the body. . . .

But we must . . . repeat that the affections of soul are inseparable from the material substratum of animal life, to which we have seen that such affections, e.g., passion and fear, attach, and have not the same mode of being as a line or a plane. [105]

Aristotle does not abandon the older conception of an unchangeable aspect of the personality; this he calls mind (*nous*) in contrast to his body-linked soul

(*psyche*): "Mind . . . is separable, impassible, unmixed, since in its essential nature it is activity."[106]

Since then the complex here is the living thing, the body cannot be the actuality of the soul; it is the soul which is the actuality of a certain kind of body. Hence the rightness of the view that the soul cannot be without a body, while it cannot *be* a body; it is not a body but something relative to a body. That is why it is *in* a body, and a body of a definite kind. It was a mistake, therefore, to do as former thinkers did, merely to fit it into a body without adding a definite specification of the kind or character of that body. Reflection confirms the observed fact; the actuality of any given thing can only be realized in what is already potentially that thing, i.e., in a matter of its own appropriate to it. From all this it follows that soul is an actuality or formulable essence of something that possesses a potentiality of being besouled. . . .[107]

Thus the fact remains for Aristotle that the only way in which activity of mind, or the feelings of soul, can be apprehended is through their effect on the physical appearance and movements of the individual. The fundamental premise of the scientific method had been established.

Only when such an attitude toward physical reality is accepted, we suggest, is portraiture in its most fully developed sense a possibility. This is not to say, of course, that artists were students of philosophy—although we have seen in fact a degree of contact between speculative thinkers and portraitists, if only in the course of business—but that the formulations of these thinkers, as well as the productions of artists working in the same time and place, could not help but reflect some general consensus of ideas on such matters as the significance of the individual or the character of visual reality itself.

Thus the portrait becomes possible only when the sentient portion of society, having reached the point of appreciating the importance of the individual for his own sake, comes to consider that a portrayal of visual appearances is itself a satisfactory means of representing what is truly significant about that individual; in other words, when it considers that the physical body is a fit and proper vehicle for the accurate expression of the total personality.

The Egyptians did not worry about the question of the relationship of body and soul in this sense; the *ba* and the *ka*, whether or not we can compare them with *nous* and *psyche*, were not thought of as localized within the body and may even have been considered to be external to the physical being. The funerary portrait, in any culture, is in the nature of a substitute or double for the physical body; in earliest Egypt, it was just that: a spare body, kept on hand in case something should go wrong with the process of mummification. All types of early depiction of the human individual, whatever the purpose for which the images

were made, lack true concern with the personality or individuality of the subject, its relation to the physical form of the person, and hence the possibility of its revelation through artistic portrayal.

Regarded from this standpoint, it is possible to see that only in Greece, and only at this relatively late moment in the history of Greek art and thought, did the circumstances requisite to the production of true portraiture come into existence.

Returning to the portraits of the philosophers themselves, we may note that it is at least in part the very sense of immediacy we have noted that has led to the assumption that the portrait of Aristotle must have been based on a contemporary prototype, an image done directly from life. An inscription on a herm of the late imperial period records an epigram stating that Alexander the Great had a portrait of his teacher set up in Athens, hence within Aristotle's own lifetime (teacher survived pupil by just one year).[108] The mention of the portrait of Aristotle in the Testament of Theophrastus, who died in 287, while giving valuable evidence (as Theophrastus' own writings did) of the new importance of such images, also confirms the existence of such a likeness by that time.[109]

On the other hand, we cannot afford to be misled by the impression of liveliness given by the portrait itself, for it is now recognized that the image of Aristotle which we possess is closely linked in style to a second portrait type of Euripides (Figure 61), that identified by the example in the Farnese Collection at Naples, which in turn must be dated some time later than the Rieti type just discussed. Here again, so vivid is the impression of personality and liveliness in the portrait of Euripides that some writers have been compelled to regard it as a work executed before the poet's death,[110] something which must be regarded as a stylistic impossibility.

Moreover, these two works can both be related to a large group of portraits which, by the precise identification of one of them, must be dated a full generation after Aristotle's death.[111] The same features which distinguish the likenesses of Aristotle and Euripides—the broad, domed forehead, with sparse locks of hair; the straight eyebrows and level gaze; the serious but not grim expression; the bushy side hair and rather short beard; above all the sense of fidelity to life and character—are to be found in a series of portraits of other men of the same generation as Aristotle, such as the orator Hyperides, who died, like the philosopher, in 322;[112] and also Aeschines, of whom we have the full-length portrait in Naples (Figure 53).[113] But we also find these characteristics in portraits of men of the following generation, such as Theophrastus himself.[114] Finally, the whole

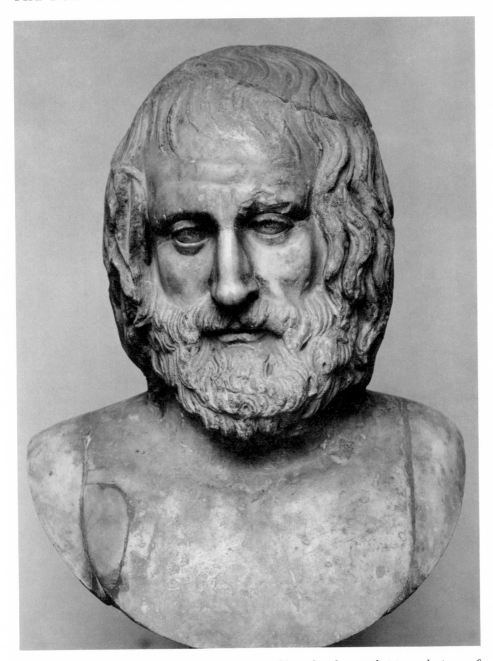

FIGURE 61 A new portrait type of Euripides, illustrated here, has close similarities to the image of
Aristotle in terms of the shape of the head, crown, coiffure, and beard, as well as in the general
sense of intellectual and emotional force.

Copenhagen, Ny Carlsberg Glyptotek

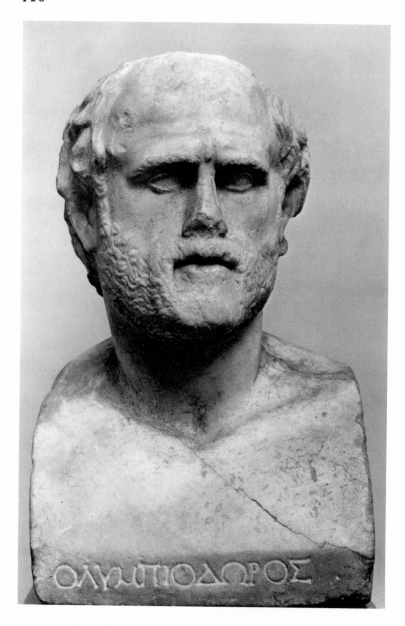

FIGURE 62 The sizable group of portraits associated stylistically with that of Aristotle can be dated by the inclusion in their number of this likeness of Olympiodorus, which is unlikely to have been created before he emerged as a leader of the Athenian revolt of 288 B.C. It is probable, therefore, that all these works represent a development in portraiture which took place about the beginning of the third century, when Aristotle had been dead for twenty-five years.
Oslo, Nasjonalgalleriet

group is linked conceptually and stylistically to the inscribed herm of Olympiodorus, in Oslo (Figure 62),[115] and, since a likeness of this eminent Athenian leader is unlikely to have been created any earlier than his heroic action in taking command of the revolt of Athens in 288, we are conveyed safely within the bounds of the third century. While we need not assume that all these portraits were made simultaneously, it can hardly be expected that, closely similar as they are in so many ways, they could have been made over a period of much more than two decades.

It is also indicative that the full-length copy of the statue of Aeschines relates in its general character, as a sort of temperamental foil as well as formal counterpart, to the well-known and widely reproduced standing portrait of his life-long antagonist, Demosthenes (Figure 63).[116] While the latter shares only its convincing character as a likeness with the group described here (its style is sufficiently dissimilar to eliminate any close correspondence of artistic hands, although not of period), it has been convincingly identified with the recorded portrait by Polyeuctus which was erected in the Agora (close to the Tyrannicides) in 280 B.C.[117] —posthumously by fully forty years!

Thus it was that Aristotle, the first of the Greek philosophers to introduce empirical methodology into the study of phenomena, the author of a theory of the integration of the human personality with the physical body—the man who insisted, against Plato, that Form could not be divorced from its Substance— became the subject of the first "biographical portrait," in which the whole life of the individual, almost existentially speaking, is presented in visible summation. Just as, in the face of this portrait, so many observers have felt a confidence in having reached portraiture "in our sense of the word," so there is implicit in the thought of Aristotle the first full summation of the human individual as an integration of both physical and spiritual characteristics, hence capable of expression in visual terms. It is a development of permanent importance in the history of art.

Such a conception was not reached, obviously enough, in one simple step. Just as the philosophers debated the problem of spirit *versus* matter, soul against body, so the artists arrived by more or less empirical procedures at the mastery, first of physiognomic, then of psychological verism, and then reached the stage of penetration of matter by spirit exemplified by the portrait of Aristotle.

After the fifth century, when the idealization of the individual may be typified by the image of Pericles, the development of portraiture was marked by three significant phases; what is more, these phases appear to be linked to the rises and dips in the fortunes of Athens and the other independent Greek city-states—for reasons obvious enough, since it was only in times of prosperity and confidence,

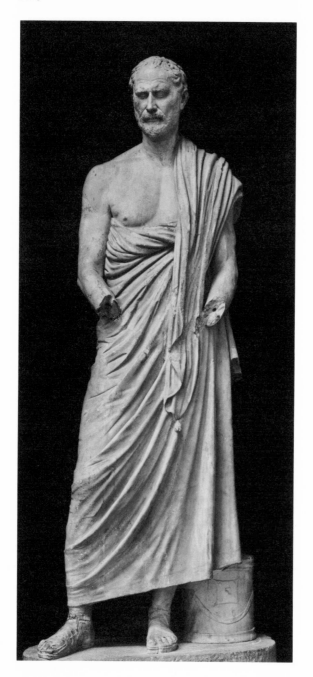

FIGURE 63 One of the most popular of all Greek portraits, to judge by the number of extant copies, was that of Demosthenes, orator and hero of Athens' last years of independence. The original, a full-length statue, like all Greek portraits, is known accurately from several complete copies. Since we know that the work, recorded as by the sculptor Polyeuctus, was erected in the Agora in 280 B.C.—forty years after Demosthenes' death—it is no more contemporary than the portrait of Aristotle just discussed. Although obviously not a product of the same studio as the group associated with the latter work, the portrait of Demosthenes shares their mature conception of the nature of portraiture.

Vatican Museum, Braccio Nuovo

whether externally or internally generated, that a sufficient base of patronage could be established.

In the first stage of development, which seems to fall between about 380 and 360 B.C., the artist was for the first time oriented toward creating a "likeness": not just a handsome image conditioned by certain of the specific features of his subject, but a reasonably accurate transcription of the details of visual appearance. It is the absence of any conception of the relation between these visible externals and the inner character of the individual, absent, as well, in the thought of the period, that seems to account for the masklike impersonality of the portraits created in this phase. The lack of intellectual qualities in the portrait of Plato, for example, induced a sense of shock in the first generation of scholars to accept, however reluctantly, its identification. The portraits of this period embody the same sort of contrast between the physical and the spiritual aspects of "reality" that is expounded, at its most extreme, in the *Phaedo*.

In the second stage of development, that falling between about 340 and 320 B.C., the increasing skill which Greek artists had achieved in accurate naturalistic representation was employed in a new and deeper way. The portraits made during the Lycurgan domination do have a quite evident intellectual and emotional content compared with their predecessors. This injection of feeling, however, is achieved in a particular way. The emotion conveyed is a single one, which is more or less immediately expressed and felt; each portrait subject is in the grip of one particular thought, one mood. Time, in the biographical sense, is not a factor in the characterization. We are presented with a snapshot, taken at an instant of highest emotional intensity.

In this factor of time, rather than in any special advance in naturalism of handling, lies the greatest difference between the Lycurgan portraits and those of the culminating phase, reached probably between about 300 and 280 B.C. In these images the transitory quality of mood is replaced by the timeless sense of enduring character. Instead of a momentary aspect of temperament, we receive an impression of the full personality of the man: Euripides is still saddened by mankind but is no longer angry.

This increasing depth of characterization must explain why, in the case of some of the most important subjects, the received likenesses were revised. For a person so important to Greek thought as Socrates, the impersonal caricature offered by the earliest portrait type was plainly inadequate to later generations, accustomed by their artists to portraits which *could* convey so much of the essence of their subjects. (It was the less discriminating Romans, interested in iconography for its own sake, who were responsible for having all the variant types duplicated in innumerable copies.) It seems significant that most of the portraits

which we know to have been revised in this "deepening" way—those of Socrates, Sophocles, and Euripides—are of men who died just before the development of the fully mature portrait. While there might have been sufficiently clear memory images of their appearance to furnish the basis for concrete iconographical formulae, it would seem that there were no actual life portraits, such as Silanion's Plato, which, however unsatisfactory to the expectations of later generations, had the simple virtue of presumptive accuracy.

In the generation following the death of Aristotle the creation of the portrait "in our sense of the word" was completed, and it is noteworthy that no further major changes of iconography seem to have been made in the likenesses of historical, as against more or less legendary, figures from the past. In a sense, the "Aristotelian" portrait has remained the definitive conception for the Western imagination ever since. Its theoretical basis—the principle that the true character of a man is revealed in his physical conformation—was rejected by some later ages; but it could not be forgotten.

The Hellenistic Age: The Inspired Ruler

The foregoing discussion may seem to be more a history of Athenian portraiture than a survey of the art in Greece as a whole. Certainly Athens was not the only center in Greece in which portraits were made—or other artistic advances were carried through—during the fourth century; ancient writers have left plentiful testimony to the wide distribution of portraits, not only in the great cult centers but in all major Greek cities as well. By the close of the fourth century the making of portraits was so common that having one's own likeness on display in one's house scarcely excited notice.[118] Furthermore, as Pliny's narrative makes clear, the personality of Lysippus of Sicyon was of decisive importance in shaping the ultimate development of the Greek portrait; it is quite possible that the chief impetus for the final stages in this development as we have described it came from outside the Athenian ambit entirely.

Nevertheless it must be recognized that, in matters of culture, Athens set the standard for the rest of the Hellenic world. A playwright like Dionysus I of Syracuse could not consider that he had "arrived" until his work had been performed in the theater at Athens. In speculative thought the schools of Athens dominated Greek philosophy throughout the fourth century and continued to attract strangers and even aliens, such as the Semitic Zeno, for almost a millennium. It is worth noting that, through Aristotle, Athenian philosophy held sway at the

Macedonian court, where another kind of portrait image of the greatest impor-
tance for the future, the ruler portrait, was being created.

While the principles of the image of the sage were being refined in the
course of the fourth century, no comparable development took place in the other
major form of honorific portraiture—that of the political or military leader. In
general, likenesses of men distinguished in this field of activity were formed within
the context of the athlete figure; beyond this, given the nature of the Greek
city-state, it was unlikely that further development could take place.

With the appearance of a new type of ruler—new to the Greek world—
in the Macedonian monarchy, a new kind of ruler image came to be needed, for
which there was no direct Greek precedent. If the identification of the portrait
of Philip II (Figure 59), discussed above, is correct, it conforms to our expecta-
tion that, in the initial phase of Macedonian expansion, a deliberate archaism
could be employed to place the ruler within the context of the heroic tradition.
The similarity of this portrait in expression and pose to the controversial
Themistocles from Ostia is then quite appropriate.

When Alexander the Great exploded his empire beyond the confines of the
Greek-speaking world, another kind of imagery was called for to replace this
archaistic evocation with the concept of a true world-ruler. Alexander's whole
system of rule was new, and it is not surprising that he employed the art of the
portraitist as an instrument for expressing his new form of dominion to his
polyglot subjects.

The sources say a great deal about Alexander's interest in the art of por-
traiture, and there exists a wealth of surviving portraits of him (Figure 64); but
unfortunately almost all the latter date from long after his death and represent
not so much his own ideas as those developed from the precedent he set.[119] His
official portraitist, we are told, was Lysippus, whose most famous portrayal of the
king was the "Alexander with the Lance," a work now known only in miniature
copies but probably fairly closely represented by the sadly weathered Azara
Herm in the Louvre.[120] In addition, a marble head found on the Acropolis
appears to be close in time to Alexander's lifetime; it has recently been attributed
to Leochares, another of his court artists.[121]

The ruler image created under Alexander, then, is an original and distinc-
tive type embodying the character of the idealized athlete familiar in Greek
sculpture for three centuries but now fused with the image of the hero of super-
human stature. In this it parallels the effort made by Alexander himself to
accommodate to oriental concepts of divine rulership without unduly offending
the sensibilities of his Greek cohorts. This carefully adjusted fusion of the
human with the superhuman became the model for all Hellenistic rulership,

FIGURE 64 The portrait of Alexander the Great created by Lysippus is probably most accurately
reproduced in the badly weathered Azara Herm, pictured here. The strong features are idealized
just enough to convey a sense of the superhuman quality both ruler and artist sought to express; the
concept of the divinely inspired ruler was one of Alexander's most lasting legacies to the West,
and his portrait was a permanent influence on those who sought to follow in his footsteps.
Musée du Louvre

FIGURE 65 This bronze portrait, found in the ruins of Herculaneum, probably represents one of Alexander's generals, Seleucus Nicator, who succeeded to the governorship of Syria and founded the Seleucid dynasty. As an example of the Hellenistic ruler portrait, it is a worthy successor to the imagery of Alexander in its effort to portray both the individual features of the king and the super-human abilities to which he owes his attainment of such an exalted office.
Naples, Museo Nazionale

finally exerting a profound influence on the founders of the Roman imperial system; thus the effect of Alexander's portraiture persisted until the very end of the ancient world.[122]

During the Hellenistic period, while the likeness of Alexander through repetition became more and more idealized, the features of living monarchs became more and more clearly individualized. The Aristotelian psychology underlying Hellenistic art cannot be denied. The third-century bronze head in

Naples which is generally taken as a portrait of Seleucus Nicator (Figure 65), although probably posthumous, serves to illustrate this tendency in comparison with the portraits of Alexander himself[123]

The process can be followed most clearly on the coins of Alexander and his successors. The issues of Philip II, of course, bore the traditional Macedonian images of divine authority, in keeping with general Greek practice. Alexander, on the other hand, in taking over the Persian Empire also took over a coinage with a tradition of using the (highly idealized) profile of the Great King as its guarantor of value. During Alexander's reign there was introduced a silver tetradrachm bearing not his true likeness, but the head of Heracles in a profile which echoes the features of Alexander. After his death this coin type was continued at many mints, and before the portrait sank into stereotype the hint of actual likeness to Alexander was made briefly explicit.[124] Finally, after 300, the surviving Diadochi took the final step of placing their own portraits, without divine attributes, on their coins; man, not god, was sufficient guarantor of the worth of their money.

The coins provide a continuing check against which Hellenistic ruler portraits—which are not always easy of attribution—can be judged. In general, the model set by Alexander is followed in each of the dynasties which were his heirs, although distinctive local traditions developed in the major kingdoms: in Egypt, where the Ptolemies sustained both the Greek and the native modes of imagery (Figure 66);[125] in Syria, where the easternmost provinces developed in autonomy one of the most distinctive portrait schools in all ancient art;[126] or in Pergamum, where the image of the eunuch-king Philetairus weighed heavily on his successors.[127] None the less, all these portrait traditions have much in common.

Taken as a whole, the portraiture of the Hellenistic period can be said to represent a consolidation of the tendencies already established by about 300 B.C. The production of individualized images increased many fold, but the principles governing their creation were those already accepted before the true Hellenistic age began.

Hellenistic portraits still tend to fall into categories; images of rulers, as we have seen, have much in common, as do other classes of images, such as the portraits of intellectuals. Each of the major schools of philosophy, for example, established its own body of iconography in the form of likenesses of its major figures. Aside from the men of the Academy and the Peripatetics, we find Antisthenes (Figure 67)[128] and Diogenes (Figure 68)[129] leading the list of eminent Cynics; Zeno[130] and Chrysippus (Figure 69),[131] the most popular Stoics; and Epicurus (Figure 70)[132] at the head of a large group of disciples. In general, the number of extant copies reflects the relative popularity of these personalities and

FIGURE 66 Ptolemy Soter, Alexander's heir in Egypt, is the subject of this vivid likeness, which, even though probably posthumous, captures the desire of the Greek sculptor of this era to convey the full sense of the life of each of his subjects.

Copenhagen, Ny Carlsberg Glyptotek

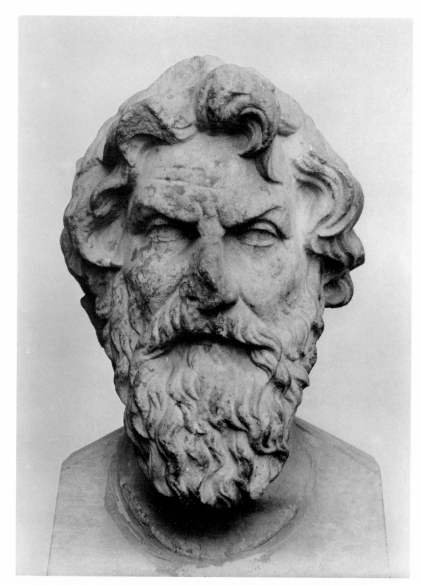

FIGURE 67 The disheveled, hard-bitten appearance of Antisthenes, founder of the Cynic School
of philosophers, is splendidly conveyed by this portrait, a posthumous work which far more probably
belongs to the romanticizing phase of the Hellenistic period—when every philosophical school had
to have its set of official icons—than to the fourth century, in which he actually lived. As such, it
exemplifies the capability of the Hellenistic portraitist in conveying the sense of immediacy of his
subject, even when he was unable to take the likeness from the living model.
The British Museum

their doctrines with the Roman literati, not their Greek contemporaries; the same is true of the large quantities of portraits of orators and poets, of whom, as we have seen, Demosthenes was by far the most frequently reproduced for the disputatious Romans.

Some of the newly created portraits of Hellenistic personalities reflect the recent development of the emotion-laden, expressive portrait initiated in the Lycurgan group but brought to an unprecedented level of intensity in the later period. The Hellenistic taste for strong emotional fare brought about the creation of new types of Sophocles (Figure 71) [133] and Homer, [134] as well as a number of portraits which, because of their very success, have defied all efforts at positive identification. [135] The desire for both a high degree of naturalism and a strong effect of pathos underlies a major segment of Hellenistic art, leading even to the

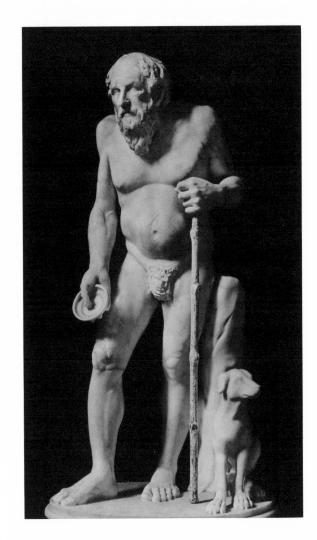

FIGURE 68 Although too heavily restored and reworked to merit serious consideration as a literal representation of an antique portrait, this full-length statue of Diogenes may stand as the final antithesis of the classical hero statue. Here is the ideal thinker, the living denial of the Greek physical ideal—a demonstration that the Greek power of generalization could achieve, not only the youthfully perfect, but all other aspects of humanity as well. *Rome, Villa Albani*

FIGURE 69 Portraits of Chrysippus, a leading Stoic, tend to portray him with the same round-shouldered, interrogative thrust of the head that is evident in likenesses of the school's founder, Zeno. It would be dangerous to consider this merely an artistic convention, however; the imitation of a physical pose within an intellectual coterie is far from unfamiliar even in modern societies.
The British Museum

FIGURE 70 Epicurus, the physically delicate founder of the school whose doctrine that the greatest good is the absence of pain was grossly distorted by later misunderstanding, is depicted here in a likeness which fuses the portrayal of his intense mental force with that of his physical attenuation. The "Aristotelian" portrait has become a matter of course.
The British Museum

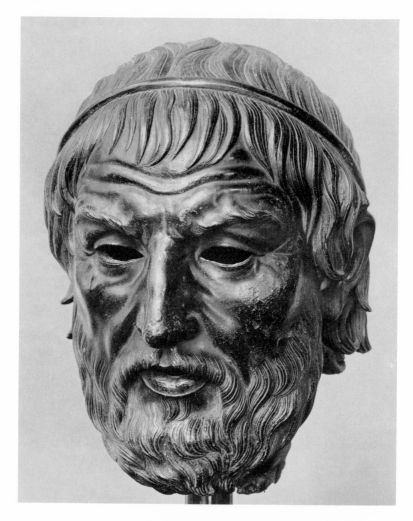

FIGURE 71 Although it exercised some influence on the portrayal of living personalities, the Hellen-
istic tendency toward emotionalism—coming at times close to sentimentality—had its greatest
freedom with more remote subjects. The portrait of Sophocles was reworked one last time during
this period to produce a wrinkled likeness of the elderly author of *Oedipus at Colonnus*.
The British Museum

identification of the period with a generalized concept of a "baroque" style;
whatever the merits of such categorization, the tendency to go to extremes must
be understood as a significant factor in the Hellenistic imaginative portrait.

Perhaps the greatest importance of the period in terms of portraiture,
however, is quantitative—in the vast numbers of portraits produced, and espe-
cially in the spread of the art at the popular level. From Hellenistic sites such as

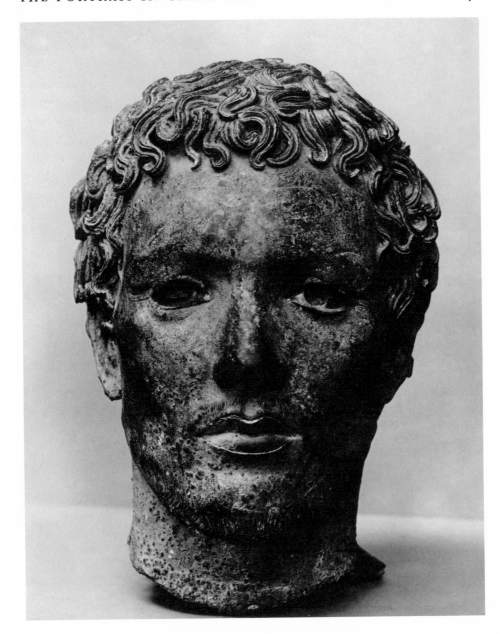

FIGURE 72 A bronze head, found at Cyrene in North Africa, evidently represents a local citizen with Berber blood. This rare original illustrates the degree to which Greek art had attained the power of fusing the ideal and the particular even in works of modest ambition.
The British Museum

Delos [136] we are offered countless likenesses of individuals, all attuned to a high level of naturalism in execution, which do not belong to the categories of famous faces but are images of local personalities done for private commissions.

These private portraits serve, therefore, as an important counterbalance to the other mass of Hellenistic portraiture, the images of the great historical figures. The latter we know from copies almost exclusively, and of these most are of Roman date, while all are at varying levels of absolute quality and of fidelity to the original. The private portraits, on the other hand, are originals as they were presented to the clients; and so, although they originate from a less lofty artistic stratum than the court likenesses, they take us closer to the normal standards of the period (Figure 72). [137]

The new tradition of individual portraiture, of the private citizen as well as the man of world renown, was a major legacy passed on by the Greeks to Rome.

Chapter IV ❦ The

Roman Portrait

THE PORTRAIT HEADS of the Roman republican period make a unique impression on the viewer, one which has often been remarked. In the presence of the finest of these heads one has a sense of the living reality of the person which is overwhelmingly convincing and quite different in its impact from the feeling one experiences in viewing the images of eminent fourth-century Greeks. This difference has been expressed by Hinks in these words:

> The Hellenistic portrait was the ideal reconstruction of a personality, in which the accidental facts of nature were indeed accepted and used, though only as the starting-point for an imaginative exercise in concretised psychology. The Roman portraitist, on the other hand, approached his sitter objectively, not subjectively; he looked from the outside at the features one by one and transliterated them piecemeal into the language of art. The resulting work was both a document and a commentary, but the former aspect was more clearly defined than the latter. The Roman portrait was the exact statement of a particular case; it was as far removed as possible from the generalized and the typical.[1]

The approach of the artists who made these Roman heads is often defined as "veristic," a term which occasions some difficulty of definition. It is not enough simply to define verism as "a somewhat dry realism";[2] there is a fundamental difference of approach involved, which Hinks has again best described:

> "Realistic" is a subjective term (in relation to the artist); "veristic" is an objective term (in relation to the work). . . . The Hellenistic artist may be called a realist because he works towards the real effect of an organic whole by using plastic metaphors which

represent the appearance of nature by analogy. The Italic work may be called veristic because it aims at reproducing the original by literal attention to detail.[3]

The Greek artist, working with Greek subjects, first conceived of the image as a whole, developing it by means of the traits which most clearly characterized the individual and his personality in the broadest, most public sense; he always relates the particular to the universal. The fact that, from the fourth century B.C. onward, he is relating his particulars of observation to universals of character rather than physique accounts for the fact that his likenesses do remain portraits of individuals rather than modified physical types, as in earlier stages of the development of the art of portraiture.

The creator of the Roman portrait, on the other hand, seizes each minute detail of his subject's appearance, every physical blemish or trait which is unique to this specific individual. By means of these, he builds up—one might almost say he compiles—the likeness. In this way, the Roman came to concentrate, as the Greeks never had, all individuality in the head and particularly the face. Whereas the Greeks always thought of portraits as full-length statues, even when miniature in scale, the Romans began the practice of making simple busts or herms. The sole exception to this generalization about Greek portraiture is the coin type, with its apparent by-product, the medallion or imago clipeata; in this case, a separate tradition, that of placing the profiles of tutelary divinities on coins for identification and authentication, influenced the practice of the Hellenistic coiners, as we have already seen.

The development of the portrait herm is not entirely clear in all its details, but the general outline of the story seems to be as follows. The herm itself, as a symbol for Hermes, is evidently of phallic significance and was aniconic in archaic Greek times. Herms were used in this period as landmarks; their employment as gravestones is partly to be understood in this sense, although Hermes' function as guide to the Underworld unquestionably plays a part. In any event, around the end of the sixth century B.C. the simple shaft began to acquire a head (as well as a carved phallus on its frontal surface), which throughout the classical period remained that of Hermes. In the fourth century, however, other heads began to be placed on herms: Pan, for example, or female deities such as Hecate, and what was apparently the Syrian Astarte, known to the Greeks as Hermaphrodite, obviously related to Hermes himself in Greek thinking. Only in the second century B.C. do we have unquestionable evidence of portrait heads being placed on herms; for the Greeks, these remain funerary images, with a heroizing or even apotheosizing significance.

The Romans, however, seem to have failed to note this special significance of the portrait herm, which to the Greeks represented not the living man but the

hero translated into the next world. Having evidently been accustomed, through their own ancestor cult, to the idea of the funerary bust, the Romans accepted the Greek herm as a fully adequate form of representation of the individual person; they took over the Hellenistic practice without embracing the meaning it held for its originators.[4]

Thus we find that, by and large, the Romans used portrait busts to represent their own people and used herms for honoring Greeks. The Roman tradition, based on the ancestor cult, and the Greek one, derived from the concept of heroization, remained separate; so did the general conception of form and style, so that we can almost always tell when a likeness of Roman date represents a native dignitary and when it honors a distinguished Greek.

It has in fact been argued that the fundamental difference between Roman portraiture and that of Hellenistic Greece is a difference in the nature of the subjects represented rather than in the artists or styles employed. As Carpenter put it, "Ancient portraiture is by its very nature an uncertain and illusive discipline, in which the subjective interest in individual personalities outweighs the objective criteria of type and style."[5] Put another way, the Romans look different because they *were* different. The Romans we see in portraiture were politicians and businessmen, while the Greeks portrayed were invariably intellectuals, philosophers, and poets.[6]

Yet is this argument really valid? Have we not seen that the Greeks were at least as interested in portraying their political leaders, their generals and their rulers, as their philosophers and dramatists? Were not Demosthenes or Aeschines, for example, just as much politicians as Cicero? (And he was at least as profound an intellectual.) In part the situation is falsified by the fact that so much of our knowledge of Greek portraiture, especially with regard to identifiable likenesses, is dependent upon the copies which the Romans themselves commissioned. Thus it may be said that the bias in favor of writers and intellectuals is a Roman rather than a Greek prejudice. Nor is this unreasonable. A few eminent figures like Alexander aside, why should a Roman collector have taken an interest in a long-dead politician from a distant city whose political autonomy had long since evaporated? Poems and orations he might still read, plays might still be performed; but the details of a past election are of interest to few but historians.

On the other hand, when archaeology has turned up a large selection of original Greek portraits, as at Delos or in the Athenian Agora,[7] it becomes quite evident that, at least in Hellenistic times, the Greeks were just as interested as the Romans in portraying the full spectrum of society in likenesses.

Furthermore, Carpenter must have been in his recurrent whimsical vein when he asserted that the appearance of these portraits is determined more by the

subjects' looks than by the artists' handling. At no time in the history of portraiture—even in that of portrait photography—can this all too common assertion be accepted. A photograph can be very securely dated to the time of its taking, without reference to externals of costume or furnishings, just as an ancient bust can be. As we have seen, in some cases, such as the Ostia Themistocles, it may be possible for a later artist to practice a deliberately antiquated manner and confuse the issue; but a student who has full command of comparative data will be able to detect the anachronisms which betray the archaizer.

To a degree, to be sure, the subject may present some of the clues for dating a given work. Coiffure perhaps even more than costume tends to conform to fashion at any given time or place, when due allowance is made for other determinants, such as class and status. But more subtle effects, such as expression and demeanor, may be conditioned by social or even political considerations. The worried frowns of the Pharaohs of Middle Kingdom Egypt are as much an indication of this as the gravity of the portraits associated with Aristotle and with the Euripides of our second type. Beyond these subjective factors, however, it is the formal characteristics of artistic practice, even technical procedures such as the particular tools in use, which play the most decisive part in determining the appearance of a given portrait likeness. If Carpenter's observation were valid, it would not be possible—as it is—to date most of the Roman copies of Greek portraits more accurately than the lost originals.

The difference between Roman portraiture and the Greek portraiture to which it is to some degree or another indebted remains, therefore, beyond easy analysis in terms other than those used by Hinks. The relation between the two schools is more complex than has been indicated thus far; and the differences go much farther than the simple matter of family resemblances between subjects represented. Although the originality of the Romans in matters of artistic creation may appear negligible by comparison with that of the Greeks, there can be no question that they had something new to contribute to the visual arts; it has long been recognized that a major aspect of this contribution was the art of portraiture.

Portraiture in the Roman Republic

Modern understanding of the basic function of the portrait among the Romans is founded largely on the remarks of Pliny, made in the course of his chapters on the arts in the *Natural History*. Especially important is one passage in which he is characteristically deploring the decadence of his own time:

That is exactly how things are: indolence has destroyed the arts, and since our minds cannot be portrayed [N.B.], our bodily features are also neglected. In the halls of our ancestors it was otherwise; portraits were the objects displayed to be looked at, not statues by foreign artists, nor bronzes nor marbles, but wax models of faces were set out each on a separate side-board, to furnish likenesses to be carried in procession at a funeral in the clan, and always when some member of it passed away the entire company of his house that had ever existed was present. The pedigrees too were traced in a spread of lines running near the several painted portraits. The archive-rooms were kept filled with books of records and with written memorials of official careers. Outside the houses and round the doorways there were other representations of those mighty spirits, with spoils taken from the enemy fastened to them, which even one who bought the house was not permitted to unfasten, and the mansions eternally celebrated a triumph even though they changed their masters. This acted as a mighty incentive, when every day the very walls reproached an unwarlike owner with intruding on the triumphs of another! There is extant an indignant speech by the pleader Messala protesting against the insertion among the likenesses of his family of a bust not belonging to them but to the family of the Laevini. . . . But . . . even to lay a false claim to the portraits of famous men showed some love for their virtues, and was much more honorable than to entail by one's conduct that nobody should seek to obtain one's own portrait! [8]

Beyond proving the mere fact of the existence of such portrait waxes and pictures in republican times, this passage clearly shows the integral part they played in the entire cult of the ancestors and the family, upon which Roman society was based (Figure 73). The heads evidently were not only kept within the home but were used as blossoms on a diagrammatic family tree; and they were displayed (presumably worn by live actors) in the funeral procession of each successive member of the clan.

On the basis of this and other passages, a number of conclusions have been drawn which, on close investigation, are not wholly justified by either the surviving evidence or the texts themselves. In the first place, the mention of "wax models of faces" of course suggests—but never states—that these were death masks or even life masks. We have seen that the practice of taking such direct impressions was not unknown to the Egyptians; but we also have, in a passage in Pliny, evidence for its introduction into Greek artistic practice just at the beginning of the Hellenistic era. We use in this case Carpenter's emendation of the usual translation:

But to the Sicyonian Lysistratus, a brother of the Lysippus of whom we have already spoken, was due the practice of correcting and improving the rendering of the human form by taking it in plaster from the living model and then pouring wax into this plaster cast. He was also the first to make actual portraits: before his time the aim was to make the faces as beautiful as possible. The same artist also discovered how to make casts of entire statues, a procedure which grew so general that neither divine nor human images were any longer made without the use of clay models. [9]

FIGURE 73 This well-known Roman statue serves to document the cult of the *imagines*, the ancestor portraits. While the work has been far too heavily restored to permit detailed analysis of the stylistic qualities of its components, the general sense of the work is fully authentic.
Rome, Palazzo Barberini

The force of Carpenter's modification of the usual translation is to make the words *hominis imaginem* refer to "the human form," not just to the face; in other words, this technical innovation was a method for obtaining more accurate transcriptions of physical reality than had been possible when relying only on the conceptually conditioned "naked" eye; and these transcriptions were used, just as in the workshops of Tell el-Amarna, as a means rather than as ends in themselves.

It is in the same sense that we must interpret Pliny's statement, that Lysistratus was "the first to make actual portraits," as meaning that this artist brought to its highest degree of accuracy the realistic approach already being practiced by most artists in his time; in any case, it is curious that nowhere does Pliny give any reference to a portrait made by this artist. What the Sicyonian appears to have done is to contribute a technique—not so new as it may have seemed—which made possible a more literal reproduction of the living form. This would have seemed desirable only at a time when this sort of veracity was sought from the artist; but at no time are we justified in believing that the making of casts was anything but a tool for the Greeks.

We are no more safe in making the cast exceptionally relevant to the production of Roman portraits. While we do have one splendid head that is demonstrably made from a slightly reworked life mask (Figure 2),[10] this is an apparently unique specimen, without surviving parallels; and while portraits taken from death masks are not uncommon (Figure 74), they too show reworking and in any case are generally the weakest and least convincing of republican likenesses.[11]

A careful reading of the ancient writers shows that they say nothing of Pliny's wax faces having been taken directly as casts from their subjects, either before or after death, or even that they attempted a close physical likeness. Indeed, the evident desire to possess an absolutely complete pictorial genealogy would almost certainly have required a degree of invention to fill gaps. What wax provided was a substance easy to work and responsive to the touch; it offered something of the appearance of a natural surface when finished, and it took color readily. Heads modeled in this way were not difficult to store within the domestic cupboard, once completed to order by the artisan. But the writers give us no firm information as to the degree to which they accurately reproduced their models.

Of course none of these waxes has survived, but we do have a group of works which seems to relate to Pliny's and Polybius' accounts of Roman customs. This is a series of terra-cotta heads, not too easy to date, but found in some quantity in central Italy; they evidently served a funerary purpose (Figures 75 and 76).[12] Examination of these heads shows that, despite some similarities to some of the later republican portraiture, their makers were not seriously attempting the creation of veristic images in Hinks's sense of the word. On these terra cottas

FIGURE 74 Roman republican portraits frequently give the impression that they are based on death masks. Drawn, desiccated features and sunken flesh are clues to the employment of such a mask in the preparation of an image that was not meant, in any case, to be only a record of past appearance. *Providence, Rhode Island School of Design*

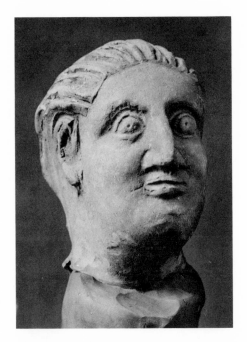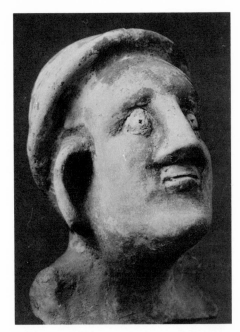

FIGURE 75 Small terra-cotta heads such as these, dating from comparatively late Italic times, give us a reasonably close picture of the appearance of the wax *imagines* the Romans preserved to commemorate their forebears. Although lively in appearance, they could scarcely be termed lifelike. *Vatican, Museo Etrusco Gregoriano*

a few salient physical features, presumably those of the departed, are singled out for emphasis to the point of caricature; they suggest the most realistic of the archaic masks from Sparta.[13] These terra cottas may well indicate a survival of the practice represented by the much earlier Italic Canopic jars of the seventh and sixth centuries B.C.; but the tectiform lids of these jars do not, of course, betray the least impulse toward portraiture.[14]

The terra-cotta heads, then, are unrelated to any sort of use of life or death masks; what is more, unlike Greek and Roman portraits in the mature sense, they show no evidence of any requirement to keep to life scale. In this connection, it may be noted that, in the passage in which he mentions the myriad honorific statues erected in Republican Rome, Pliny specifically observes "the fact noted by the annals that the statues of these persons erected in the Forum, were three feet in height, showing that this was the scale of these marks of honor in those days."[15] There was, almost certainly, something deliberate in this reduction in scale; but of course the masks that were actually "worn" in funerary processions (were they really those wax faces, or special masks based on them?) must have approximated life size.

The documentary evidence and the earlier archaeological material combine to give us a picture of the general cultural background for the Roman republican portrait as we know it. But they offer no direct account of the creation of the specific veristic form in which that kind of portraiture makes its enormous impression on the modern observer. There is nothing inherent in the ancestor cult, or in the making of funerary likenesses of any sort, to account for the particular turn taken by the art of the portrait in the late Roman republic.

Even allowing for this circumstance, it is still surprising to recognize that we have been unable to date any surviving life-sized portrait of the "Roman" type any earlier than about 100 B.C.[16] and, despite some tentative efforts at identification of some likenesses with Roman dignitaries of an earlier age, the first

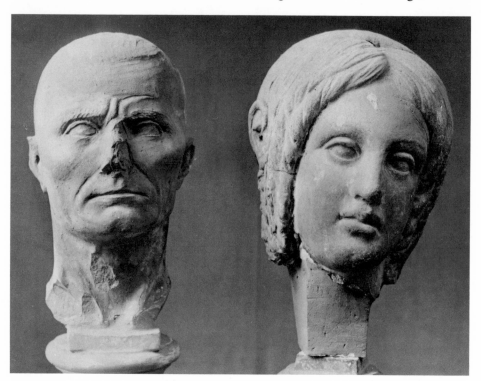

FIGURE 76 Other Italic terra-cotta heads show traces of the influence of the developing Roman veristic style toward the beginning of the first century B.C. Even so, individualization remains concentrated in the details of a few features of the head and does not condition the portrayal as a whole.

Vatican, Museo Etrusco Gregoriano

such incontrovertibly identifiable portrait remains that of Pompey the Great (Figure 77), which could not have been made much before 60 B.C.[17]—and which is by no means typical of the "Roman" portrait we are discussing. Despite Pliny's accounts of images of eminent Republicans who had lived as early as the sixth century B.C.,[18] nothing in the surviving archaeological evidence makes it possible for us to ascertain exactly how these would have looked. The most probable assumption is that they were not too different from the rather folk-arty terra-cotta heads described above; in any case, no clues we possess to these early images of Roman dignitaries give any indication that a distinctive "Roman" portrait style had emerged.

The only absolutely datable likeness of a living Roman that we possess from a period earlier than 100 B.C. is on a small scale and in a different medium from the portrait statue or bust. This is the profile of the conqueror of Greece, Titus Quinctius Flaminius, on a scarce issue of gold coins minted far from Rome follow-ing his victory over Philip V of Macedon in 197 B.C.[19] In this image the Roman warrior is presented, not in some version of Italic verism, but in the heroizing tradition of the successors of Alexander the Great, in a purely Hellenistic ruler portrait. But of course, since a Greek must have cut the die, and the coin was made to circulate only in areas where the Hellenistic concept of rulership pre-vailed, it tells us nothing of the nature of contemporary Roman portraiture. The very fact that Flaminius' initiative in striking coins with his own image was not followed by any of his countrymen for almost two centuries is a reasonably reliable indication that republican Roman ideas of when and how the individual should be portrayed were considerably at variance with those illustrated on this issue of coins.

Equally within the general ambience of Hellenistic, rather than Roman, art lies the famous ring from Capua, in the Museo Nazionale of Naples, signed by the artist Herakleidas but evidently portraying a specifically Roman profile.[20] If, on the one hand, the dating of this gem to the second century B.C. may be accepted —a matter of less than unanimous agreement—and if, on the other, the resemblance to two coin issues apparently portraying Scipio Africanus—one from Nova Car-thago (Cartagena) in Spain, and the other from Canusium in southern Italy[21]—is more than just an accidental similarity, of the sort always possible in works of such reduced scale, then we have another revealing instance of the way in which the most successful Roman military leaders were beginning to be honored by the character-istically Hellenistic device of the heroized portrait.

The fact remains, of course, that all these putative cases occur within the Hellenistic ambience, and none have been found within strictly Roman territory.

FIGURE 77 Pompey the Great wished to be portrayed as a conqueror in the style of Alexander the Great, and yet he could not forego the Roman desire to be seen as he really looked. The result, seen here, is a curious hybrid of Hellenistic glamour and Roman literalism which cannot quite succeed on either count.

Copenhagen, Ny Carlsberg Glyptotek

The same may be said of the portrait of an elderly Roman which has recently been offered as a contemporary likeness of Cato the Elder (234–149 B.C.);[22] whether or not the identification is accepted, it is clear that the original of this portrait was the work of a Greek rather than a Roman, or Roman-inspired artist.

Let us return to the question of representations on coins. Insofar as strictly Roman issues are concerned, the images of living men were not admitted or authorized until the very last year of the republic. Posthumous portraits began to be introduced just before the turn of the first century; the first seems to have been that of Scipio Africanus, on denarii of 108 B.C.[23] The practice began as a form of allusion to the moneyer in a more specific family reference than the heraldic or symbolic emblems previously used. The portraits were a sort of historical reference, then, to the family of the moneyer or other issuing authority; in a way, this was an aspect of the ancestor cult. Alternatively, they might be used as a form of allusion to the political allegiances of these authorities. Most of the portraits employed in the first half of the first century B.C. were family references; but when, for example, Sulla was portrayed in 57 B.C., or Pompeius Magnus after his death, the use of the image was obviously political rather than dynastic in nature.[24]

By about 46 or 45 B.C., on the other hand, we seem to recognize the features of Julius Caesar conditioning the representation of "Pietas" on the denarii, just as those of Alexander had influenced the profile of Heracles on the Macedonian tetradrachms of the late fourth century B.C. The final step, a law authorizing the representation of living men on the official Roman coinage, was one of those measures of the first months of 44 B.C. which drew upon Caesar suspicion of imitating to too great an extent the practices and ambitions of the oriental—that is to say, Hellenistic—monarchs. The actual coins portraying Caesar, consequently, were in fact issued posthumously.[25]

As for the profiles actually employed on the republican coinage to represent the dignitaries of the past, most of them are of an excessive aridity and sharpness, with the drawn linear look that suggests derivation from death masks or, at least, those superficially caricatured Italic terra-cotta heads. An attempt has been made to group some of the less arid of these profiles in a class of Greek-inspired types;[26] but while general validity may be granted to the thesis that there were two streams within the flow of republican imagery, one more or less Italic and the other more or less Hellenic, its application to specific cases such as this one is generally perilous. It does not seem unreasonable to assume that at least some of these first-century coin types were based on the kind of memorial waxes cited by Pliny; but in any case, whether we discuss the coins or their putative models, we must keep in mind that what we are dealing with is not art at all, but a form of craft with a magical function.[27]

When dealing with extant works of art—the life-sized heads and busts that are found in such quantities in all collections of ancient sculpture—we are forced to recognize, therefore, that we possess no authentically Roman works securely datable before 100 B.C. The number of clearly identifiable portraits remains embarrassingly small. Aside from inscribed portraits of such nonentities as C. Norbanus Sorex, whose bronze bust was preserved at Pompeii,[28] we have only a limited number of clearly identified likenesses of the great figures of the republic; Pompey (Figure 77), Cicero (Figure 78), and Julius Caesar (Figure 79) remain the best-established.[29] Of the appearance of Sulla or Marius we are quite uncertain, although many attempts at identification have been made. We do possess, in all probability, a portrait of the third member of the first triumvirate, Crassus;[30] and at least some of the members of the plot against Caesar, in addition to Cicero, are represented by surviving portraits other than those on their coins: Brutus and Cassius.[31] Add to this brief list the portrait of Cato Uticensis, who fell in the civil war of 46 B.C.,[32] and the probable likeness of the father of Augustus, Gaius Octavius,[33] and we have largely exhausted the list of the eminent men of the republic, as distinct from the early principate, who can be identified in portraiture.[34]

The information to be gained from this body of likenesses about the chronology of Roman portrait style is limited, to say the least. In the first place, the creation of this group of images spans at most a period of twenty years, from about 60 to 40 B.C.—more probably less; yet the variations in style between the strongly Hellenized head of Pompey and the drily veristic likeness of Caesar, of the type of the head from Tusculum, now in the Turin Museum, encompasses the largest part of the stylistic range to be found in all of republican portraiture.

Attempts have been made to classify republican portraiture on purely stylistic grounds and to derive a general chronological sequence from this classification. The most elaborate scheme is that of Schweitzer, which can be outlined as follows.[35] Works of the first third of the century are grouped in contrast with those of the second third. Within the first period the classes are, first, the Mid-Italic group, closest to the memorial terra-cotta heads, which may well represent a folk parallel; second, a Hellenistic group, which is split into Hellenizing and Latinizing classes; and third, the group of portraits of elderly Romans most closely related to death-mask literalism.

Within the later period, in which would fall most of the identifiable portraits of eminent republican heroes, Schweitzer uses Wölfflinian terminology to make his stylistic discriminations. First come two groups under the general heading "Painterly-Pathetic," the first related to the bust of Sorex and the other to that of Pompey; then comes a "Plastic-Idealistic" style, typified by (of all things)

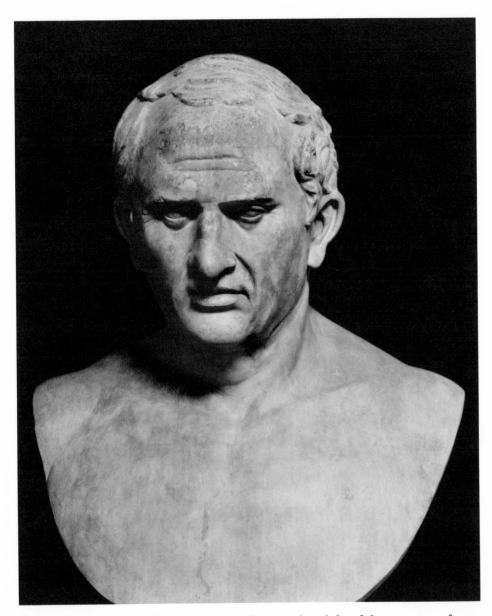

FIGURE 78 Uncertainties of identification complicate our knowledge of the appearance of many eminent figures of the late Roman republic, but there can be no doubt as to how Cicero looked. The difficulty is to distinguish, amid a swarm of overrestored and too-imaginative copies, those likenesses that are closest to the actual man. This uninspired copy is probably one of the most faithful, and it also best illustrates the modest Hellenism toward which Cicero's portrait aspired. *Vatican Museum*

FIGURE 79 The likeness of Julius Caesar was reproduced far more often after his death than before;
this type, which resembles the portrait of Cicero in its blend of verism and Hellenism (seen in the
Polyclitan coiffure), nevertheless seems to date from the period of the dictatorship and the new
wave of interest in things Greek then affecting both patrons and portraitists in Rome.
Vatican, Museo Chiaramonti

the Apsley House bust of Cicero, which in turn merges into a "Plastic-Stronger" style, characterized by the Chiaramonti Cicero; and finally there is a "Plastic-Richer" style, exemplified by the Uffizi and Capitoline Ciceros, which merges into the classicism of Augustan art.

The weakness of this oversubtle schematization may be exemplified by the treatment of the portraits of Cicero in the last section. Under the empire Cicero was honored more as a *littérateur* than as a politician of the old school, and his bust was reproduced time and again. This was even truer during the Renaissance and after, with the result that most of the surviving portraits (including the keystone Apsley House portrait, which is inscribed) are heavily restored, and a goodly number are forgeries. Behind all these likenesses there lies, in all probability, not three but only one original portrait type.[36] The categories derived by Schweitzer from the best-known extant copies, therefore, pertain to the period of the creation of these copies—no earlier than the beginning of the empire—rather than to the time of the republic.

If we must characterize the portraiture of the last century of the republic, all that can safely be said is that its style ranged from a fairly strict verism, exemplified by the images evidently based on death masks and the Boston Museum's apparently unique terra cotta transcribing a life mask, to a not too secure Hellenism, found most commonly in portraits of men in public life and ranging from the almost satirical portrayal of the great Pompey to the more genial image of Cicero.

It appears possible to suggest, then, that there are two basic trends in this portraiture: one more Latin and veristic, the other more Hellenic and heroizing. In general, the portraits of the eminent republicans fall closer to the latter end of the scale—as might, in fact, be expected—while the scale itself is a matter of infinitely fine gradations rather than a sharp dichotomy.

The question remains whether the portraits of the Roman man-in-the-street may not be differentiated in terms of function, that is, whether they tended to be made only for memorial or funerary purposes, while the images of the leading politicians were now created for public rather than private display. This in itself could be enough to explain the greater Hellenism of the latter type of image, intended to impress rather than merely to record.

In any event, the stylistic range of first-century portraiture in itself tells us nothing of importance about the question of why this art form, apparently integral with Roman beliefs and attitudes toward life, death, art, and the individual from far earlier times, should have emerged so late; nor are we offered more than a hint as to the mechanism through which it came into being.

The Origins of Republican Portraiture

Given the assumption that an art form does not spring from hitherto barren soil without some sort of insemination, the question of origins is always of interest. In the case of Roman republican portraiture, it has received a great deal of attention, and the conflict of opinion is far from being resolved at the present time.

In explaining how the republican portrait came into existence, we may take it for granted that Roman funerary customs, related to the ancestor cult and derived from practices found elsewhere in ancient Italy, offered fertile ground for the creation of portraits, but that, just as in Egypt, where similar conditions existed, there was no necessity that the images made under the pressure of this cult should take the fully developed form of the veristic portrait. To account for the particular form taken by the republican portrait in the last century of the republic itself, three sources of inspiration have been suggested: in the first place, Etruria; in the second, Hellenistic Greece; and in the third, Ptolemaic Egypt.

The Etruscan theory, to which is linked the comparison of Roman art with the Italic works created both prior to and contemporary with the Etruscan domination, is the most obvious, and hence probably the oldest-established, of these explanations. There are, on the one hand, the Italic funerary terra cottas discussed above (Figures 75 and 76); then the Etruscan sarcophagi, with their highly specific heads placed on the reclining bodies forming the coffin tops (Figure 80); and finally, a number of Etruscan bronzes, such as the heads from Fiesole in the Louvre, from Bovianum Veterum in the British Museum, and from various Etruscan sites in Florence—not to mention the famous full-length "Arringatore" (Figure 81).[37] All these attest to the ability of Italic artists, and especially the Etruscans, in the depiction of individual persons and to the interest of various Italic societies in having such depictions made. Finally, until Greek influence became too strong, these Italics appear to have found the partial image, that is to say, the detached head or bust, a fully adequate form of representation.

The objections to this thesis, however, are too strong to be ignored. In the first place, such a presentation of the state of the art of portraiture in Italy is a substantial falsification if it attempts to present the picture of a fully homogeneous and continuous development; this is simply not the case. The earliest "likenesses" found in Italy, the Canopic jars, dating from the seventh and sixth centuries B.C., are hardly to be considered naturalistic in any sense; after them comes a large gap in the sequence, filled only by the archaic phase of Etruscan art, which was no more concerned with individualization than was the comparable phase in Greece. The flowering of the Etruscan portrait bronzes, sarcophagi, and

FIGURE 80 Burial sarcophagi from Etruscan territories, like this one, carry impressive images of
the departed enjoying the funeral feast; but they were made long after the Roman ascendancy, so
that any relation to the Roman funerary portrait is apt to have been in terms of Etruscan artistic
dependency rather than the opposite.
Florence, Museo Archeologico

the later Italic terra cottas begins, at the earliest, in the third century (Figure 82)
and must be dated for the most part to the second and first centuries B.C.[38]

Thus, although a continuous funerary tradition supplied the soil in which
effigies were continuously manufactured, the truly realistic portrait in Italy cannot
be dated any earlier than the full flowering of this art form in Greece; and examina-
tion of the works of the best quality from Etruria, such as the "Arringatore,"
clearly demonstrates that they must be considered a provincial branch of Hellenis-
tic art rather than a separate school in their own right. Once again, their creation
may have been encouraged and stimulated by the existence of a strong funerary
cult, absent in Greece, so that these works occupied a far more prominent place
in Italian artistic production as a whole than was ever the case in Hellenic lands;
but the form taken by this production was determined by foreign, i.e., Greek,
influences.

FIGURE 81 This bronze statue, the so-called "Arringatore," the Etruscan Orator, gives a strong conviction of portrait realism; yet chronologically it falls well within the time span of Greek Hellenistic art and so cannot serve to demonstrate Etruscan primacy in the art of depicting individual personality.

Florence, *Museo Archeologico*

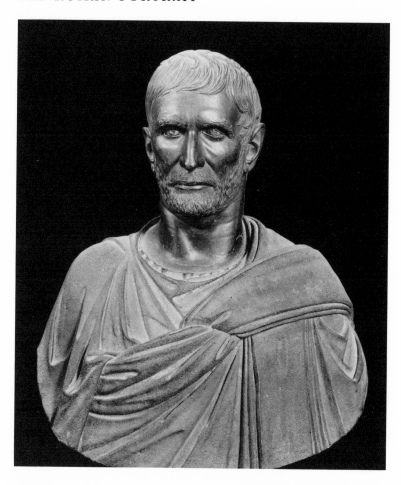

FIGURE 82 Identification of this bronze bust as a portrait of Lucius Junius Brutus, founder and first consul of the Roman republic, is not unreasonable; but there is no question of its being a contemporary likeness of the sixth century B.C. Its style conforms to that of Italian art of the third century, and rather than exemplifying any continuing Italic portrait tradition it is a gauge of the penetration of Hellenistic concepts—including that of archaism—into Italy by that date.
Rome, Palazzo dei Conservatori, Museo Capitolino

The Etruscan theory, then, is refuted by partisans of the Greek origin of Roman portraiture on the grounds that Etruscan art, at the time that it took the direction toward a naturalistic portraiture, was as much a province of the Greek world in cultural terms as was Rome. Advocates of this second theory would deny that there is any significant difference between Roman portraiture of the first century B.C. and contemporary portraits from the Hellenistic sphere of the eastern Mediterranean, which are the product of a continuous development in

local conditions (Figure 83). They are able to point to the further fact that we have little or no evidence that there were any actual Roman artists working in sculpture in this period, so that all the Roman portraits must have been made by imported Greeks.[39]

Certain of the arguments made by this group of advocates must be conceded, especially with regard to the dominance of Greek artists in Rome, so far as our documentary knowledge goes, at this and later periods. Still, it fails to account for the fact that Roman portraits *look so different* from Greek ones, not in stylistic details so much as in the atmosphere of personality and individuality gained from them. As we have seen, the "Hellenists" explain this as the result not of differences in artistic approach but simply in subject; it is, to twist Hinks's word, objective—residing in the nature of the individuals represented—rather than subjective—residing in the outlook and approach, or for that matter in the identity, of the artists executing them. Whereas the subjects of Greek portraits, aside from rulers, who tended to employ a certain degree of idealization for purposes of propaganda, are most commonly intellectuals, the Roman subjects are strictly men-of-affairs—as we have seen. Here, according to this school of thought, lies the difference between portraiture of Greeks by Greeks and portraiture of Romans by the same Greeks.

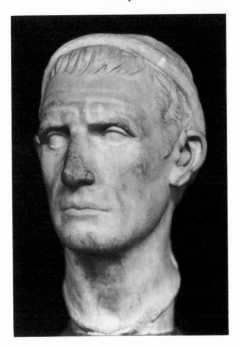

FIGURE 83 The Hellenistic rulers of Syria, like Antiochus III, who is the probable subject of this portrait, were among the models for the Roman leaders who came to aspire to world leadership. This portrait shares a degree of idealization with other Hellenistic ruler portraits, but it maintains an attention to individual features of its subject in a way which the Romans could understand and admire.
Musée du Louvre

Once again, examination of the material remains blunts the force of the argument: not that we cannot admit the creation of portraits of Romans by Greek artists, but that it is possible, even in Rome, to distinguish at least the most "Hellenistic" of these. It is not, furthermore, because of Hellenized glorifications, such as the head of Pompeius Magnus, that we prize the Roman republican portrait; it is because of the homelier virtues of more unassuming likenesses, such as those of Lucius Cecilius Giocundus of Pompeii (Figure 84) and his innumerable anonymous contemporaries.

It is worth noting in addition that Charbonneaux has recently pointed out that portraiture in the purely Hellenistic world was moving *away* from an interest in verism precisely in the second and first centuries B.C., when the Romans were falling under the sway of Greek art.[40] On balance, while the impact of the art of the Greeks on that of the Roman republic cannot be undervalued, an analysis of the republican portrait in terms of the portrait in the Hellenic world leaves an undissolved residue, a precipitate unaccounted for by the Greek portrait tradition.

If the Roman republican portrait is not adequately explained in terms of earlier work done on Italian soil, and if Hellenistic portraiture accounts better for Etruscan than Roman portraiture, then it seems necessary to look elsewhere for a better explanation of what happened. The only remaining locality within the sphere of Roman politics and culture where a significant quantity of portraiture had been produced—but that a very great quantity indeed—was, of course, Egypt. From Egypt come portraits of a level of verism comparable only to the Roman likenesses we are investigating; in Egypt, too, there still flourished a funerary cult attuned to the creation of portrait likenesses in much the same general way as the funerary cult of Italy—enormous though the differences were in detail.

Of the portraiture produced before the Ptolemaic era, the most highly veristic, such as the sculptors' models from Amarna, were of course safely buried. On the other hand, the wide range of sources drawn upon by the revivalist artists of the late period, from the Kushite and Saite dynasties onwards, is a good indication that at least a sampling of the great range of Egyptian art was still visible and available for study.

The discussion in Chapter II may have defined adequately both the character and the limitations of earlier Egyptian portraiture in terms of the requirements established for the fully developed state of the art. It cannot be denied, however, that, at some point after the Kushite resurgence in the eighth century B.C., the Egyptian portrait did in fact break through to new ground, developing to a point

FIGURE 84 Lucius Cecilius Giocundus, a Pompeiian businessman, was portrayed in a bronze which exemplifies the "speaking likenesses" for which Roman sculptors strove: meticulously literal in detail, yet achieving a synthesis of the whole personality which is needed to convey the full vividness of life itself.

Naples, Museo Nazionale

where not only was the surface of the individual portrayed with undeniable verism but a concern with the revelation of the inner character of the subject was also present. Our first problem is to decide just when this development reached fruition; the second is to determine whether it was the consequence of a self-motivated indigenous process or the result of some external influence.

To a degree, the answers to these questions may have to be subjective; at least for the moment, the matter is in much the same state of controversy as the question, for students of Greek portraiture, of whether the fully individualized likeness was first created in the fifth or the fourth century. Regardless of this difference of opinion, it is safe to say that all authorities do agree that portraits in the most complete sense of the word were being made in Greece by the middle of the fourth century. Similarly, there can be no doubt that equally profound portraits were being made in Egypt from early in the Ptolemaic period, not only in the Hellenized ambience of Alexandria and its alien court, but also in the native workshops up-country—the products of artists trained in traditional styles, techniques, and materials. How much earlier than the Macedonian conquest had this been the case? Not that the Greek concept of the portrait need have waited for that conquest to penetrate Egypt; there had been close relations between the two lands for centuries before the arrival of Alexander's troops, and we have ample documentation for constant interchange of both artifacts and ideas.

The thesis that Egyptian sculptors did in fact evolve fully developed portraits prior to receiving any hint of Greek innovations in this field has recently been advanced with great persuasiveness by Bernard V. Bothmer and illustrated in a magnificent exhibition and catalogue.[41] According to this argument, the "true portrait" appeared in Egypt, admittedly in neither the Kushite nor Saite period (to which it was once attributed), but under the Persian domination, which lasted, with interruptions, from 525 until 333 B.C.

The difficulty lies, unfortunately, in the location of the relevant works within this critically long period. Very few of the portraits made between the Twenty-Seventh and Thirty-first dynasties can claim to represent the form in its most fully developed sense. Such an imposing masterpiece as the "Louvre Head," dated by Bothmer to the fifth century,[42] is impressive enough as a work of art in its own right, but it cannot be said to convey any sense of direct apprehension of personality; indeed its very power derives from its remoteness, an aloof quality which eliminates any possibility of establishing contact with the individual portrayed. In this respect the "Louvre Head" bears comparison with the famous image of Pericles of comparable date—although we intend no deeper significance by the analogy. This is a portrait in the ancient Egyptian tradition, worthy to rank among the finest of any dynasty.

FIGURE 85 This tiny bust was undoubtedly a sculptor's model; it was used as the basis for a comparatively individualized portrait in later Egyptian times. Just how late is uncertain, but the work most probably dates from sometime in the fourth century B.C., just before the conquest of Egypt by Alexander and his Macedonian army.
Baltimore, Walters Art Gallery

The first work adduced by Bothmer which can be accepted unreservedly as wholly free of idealization is a small bust in the Walters Art Gallery (Figure 85), made from either terra cotta or gypsum.[43] This little bust, whose realism seems truly comparable to that of Roman portraiture, is clearly a work based on observed fact, not on preconceptions or generalizations, and it successfully conveys

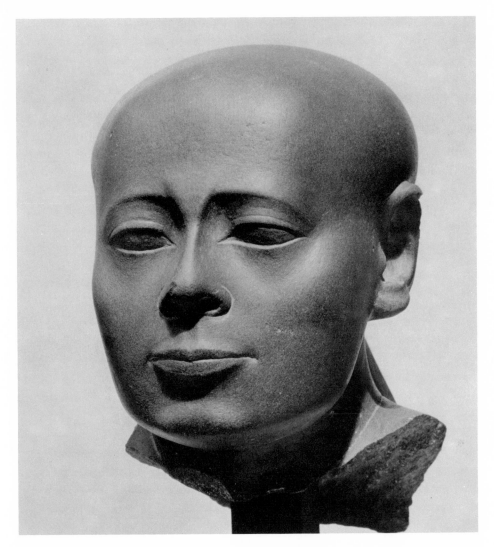

FIGURE 86 More typical of fourth-century portraiture in pre-Ptolemaic Egypt is this imposing image of the priest of Monthu, Wesir-Wer, dated *ca.* 360–340 B.C. in the Thirtieth Dynasty, formerly known as the Brooklyn ''Green Head.'' The individual features are reconciled to a concern for the formal structure of the traditional portrait; an interest in individualization modifies, but does not truly alter, the standardized ideal.

The Brooklyn Museum

a sense of the character and personality of its subject. Unfortunately for the solution of the problem at stake, however, its obvious function was as a sculptor's sketch or model—just like the Amarna masks, its closest antecedents in Egypt. Hence it proves little about the nature of the finished studio product, which would

have given culturally acceptable form to the artist's observations. In any case, Bothmer is unable to date this model more precisely than to the general period 450–340 B.C., which makes it contemporary with the development of portraiture in Greece.

For a more valid picture of the type of portrait image produced for public "consumption" in fourth-century Egypt, it is better to take the magnificent Brooklyn "Green Head" (Figure 86),[44] which, though possessing certain attributes of realistic portraiture, gains its greatest impact through its allegiance to traditional Egyptian criteria of imagery, not to its modest effort at individualization.

Thus if we search for a fully convincing and wholly completed "true" portrait from Egypt, we must go to the Ptolemaic period, after Greek culture had been definitively transplanted to a corner of Egyptian soil. While the Hellenistic artists of Alexandria practiced an unadulterated Greek style (Figure 87), the traditional art of ancient Egypt not only survived but flourished up-river under the patronage of the Ptolemies and the native dignitaries as well. Images of the Greek kings were made so successfully in Egyptian style that they can be extremely difficult to distinguish from those of much earlier centuries; the archaizing of the preceding dynasties still prevailed. The finest of these native works, however, betray an interest in realism of delineation and psychology utterly different from anything hitherto produced in Egypt, much as their outward traits conform to tradition.

Such a work is the "Green Head" in Boston (Figure 88),[45] another specimen of native work in those hard stones whose handling aliens never mastered; dated by Bothmer to the end of the third century, it can only be understood as a result of the penetration of new concepts of portraiture: an interest in what makes a man different from his fellows rather than the aspects in which they are most similar; and this interest we must, on the evidence, credit to the Greeks.

The more precise chronology established by Bothmer's researches reveals that the phase of most powerful individualization in portraiture occupied the first century after the Greek conquest of Egypt; in succeeding generations there was a tendency to diminish the sense of specific characterization conveyed by heads like the one in Boston. The Egyptian artist returned, that is to say, to a more generalized treatment in conformity with his historical tradition, once the impact of novelty had worn off.

A clear instance is the famous Berlin "Green Head" (Figure 89), long considered a Saite work but now securely dated a century later than the Boston example, to which it is at first glance closely related. Bothmer describes it in this way:

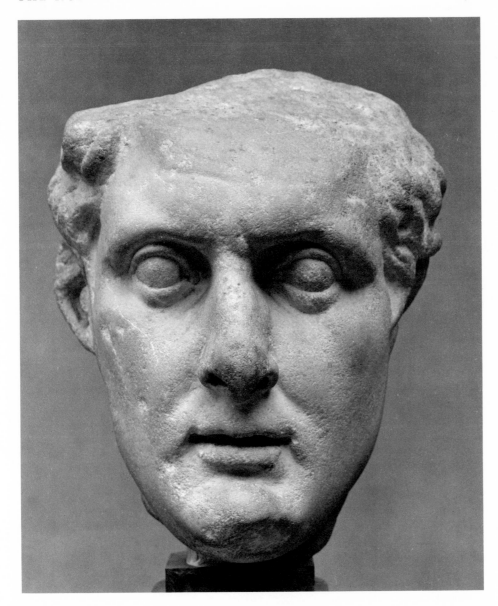

FIGURE 87 The newly established city of Alexandria was the seat of a completely Hellenized culture at the court of the Ptolemies. This fragment of a portrait of Ptolemy I (seen in profile in Figure 66), although posthumous, reflects the dramatic liveliness achieved by the best Greek portraiture in the third century B.C.

Copenhagen, Ny Carlsberg Glyptotek

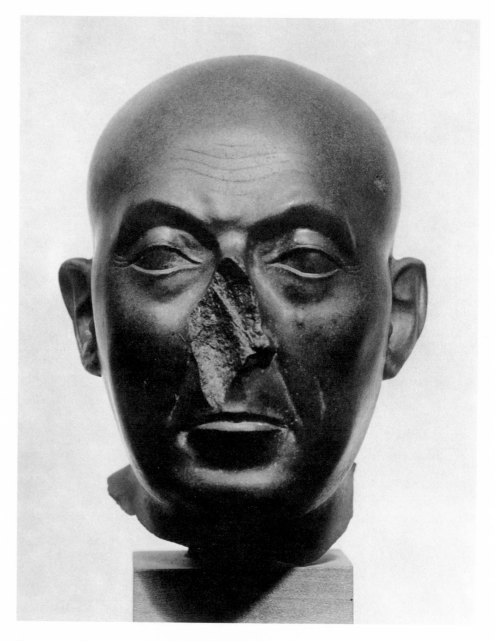

FIGURE 88 The most completely individualized portrait ever made by a traditionalist Egyptian sculptor is the Boston ''Green Head.'' Complete faithfulness to the over-all form, the bone structure, and also the natural asymmetry of the actual subject enabled the artist to pursue the revelation of character to the most profound—though not entirely flattering—degree. It is dated about 200 B.C., still early in the Ptolemaic period.

Boston, Museum of Fine Arts

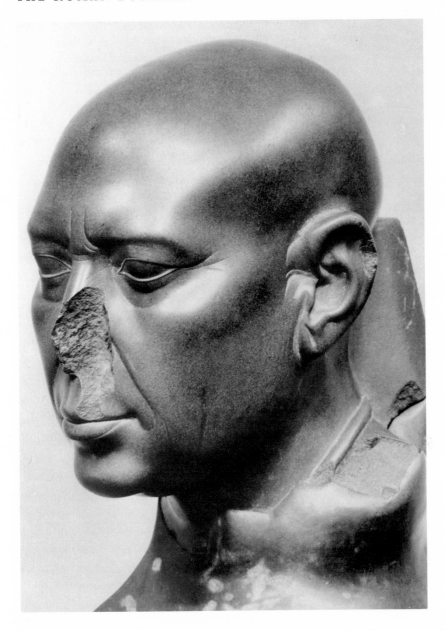

FIGURE 89 Another "Green Head"—this one in Berlin—appears at first glance very similar to the preceding example, but closer examination reveals that a symmetrical design has been reimposed upon the image and that the entire organization of the form is now subjected to the rigorous schema of traditional Egyptian imagery. Long thought a Saite work, it is now securely dated to about 100 B.C. and represents a later development in Ptolemaic portraiture than the Boston head.
Berlin, Staatliche Museen, Aegyptische Abteilung

The eyes are very formally drawn; the manner in which the upper lid cuts over the lower is especially reminiscent of the treatment of the eyes in the well-known bust of Mentuemhat in Cairo [of the seventh century]. . . . The face betrays a preoccupation with symmetry that is very unusual. . . . The treatment of the nasolabial furrows is unique. They descend in an almost straight line down from the nostrils, to end in an elegant curve that bends upward. . . . Realistic rendering and strangely calligraphic treatment of detail have been combined by what must have been one of the most capable sculptors of ancient Egypt to produce a portrait revelatory of the nature and mind of an extraordinary person.

In other words, the objectives of the naturalistic portrait are now being achieved by formalized means, not by direct transcription of observation. Bothmer concludes:

The head shows every sign of being the result of long experience and practice. . . . Native sculptors, having created portraits (especially the Boston "Green Head") that were true to life in the widest sense, rendering not merely physical but innate characteristics, began to play variations on the theme. . . . Notable among these variations is the Berlin "Green Head." Avoiding verism in outer form, even approaching unreality in its symmetry and calligraphic lines, it nevertheless manages to reflect the individual, inner being of a man.[46]

Writing of another magnificent example of later Ptolemaic portraiture, the splendid granite head in Providence (Figure 90), Bothmer again points out the contrast between certain highly individualized details (this time the nasolabial furrows, as well as the forehead wrinkles and the asymmetry of the face as a whole), with other scarcely modulated areas, such as the surface of the skull, the impressionistically rendered hair, the sides and back of the head, and so forth.[47]

When we consider that the vast bulk of Ptolemaic Egyptian portraits was of the wholly idealizing type of the extant pharaonic portraits, in due conformity with the traditional preference of funerary art for representing the deceased in the full bloom of vigorous youth, it becomes evident that veristic portraits such as the Boston "Green Head" were, at any time, rare exceptions, not the rule. Furthermore, just as in earlier dynasties when a new and more realistic approach to the subject was introduced into Egyptian artistic practice, the artists gradually returned to their normal mode of idealization, as exemplified at the highest level by the Berlin head. In the Ptolemaic period the factor that altered the character of Egyptian portraiture was the intrusion of Greek ideas of individual characterization, and they had their strongest impact in the first century of the dynasty, thereafter being gradually assimilated and normalized.

We feel justified, therefore, in accounting for the introduction of the "true" portrait into strictly Egyptian practice through the influence of Greek ideas, works of art, and artists; the first fully individualized portraits may well have been made in Egypt prior to the Macedonian occupation—although that point remains

FIGURE 90 This Egyptian portrait of the late second century B.C. uses remarkably limited means
to achieve an affectingly pensive mood. Much of the head is quite generalized, but the artist's hand
focuses attention on just those features which best convey the sense of the subject's individuality.
Providence, Rhode Island School of Design

to be proved; but even so we have no reason to consider that they had any actual priority to the individualized Greek portrait or that they were motivated by anything native to the Egyptian tradition.

As regards the possibility of the native Egyptian type of portrait having had a determining influence on the appearance of the Roman republican portrait, it is difficult to see that the Romans could have learned anything from the Egyptians that they could not have gained more easily and directly from the Hellenistic Greeks, whether of Alexandria or from elsewhere in the Mediterranean basin.

Certainly, close Roman contact with Egypt began considerably later than with Greece. In the gold coins of Flaminius we have evidence of the adoption of Hellenistic portraiture—albeit outside the strictly Roman area—at the beginning of the second century B.C. While Romans were active in Egypt during the second century, and were even employed in the administration there, the real vogue for things Egyptian arrived in Rome itself at the end of the republic—with Caesar's final conquest—and continued into the first century A.D., when the Isis cult reached its apogee. Thus virtually all portraits of priests of Isis (which, as a type, stand out markedly from the general run of Roman likenesses) are from the imperial period,[48] while other clear examples of Egyptian influence on Roman art are largely of the same era. The famous Nilotic mosaic at Praeneste (Palestrina), cited by Bothmer as an instance of Egyptian influence at the height of the republic, has never been dated with precision, but it would be difficult to argue that it could have been located there prior to the Sullan foundation of about 70 B.C.[49] It would seem to represent, in any case, an example of the art of Hellenized Alexandria rather than the native culture of Egypt. By this date, unless the chronology of republican portraiture is even more remarkably late than now seems the case, the veristic portrait was well established.

At the end of the republic—when we might expect Egyptian influences in any case—there is a group of portraits of Romans done by Egyptian artists in characteristic Egyptian materials. Bothmer himself has drawn an extremely valuable comparison between the Berlin "Green Head" and the well-known basalt head of Julius Caesar in Berlin.[50] A comparable head at Kingston Lacy, for which an identification with Mark Antony has been offered,[51] is equally far from contemporary Roman practice in its generalization of the features of the subject—its imposition of formulae upon the specific traits. The full integration of Egyptian style with Roman art was realized only after the beginning of the empire, when a more Hellenistic manner was imposed on the Egyptian materials and a series of beautiful, but strongly idealized, portraits of members of the Augustan family was created by Egyptian artists (Figure 91).

FIGURE 91 With the conquest of Egypt by the Romans, a new dynasty was imposed on the ancient
land, and its artists turned to the portrayal of their new rulers. This portrait of Augustus' empress,
Livia, is made of basalt, a dark hard stone popular with Egyptian sculptors and requiring too much
patience to be used elsewhere. Despite the strong limitations imposed by the material on the sculp-
tor's freedom to render details of surface modulation, the force of the subject's personality can be
glimpsed in a portrait which links the ancient Egyptian with the new Roman imperial art.
Musée du Louvre

Future research may alter this picture of the cultural relations between
Egypt and Rome in the republican period, especially with regard to the pene-
tration of the worship of Isis at an earlier date, but also in terms of at least a
limited number of works of art reflecting specific aspects of Egyptian art. Even
so, it is difficult to see this Egyptianizing taste as more than a rivulet beside the
roaring torrent of Roman enthusiasm for all things Greek.

The actual course of Ptolemaic art in any case took a different direction from
the high verism of republican portraiture. We have seen that the Boston "Green

Head'' is far more veristic than the later one in Berlin, in which all the acute observations of visible reality have been subordinated to an over-all design, with the individualizing traits—as in all great Egyptian art—used as modifications rather than determinants of the type. The final formulation of the Ptolemaic style, achieved only in the very last decades, before Roman conquest brought to an end the millennial Egyptian tradition of large-scale sculpture, is to be seen in a series of splendid first-century portraits (Figure 92), whose true place and significance have now been clarified by Bothmer's studies.[52] In these wholly native likenesses the type is given individuality by the indication of the most essential and significant traits of the subject, not by the meticulous rendition of all the details of appearance. They form, in other words, a culmination of the tendency inherent in the artist's approach in making the Berlin "Green Head.''

This kind of image need not be any less a portrait, in our fullest sense of the word, than the factual sort then being produced in Rome. Once the idea has entered the conceptual framework of a society that a man's personality is the essential concern of the portraitist, it is very difficult either to ignore it or eradicate it. The concern of Egyptian artists, in the most profound of their original works from the end of the Ptolemaic period, was quite clearly with the portrayal of real human beings. Certainly we get as full a reading of the personality of the subject from the Berlin head as from the Boston one. It is only the means that differ. And it is exactly in the difference of the means used to arrive at the likeness that these Egyptian works also differ from the portraits of republican Rome.

Up to this point we have been concerned to point out weaknesses in the various proposals which have been made to account for the sudden flowering of the Roman veristic portrait. On the one hand, there is not enough in native Italian art, prior to the appearance of the republican portrait itself, to account for its character; on the other, however great the admiration for, and dependence upon, Greek art and artists in Rome, the portraiture we have from the Greek sphere of the Mediterranean—even the highly individualized heads found at Delos—is not truly of the same character as that of Rome; and finally, although Egyptian portraits exist whose verism almost equals that of the Romans, they are extremely rare and are difficult to relate to Rome in any direct way.

None of these proposals is entirely fallacious. The real fault with each lies in its insistence on exclusive consideration. The truth is that all of these areas could have had a part to play in conditioning the creation of the Roman portrait.

The predominance of Greek artists in Rome in the first century B.C. can scarcely be gainsaid, although they may not have had the total monopoly claimed by Miss Richter.[53] None the less, and even if every Roman work of art was made

FIGURE 92 Probably the finest of the colossal portrait sculptures created in the last period of Egyptian autonomy is this diorite head, known as the Brooklyn "Black Head," dating from the first century B.C. and portraying an important native dignitary in terms of the eternal constancies of Egyptian art. Modified by Hellenistic ideals, it nevertheless belongs to the great sequence of Egyptian portraiture which originated in the age of the pyramids and to which it stands as a fitting conclusion. *The Brooklyn Museum*

by an imported artist, the Romans got an art quite distinct in character from that of Greece. In portraiture, even if they did not, perhaps, have an indigenous craft tradition for the making of veristic likenesses, they evidently had a desire for accuracy of portrayal, as a corollary of their ancestor-directed funerary cult— a desire which the high technical competence of Greek craftsmen was able to satisfy. The Romans got, in other words, the kind of art they wanted, whoever made it for them. They directed the skills of alien artists toward mastering the representation of the individual in the most literal sense, to provide an art that was far more specific and nongeneralizing than anything the Greeks themselves were interested in having.

Hellenistic Thought, Lucretius, and the Portrait

Such use of Greek techniques, Greek styles, and Greek art forms for new aesthetic and conceptual ends is not confined to the art of portraiture in Rome. We need only compare what Vergil did with the Greek epic to see the same tendency toward adaptation of Greek modes to the different experience of Roman life; the clearest example of this tendency, the adoption of certain modes of later Greek philosophy by the Roman intellectuals of the late republic, also has particular relevance to the problems of this study.

The practical Roman attitude toward the farther reaches of speculative thinking may be epitomized by Cicero's observation that a man who read Plato could be impressed and believe; but "when he closed the book, the reasonings seemed to lose their power, and the world of spirits grow pale and unreal." [54] The philosophers with whom the Romans came in contact were those who lived in the troubled society of the Hellenistic kingdoms which Rome was absorbing one by one; for such people, the metaphysics of neither a Plato nor an Aristotle offered practical guidance. In this harsh new world every man stood alone, bereft of the comfort of the status-secure city-state of his fathers, beset by the twin menaces of fear and desire. The philosophers who offered guidance for the men of this world were moralists and dogmatists, not metaphysicians.

Insofar as a metaphysical substructure was required for the doctrines of the Hellenistic philosophers, they contented themselves with the simplicities of pre-Socratic speculation: for Zeno, Heraclitus, and for Epicurus, Democritus offered adequate physical theory to underlie their practical moral and ethical dogma. In each case the physical theory was thoroughly materialistic in character—even more than in the hands of its originator. All of nature, to the philosopher of this

age, could be understood in terms of sensory phenomena, and all phenomena could be explained in terms of physical matter and forces.

The doctrines of Epicurus (341–270 B.C.) are the most uncompromisingly individualistic of all the systems of Greek philosophy (if we except the Skeptics, who had less a system than an attitude—an antidogmatic dogma). Epicurus found in the theories of the atomists a physics adequate to the needs of his system; he re-expounded this species of materialism in thirty-seven books. His logic, too, was materialist; his so-called canonic, avoiding the mechanics of either formal logic or dialectic (to both of which he was, to say the least, unsympathetic), establishes simple sensation as the test of truth. "Whatever we experience is true."55 "Notions," or conceptual reconstructions and generalizations, arise through a repetition of experience, and reflection upon notions gives rise to opinion. Subjectivism is unadulterated.

Epicurus was unable to carry his subjectivism—and his materialism—through to its logical conclusion of rejecting all belief in the divine personalities of in-herited religion. Although he rejected any thought of an afterlife or any sort of personal immortality ("that which is dissolved is without sensation; and that which lacks sensation is nothing to us"56), Epicurus none the less admitted the existence of immortal gods. They existed for him, however, on an interstellar plane utterly removed from mortal activities and utterly unconcerned with man's fate. In other words, they might as well not exist; it was simply not worth his effort to abolish them entirely.

Since the gods were not concerned with man, and since there was no after-life to terrify the living, the wise man could face life on its own terms. It was in his ethic for existence that Epicurus conveyed his real message. This ethic seems, in fact, to make all the theoretical substructure described above nothing more than an *ex post facto* exercise in justification—which it must have been.

It is a truism that Epicurus' doctrines have been largely misunderstood. He held that the only unconditioned good is pleasure, just as the only unconditioned evil is pain. But since pleasure lies in freedom from pain, it is not to be found primarily through hedonism—as was held by the earlier Cyrenaics, to whom he was partially indebted—but through a more negativistic avoidance of pain. Epicurean *ataraxia* is indeed a state of equilibrium established through the gratification of desire; but even more it is a state of repose in which desires are not felt.57

The ideal product of the Epicurean ethic is the wise man who has freed himself of the distractions of physical wants, who has gained control over his passions and desires. Such a man did not, however, live outside the world but in it. The demands of day-to-day life were not ignored by Epicurus, and he did not

expect a supramundane perfection of his sage but rather the construction of a *modus vivendi* conducive to repose *despite* the concerns of living. Salvation, then, was to be found within one's self; there was no teleological purpose at work in the universe, and so there was no superimposed pattern to which man needed to conform. In many ways, therefore, Epicureanism represents the farthest extreme of Greek humanism, a *cul de sac* which permitted no continuation.

Although Epicureanism found its way to Rome in the second century B.C., and found in Lucretius its most eloquent exponent after its founder, it never dominated Roman thought as Stoicism did. For one thing, its dogmatic nature—the fact that the founder's thought was taken whole and was never significantly expanded or even expounded—meant that it was fundamentally unadaptable to the new situations the Roman world empire brought into existence. As Cicero tells us, converts were compelled first of all to commit the words of the master to memory.[58] For the pragmatic Roman temperament, the more flexible, if slightly more mystical, doctrines of the Stoics were to prove in the long run more attractive.

Zeno, founder of the Stoic school, was a close contemporary of Epicurus. Born in Cyprus in 336, he died at Athens—appropriately, by his own hand—in 264 B.C. Although he gave shape to the doctrines of his school, his successors Cleanthes and Chrysippus expanded and organized them extensively; then the Romans, taking them over with enthusiasm, gave their own emphasis to certain aspects of Stoic philosophy, so that a body of thought evolved that was far more alive and pertinent than the teachings of Epicurus.

This very flexibility can be seen as a correlative of the Stoics' simple Heraclitean physics: "Fluxes and changes perpetually renew the world, just as the unbroken march of time makes ever new the infinity of ages."[59] There is a dynamic force driving the world, through the medium of fire, the primal material of the universe. Changes are directed by the God-force toward a worthy end. Knowledge is gained through the senses, then extended by logical deduction of "compelling force."[60]

The Stoic teleology, if not their metaphysics, was essentially Aristotelian. The rational God-force driving the world process, which they variously called the World-Soul, the World-Reason, Destiny, or simply God, imposes order on nature; the ultimate ethical principle thus became conformity to nature. "All things come from that one source, from that ruling Reason of the Universe, either under a primary impulse from it or by way of consequence."[61] Hence the great emphasis of the Stoics, so attractive to the rulers of Rome, upon order and law. "For those creatures who have received the gift of reason from Nature have also received right reason, and therefore they have also received the gift of Law, which is right reason applied to command and prohibition. And if they have received Law, they have received Justice also."[62]

Unlike the Epicureans, then, the Stoics see virtue as an end in itself, an end to be achieved by law—natural law, not convention. Here the Romans come into their own, with enormous consequences for postclassical thought.

True law is right reason in agreement with nature; it is of universal application, unchanging and everlasting; it summons to duty by its commands, and averts from wrong doing by its prohibitions. . . . One eternal and unchanging law will be valid for all nations and all times, and there will be one master and ruler, that is, God, over us all, for he is the author of this law, its promulgator, and its enforcing judge.[63]

Thus far Cicero; but also Aquinas:

Now among all others, the rational creature is subject to Divine providence, by being provident both for itself and for others. Wherefore it has a share of the Eternal Reason, whereby it has a natural inclination to its proper act and end: and this participation of the eternal law in the rational creature is called the natural law.[64]

As with the Epicureans, the Stoic ideal was embodied in the sage, the wise man. But this wise man was of a different order from the worldly Epicurean—a difference sometimes explained as due to Zeno's Semitic background. For the Stoic sage, at his highest level of existence, withdrew completely from the world and its concerns; perhaps his highest act was that of suicide. The concept of the sage as an ideal was of course an important heritage in Greek thought; but even Plato's philosopher-kings have more flesh and blood to them than the Stoic sage. Something of the times is surely reflected in this. Whereas the sages of Plato's Republic were the active rulers of the state—and such an alumnus of the Academy as Lycurgus might find himself in this position in real life—and whereas Aristotle's pedagogy was directed to the education of leaders properly adjusted to the realities of an already changing world, the Stoics gave up hope that man might control destiny, even in small part; rather than adjustment, resignation became the only aim to be taught. The sage's knowledge is now knowledge of the universal law that shapes all our ends; his wisdom lies in his acceptance of these naturally determined events. Even when a Stoic became ruler of the world, his feeling was of total absence of control: "For to grumble at anything that happens is a rebellion against nature, in some part of which are bound up the natures of all things."[65] Aristotle's most famous pupil, Alexander the Great, had sought to bend the whole world to his will—and all but succeeded; but the Stoic Marcus Aurelius could meet the trials of his own time only with acquiescence.

Though no man could fulfill the Stoic ideal to perfection, it is evident that the doctrine as such was more attractive to the ruling class of Rome than the more realistic, yet in practice still more introspective, teachings of Epicurus. The first Stoic with whom the Romans came in contact was Diogenes of Seleucia, who was sent as Athenian ambassador to Rome in 175 B.C. and quickly fascinated

his hosts with his disquisitions; another Stoic, Panaetius, was a close friend of
Scipio Africanus and Polybius. A century later, as Pliny notes, "Cato on his
expedition to Cyprus [58–56 B.C.] sold all the statues found there except one of
Zeno; it was not the value of the bronze nor the artistic merit that attracted him,
but its being the statue of a [the?] philosopher." [66]

Together with its concern with universal law, it was Stoicism's emphasis on
individualism—one of the points on which it approaches Epicureanism most
closely—which obviously constituted its greatest appeal to the Roman aristocracy.

> Even more than Aristotle, the Stoics gave a unity and integrity to the individual soul
> (over its temporary states and functions) that could result only in a strong assertion of
> personality. . . . For the governing faculty of the soul is the organ of assent; through it
> one controls or surrenders to passion, and thus the individual is made solely responsible
> for the state of his soul. The Stoic relied upon himself; a citizen of the world of expanding
> geographical and political limits, he, unlike Plato and Aristotle, could find no ethical or
> educational corrective in the intensely communal city-state. Stoicism purported to be
> practical: its ambiguity about the promise of a future world and its insistence on moral
> conduct here and now reveals its purpose of inducing that rational tranquillity that comes
> from utter self-control and self-reliance.[67]

What is important to our study are the doctrines the Stoics and the Epicureans
held in common. In the first place, both believed that all that we can know is to be
found in the world of the senses. Hence, in art, a presentation of visible reality
could be accepted as a "true" statement; and a portrait of a person which
accurately portrayed his specific appearance could be taken as an adequate sum-
mation of the "true" nature of that individual.

Furthermore, since both schools were oriented toward an appreciation of the
value of the individual human being—in fact they found in him the whole justifi-
cation of their speculations—such a work of art not only would be felt to be worth
creating; it was to all intents and purposes a necessity. So the Romans found it.
Theirs was the first society in which the portrait was actually the primary form of
artistic expression.

The first century B.C. in Rome did see the appearance of a philosopher worthy
of joining the company of the admired Greek masters; Lucretius is, as we have
suggested, the only Epicurean to add significantly to the founder's body of thought.
While it may seem inconsistent to focus on an Epicurean after such stress on the
Roman preference for Stoic doctrine, the fact is that the originality of Lucretius
lies exactly in his ability to reconcile the two schools, so that in the manner of his
death he becomes more Stoic than Epicurean.

Lucretius' materialism is as uncompromising as that of his masters, the
Greeks:

All nature therefore as it is in itself is made up of two things; for there are bodies, and there is void, in which these bodies are and through which they move this way and that. . . . Nothing can act or be acted upon without body, nothing can afford space but the void and the empty. Therefore beside void and bodies no third nature can be left self-existing in the sum of things; neither one that can ever at any time come within our senses, nor one that any man can grasp by the reasoning of the mind.[68]

Lucretius' analysis of what has come to be known as the "mind-body problem" presents a complex synthesis of Hellenistic concepts, within the context of this thoroughgoing materialist viewpoint:

First I say that the mind, which we often call the intelligence, in which is situated the understanding and the government of life, is a part of man, no less than hands and feet and eyes are parts of the whole living being. . . . There is . . . within the body itself a heat and a vital wind which deserts our frame on the point of death. . . . Mind and spirit are held in conjunction together and compound one nature in common, but . . . the head so to speak and lord over the whole body is the understanding which we call mind and intelligence. And this has its abiding-place in the middle region of the breast. . . . The rest of the spirit, dispersed abroad through the whole body, obeys and is moved according to the will and working of the intelligence. . . . This nature then is contained in every body, being itself the body's guardian and source of its existence: for they cling together with common roots, and manifestly they cannot be torn asunder without destruction. . . . So interwoven are their elements from their first origin in the life which they live together; and we see that neither body nor mind has the power to feel singly without the other's help, but by common motions proceeding from both conjointly sensation is kindled for us in our flesh. . . .[69]

Such a doctrine uses materialism in such a way that a naturalistic art would seem almost an inevitable concomitant. The typical Roman was, as has so often been remarked, a thoroughly practical and matter-of-fact person. He was interested in what he could see, hear, and touch. Demanding a concern with this sort of sensual fact from his artists, the Roman patron transformed the portrait as it had existed up to his own time. The very intensity of his conviction that matter was all the evidence we have of the existence of spirit was sufficient to bring into existence a new level of naturalism in artistic representation.

It is thus the concern for actual, visible fact that distinguishes Roman portraiture from its predecessors. The Greeks, in all probability, provided the artists who raised it to the level of true art; the Egyptians, to a degree, had even anticipated its means; but the real demand, one might say the necessity, for this type of representation did not exist before the Romans called for it.

If we are prepared to look at Roman art in this way, freed of the tyranny of concern for "influences" and the art historian's eternal search for precedent, we may obtain a more satisfactory understanding of the nature of Roman art and an appreciation of what was truly creative in it. Roman poets were interested in more

than just facts, just as there is more to Roman art than mere verism. But in the visual arts, just as in literature and philosophy, the Romans were true eclectics in the fullest and also in the highest sense of the term. An awareness of manifold forms of artistic expression and their use and adaptation to contemporary requirements do not of necessity make an art merely derivative. All art, as Gombrich has pointed out, is in a sense derivative, based on art itself. This consideration has nothing to do with the intrinsic value of any particular work or school of art.

Portraiture in the Early Empire

The surviving identifiable portraits of leaders of the last generation of the Roman republic show that these politicians had become interested in evolving a ruler imagery, based, undoubtedly, on that of the Hellenistic monarchies, which would serve as a vehicle for the expression of the new political conceptions emerging within the Roman state. The first tentative attempts are most obviously illustrated by the portrait of Pompey *à la* Alexander (Figure 77); fulfillment came only under Augustus himself, at the time that the political situation itself was finally resolved in its permanent imperial form. Nevertheless, just as the political structure of the principate was clearly anticipated during the dictatorship of Caesar, the easily defined style we designate "Augustan" also had its beginnings before the establishment of the second triumvirate.

The critical period, then, in art as in politics, is that of Caesar's dictatorship. The portraiture of Julius Caesar, complicated though it is by many phases of posthumous revision and idealization, can be traced to two basic types. One, realist and "republican" in character, best exemplified by the head from Tusculum now in the museum at Turin,[70] shows the lean features and bald forehead known from the coin types; the other, typified by the famous but controversial portrait in the Museo Chiaramonti at the Vatican,[71] is rather more idealized and has a full head of hair, stylized in the manner of Polyclitus (Figures 79 and 93).

While the latter type has customarily been treated as a posthumous idealization, probably of Augustan origin, new discoveries and comparisons with portraits of Cato Uticensis and Brutus—scarcely Augustan in origin—which share its strongly classicizing Hellenism suggest that the Caesar of the Chiaramonti type is also a product of the dictator's lifetime.[72] We seem to have evidence, therefore, that during the decade of the 40's B.C. there was already present in Roman

FIGURE 93 A fragment of a heroic nude portrait of Julius Caesar following the likeness established
by the portrait in the Museo Chiaramonti (Figure 79), but made considerably after his lifetime;
probably in the reign of Trajan.
Copenhagen, Ny Carlsberg Glyptotek

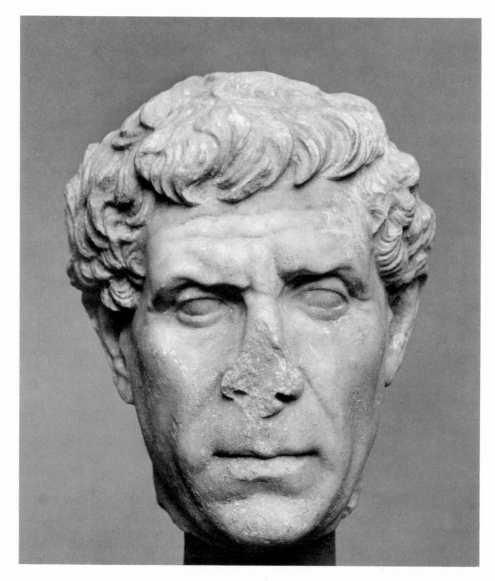

FIGURE 94 The idea that there are no portraits of Roman artists or intellectuals may be refuted, if not by the likeness of Cicero, then by the recent identification of this image as that of Vergil. Although this attribution remains tentative, there can be little doubt that we are in the presence of a psychological masterpiece in the portrayal of a sensitive yet tough-minded man of culture. *Copenhagen, Ny Carlsberg Glyptotek*

portraiture the tendency toward a classical (and anti-Hellenistic) revival which was to become the touchstone of Augustan art.

This classicistic trend was only one phase, and a very limited one, in the portraiture of the 40's. The established Hellenistic manner was far more popular, if we are to judge by the identifiable portraits of the chief actors in the years following Caesar's murder. In the case of Mark Antony, as we have seen, there is even a type created by Egyptian artists in an attempt to reconcile Roman tradition with the manner of late Ptolemaic heroization. [73] An Attic strain in late Hellenistic style seems represented, appropriately enough, by the portrait of a Roman poet which almost certainly is of Vergil (Figure 94); [74] this likeness is known in five copies, of which one is coupled in a double herm with an example of the famous— and strongly Hellenistic—"Pseudo-Seneca," a widely reproduced but still unidentifiable image, probably of a Greek poet.

With Augustus, however, the Roman portrait enters a new phase, partly defined by the classicism described above, but expressing something far more than just a new combination of stylistic influences. Poulsen has made the intriguing analogy with the emergence of the Hellenistic ruler image under Alexander: "La vue due portrait du jeune triumvir nous fait immédiatement comprendre qu'une des sources du nouveau style a simplement été la jeunesse physique du noble modèle." [75] Into the grim-visaged ranks of graybeards there intrudes, just as in the fourth century B.C., a handsome adolescent who sets new engines of power in motion; through his youth alone Octavius was able to break the link of republican portraiture with the funerary memorial (Figure 95).

The portraits which establish the new style were created at the time of the establishment of the second triumvirate, about 43 B.C., and form a continuation of the Phidian-Polyclitan classicism identifiable in the Chiaramonti Caesar. [76] While some rather more Hellenistic images of Augustus were in fact created in the early part of his sole reign, all the evidence points toward a course of development linking these earlier, classicist likenesses to the final, more or less definitive image: sober, realistic, yet strongly Hellenic, and best known from the full-length military statue from Prima Porta (Figure 96). [77] While it can no longer be accepted that this particular statue was the initiator of the type, neither can it be granted that all the examples represent a posthumous deification. [78] If nothing else, there are simply too many extant copies to be accounted for in this way. The Prima Porta statue evidently was made for Livia and quite possibly was made after Augustus' death; but it must reproduce a type established during the prime of his life. [79] The decoration of the cuirass makes it all but absolutely certain that the model was made as a consequence of the bloodless victory over the Parthians celebrated in 20 B.C., although it is arguable that the portrait image might have

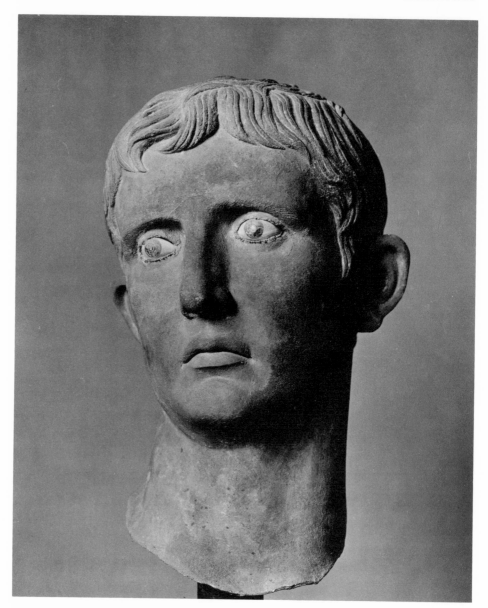

FIGURE 95 Augustus was the first Roman to be served by portraitists capable of reconciling success-
fully the native Italic demand for literal portrayal with the desire, learned from the Greeks, for
visual depiction of the glory inherent in world dominion. This bronze head was found in Meroë, in
Egypt—an example of the images distributed throughout the provinces of the new empire as con-
crete demonstration of the ruling power.
The British Museum

FIGURE 96 The most widely known portrait of Augustus is the statue in military dress found in the ruins of Livia's villa at Prima Porta. Probably based on a type created at the height of his maturity, this image most successfully represents the nature of the new world rule established by this remarkable personality, in terms of a strongly classicizing artistic conception.
Vatican Museum

FIGURE 97 Tiberius, son of Livia, heir and son-in-law of Augustus, was portrayed according to many of the same conventions as his predecessor. If anything, his portraits are even more strongly Hellenized than those made during the first generation of imperial power.
Vatican Museum

been initiated still earlier, some time after the conferring of power in 27 B.C. Beyond this, we cannot be precise.

As this portrait and its many derivatives make clear, Augustus had finally turned his back on Hellenistic concepts of representation, just as he had rejected their concepts of rulership. Instead, he reconciled Roman traditions of oligarchy to his new concentration of personal power in a unique political structure which

it is possible to see reflected in his portraits, fusing as they do Roman verism with Greek idealism in a way which, in the event, proved inimitable: "Dans toute l'histoire mondiale de l'art, aucune représentation de souverain ne possède un équilibre plus fin entre les éléments humains et idéologiques que le portrait d'Auguste." [80] For the three centuries that the state he established survived in its essential form, the ideologically related mode of representation also persisted; but in neither case could the exact state of balance achieved by Augustus be maintained.

So much is borne out by the art of the decades following Augustus' death. Although the style we recognize as "Julio-Claudian" was based on that established under Augustus, already with Tiberius the exact equilibrium begins to be lost. It would seem that the artists of this age, encouraged to develop a mode of absolute clarity of perception which could safely reveal the serene psychological assurance of an Augustus, found themselves unable to suppress what these same perceptions uncovered in the increasingly unstable personalities of his successors. In the finest of the portraits of Tiberius we see plainly the frigid, withdrawn temperament at whose urging the emperor gradually isolated himself from normal human contact (Figures 97 and 98).[81] When it comes to Caligula, the portraits

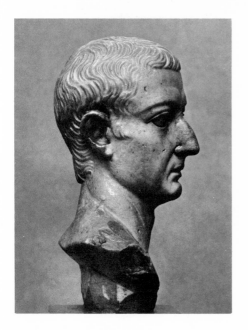 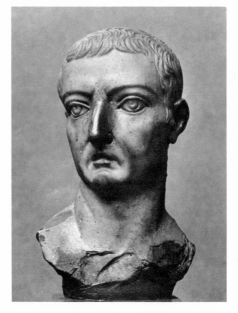

FIGURE 98 Much of the force of characterization to be found in full-scale imperial likenesses is conveyed even in this miniature faïence portrait of Tiberius, undoubtedly a product of Egyptian workshops.

Paris, Bibliothèque Nationale

FIGURE 99 The posthumous portraits of the deified Claudius demonstrate clearly the growing difficulty faced by court artists in reconciling the growing taste for Hellenistic heroization with traditional Roman values. Only at rare moments, as in the portraiture of Augustus, could the balance be maintained; as time went on, there was an ever present danger of toppling over into absurdity.
Vatican Museum

FIGURE 100 Found in Greece and undoubtedly made there, this bronze portrait head combines
force of expression with lack of finished execution to a degree remarkable in Roman art. Its com-
bination of classic (more or less Lysippan) and Roman traits indicate that it must have been created
in the Augustan period, while the bit of military costume at the shoulder suggests that a member
of the imperial family must be the subject. Once identified with Augustus himself, comparison with
other representations confirms that it is most probably of Lucius Domitius Ahenobarbus, son-in-
law of Augustus' sister Octavia, and grandfather of Nero.
Copenhagen, Ny Carlsberg Glyptotek

tell us all we need to know of the light of madness kindling under the youthful, handsome brow;[82] but the case of Claudius is especially poignant, for the image is sympathetic and yet utterly revelatory of the weaknesses which made this intelligent man so inadequate in the role of world-ruler (Figure 99).

It is quite evident that, although the Augustan classicist style dominated court portraiture during these reigns (cf. Figure 100, as well as the ladies'

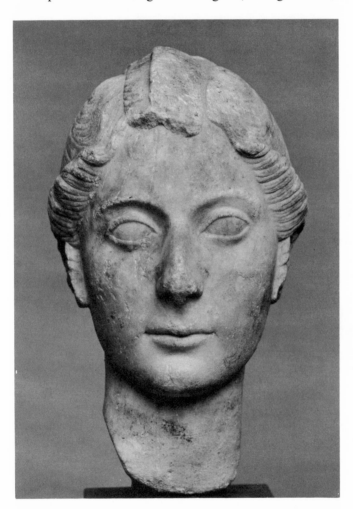

FIGURE 101 A strong family resemblance, emphasized by the classicizing artistic style sponsored by the dynasty, links members of the Augustan house and gives rise to many problems of identification. This is most probably a portrait of Julia, spoiled only child of Augustus (not by Livia), who became the wife of Tiberius but ended her days in exile.

Copenhagen, Ny Carlsberg Glyptotek

portraits, Figures 101 and 102) and hence had a wide popularity among the general public (Figure 103), it could not totally supplant older traditions. The veristic mode survived in its most uncompromising form in the service of the middle class,[83] while the Hellenistic manner was ever ready to be summoned up whenever the desire arose to present ideas of a more grandiloquent nature than those comprehended by the Augustan theory of style. It was this Hellenistic manner, in almost pervertedly overblown form, which was revived at the behest of Nero, the first emperor to attempt to transcend the limitations set on the imperium by Augustus.

In the portraiture of Nero we can see the re-emergence of this style, step by step. The earliest portraits are based on the Claudian manner but already betray

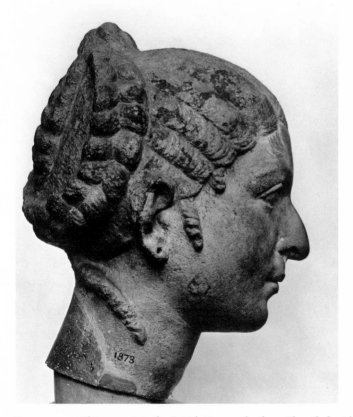

FIGURE 102 This portrait in the British Museum has been identified with Cleopatra, but this is unlikely on numerous counts. The strong resemblance to the preceding head in Copenhagen suggests that this in fact may be another portrait of the notorious Julia.
The British Museum

some traits in the coiffure and the angle of the neck that look to the heritage of
Alexander more than Augustus (Figure 104); only about 64 A.D., at the time of the
great fire at Rome, does his "late" personality emerge in bloated images that
lead to the absolute gigantism recorded by Pliny.[84]

If portraiture under Nero swung to a far extreme of Hellenistic idealization,
it is not surprising that a period of extreme uncertainty followed his fall, in which
artists, deprived of any sure ideological framework for their rapidly changing

FIGURE 103 The Hellenizing style of the Augustan house proved popular enough to be emulated in
portraits of private individuals; this marble head stands out in contrast to the more typical verism
which survived in much ordinary portraiture as late as the middle of the first century A.D.
The Art Institute of Chicago

FIGURE 104 The likeness of Nero did not at first depart noticeably from the general mode of those of earlier members of his family, but, like his career, it leaned increasingly heavily toward Hellenic influences and ideals, however distorted. In this comparatively youthful portrait—perhaps showing him as Caesar, before he became emperor—a clue to the future may lie in the massing of hair over the broad Claudian brow. Such emphasis was apt to have less to do with the facts of nature than with the emulation of certain Hellenistic forms of idealization.

Worcester Art Museum

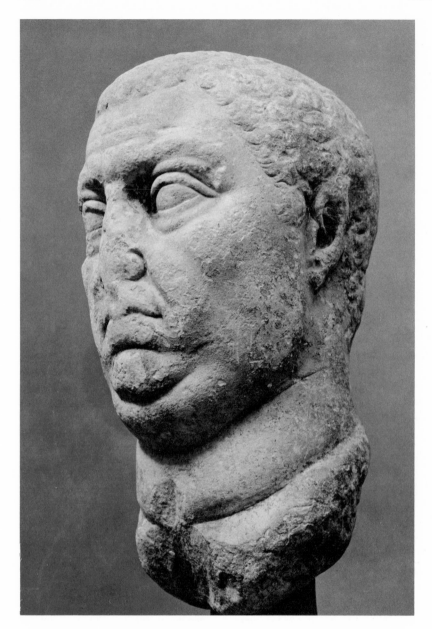

FIGURE 105 The complete, if temporary, disruption of the Roman state which followed the fall of
Nero is graphically illustrated by this monstrous colossal portrait of Vitellius, one of the contenders
for the imperium in 69 A.D. The break with Nero's burgeoning Hellenism had cut the artist free of
any conceptual roots whatsoever. The result is seen in this quite unprecedented example of ex-
pressionist portraiture.

Copenhagen, Ny Carlsberg Glyptotek

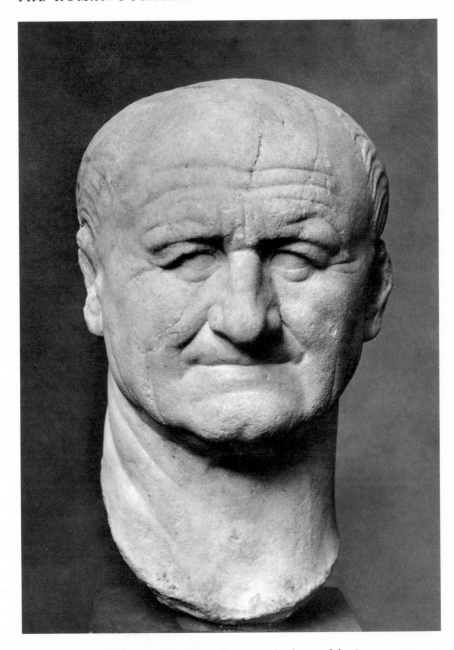

FIGURE 106 Establishment of the Flavian dynasty on the throne of the Caesars was accompanied by
an effort at court to suggest a return to the sobriety and dignity of the republic. This effort is reflected
in the modified verism of portraits like this of Vespasian, but the stylistic clock could not in reality
be turned back so far: the power of the imperium must be expressed.
Copenhagen, Ny Carlsberg Glyptotek

rulers, could reach a state of what may well be termed expressionism (Figure 105).[85] It is equally understandable that the return of stability under the Flavians saw a reversion to a more literal style of representation that obviously drew upon the "Latin" tradition for its models (Figure 106). A certain tendency toward idealization was always present and became especially evident under Domitian; in any case a "bourgeois" society is far from immune to the appeal of glamour (Figure 107). But an anti-Hellenic bias may be considered the dominant character-

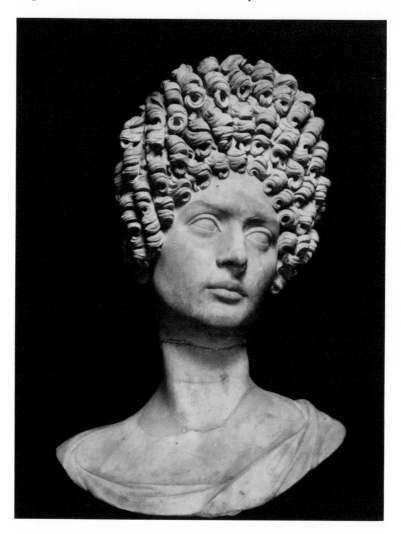

FIGURE 107 Luxury and ostentation did not disappear with the death of Nero; on the contrary, the Flavian era became a time of increasing richness and delicacy in the arts, as is suggested by this striking portrait of a lady, made about 90 A.D.
Rome, Museo Capitolino

istic of imperial portraiture for the remainder of the century. Its irreconcilability with Hellenism is exemplified by the statues of the deified Nerva, which show the same ludicrous incompatibility of head and torso already found with Claudius, pushed to a more extreme degree. Finally, Trajan, at the beginning of the second century, deliberately returned to a revival of Augustan types as well as styles in his official art.

In a sense, however, it must be recognized that, even in its lapses, all Roman imperial portraiture reflects the standards established by Augustus, just as the political framework of the Roman state must always be measured against the Augustan solution.

The story of the formulation and establishment of the "true" portrait in Rome is, then, one of Greek artists meeting an essentially Roman requirement. The literalism demanded by the Roman patrons was something new for Greek artists to master, but they were able to evolve an art form which not only satisfied their clients but has survived as a significant force in the European artistic heritage. The Romans transformed Greek art into something quite their own, just as they took Greek philosophy and founded new schools on its doctrines. The pragmatism which led Lucretius to reject Stoicism because of its genuflection to religious traditionalism is paralleled by that which led Augustus to reject the final stage of monarchic deification, in its Hellenistic form, both politically and artistically, in favor of a less codified, but more workable, state, and a psychologically convincing form of portraiture.

Roman portraiture, therefore, although it is unique and truly native, can be seen in terms of a continuous series of reactions to Greek influence. In the second century B.C., so far as our present information extends, portraits of Romans other than mere *imagines* for the family shrines were made by Greek artists in a wholly Hellenistic style. When these artists were acclimated to Rome, around the time that portraits were also authorized on the official coinage—that is to say, just prior to 100 B.C.—there begins to appear a spectrum of approaches to the portrait, from the strongly idealized Hellenic forms to the literal and veristic ones we think of as peculiarly Roman. The last decades of the republic give evidence of a continuing interaction between these two poles, with many political leaders favoring idealization, while the man-in-the-street preferred a more veristic imagery. Finally, under Caesar and then Octavian, a type of ruler portrait was evolved which went behind Hellenistic revivalist forms to a more authentic classicism, arriving at an enormously impressive portrayal of earthly majesty in terms of physical strength and psychological force.

This was a part of the legacy which Augustus left, together with the empire he had created, to his unequal successors.

Chapter V ✦ Late

Antique Portraiture

ALL AGES ARE CRITICAL ONES; yet, even with this understood, there are few periods in the history of man more significant, more seminal—and more obscure—than the third century of our era. It would have been a time of trouble for the Roman state even without the concurrent explosion of barbarian tribes out of Asia into Europe, which forced the contraction of the imperial boundaries, then breached them with settlements of tribesmen who lived within and owed putative allegiance to the empire itself. The inherent instability of the imperial system, which lacked even a single constitutional form for the selection of a new ruler, would have brought increasing internal stresses in any case, but when this was coupled with the heavy exterior pressures, near chaos was unavoidable.

Against the traditional emphasis on the disastrous side of the period—civil war, invasion, famine, pestilence, all combining to bring about a catastrophic population decrease—there has been a recent tendency to stress its positive aspects. After all, the empire did survive, and so did the culture it supported; the concept of the Roman empire, and the traditional Greco-Roman civilization, formed the basis of medieval European assumptions and aspirations, as they continue to influence the age we call modern. If the Augustan principate becomes unrecognizable in the third century, the forms into which it was transmuted by a

series of rulers, the last of whom was Constantine, are those employed not only by the Byzantines in Constantinople but by western European rulers from Charlemagne to Napoleon. If the military organizations of the great soldier-emperors like Augustus and Trajan were inadequate to cope with the new invasions, the reorganized Roman army formed the basis of medieval military systems. In all categories of life, from agriculture to urban trade to religious belief, this century seems the greatest watershed between the ancient world and the one which, for better or worse, succeeded it.

Other periods are marked by more specific and clear-cut events. The term put to Roman territorial expansion by Hadrian precedes our era; the recognition of Christianity by Constantine follows it. The third century is less well documented, in terms of the sort of information we would like to possess, than almost any in Greco-Roman history. The reason we can assume so much about its significance, of course, lies in the inferential fact that the situation in the empire is so different around 300 A.D., when the curtain lifts, than it had been a century earlier, at its fall.

The Portraiture of Gallienus

The pivotal position of the reign of Gallienus in the development of later imperial culture has long been recognized; it has even been possible to justify the term "Renaissance" as applied to its various manifestations—the first moment at which such a concept can legitimately be discerned in postclassical times.[1] Gallienus, who was coruler with his father, Valerian (Figures 108 and 109),[2] from 253 until Valerian's grisly death at the hands of the Parthians in 260 A.D., held the throne as sole ruler for eight more years before his own fall. Difficult as were the trials of these fifteen years, they looked like an oasis of tranquillity when viewed from the anarchy of the later third century.

There is no question that, like most of his predecessors, Gallienus consciously used art as a political instrument. In his case, a deliberate classicism was based on the model of Augustus, while the empress Salonina emulated Livia.[3] Many of the legends of Gallienus' coins and medallions were taken from Augustan numismatic series: Pudicitia and Fecunditas for Salonina, Principi Iuventutis for their son Saloninus, Virtus Augusti for himself.[4] Still another significant element appears in the last-named issue: the emperor is portrayed as a protégé of Hercules, whose endurance and prowess at overcoming difficult tests of strength served as an obvious allegory of the imposing tasks presented to the imperial authority in the middle of the third century. Hercules had been a favored patron in Antonine

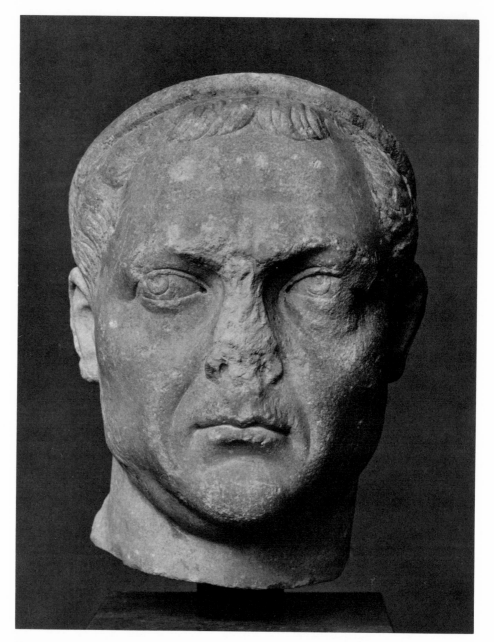

FIGURE 108 A recently discovered pair of portraits of more than life size represents the Emperor
Valerian and his son and coruler Gallienus. Valerian wears the fillet, a simple band of cloth over the
head, which was a familiar emblem of the imperium, particularly in eastern parts of the empire.
This is in accord with the probable origin of the portraits in Asia Minor.

Copenhagen, Ny Carlsberg Glyptotek

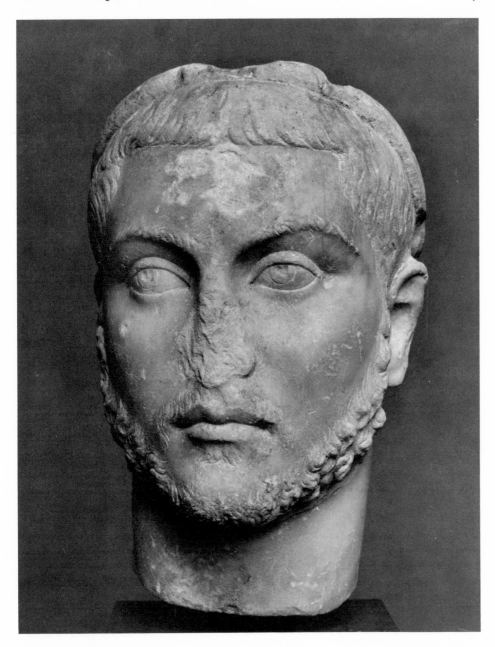

FIGURE 109 The fillet worn by the youthful Emperor Gallienus is drilled with seven holes which probably held rays—an allusion to the increasingly popular cult of the sun-god. The apparent ages of the subjects and the chronology of their joint reign suggest that the portraits were made to commemorate their (ephemeral) victory over the Germans in 255 and 256.

Copenhagen, Ny Carlsberg Glyptotek

times a century earlier, in the reigns of Commodus and Caracalla (Figure 117);
he was to be canonized as an imperial ancestor half a century later, with the
Herculean Dynasty of Diocletian's tetrarchal system. Thus the adventuresome
iconography of Gallienus' coins casts light both backward and forward over the
gulfs of upheaval that marked the great century of trial of the Roman state.[5]

One of the most intriguing details we learn from Porphyry's biography of the
philosopher Plotinus is that the founder of Neo-Platonism was known to and
honored by Gallienus and Salonina—although the project of creating a City of
Philosophers called Platonopolis in Campania came to naught.[6] This may be no
more than a snobbish trifle, but even so it has significance in offering one of the
few specific clues linking political figures with leaders of intellectual life in any
age.

Plotinus' devotion to the name of Plato took clearer form than that of wishing
to name a city after the master; his was in fact the first intellectual system to
develop a strong new superstructure on the Platonic foundation, and as such it
became the basis for most serious speculative thought, not only in later antiquity
but through the first half of the Middle Ages.

Reality, for Plotinus the Egyptian, lay entirely in the supreme unity, the
One, the Infinite—The Good—without attribute and beyond intellection, being,
or sensation. It is the final unified Form of the Platonic Ideas, here made into the
source and origin of all creation, the center from which emanates creativity out
and downward to the world of the senses. In this view, however, the fact that life
did derive from the One and flowed back to it carried the implication that created
things did share some of the divinity and goodness of that One. It may seem an
inconsistency that for Plotinus an appreciation of the visible world can go side by
side with a rejection of its matter but the inconsistency is superficial.

In contrast to [the Gnostics, Plotinus] makes the most of the beauty of the world,
of Providence, and to such an extent that one wonders how his praise, which seems
to be made without any reservation, is compatible with his description of the world as the
land of exile and the habitation of evil. This double appraisal brings out clearly the state of
tension to which the image of the sensible world gives rise in Plotinus. The admiration for
its beauty arises from the fact that we see in it the intelligible beings whose radiation has
produced it. The disparagement of the world, on the contrary, arises because, in referring
these beings to the intelligible world of which they are members, Plotinus considers only
the equivocal and incomplete way in which this radiation has been received and the
ugliness of matter which has obscured its brilliance.[7]

Plotinus' system is carefully organized according to a rational, even an
aesthetically apprehensible, form: Nature is ranged in a hierarchy of spheres

emanating from the One, the Prime Mover. From Being itself emanates Mind or *nous*, the realm of Forms, beyond which lies the objective world of the senses. *Nous* differs from the One in that it is accessible to the human mind; it is linked to the soul which bridges the gap between ideal Form and the world of sense; unlike *nous*, soul is divisible and in its penetration of the material world is like the link that gives form to the incoherent matter of the cosmos. Insofar as soul penetrates and informs matter, then, divinity is working within the world of sense; but as soul emanates farther and farther from its Source, the benefits diminish, and finally nothing remains but brute matter.

In this metaphysic is rooted the ethic which Plotinus expounded, in which the sole way in which man could improve himself was by ignoring the world of the senses and devoting himself to that of the spirit. "The anthropocentric and humanistic tendency of earlier ethics, even Plato's, which attempted to make possible man's well-being as a man, disappears in Plotinus' fear of the world's contagion. He attempts not a harmony of soul and body but a repudiation of body by soul." [8] At the same time, a Plotinian aesthetic developed which gave more value to the world of art than any previous idealist philosophy had allowed. Artistic creation was for Plotinus a paradigm of the working of soul within the world:

It is a principle with us that one who has attained to the vision of Intellectual Beauty and grasped the beauty of the Authentic Intellect will be able also to come to understand the Father and Transcendent of that Divine Being. It concerns us, then, to try to see and say, for ourselves and as far as such matters may be told, how the Beauty of the divine Intellect and of the Intellectual Cosmos may be revealed to contemplation.

Let us go to the realm of magnitudes: —suppose two blocks of stone lying side by side: one is unpatterned, quite untouched by art; the other has been minutely wrought by the craftsman's hands into some statue of god or man, a Grace or a Muse, or if a human being, not a portrait but a creation in which the sculptor's art has concentrated all loveliness. Now it must be seen that the stone thus brought under the artist's hand to the beauty of form is beautiful not as stone—for so the crude block would be as pleasant— but in virtue of the Form or Idea introduced by the art. This form is not in the material; it is in the designer before ever it enters the stone; and the artificer holds it not by his equipment of eyes and hands but by his participation in his art. The beauty, therefore, exists in a far higher state in the art; for it does not come over integrally into the work; that original beauty is not transferred; what comes over is a derivative and a minor: and even that shows itself upon the statue not integrally and with entire realization of intention but only in so far as it has subdued the resistance of the material.

Art, then, creating in the image of its own nature and content, and working by the Idea or Reason-Principle of the beautiful object it is to produce, must itself be beautiful in a far higher and purer degree since it is the seat and source of that beauty, indwelling

in the art, which must naturally be more complete than any comeliness of the external. In the degree in which the beauty is diffused by entering into matter, it is so much the weaker than that concentrated in unity; everything that reaches outwards is the less for it, strength less strong, heat less hot, every power less potent, and so beauty less beautiful.

Then again every prime cause must be, within itself, more powerful than its effect can be: the musical does not derive from an unmusical source but from music; and so the art exhibited in the material work derives from an art yet higher.

Still the arts are not to be slighted on the ground that they create by imitation of natural objects; for, to begin with, these natural objects are themselves imitations; then, we must recognize that they give no bare reproduction of the thing seen but go back to the Reason–Principles from which Nature itself derives, and, furthermore, that much of their work is all their own; they are holders of beauty and add where nature is lacking. Thus Pheidias wrought the Zeus upon no model among things of sense but by apprehending what form Zeus must take if he chose to become manifest to sight.[9]

Art, then, is removed by Plotinus from the low category to which Plato had relegated it in the hierarchy of ideas: Rather than being held down by the baseness of its material, it is elevated by the quality of the artist's genius which informs it.

[Art] is the transfer to matter of the conception of beauty on the part of the artist; in other words, the expression in a time-space medium of the recognition of the presence of the Ideal World in a time-space entity; or, in yet other words, the expression of the emotions of the sentient artist when, by virtue of his own continuity with the eternal, he recognizes the immanence of that eternal principle in some time-space entity. . . .

We have here, then, a certain imitation, a mimesis. But it is not the mimesis of Aristotle, where the work of art is a copy of a material entity. It is the mimesis of the immaterial Ideal World, of the *noeta*, in the soul of the artist. Aristotle says: "Since the objects of imitation are men in action, and these men must either be of a higher or a lower type, it follows that we must represent men either as better than in real life or as worse, or as they are" (*Poetics*, 1L). Art, according to Aristotle, is therefore the imitation of the good or the evil, and above all, it is the imitation of material or semi-material entities. For Plotinus it is the imitation of the immaterial and perfect Ideal World, in a material or semi-material medium. For Aristotle the work of art would be lower than the entity that it represents. I make a statue of Socrates. It is only an imitation of Socrates, and therefore less than Socrates. With Plotinus it is otherwise. The statue of Socrates is not an imitation of the time-space entity that is Socrates, but of the idea of Socrates, the *noeton* of the man, or in other words, of the manifestation of the Ideal World in the time-space entity Socrates. The work of art is therefore higher than the time-space entity. . . .

The Plotinian standpoint is that nature and art are equal in rank, because both are derived from the one source, namely God. The subject and the object of the perception of beauty are related by their common participation in the Ideal World, and it is by virtue of that kinship that the artist perceives beauty in the entities around him.[10]

Plotinus thus gives the artist a more important part to play than any contemplated by earlier philosophers. For him an image, though meaningless insofar as it

is a direct imitation of visual appearances, is of profound significance when it reveals the true essence which underlies those appearances. Thus there is a place even for the portrait as an intimation of the inner reality of the subject, but there is no place for the pure veristic likeness, which shows only the outer, meaningless shell. In a general way, art created under the sway of this mode of thought will ignore the requirements or demands of its material substance; the medium will determine very little of the quality of the art, just as the subject in its visual form will be merely the point of departure for the artist's creative process.

The aesthetics of Plotinus overturned completely the inherited classical definitions of formal beauty. Whereas the Greeks saw beauty expressed through proportionality, through numbers and measure (as in the Canon of Polyclitus), the Neo-Platonists, as we have seen, found beauty only in the inner illumination of the form, that is to say, in expression. As L'Orange has observed,[11] a comparable shift is noticeable in ethical doctrines, from the classical emphasis on harmony—due proportionality of soul and body—to the Neo-Platonist antithesis between those same elements, which led to asceticism, contemplation, and ecstasy rather than the social virtues.

Seen in this light, the portraiture of Gallienus takes on great interest, for a situation comparable to the one we observed in Greece of the fourth century B.C.—the creation of more than one portrait type of the same historical individual, delineating irreconcilable physical traits, produced in conformity with evolving concepts of the nature of the portrait itself—apparently recurs at this critical moment in the agony of classical civilization, for two physically irreconcilable likenesses of the same man, the emperor Gallienus, seem to have been produced.

The first type of portrait of this emperor (Figure 110) shows a young man, no more than in his thirties. The face is a lean oval, the head long, the hair quite short; in brief, it is an image closely modeled on that of Alexander Severus in both its high degree of a particular kind of detail and finish and its general concern with the conviction of visual realism.[12] The second type (Figure 111) shows an apparently older man, with a broad, fleshy, and powerful face, a squared, blocky head and skull, and heavy masses of hair with a quite noticeable beard.[13]

It has been the convention to equate these two types with the younger and then the mature Gallienus, before and after his assumption of sole rule in 260. It is true that, while the "youthful" type is generally similar to the profile depicted on coins issued jointly with Valerian, the "mature" type has numismatic parallels which can be found only on coins struck after Valerian's death.[14]

An examination of the portraits themselves, on the other hand, belies this easy assumption of an age differentiation from one type to the other. Just as in the

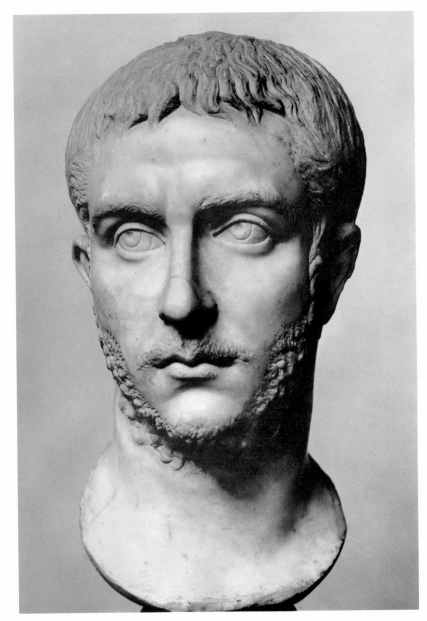

FIGURE 110 The portraiture of Gallienus falls into two radically distinct groups, of which the earlier
is exemplified here. So strongly "Augustan" is this head that it has sometimes been dated to the
much earlier reign of Alexander Severus; but comparison with coin types, and now the positive
evidence of the preceding pair of portraits, assures its identification with Gallienus and its dating
to the decade of the 250's.
Berlin, Altes Museum

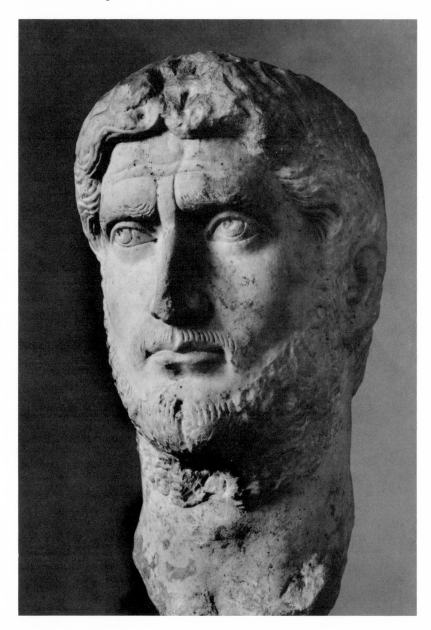

FIGURE 111 At about the time of Valerian's defeat and capture by the Persians in 259 (he died in captivity the next year) and Gallienus' assumption of sole rule, a new portrait type of the latter was introduced, so different from the earlier that the features and even the bone structure are incompatible. The source of the later image is unquestionably the Hellenistic tradition of ruler portraits, translated into the increasingly dematerialized stylistic conventions of the mid-third century. *Copenhagen, Ny Carlsberg Glyptotek*

earlier and later recensions of the portrait types of Socrates or Euripides, the physical forms cannot be reconciled as veristic representations of the same person, whatever the chronological distance. Questions of stylistic approach aside, the whole shape of the skull, the proportions of the brow, the width of the cheek-bones, the profile of the jaw, the shape of the mouth, and even the proportionate relation of neck to head are impossible to explain in the physical development of one and the same man. So great is the discrepancy between the two types that, just as in the study of different portrait types of Sophocles and Euripides, at least one scholar has sought to reject the "youthful" image entirely from the Gallienic iconography, declaring it to be merely the likeness of an anonymous contemporary, not the emperor himself.[15]

The coins disprove this thesis. The "Severan" portrait is quite similar to the profile employed on the issues of Gallienus' joint reign with Valerian. Although it is true that the "mature" portrait type appears only on coins of the sole reign, that is to say, after 260, and is employed on the great majority of obverses from that time forward in all parts of the empire, nevertheless this type does not wholly supplant the "youthful" one, which continues to occur sporadically down to the last year of Gallienus' reign. This survival is no local phenomenon in terms of either style or geography, for the type appears at widely separated mints,[16] and the same mint is found to issue coins bearing both portrait types more or less simultaneously.[17] Thus it appears to be incontrovertible that, during the sole reign of Gallienus, two physically irreconcilable likenesses of the emperor were employed by the imperial authorities themselves.

A full explanation of this situation is probably beyond our reach. As Mathew wrote, "Any attempt to determine the character of the Gallienic renaissance can be only the construction of a hypothesis."[18] Nevertheless, certain points are clear. The "youthful" portrait was deliberately based on the image of Alexander Severus, as we have seen. But the "mature" type is derived ultimately from the portraiture of another Alexander—Alexander the Great; and it is derived, not from the portraits created during Alexander's lifetime, but from the apotheosized images of the Hellenistic era, the portrayals of the divinely inspired ruler which formed one of the most significant artistic legacies passed on by the Greeks to Rome (Figure 112).[19]

At the same time, there is no question that the type of apotheosized portrait which was created for Gallienus—in his lifetime, as the coins prove—is a totally new development in Roman imperial art. Earlier Roman representations of this sort of apotheosis portray the emperor transfigured into a specific patron god, e.g., Claudius-Jupiter, Antoninus-Serapis, or Commodus-Hercules. Gallienus, on the other hand, appears even in apotheosis—as far as it is possible to

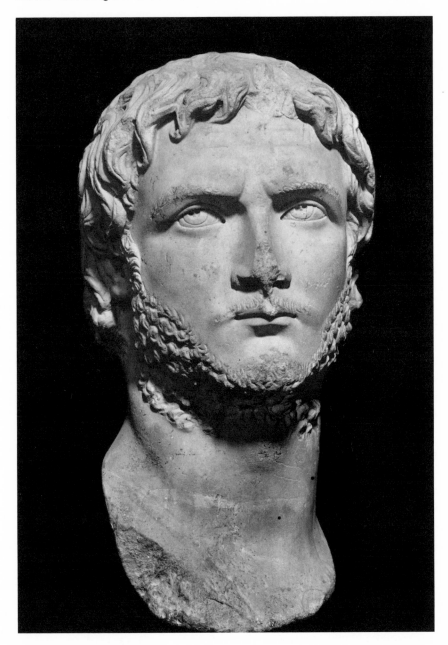

FIGURE 112 A trait of the later imagery of Gallienus, evident in some of the coin types as well as in portraits such as this, is the upturned gaze, which suggests the ruler's communication with divine powers. This had been an aspect of the portrayal of the "divine ruler" since its introduction by Alexander the Great six centuries earlier.

Rome, Museo Nazionale

determine—as no one other than himself, although he is indeed transmuted into a different, more divine form than that which he bore as a man among men.

It may be more than mere coincidence that this creation of an image of "living apotheosis" occurred in the same generation as the call of Plotinus for the portrayal of the spirit rather than the body in order to show the "true" nature of the man depicted. Gallienus' artistic innovation was assuredly not a conscious attempt to translate a philosophical concept into visual terms; yet it does in some way represent a response to the Plotinian emphasis on the antithetical relation of body and spirit. If Gallienus' second portrait type can be understood as an attempt to portray this antithesis in visual form, in an age which was prepared to accept this rather than the veristic masks of the republic as the most appropriate representation, we may have obtained some small new insight into the ideation of an obscure and critical period in Roman history and of a seminal intellectual and artistic generation.

Imperial Portraiture in the Second Century

To base a discussion of Roman portraiture exclusively on the imperial likenesses is to take a very limiting viewpoint. In many ways, these images were of an extraordinary character in relation to portraits of normal citizens of the Roman state. The study of portraits of ordinary Roman individuals offers a special attraction, that of quality, for these likenesses are almost always unique "originals," whereas virtually all surviving portraits of members of the imperial family are copies, reproduced more or less mechanically for either official or private distribution. It is the private "originals" which offer us our best glimpses of the capabilities of the portraitists of the empire, who are too easily condemned as hacks on the evidence of the surviving copies.

The study of these series of copies of imperial portraits has attracted much attention in recent years. The possibility of dating these copies, quite apart from their originals, offers some insights into Roman political history. Still more intriguing is the question of just how copies were distributed throughout the empire for display: Were full-scale sculptures shipped from Rome, or merely sketches or models? Undoubtedly a combination of methods was used, for though the general iconography of the imperial likeness was quite carefully controlled, in at least some important reigns considerable regional variations in style were permitted.

Thus, whatever the attractions of private portraiture, its study must remain ancillary to that of the imperial imagery. Chief among the causes of our dependence

upon the latter is the fact that they are fairly closely datable to a point of origin in time, posthumous honors being, ordinarily, quite easily identified.[20] Again, so far as responsibility for prototypes is concerned, there is little doubt that nearly all the best artists were employed on imperial commissions of one sort or another, especially in Rome,[21] so that even as copies the works produced represent the best average of current craftmanship. It would also appear that, as far as we can tell, innovations in both style and conceptualization tend to be picked up rapidly by the official workshops, filtering thence in a gradual way to other studios. In short, our best means of dating the portraits of the imperial period, and hence of establishing a general chronology of technique, style, and form, is through the criteria established through examination of the portraits of the emperors.

By this means, for example, a major technical innovation in sculpture can be dated safely to the first part of the second century A.D., during the reign of Hadrian: the beginning of the practice of marking the outline of the pupil of the eye on the surface of the eyeball, which had hitherto been left completely unmarked.[22] By this one criterion we have a significant test for the date, not just of portraits, but of all types of sculpture; it is particularly invaluable in dating copies of earlier works, which, as it happens, were just then being duplicated in even greater quantity than ever before.

This innovation is not a mere technological device, however; it is part of a far more general change in artistic practices, representing a major aesthetic shift in Greco-Roman art. The reason that the eye had never been carved in detail on marble sculpture before this time is of course that such features, including hair, clothing, and attributes, had always been painted over the surface of the stone; they can still be seen on occasional well-preserved specimens. In the second century, for the first time, this use of applied color came to be replaced by a reliance on the pictorial effects which could be achieved solely by the sculptor's proper tools—the chisel, file, burin, and, above all, the drill.

The drill had always been a useful tool for working stone, but earlier generations had largely confined its employment to preliminary rough cutting; all obvious traces of its use were eliminated by abrasion on all surfaces which would be apt to meet the spectator's eye. Now the drill, on the other hand, began to be used to gouge out deep holes, to create pockets of black shadow in contrast to the stone's surface sheen—a pictorial effect obtained solely through the untreated stone, not through the application of paint or gilt over the surface, although such decoration could, of course, still be applied if desired.

Although this use of the drill had begun to become obvious in works of the "Flavian Baroque" (Figure 107), the new technique in its fully developed form seems to have been the specialty of a particular school of sculptors, those from

Aphrodisias in Caria, Asia Minor, who appear to have been especially patronized by Hadrian;[23] but such an explanation tells only how, not why, the aesthetic change took place. The difference of approach in the new technique is profound. In the tactile realism of republican and early imperial art, the chisel and file seek to create surfaces as similar in appearance to that of the subject as is physically possible. The new form is one of wholly visual realism, in which the drill marks out the effects of light and shadow without concern for similitude of surface as such. The latter approach is often termed "impressionism," and the usage is not wholly inappropriate. Like the paintings of the nineteenth-century school of that name, these works should be viewed, not from too close a point, but from a suitable distance, at which the optical effect is not only convincing but is unmatched in vividness by the meticulous attention to detail of either first-century sculptors or earlier nineteenth-century painters. The realism achieved is of a new order, but it is realism none the less.

Whatever the specific source of the new aesthetic, it would appear that the introduction of the new technique is but one aspect of the new and stronger Hellenism which is a major feature of the second century. It is quite possible that the revered, but by now heavily weathered, masterpieces of classic Greek architectural sculpture, having lost the brilliance of their original coloring, themselves revealed to the patrons and artists of the Hadrianic age the possibilities of a purely tectonic approach to pictorial effect, hitherto visible only in the sculptor's workshop before the coloring was applied.

The Hellenism of this period cannot, in any event, be casually dismissed as a mere sterile *détente*; even this single technical innovation is far too significant to be regarded as an accidental offshoot of an uncreative era. Hadrian cannot be credited with responsibility for all the manifold changes in the life of his time, but the fact remains that this was an age of change in virtually every aspect of politics as well as culture. The renunciation of further geographical expansion, for example, taken at the emperor's own initiative, marks an epochal shift in imperial policy which, however reasonable, can yet be taken as a sign of the beginning of the ossification of the Roman state. Culturally, Hadrian's version of philo-Hellenism was far more extreme than that of any of his predecessors in its enthusiasm for things Greek; as such, it had an even more forceful impact on future developments than earlier waves had had.

We have already noted that in the first century the adoption of Hellenistic manners and artistic models tends to be a symptom of an effort by an aggressive emperor to achieve total domination of the machinery of the state. This is true under Caligula, under Nero, or under Domitian. In the intervening periods, when, although one can scarcely refer to senatorial ascendancy, a certain rapprochement with the oligarchy was in evidence, a more "republican" flavor of

homely verism is discernible in the imperial likenesses. The portraiture of Vespasian and Titus, and then of Nerva, has traits of this verism when compared with that of the Hellenizing emperors. The same tendency can be traced through other types of official monuments and reliefs under the same rulers.[24]

After the turn of the second century this pattern disappears. To a certain extent Trajan seems to conform to the "republican" standard, yet there is little evidence of Flavian verism or even the unresolved dichotomy of styles which makes the official portraiture of Nerva as inconsistent in spirit as that of Claudius. As Hanfmann has observed,

> A new concept of personality begins in the time of Trajan and Hadrian; long ago, F. Leo in one of his brilliant *obiter dicta* noted that a fundamental break in the representation of historical personalities occurred at this point. In the sculptured portraits of Trajan, the typical postulates of Imperial dignity and of virile, heroic virtue begin to gain ascendance over specific elements of individuality. As in the Augustan Age, the possibility of conflict and weakness is denied.[25]

The key to Trajan's official art, of course, is this neo-Augustanism, a conscious evocation of the art of the principate whose most concrete proof is the direct imitation of the "Prima Porta" Augustus statue type in an image of Trajan as *triumphator*.

If Trajan employed the artistic legacy of Augustus as one aspect of a general effort to base his reinvigorated imperial policy on that of the empire's founder, it was Augustus himself who had, as we have seen, found his artistic precedents in Greece of the classical period. It was to this phase of the Greco-Roman cultural heritage that Hadrian turned directly, by personal inclination as well as calculated policy, when he modified Trajan's still dynamic program into one limited to maintenance of the status quo.

Supposedly just because of a bad complexion, the Spanish-born emperor introduced a new monarchic image into Roman art. For the first time, the emperor was bearded (Figure 113). The fashion thus set lasted through the century and was of course imitated widely in the court and among the general populace. The image of Hadrian, however, differs in more than just its *chevelure* from that of his predecessors; it is more strongly Greek in character than the likenesses of even the most ambitious of the first-century Hellenizers. But instead of deriving his concept from that of the Hellenistic monarchies, Hadrian turned to the images of the wise men whose legacy was more and more the basis of Roman thought. His portrait thus belongs to the list of philosopher types. For this very reason it lacks the dynamism of the earlier Hellenized emperor portraits or even the images of the Augustan or republican traditions; the subject is portrayed in introspection, musing on his *animula vagula*, rather than projecting the force of his personality toward the outer world.[26]

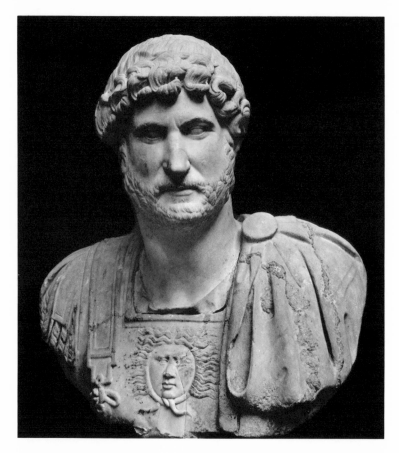

FIGURE 113 The Emperor Hadrian, Spanish-born Hellenophile and patron of the arts, is portrayed in a variety of roles, not least important of which is that of *imperator*, military commander. Although sculptors began during his reign to use the drill to indicate the pupil of the eye—obviating the use of color or inlay—this portrait shows the untooled surface typical of earlier sculptural technique. *Rome, Museo Nazionale*

Particularly when it is comparatively unfamiliar, the beard is a sort of common denominator, an instrument for imposing uniformity on varied countenances. This is why it makes such a useful disguise, since individual traits or features are less apparent than the general resemblance of one beard of similar cut to another. Thus, almost automatically, Hadrian's new ruler image appears as a more generalized type than the likenesses of his predecessors (Figure 114). In time the beard might be employed as subtly for purposes of characterization as any other personal attribute, but for the second century it was, by and large, a means of standardization of types.

As a complement to the mature, bearded philosopher-emperor, the Hadrianic reign had another widely distributed cult image. If Antinous had not existed, it would no doubt have been necessary to invent him; in point of fact, it is possible to argue that he was an invention of Hadrian's rather than a real human being in his own right. The vast quantity of portraits distributed by the sorrowing emperor to all parts of his realm show nothing of the living, breathing youth who existed on earth; he is a glamourized ephebe, a sensuous youth-figure embodying the emperor's ideals, not the individual living vehicle of those ideals (Figure 115). It may be said that Antinous could have looked just like this and that the portraits are in fact excellent likenesses; there is no denying that an immature stripling, cushioned from all the stresses of life by the imperial infatuation (all stresses but one—the sense of uselessness), could easily have been as emptily handsome, with a body as unmarked and a face as void of any trace of emotion or character. But this is only to admit the obvious—that life does on occasion imitate art. Antinous may have been a work of art even before his death; but the portraits we have of him are merely exemplars of Hadrianic classicism, and their uniform dullness has had a great deal to do with the exaggerated denigration so commonly visited on all the art of the era.

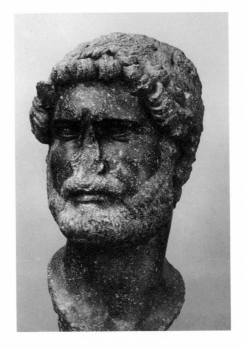

FIGURE 114 This recently discovered portrait of Hadrian, executed in the imperial stone, porphyry, is considerably more idealized in its handling of the features of the emperor than the preceding work (Figure 113). This simplicity is at least partially a result of the extreme hardness of the stone, which only Egyptian sculptors had the knowledge and patience to work. A head like this one would be set into a torso or bust made of stone of another color, to obtain an extreme richness of effect through the materials themselves rather than from any superimposed decoration.
The British Museum

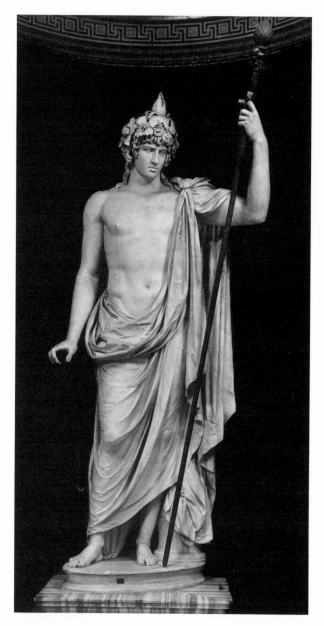

FIGURE 115 Portrayals of Hadrian's adored Antinous never show the youth as himself, but always apotheosized. In the present instance he appears as Dionysus. Thus these portraits represent a high point of Hadrianic idealization—which is not to insist that they might not have been excellent likenesses. The youth himself would seem to have approached a perfection of form approximating the actual Hellenic ideal of physical beauty—a case of nature imitating art.
Vatican Museum, Sala Rotonda

The image of the philosopher-emperor was adopted by Hadrian's successors, Antoninus Pius and Marcus Aurelius, just as they accepted the responsibility of trying to be philosophers as well as rulers (Figure 116). So standardized are their portraits that, in less successful examples, identification can be difficult to establish. As time went by, the technical changes of the pre-Antonine period were pushed to a further extreme. The drill was employed more and more obviously, until the whole coiffure became a mass of ringlets centered on deeply shadowed hollows. The process of idealization also continued, with abstract representations of the imperial myths being employed with less and less reserve. Many comparisons of earlier works with those of the Antonine period bear out the picture of a gradual shift toward a more rigid and static mode of expression in the course of the second century. The differences between the reliefs of the Column of Trajan, for example, and those of Marcus Aurelius are largely concerned with a change from almost direct reportage to a formal, almost schematic exposition of propaganda themes. It is also noticeable on Antonine reliefs reused on the Arch of Constantine that the artists have employed two devices normally associated with art of a much later period: the major figures are portrayed almost completely frontally rather than in profile, as was invariable on the Flavian and Hadrianic reliefs of similar subjects, and ways are found to make the emperor considerably larger in scale than any of the other participants in a scene—although the scale change is partially concealed because he is shown seated.[27]

The portraits of the later Antonines and their successors show a new dichotomy in the use of sources. Whereas Lucius Verus continues the philosopher tradition of his father's portraits in form as in style, Commodus reverts to Julio-Claudian concepts—but not style. He turns back to the Hellenistic ruler images once more, finding the ideal he sought in the portraits assimilated to Hercules, on a model initiated by Alexander the Great, but now reduced almost to parody (Figure 117).[28]

The new Severan house, on the other hand, did not wish to make any conscious break with the earlier Antonine tradition. Septimius Severus plainly based his own portraits on those of Marcus Aurelius. On the other hand, the introspective serenity once valued by the reflective rulers of mid-century could no longer be recaptured; an air of suppressed violence underlies the elaborate surfaces of the likenesses of Septimius, expressing itself at first only in the serpentine writhings of the curls of his hair and beard, so unlike the tranquil ringlets of Marcus Aurelius. With Caracalla all this violence comes to the surface, in an imagery that, once more, looks backwards to that of Alexander the Great. The storm and stress of the third century are prefigured at its outset in the art of the Severans, who sowed so many of the seeds of coming conflict.

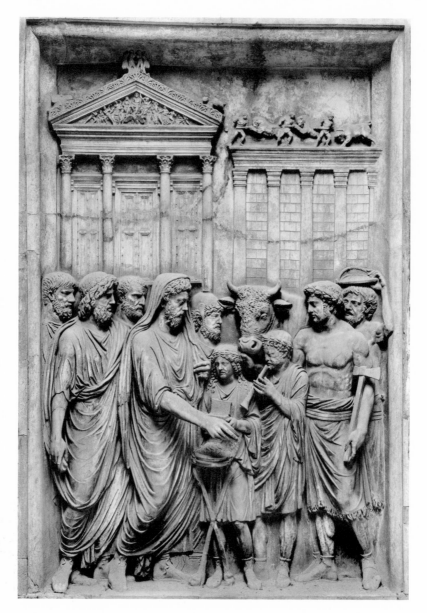

FIGURE 116 Marcus Aurelius is portrayed in the act of sacrifice, in his official role of *pontifex maximus*. Most of the other figures in the relief appear to be officiants and attendants at the actual ceremony, but the full-length bearded figure immediately behind the emperor is probably a god. The relief shows not a photographic record of a historical event but its symbolic significance in concrete terms. Technically the relief illustrates the growing tendency of sculptors to leave evidence of their use of the drill on the surface of the work, to obtain more vivid effects of light and shade.
Rome, Museo Capitolino

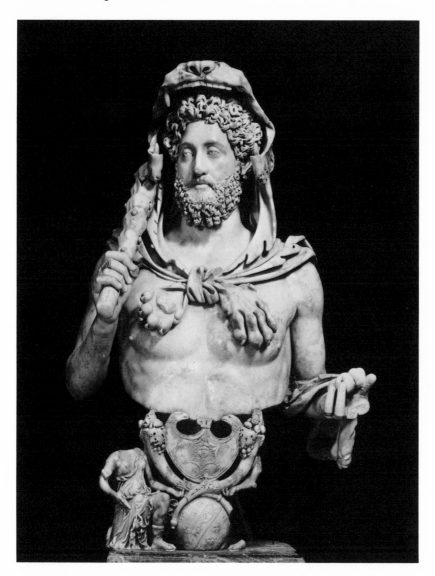

FIGURE 117 Commodus, son and heir of Marcus Aurelius, lacked not only his father's philosophical turn of mind but also his good taste. Pleased to be identified with Hercules, he would battle in the arena to display his physical prowess. His portraits demonstrate the culmination of the "baroque" tendencies evident in second-century sculpture which had been encouraged by new techniques of drilling and undercutting the stone. Even in a bronze prototype, a bust like this would appear bizarre and unstable in the extreme.

Rome, Museo Capitolino

Imperial Portraiture in the Third Century

In the violent decades that followed the whimpering fall of the Severan dynasty in 235, there are many signs that the character of imperial portraiture once more followed the swings in political orientation of the emperors themselves. We see a reign-by-reign alternation of stylistic approaches not unlike that which came into effect in the first century of the empire. As Mathew put it,

> The co-existence of distinct cultural traditions differentiated less by their ingredients than by the proportion of their ingredients, the economic survival of great vested interests like that of the central senatorial grouping, the wide acceptance of the inevitability of classical standards, may all explain why the third-century changes within the Empire are recurrent, not continuous.[29]

He went on to trace three chief threads of continuity within the period of confusion, one linking the reigns of the militarist emperors Decius (249–51), Aurelian (270–75), and Diocletian (284–305); another, distinctly senatorial in character, relating the three Gordians (238–44), Pupienus and Balbinus (238), Tacitus and Florian (268–70), and possibly Claudius II and Quintillus (275–76); and a third connecting the more "Augustan" reigns of Alexander Severus (222–35), Gallienus, and Probus (276–82). Within each group, he felt, could be discerned a degree of unity proceeding from state policy to coin types and so to the general character of the arts as a whole.[30]

The stylistic seesaw upon which this categorization is based evidently began to be apparent under the later members of the Severan house, when a strong reaction against the ultraplastic forms of Septimius Severus' portraiture and its Antonine precedents takes place (Figure 118). Just how "Augustan" these images may be considered is a question not without its debatable aspects; but they do in any case embody an expression of calm and even introspection quite at odds with the portraits of either their predecessors or successors. The sudden shock of political upheaval is expressed in the contrast between the likenesses of Alexander Severus just cited and those of Maximinus Thrax, who overthrew him (Figure 119).

> The whole brutality of the Soldier Century is revealed in the mighty head of Maximinus, in everything corresponding to our knowledge of this imperial cyclops. . . . To a degree as never before in ancient art the whole personality is caught in a snapshot, in transitory movement, in a sudden glimpse. Thus also the realistic determination of *time* is introduced in portraiture. The image does not only intend to give the objective physiognomic forms, it also aims at revealing them *in time*, in the very movement of life, at depicting the play of features in the nervous face, the very flash of personality.[31]

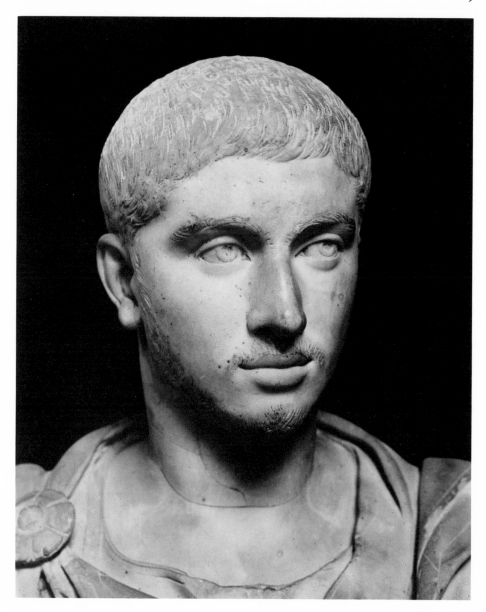

FIGURE 118 An "Augustan" reaction in the art of the early third century becomes evident in the
official portraiture of the last emperor of the Severan dynasty, whose very name Alexander suggests
something of the mood of the times. In contrast to the fantastically drilled coiffures of earlier Severan
portraits, his hair is indicated in an almost antithetical manner, through short scratches and chisel
marks on a barely raised caplike mass. Incised lines also delineate some of the facial features, while
the drill continues to be used to indicate the eye pupils.

Vatican Museum

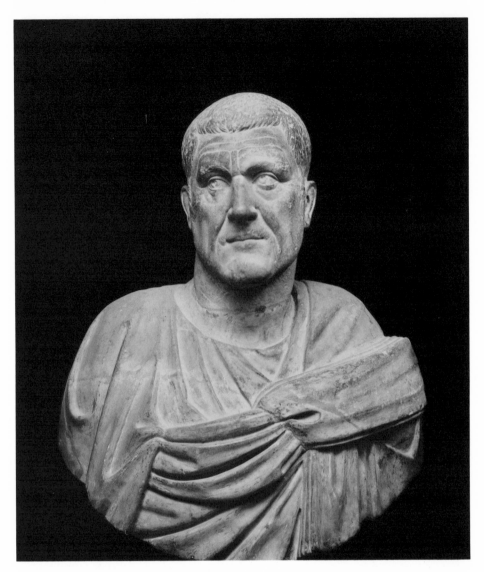

FIGURE 119 Maximinus Thrax, first of the soldier-emperors who sought to bring some order out of
the chaos created by the Severans, is depicted in a series of powerful images which translate the
Severan-Augustan style into something completely new. The equally radical sense of transitory
states of feeling, of time itself, is first evident in likenesses of this emperor.
Rome, Museo Capitolino

Yet this new portraiture represented comparatively little shift in style or technique from what had been in use under Alexander. The hair, which had been cut and drilled into such fantastic plasticity in the Antonine and earlier Severan reigns, began to be de-emphasized in the second decade of the third century, so that by the end of Alexander's rule it was treated in the almost antithetical technique seen in the Thrax portraits—as a caplike mass showing just the barest chisel scratches as an indication of close-cut, not flowing, locks (Figure 120).[32]

Nevertheless the brutal frankness of the portraits of Maximinus Thrax and the other militarist emperors who followed is far different from the slick, flattering likenesses of Alexander and his unpleasant family. We are driven to comparisons with much earlier Roman portraiture:

In the "Late Severan" (220–250 A.D.) period, the individual is thrown back upon himself in the turmoil of a crashing world, as he was during the late Republic. Once again the specific appearance of personality is asserted with uncompromising honesty. . . . Some of these portraits may be interpreted as a form of defiant self-assertion, not unlike that of the condottieri and other individualists of the Quattrocento. They differ from the late Republican "veristic" portraits in their highly expressive, dramatic use of specific features. Late Republican sculptors accepted ugliness, age, and decay as an objective fact; the late Severan sculptors use the same physical traits to underline the dominant theme of worry, uncertainty, and distrust. This common mood, in turn, distinguishes the late Severan interpretation of personality from the "realistic" portraits of the first century A.D. With the Flavian sculptors, the individual experience and individual conflicts of that particular person come first, and the person is capable of action as well as thought. The late Severan portraits deal with the general feeling of men about a world which frustrates and stultifies all. The individual personality is but a specified example of a general mood.[33]

Actually the affiliation with Flavian art may prove, from another point of view, more direct than that with the portraiture of the republic, which is more a matter of parallel circumstance than of truly comparable artistic expression. It is in the time of the Flavians that there occurred for the first time a handful of works which capture certain aspects of momentary action and transitory emotion or mood.[34] It could be expected, in fact, that the artists of the third century would be better students of imperial than of republican art; they are most likely to have seen the latter through the lens of Flavian style, when a degree of republicanism was in any case fashionable. In any event, we must not overemphasize the historical influences which played a part in shaping the art of the so-called Soldier Century, for that art is essentially original. A new crisis had in fact evoked a new form.

After the sudden burst of innovation in the images of Maximinus Thrax, the senatorial reaction brought in the Gordians, whose images are, although fundamentally realistic in approach, rather neutral in emotional content, perhaps at least as much Severan as "Augustan" (Figure 121, a portrait of Gordian III

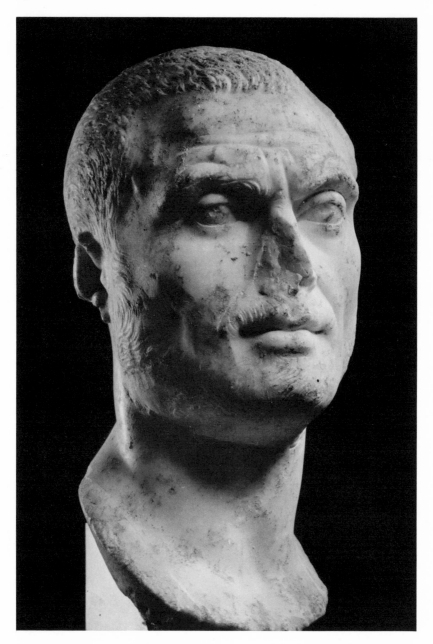

FIGURE 120 This unidentified portrait from Alexandria in Egypt compares closely with the late
Severan style but may in fact be somewhat earlier in date, a manifestation of the growing anti-
baroque tendencies which finally surfaced under Alexander Severus in the official art.
Kansas City, Nelson Gallery–Atkins Museum of Fine Arts

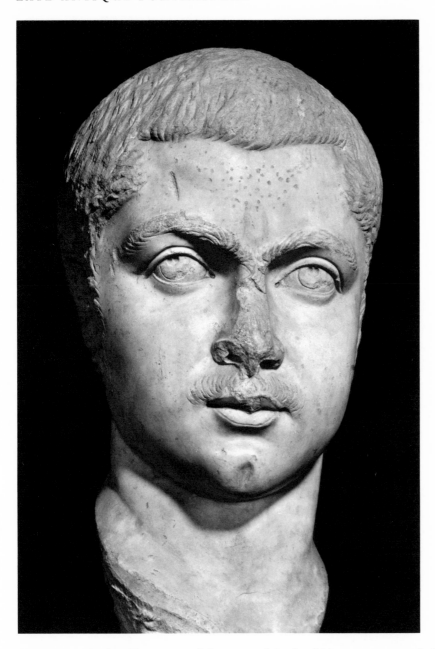

FIGURE 121 Gordian III, youngest of the senatorial family which strove to control the empire after the fall of Maximinus, is portrayed in a more purely Severan manner; yet some of the new temporal quality is present even in likenesses such as this, betraying the spiritual change since Severan times.

Rome, Museo Nazionale

which has in fact been claimed by one authority for Alexander Severus[35]). This neutrality of spirit is characteristic of what Mathew characterizes as the "senatorial" type in general—although there is some doubt whether the "senatorial" and "Augustan" groups can be distinguished as clearly in art as in political programs. In any event, the aggressive "military" image was ever ready to reappear. Philippus Arabs (244–49) is the subject of portraits whose quivering power equals or surpasses those of Thrax (Figure 122); while the likeness of his successor, Decius, employs the same means to convey the opposite impression, that of uncertainty and irresolution (Figure 123). The portraiture of Decius seems most preoccupied of all with aspects of temporality:

> The sidewise turn of the head expresses movement, and so does the entire facial composition. Notice the stress which is laid on *asymmetrical* configurations of folds and wrinkles, especially striking in the muscles of the forehead and round the mouth with their violent waving furrows. Such asymmetries do away with any sort of stability, firmness or permanence of form, creating, one might say, a physiognomic situation, only transitorily possible and bound to change every moment.[36]

Yet another example of the same artistic means being employed for still another mode of expression is found in the contemporary portrait of a seer—identified by L'Orange as possibly Plotinus himself[37]—where the vision is turned upward, away from the troubling world of sense and toward the realm of contemplative withdrawal.

> During the third century, the feeling of doubt grows stronger decade by decade; it often verges on stupor or despair. At the same time, the inward withdrawal assumes the form of intuitive search for a reality more assuring than this world. Under Gallienus, a crisis occurs which we can observe even in the portraits of the emperor, despite the concomitant phenomenon of heroization and deification. The inner quest for an invisible reality becomes permanent and begins to overshadow any momentary disposition or mood. . . . The physical appearance is a background, at times even a prison, from which the soul conducts its perennial quest. The old dichotomies of Roman analysis of personality —beauty and ugliness, weakness and strength, virtue and vice—are yielding to the new dichotomy of body and soul.[38]

Thus we return to our point of departure, the irreconcilable dichotomy in the portraiture of Gallienus, which suggests this very concern with the antithetical relation of body and soul.

If some sort of renaissance can be discerned during this reign, it is a two-pronged revival, represented in the two antithetical portrait types created for the emperor. In the first place, there was an early assertion of continuity with the Severan tradition—possibly continuing an emphasis begun under Trebonianus Gallus in the two years preceding Valerian's accession in 253 (Figure 124).

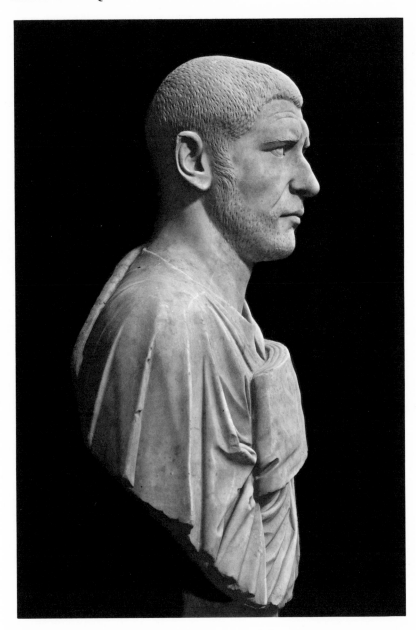

FIGURE 122 Philip I, "the Arab," another military chieftain, succeeded the Gordians. His image
is firmly in the now established military tradition, a still more crystalline version of the portraiture
of Maximinus. The chisel marks in the hair are shorter and more abrupt, the face is more scratched
with linear markings, and the expression is even more constrained to the force of a single
overpowering emotion.

Vatican Museum

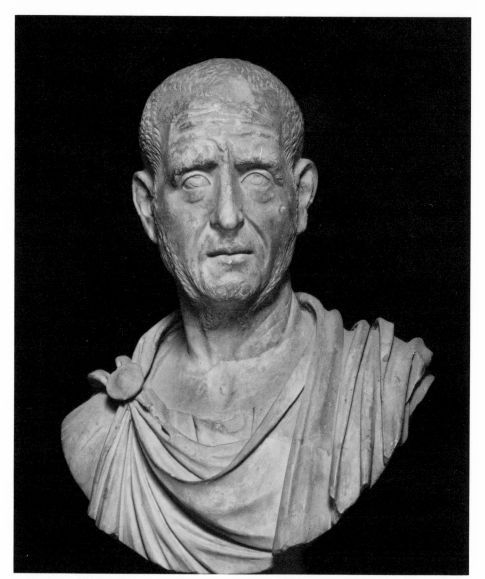

FIGURE 123 In the portraiture of Trajan Decius, at mid-century, the trend toward portrayal of
transitory temporal states reaches its culmination, breaking the crystalline mold which had been
characteristic of the earlier types. The forcefulness of a Maximinus or a Philip is replaced by a sense
of harrowing uncertainty; absolute asymmetry reinforces the sense of movement; the hardness of
forms dissolves into softer surfaces and planes. Also becoming evident is a new emphasis on the eye,
through an enlargement of its socket, which is to have great consequences in later portraiture.
Rome, Museo Capitolino

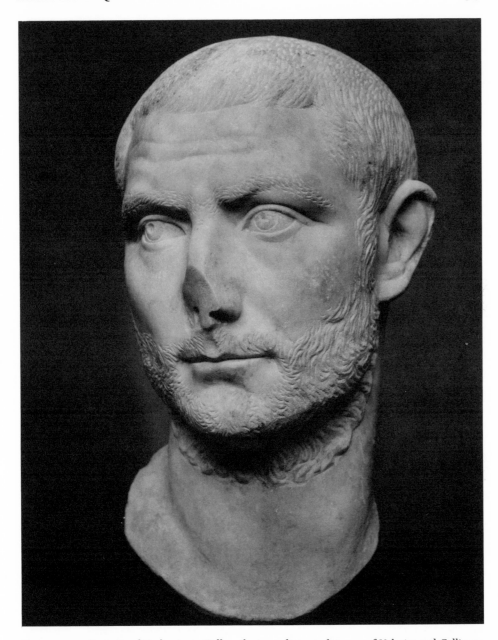

FIGURE 124 Portraits of Trebonianus Gallus, the immediate predecessor of Valerian and Gallienus (cf. Figures 108 and 109), demonstrate a new reaction toward Severan classicism and a revival of its pictorial techniques, a trend which continues into the next decade.

Copenhagen, Ny Carlsberg Glyptotek

Continuity with the empire of the Severans was no longer to be disdained, since that dynasty's era must by then have seemed a golden age by comparison with what had followed. Like the portraits of Trebonianus Gallus, the "realistic" or "youthful" likeness of Gallienus (Figure 110) is obviously imitative of Severan style and the Severan mode of idealization. This rather shallow retrospection was to be followed by a deeper and more radical step—evidently about 260—when the second, "apotheosized" type of portrait (Figures 111 and 112) first appears on the coins. Here a far-distant Hellenism is drawn upon to create a portrait as dematerialized and unworldly as the doctrines of the philosopher admired by the emperor, Plotinus.

Yet even here there is some imperial precedent for the new forms. This Hellenism was based on that of the empire's greatest Hellenophile, Hadrian.

> The art-movement that centres in these eight years seems marked by a straining effort to recapture the stability, the world-view, and the standards of the Hadrianic age. Gallienus himself was clearly the patron, and perhaps the representative, of this renaissance, but he was not its cause. For the movement is equally apparent at the mints under the control of his rival Postumus and on the Gallic sarcophagi. As a movement it was perhaps to be ultimately frustrate because the Hadrianic world-view presupposed a world-order which was no longer economically conceivable. . . . Even the passion of the emphasis on stability may mark a bourgeoisie in the process of being liquidated.[39]

The passion for stability is a key to the ultimate Gallienic style and to its legacy to the last decades of the third century (Figure 125). The most significant result of the creation of this new form of ruler image was the freezing of that momentary effect which had been so striking in portraits like those of Decius. Instead of the breath of transitory feeling, we have the chill of a new timeless fixity. The alternate world into which Gallienus sought to retreat was a world outside time, and the images of him exist as representations of utter immutability. "The . . . development up to Diocletian paralyzes . . . the very nerve in this portraiture: the movement. The nervous life in the surface is killed by abstraction, the muscular vibration petrifies—it is as if the blood coagulates in the veins, as if the expressive movement of the 250's sets into a paralytic mask."[40]

The period between Gallienus' fall and the rise of Diocletian is an obscure one in all fields of history; in artistic remains, precisely datable works are all but nonexistent.[41] On the basis of even the meager surviving evidence—largely numismatic—it is tempting to hypothesize the continuation of stylistic categories and sequences discerned in the first half of the century: an Antonine-Severan look on the coins issued by Postumus and Tetricus in Gaul during and just after the reign of Gallienus, verging toward a Gordianic "senatorial" style as early as the contemporaneous issues of Claudius Gothicus but gradually taking on a tetrarchal

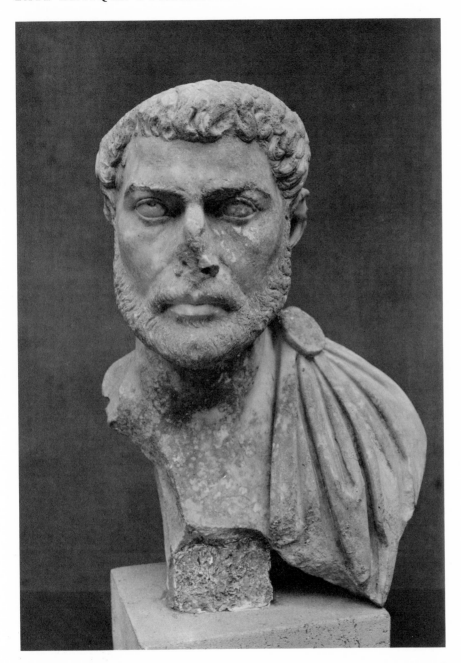

FIGURE 125 The diffusion of the new Gallienic mode of portrayal may be demonstrated in this portrait of a military leader from the second half of the third century, when the upturned gaze of the eyes had become a common mode of expressing otherworldly inspiration and aspiration. *Copenhagen, Ny Carlsberg Glyptotek*

crystallinity—under the influence of Gallienus' apotheosized coin types—in the mid-270's with Tacitus. While any such attempt at stylistic grouping is purely speculative, there is no doubt that whatever did follow was conditioned by that apotheosized image of Gallienus, whose Hellenism so lacks the structural form of either classic Greek art or the Hadrianic imitations. The artist has no real interest in inner structure; he merely reduces matter into a generalized form on which the features are applied. It would seem that, with the passage of time, this reduction of form tended toward ever increasing compaction, until we reach the enormously dense images of the tetrarchs.[42]

Such compaction is present in an apparently realistic (though not veristic) portrait of Diocletian himself (Figure 126)[43] but is especially characteristic of the images which seem to epitomize the art of his tetrarchy, the two pairs of porphyry figures now built into the corner of the church of San Marco in Venice (Figure 127). Another but cruder set of likenesses is in the Vatican, and several works in the same style and material can be related to these;[44] but it is in the Venice group and the porphyry bust in Cairo (which is probably from the second tetrarchy rather than the first[45]) that we find the epitome of a style which evokes the word "icon" for the first time. The highly compressed form is organized in a strongly symmetrical way, with the features carefully composed into expressive masks, showing great emphasis on the heavily arched brows and enormous eyes. The paired corulers, instead of being individualized, are depicted as physical twins, each pair of senior and junior emperors having identical features which conform to the appearance (within the conventions of the style) of the older man.

Although other materials, even soft chalk, were employed in works which share this powerfully stylized mode of expression, the manner seems conditioned by the requirements of that hardest of all stones, porphyry, which had suddenly come into some currency after two centuries of almost total neglect.[46] It would be futile to debate the priority of means and ends in the question of the formation of the tetrarchal "hard style," but there can be no doubt that the imperial stone of Egypt was perfectly suited to its expression.

The material itself suggests that the style was local in origin. Porphyry is found only in the Mons Claudianus on the Red Sea, and in earlier times, at least, only Egyptian sculptors had either the technique or the patience to work it.[47] The distribution of surviving works in porphyry made under the tetrarchy (provenances around the north end of the Adriatic, as well as single specimens in Bucharest and Cairo) do not controvert the possibility that Egypt was the source of the technique even at this time—and hence of the fully developed "hard style." On the other hand, there is a strong probability that a special workshop was set up at Spalato during the construction of Diocletian's palace there; and this makes

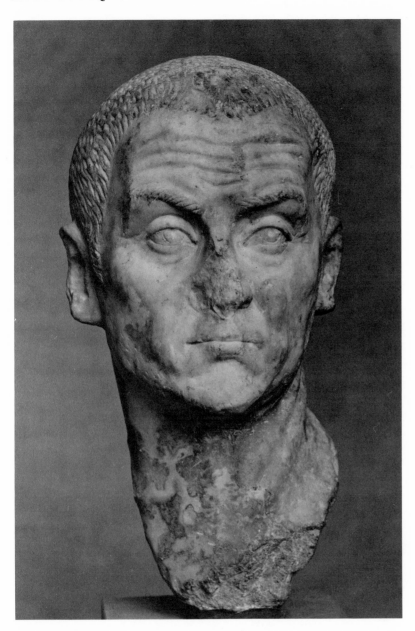

FIGURE 126 The saviors of the empire in the late third century were military leaders like Diocletian, the probable subject of this striking portrait. In style the image is still linked to the "military" tradition of half a century earlier, with even more compact forms and sharply chiseled hair; but tetrarchal sculpture shows a compactness and precision of form far more positive than any seen before in Roman art.

Copenhagen, Ny Carlsberg Glyptotek

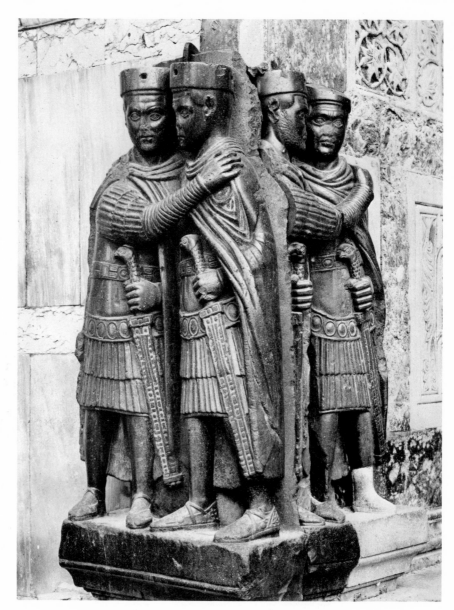

FIGURE 127 The famous group of statues of the four tetrarchs, fixed into the corner of the church of S. Marco in Venice, represents the extreme of compaction seen in art at the turn of the fourth century. The very material, porphyry, encourages an abstraction of forms and features which seems to exemplify an eastern stylistic tradition as contrasted with the comparatively more open and modulated forms of western sculpture. But these are differences of degree rather than kind, and all tetrarchal art exhibits stylization.

Venice, Piazza San Marco

Spalato a logical center of diffusion of most of the known specimens.[48] It would still be possible to assume, of course, that the finest examples, such as the Venice group, were made by masters brought from Egypt, while cruder examples of the style, such as the Vatican ones, were the work of less skilled local craftsmen working alongside.

Whatever the details, we are dealing in this tetrarchal style with something much more general than the work of one local and limited workshop. The forms of the finest porphyry portraits, such as the Daza-Licinius, compare closely with the profiles seen on one class of coin types of the tetrarchy, a style most common in the mints of the eastern provinces under the direct control of Diocletian—Alexandria, Antioch, Cyzicus, and Nicomedia (where Diocletian built a second great palace)—but used, in modified form, in the Balkan mints at Heraclea, Serdica, Thessalonica, and Siscia.[49]

In other imperial mints, such as those of Italy and the West, a different style was employed in the coin portraiture. Compacted and formalized, but without the strongly abstract stylization of the eastern "porphyry" types,[50] these coin profiles have their parallels in extant full-scale likenesses far more naturalistic than the ones of the "hard style" (Figure 126).

It would appear, then, that the imperial imagery was again, or still, capable of embracing multiple forms of representation of the ruler or rulers—a practice that, as we have seen, began under Gallienus. The coins give evidence as to the way in which the portrait types and their respective styles were distributed. Thus each of the tetrarchs, within his own territory or "diocese," was portrayed by a distinctive portrait image which, however stylized, has an evident relation to natural appearances; this is the type used on the coins issued by his own mints. These same mints, however, struck a certain number of coins of most issues in the names of the other coemperors, senior and junior; but the same fidelity to individual appearance is not uniformly observed in these "courtesy" issues. Instead, although some dies may follow the model of issues from the named ruler's mints, most tend to resemble the appearance of the ruler of the issuing mint. Thus, within Licinius' diocese, most of the coin portraits, whether in the name of Licinius, Maximinus, or Constantine, are conditioned by Licinius' original portrait type; and the same thing is generally true of the other regions. This might seem to be a mere product of laziness among the imperial die-cutters were it not for the Venetian porphyry groups, where the likenesses of the senior emperor in each pair determines the appearance of his junior. This is no casual error; it follows a plan.

Doubtless it is possible to argue that these differences in the appearance of coins from different parts of the empire are the simple result of regional variations

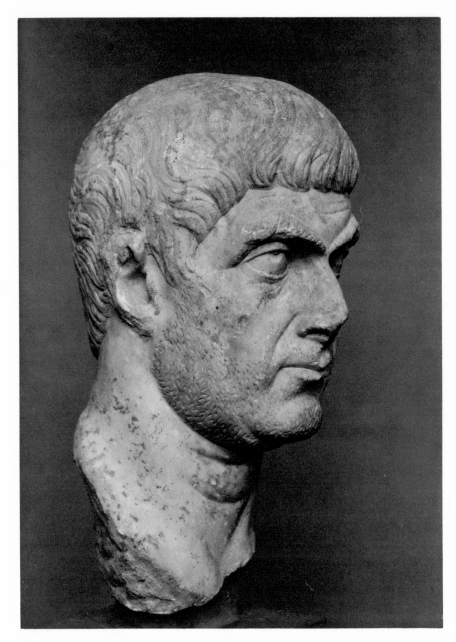

FIGURE 128 This portrait, like the Diocletian of Figure 126, exemplifies the western tetrarchal style; it probably represents Galerius, colleague of Diocletian in the first tetrarchy. Later in date than our Figure 126, this image still recalls its derivation in late Severan "Augustan" portraits, transformed by a new sharpness of forms and outlines and a new concern for the gaze of the eyes. *Copenhagen, Ny Carlsberg Glyptotek*

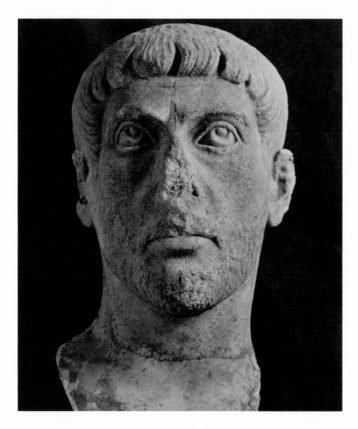

FIGURE 129 This head, which can be dated to the early part of the reign of Constantine I, gives evidence of the softening of the tetrarchal artistic style—a curious parallel to the political dissolution of the tetrarchal system itself in the struggle of Diocletian's successors for sole power in the revived imperial structure.
Musée du Louvre

in artistic style and that we are not dealing with "multiple portrait types" in the true sense. We have already seen that the "hard style" is centered in the eastern mints, while the western ones employ a "softer" manner, with a greater impression of naturalistic representation. Yet it would be a clear mistake to over-emphasize these geographical differences. To take only one example, the porphyry groups were found, and perhaps made, in the officially western area around the northern end of the Adriatic, while works in a "softer" style are not un-known from localities much farther east. The over-all character of the art of the tetrarchy is more consistent than variable, both in style and in conceptual approach (Figures 128 and 129).[51]

For the purposes of the present study, the critical point lies in the continuing possibility of parallel and dissimilar likenesses, as found under Gallienus. Of the period of the tetrarchy we can certainly say that dissimilar portraits were made and apparently tolerated officially, whatever the reasons for the dissimilarity. In the case of Gallienus' portraiture there is the hint of a difference in meaning underlying the dissimilar types; in the tetrarchal images we can find no such difference on the basis of our present knowledge. Whatever the cause, however, the fact of the dichotomy remains.

Constantine the Great and the Christian Empire

The reign of Constantine I saw the reintegration of the empire into a unified whole. The unwieldy apparatus which Diocletian had sought to save by decentralization, Constantine was able, under more favorable external circumstances, to weld once more into a single state. In art, too, the period is distinguished first by a continuation of the styles of the tetrarchy, then by a reaction, and finally by the attainment of a new synthesis.

Numismatic evidence supplies fairly continuous and pertinent information on the course of stylistic development, at any rate by comparison with large-scale sculpture for this period.[52] At the outset of Constantine's reign, in 306, when he shared the West with Maxentius, the major mints in their half of the empire were at Rome and Trier; these were, at any rate, the only ones striking gold. Both mints employed the familiar western tetrarchal style of relatively compact and relatively realistic portraiture (Trier was rather strongly influenced by Rome in most matters). What is notable in these years at Rome—and, after 310, at the newly established Ostia mint[53]—is a marked improvement in the quality of the dies as well as an inclination to revive both the stylistic traits and the actual reverse types originated during the reign of Probus (276–82), when, on the eve of the tetrarchy, a brief upsurge in the quality of numismatic technique had occurred.

When, after the Battle of the Milvian Bridge in 311,[54] Constantine assumed control in Rome, a new portrait of him was created for the local mint at Ostia, an image looking back to Trajanic precedents.[55] It would appear that this decade of Constantine's rise to sole power was one in which, in general, the model of the soldier-emperor Trajan was the most honored prototype for artistic (and political) emulation. The statue of Constantine in the Lateran Museum (Figure 130), found with two other statues in military dress in the ruins of the Baths of Constantine, is clearly based on a Trajanic precedent of the imperial victor statue rather than

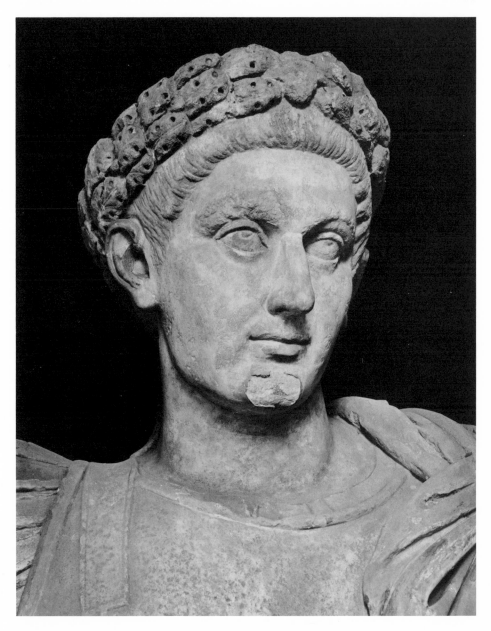

FIGURE 130 The dominance of Constantine after his victory at the Milvian Bridge is reflected in military portraits which are part of a general revivalist movement in art and culture modeled on the period of Trajan. This portrait probably dates from the period just after the capture of Rome, about 313 A.D., the time of the erection of the Arch of Constantine, which is itself another example of the tribute paid by Constantine and his artists to the art of the past.

Rome, San Giovanni in Laterano

on the Augustan type to which Trajan himself had looked; the three Constantinian statues may be dated, on the basis of the various related works, to the first imperial stay in Rome, which lasted until about 313 A.D.[56]

The Trajanic look of the coins of the decade, which confirms the evidence of the Lateran statue and its companions, is shared by the portrait heads added to the earlier reliefs (the earliest of them Trajanic in original date) that were "borrowed" for the ornamentation of the Arch of Constantine, the most important memorial to the Milvian battle. While the two heads of Licinius inserted on the arch still sport the short tetrarchal beard and have the stylized blockiness of the eastern manner, the six beardless heads of Constantine are oval in shape, the features are far less firm, and the hair is more plastic and arranged in a rather Trajanic coiffure; the whole effect is quite naturalistic when compared with typical tetrarchal work.[57] These portraits conform to the coin images of their respective subjects to a remarkably close degree; this is further evidence that the varying tetrarchal styles were not purely a regional matter.

Just evaluation of the Arch of Constantine is difficult; it has aroused a wide range of polemic. Certainly the circumstances of its erection and the haste with which it was brought to completion help to justify the use of earlier reliefs to complete its decoration. But this borrowed plumage has a further significance. The use of works from the Trajanic, Hadrianic, and Antonine periods is still another indication of the interest that was being taken in the imperial past; it is in fact one of the primary indications that another "renaissance" was blossoming.[58] The contemporary historical reliefs on the Arch, with their dumpy, leaden forms and rigidly symmetrical compositions, are less ornamentalized but are otherwise not too dissimilar from such works of the first tetrarchy as the reliefs on the Arch of Galerius in Thessalonica; they belong to the waning tetrarchal style. The real interest of the new dynasty, however, lay in the adaptation of the past to the new exigencies of the present; and one of the first forms this interest took was the creation of this outdoor museum of imperial sculpture called the Arch of Constantine.

The Trajanic style of the second decade of the fourth century, then, found its first monumentalization in the heads added to the Arch reliefs and in the military statues found in the Baths. None of these can be compared, technically, stylistically, even conceptually, with their second-century models; one suspects that the artists themselves were aware of this and that this is one reason for the extensive borrowing of authentic earlier sculpture for the decoration of the Arch. Like all retrospective and more or less Hellenizing art since the time of Gallienus, the Constantinian works totally lack the sense of inner structure and articulation that are integral to the authentic Greek tradition and which had still been accessible

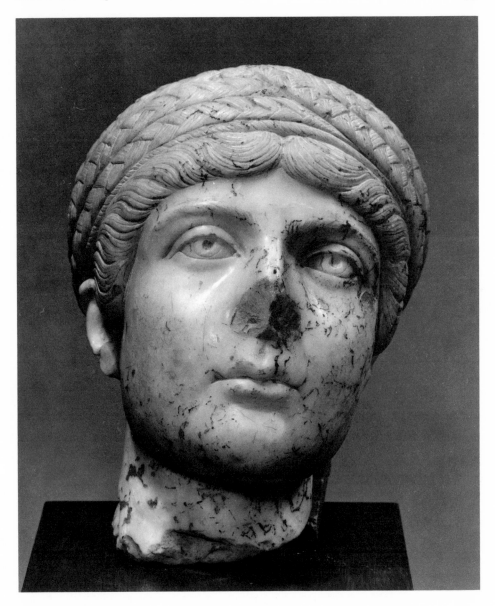

FIGURE 131 A different aspect of Constantinian revivalism is reflected in this delicate head of Athenian marble, whose inspiration lies in the early Antonine tradition. Identified as a likeness of Constantine's half-sister Constantia, wife of the luckless coemperor Licinius, it probably was made about the same time as the Lateran statue of Constantine himself, however different the artistic traditions exemplified.

The Art Institute of Chicago

to sculptors of the second century. That this was not purely a regional matter can be demonstrated by a female portrait from Athens (Figure 131); probably representing Constantine's half-sister Constantia during the time of her marriage to Licinius, it has a finesse and delicacy of execution lacking in the Lateran portrait of her brother (of which it would be a close contemporary) but no greater firmness of structure.[59]

The new style is not to be described completely in negatives, however, for there are positive strengths emerging. Starting essentially as a reaction to the tetrarchal style, the Trajanic one matures through a continuing reduction of surface modulations into a firmer, more linear organization of forms. The end product of the evolution of this style is to be seen in works of a decade later than the Arch, such as the head of Dogmatius, datable to 323–27 (Figure 132).[60]

Once again the coins confirm the evidence of the other monuments. Just about the year 325, the year after the fall of Licinius, and the year celebrating Constantine's *vicennalia* (the conclusion of his first twenty years of rule), the tetrarchal dichotomy of styles disappears from the coins, and a standardized manner, firm, clear, and linear but not schematized, becomes all but universal. This is the style of the mint at the new capital, Constantinople, but it affects the rest of the imperial mints.[61] At about the same time, a new imperial portrait is introduced on the coins; it is the emperor in apotheosis—his neck arched, his eyes fixed on the heavens—in the tradition founded by Alexander the Great and lately adopted by Gallienus.[62] The inspiration for this new stylistic swing, then, is fundamentally Hellenistic.

Just as the Hellenistic diadem replaces the wreath on this new coin type, supplying a chronological tool for comparison of monumental portraits, the new image can be related to the last group of likenesses probably representing Constantine (although frequently referred to various of his successors, we keep returning to the founder for the basic point of departure). The most important of these are the colossal fragments, one of marble and the other of bronze, in the Conservatori Museum. The marble, which was found in the Basilica of Maxentius (Figure 133), has recently been redated to the period of these new coin issues—perhaps as a memorial of the *vicennalia* itself—while the bronze is evidently later, perhaps from the *tricennalia* of the mid-330's (Figure 134).[63]

In style these works fulfill the implications of the Dogmatius portrait. The forms become harder, the features more ornamentalized, and the individualization is not so much a matter of physical details as of superhuman forcefulness; hence our problem of making absolute identification as between Constantine and his immediate heirs and successors. It is as if, with the passing of the pagan empire, the problem stated in the third century had at last been resolved; after his long struggle to reconcile the conflict between outward and inward realities, the

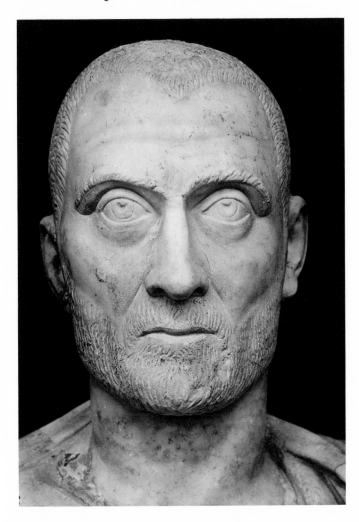

FIGURE 132 A new process of compaction and integration, this time imposed on the "Trajanic" forms of the first decade of Constantine's rule, matures by the 320's, when this portrait of the high Roman official Dogmatius was made. Once more the eyes of the subject become the focal point of the portrait's expressive power.
Rome, Palazzo Lateranense

artist has cast his lot with the latter. This is not to say that physical appearance is ignored; these portraits remain distinctive and for the most part identifiable. But the truth to which they conform is above all the truth of the invisible world, which the artist has now found means to render visible.

Just as Constantine's political legacy shaped the Christian empire for centuries to come, the character of the artistic style of his maturity provided the dominant heritage for later antique art. The factor of change, the element of time,

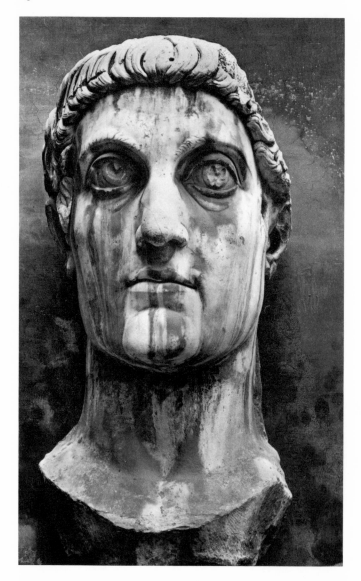

FIGURE 133 The later portraiture of Constantine the Great represents a new expressive synthesis of
forms only intimated in works like the portrait of Dogmatius. Although traces of Gallienic Hellenism
may be discerned in the ''apotheosized'' portraits made of Constantine long before his death, the
new mode of portrayal is essentially original, the product of a century-long evolution away from
tactile or optical naturalism toward an inward-looking spiritual idealization. This colossal marble
head, found in the ruins of the Basilica of Maxentius, may well date from the commemoration of
Constantine's twentieth year of rule, a celebration which began in 325 A.D. Comparable coin
images were issued at this time.

Rome, Palazzo Capitolino

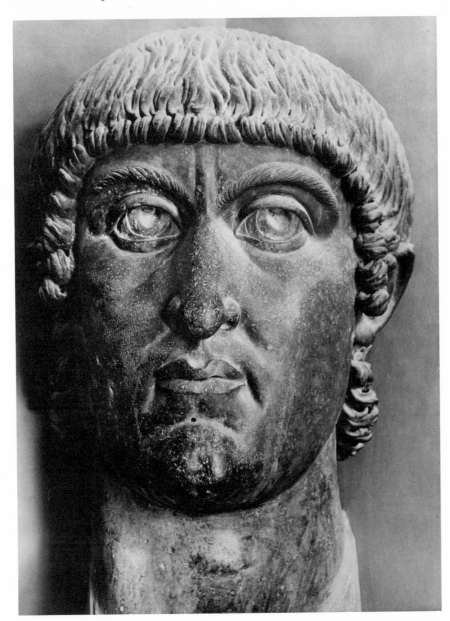

FIGURE 134 So far had the process of spiritualization advanced in this colossal bronze portrait head
that identification on the basis of physical resemblance has become impossible. The spiritual force
invoked by the artist transcends all limitations of physical identity. Thus, although its subject may
be Constantine's successor, Constantius II, it is far more likely that it is a portrayal of Constantine
the Great himself, near the close of his reign, at the time of his thirtieth anniversary in 335.
Rome, Museo dei Conservatori

had been totally eliminated from representation; all images henceforth exist outside the realm of temporality. In this, art imitated life—or perhaps the converse was, after all, operative. In any event, a famous passage in Ammianus Marcellinus describes the entry of Constantius II into Rome, in 357, in terms which suggest that the emperor was making the greatest effort to look just like a statue of himself:

> And as if he were planning to overawe the Euphrates with a show of arms, or the Rhine, while the standards preceded him on each side, he himself sat alone upon a golden car in the resplendent blaze of various precious stones, whose mingled glitter seemed to form a sort of second daylight. . . . Accordingly, being saluted as Augustus with favouring shouts, while hills and shores thundered out the roar, he never stirred, but showed himself as calm and imperturbable as he was commonly seen in his provinces. For he both stooped when passing through lofty gates (although he was very short), and as if his neck were in a vise, he kept the gaze of his eyes straight ahead, and turned his face neither to right nor to left, but (as if he were a lay figure) neither did he nod when the wheel jolted nor was he ever seen to spit, or to wipe or rub his face or nose, or move his hands about. And although this was affectation·on his part, yet these and various other features of his more intimate life were tokens of no slight endurance, granted to him alone, as was given to be understood.[64]

As the fourth century passes into the fifth, portraits portray less and ever less of the material aspect of their subjects; we can feel ourselves in the presence of images which conform to the sense of the word "icon." The face, when orientation exists, is almost invariably frontal (frontal portraits appear rather suddenly on the coinage of Licinius and Maxentius, disappear with the fall of the former, but seem to be reflected in the almost frontal military type introduced by Constantius II at mid-century[65]), symmetrical, and shaped according to abstract geometrical rhythms; details are linear and clear, the surfaces hard and continuous (Figure 135). Above all it is the eyes which overcome us, larger than life, emphasized by all the devices of form and line, staring fixedly into infinity (cf. Figures 132 and 137).

There is a striking parallel in the description of Proclus, last of the pagan Neo-Platonists, by his biographer Marinus: "He did not seem to speak without divine inspiration. For words came from his discreet mouth like flakes of snow, his eyes seemed to flash with some inner light, and his whole face was filled with divine radiance."[66]

As the heir of Plotinus' philosophical tradition, Proclus readily accepted the master's emphasis on the spiritual rather than the material in nature. As Plotinus put it:

> We have to recognize that beauty is that which irradiates symmetry rather than symmetry itself and is that which truly calls out our love. Why else is there more of the

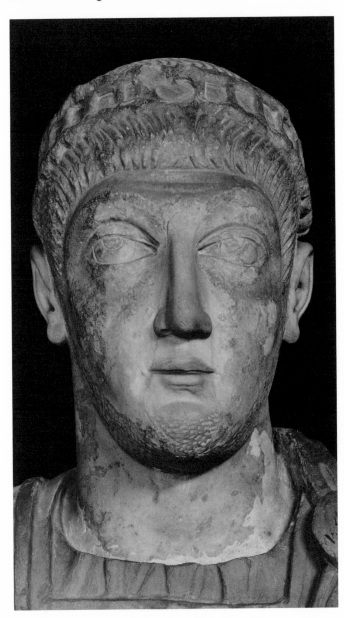

FIGURE 135 Imperial portraiture was conditioned for generations by the imagery established by the first Christian emperor, Constantine. This portrait of Honorius, who ruled the West at the close of the fourth century, shares the formal characteristics of Constantinian iconography, including the greatly enlarged eyes; but all is now formalized, geometric, static, and totally inexpressive. The force is absent in art as it was in statecraft.

Musée du Louvre

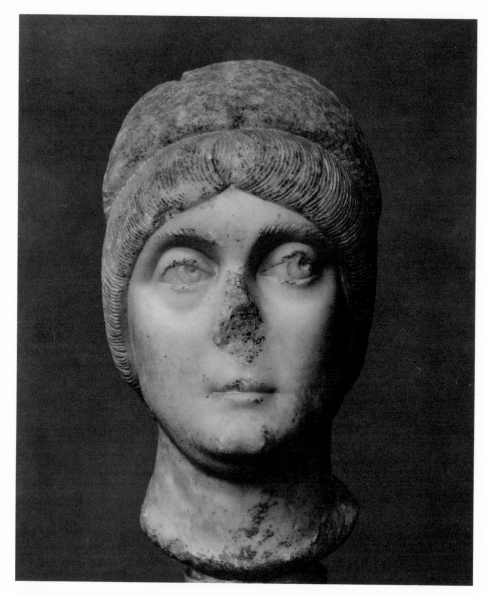

FIGURE 136 As a reminder that all late imperial art was not so vacuous as the portraits of Honorius, we have the likeness of that emperor's mother, Aelia Flacilla, which, although sharing common stylistic characteristics, is executed with a delicacy altogether appropriate to its subject. *Copenhagen, Ny Carlsberg Glyptotek*

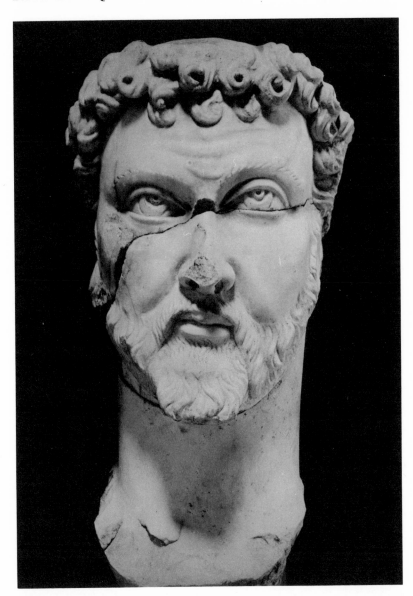

FIGURE 137 Outside the purely imperial tradition, portraiture in the Christian empire pursued a
direction set in late antiquity when men were also greatly interested in the portrayal of inspired
and visionary personalities. In this colossal portrait from Ostia, which has been dated anywhere
from the late fourth to the middle of the fifth century, post-Gallienic tendencies are formalized
into polished shapes, with large, upturned eyes, and a twisted asymmetry that is less a heritage of
third-century mobility than it is part of an attempt to convey the total emotional concentration of
the subject.

Ostia, Museo

glory of beauty upon the living and only some faint trace of it upon the dead though the face yet retains all its fullness and symmetry? Why are the most living portraits the most beautiful, even though the other happen to be more symmetric? Why is the living ugly more attractive than the sculptured handsome? It is that the one is more nearly what we are looking for, and this because there is soul there, because there is more of the Idea of The Good, because there is some glow of the light of The Good and this illumination awakens and lifts the soul and all that goes with it, so that the whole man is won over to goodness and in the fullest measure stirred to life.[67]

The doctrine of Proclus held that ''every soul can know only provided it possesses its own mind; the mind which is possessed by a certain soul, therefore, is the cause of its being able to know.''[68] Human identity lies not in the body itself but in the power which moves the body to action; it lies not in the mind itself, since we can become unconscious of our mind without losing our identity, and we are not the same as the objects of our knowledge. We are instead our soul, which moves the body and knows the mind; as Proclus defined it, ''Man is a soul using a body and conscious of a mind.''[69]

How do the body and the soul interact? They are definitely not parallel to each other; that is, the state of the body does not necessarily reflect the state of the soul or vice versa. On the contrary, the body is always a hindrance to the soul, although sometimes more, sometimes less. On the other hand, the soul is sometimes able to influence the body as when ''from the soul of an exalted person there descends even upon his body a kind of handsomeness and nobility.''[70]

In articulating this doctrine, Proclus wrought a refinement of the Plotinian theory of diffusion of spirit,

a characteristic doctrine of his own, according to which the higher cause—which is also the more general—continues its activity beyond that of the causes that follow it. Thus the causal efficacy of the One extends as far as to Matter, in the production of which the intermediate causes, from intelligible being downwards, have no share. . . . The more universal precedes in its causal action the more particular and continues after it. Thus ''being'' comes before ''living being'' and ''living being'' before ''man,'' in the causal order as in the order of generality. Again, at a point below the agency of the rational power, where there is no longer ''man,'' there is still a breathing and sentient living being; and where there is no longer life there is still being. That which comes from the more universal causes is the bearer of that which is communicated in the remitting states of the progression. Matter, which is at the extreme bound, has its subsistence only from the most universal cause, namely, the One. Being the subject of all things, it proceeded from the cause of all (Theological Elements, 72). Body in itself, while it is below participation in soul, participates in a manner in being. As the subject of animation, it has its subsistence from that which is more universal than soul.[71]

Thus the work of art, transforming matter into a reflection of spirit, remains a viable possibility, and it is still conceivable that a portrait may be a true likeness of

its subject. It is not improbable that Proclus, as an eminent Athenian intellectual of the fifth century, was the subject of the portraitist's art; in that case, the image must certainly have resembled those "iconic" portraits, with their immense staring eyes, just examined.

While the force of the gaze—rather the stare—of these portraits creates a strong impression on the modern viewer, for full understanding of their significance he needs to comprehend the importance placed upon the eyes—upon sight —in all of the ancient world.

> In antiquity men lived their spiritual life *visually*, to a degree and in a manner that we can scarcely imagine. . . . It is characteristic that the ancient mystery-religions culminate in a holy vision. . . . In divine men the spiritual vision is developed to a specially high degree. . . . In late antiquity this religious vision is especially conspicuous. The palaeo-Christian's relation to God also attains its climax in a vision, which in some of the Fathers reminds us of the Neoplatonists' ecstatic contemplation of the Supreme. *Et pervenit ad id quod est, in ictu trepidantis aspectus*, says Augustine. The entire philosophical and religious life of the time . . . is consummated in the transcendent vision of the One, of God. In this visionary union with the Supreme the god-possessed man is released from his human limitations and partakes of the nature and operations of the deity: he becomes a divinely exalted, "holy" being and receives daemonic powers. Here we have to do with ideas widely current and also met with on a lower level: they appear in popular religions and superstition, and play a considerable part in magic. In a visionary meeting with the god . . . the threshold of the divine is crossed and man himself operates with the powers of the god. There is thus a special connection between the stereotyped wide open eyes in late antique portraiture and the late antique conception of the holy man, the saint. The visionary gaze affects the ancient beholder with suggestive force: he feels he is in the presence of a man with supernatural spiritual powers and capacities.[72]

This suggestion of spiritual powers through enlargement of the eyes has an enormously long history, as a glance at Figure 34, the statue group from Tell Asmar, indicates. In terms of our immediate period, a starting point might be indicated with the portraiture of Trajan Decius (Figure 123), where, although at first glance nothing unnaturalistic is evident, further examination reveals that the structure of the skull has been violated to create deeply hollowed orbital cavities. The portrait is as arbitrary in its expressionism as a Romanesque column-sculpture.

The tetrarchal style emphasizes the eye with linear patterns; but the first portraits to rely on completely obvious enlargement of the eyes themselves are the later representations of Constantine the Great, the Conservatori fragments (Figures 133 and 134). The culmination of the tendency, in terms of the antique tradition, is perhaps to be found in the amazing group of portraits found at

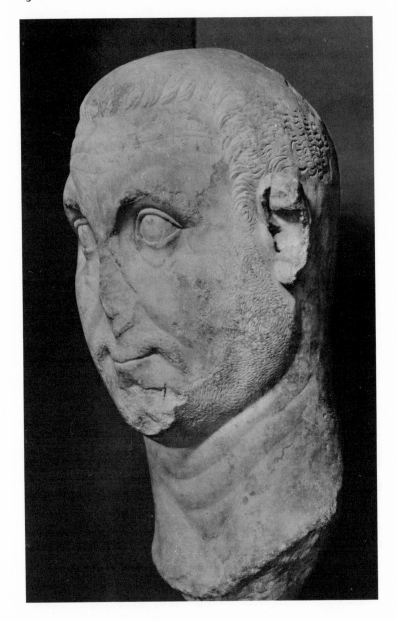

FIGURE 138 A group of portraits found at Ephesus in Asia Minor, all dated around or after the middle of the fifth century A.D., represent on the one hand the variety of stylistic approaches to the human image current in that important region at that time, and on the other the fundamental concentration of all art of the period on the immaterial and otherworldly aspects of subject matter. This head shows a farther extreme of the tendency toward asymmetric mobility of expression so successfully employed in the Ostia head.

Vienna, Kunsthistorisches Museum

FIGURE 139 This head from Ephesus bespeaks a differing tradition, within the same genre of spirit-
ualization. The forms are more focused and concentrated, the vision more fixed, the surfaces them-
selves less crisp than in the example seen in Figure 138.
Vienna, Kunsthistorisches Museum

Ephesus, usually dated to the latter half of the fifth century (Figures 138–40).[73]
The slow curvilinear rhythms of the design of the finest of them, defining traits of
profound intellectual maturity, create an image of the seer, the visionary, the
saint, as convincing as any ever made.

It is significant that, when we discuss portraiture of the fifth century, we no
longer turn to the imperial sequence, although a good number of official images is
still available. No longer does the most significant portraiture seem to be of men
of worldly power and dominion, as it had been in Rome; or of the man of letters
and speculative thought, as in classical Greece. It is the seer, the mystic, who
embodies in his likeness the highest concepts of the age (Figure 140). If this world
had failed, then the best example for guidance was the man who lived in and for the
next one.

FIGURE 140 The supreme example of spiritualized portraiture, not only from Ephesus but from all of late antiquity, is this magnificent fragment. The formal geometric scheme controls the expressive character of the masklike face, organizing the total representation into a rhythmic harmony of forms that foretells one of the secrets of medieval art.

Vienna, Kunsthistorisches Museum

As we have tried to show, the formal and conceptual basis for the iconic portrait was laid in the late imperial portraiture. In the centuries immediately following the reign of Constantine, the religious portrait in this iconic form was to become the dominant kind of devotional picture;[74] but, as with so much of Early Christian art, it is to the intellectual formulations and artistic statements of late pagan antiquity that we must turn to find the roots.

Chapter VI ❧ The End

of the Ancient World

I T WOULD BE DIFFICULT to conceive of a point of view more antithetical to the materialism of Lucretius than that represented by the Neo-Platonic authors of late antiquity. Even within the context of their shared idealism and mysticism, we progress farther and farther from the world of the senses as we pass from Plotinus, the third-century Egyptian teacher at Rome, to Proclus, the fifth-century Athenian, and finally to Pseudo-Dionysius, a Syrian monk of the fifth or early sixth century.

Their rejection of the material world is epitomized by parallel anecdotes and descriptions in the biographies of the two pagan philosophers regarding the question of the relevance of physical likeness in the portrayal of the individual. Porphyry, the pupil of Plotinus, states that his master

seemed ashamed of being in the body. So deeply rooted was this feeling that he could never be induced to tell of his ancestry, his parentage, or his birthplace. He showed, too, an unconquerable reluctance to sit to a painter or a sculptor, and when Amelius persisted in urging him to allow of a portrait being made he asked him, "Is it not enough to carry about this image in which nature has enclosed us? Do you really think I must also consent to leave, as a desirable spectacle to posterity, an image of the image?" In view of this determined refusal Amelius brought his friend Carterius, the best artist of the day, to the Conferences, which were open to every comer, and saw to it that, by long observation of the philosopher, he caught his most striking personal traits. From the impressions thus

stored in mind the artist drew a first sketch; Amelius made various suggestions towards bringing out the resemblance, and in this way, without the knowledge of Plotinus, the genius of Carterius gave us a life-like portrait.'' [1]

With the passage of time, even the feeling that such a surreptitiously derived memory-synthesis could be an adequate portrayal of such a man was banished. According to the biographer Marinus, Proclus

had that bodily virtue which corresponds to temperance, and which men rightly feel can be perceived in physical beauty. For just as the former is the harmony and agreement of all faculties of the soul, so the latter is the symmetry of all parts of the body. Now Proclus was very lovely to see, for not only did he have this outward symmetry, but the inner beauty of his soul bloomed forth upon his body and, like a living light, shone in a wonderful and indescribable way. He was so beautiful that, although all his pictures are excellent, none of the painters was able completely to capture his likeness, but all remained far behind in the imitation of his true form. [2]

The circle is thus completed: from Plato's insistence on the inadequacy of the image-maker's art, to Lucretius' assertion that what is visible and tangible is all that is relevant, and on to the new form of Platonism which was late antiquity's legacy to the Middle Ages—a stronger, because less Hellenic, negation of the material world in favor of the immaterial sphere of Ideas. These very Ideas, borrowed from Plato and the Middle Platonists, are given a coherence of organization never contemplated in the original formulation.

Neoplatonism climaxed and extinguished the tradition of Greek humanism. In no other system is man regarded so highly, his superiority to nature so vehemently affirmed, his divinity so intensely argued. Conversely, in no other system is the objective world of sense, of which he is a part, so despised. Man's importance and dignity lie not in his material but in his mental being. The emphasis, however, is not on his capacities for conceptual thought or on reason, but—and this is uniquely Neoplatonic—on his suprarational prowess, his divine faculty that lies above reason as reason lies above sensation. Rationalism gives way before mysticism, about which, as is notoriously known, no one has succeeded in being either articulate or rational. [3]

If a general survey of the course of portraiture can demonstrate one point, it is surely the invalidity of the frequently repeated statement that the art of the portrait in some way fails to conform to the general characteristics of other art forms because of the unique relationship established between artist and sitter. A typical version of this thesis was expressed by Alazard, in writing of portraiture of the Italian Renaissance:

The personality of the painter is limited to a certain extent by the very existence of the model whose essential features at least must be rendered; it even, on occasion, forces him to modify his technical principles; it can lend vigour to him who, up till that time, has employed a subtle and soft technique; it can also on the other hand give elegance and

charm to a painter who is above everything powerful. It often happens . . . that a mediocre painter raises himself for a moment to the ranks of the great, if he is strongly impressed by a face which is very full of character; his work takes on a brilliance of which we doubted him capable. . . .[4]

The statement is perhaps best analyzed in terms of its separate assertions:

1. *The necessity to render the features of the model may inhibit the artist's self-expression.* As an examination of the phases of portraiture surveyed in the present volume would seem to show, any such necessity has been understood in widely different ways by artists of various regions and periods; about all that can be said is that, where art lacks any orientation whatever toward visual representation—as in some phases of the Neolithic—portraiture, in terms relevant to our discussion, is not produced. Neither is any other sort of representational art. The demands of the portrait are not really different from the demands made by any other sort of subject in nature, whether landscape, still life, or the figure. If an artist is attuned to a naturalistic mode of expression, his work will conform more closely to the details of the appearance of his model than in other times, when more subjective attitudes are encouraged. We cite once again Gombrich's remark, "The correct portrait . . . can be constructed to any required degree of accuracy."[5]

2. *The artist may modify his customary technique and style in order to conform to the character of a particular subject.* While less susceptible of demonstration in terms of antique portraiture, in view of the difficulties of pinning specific works to specific artists, it certainly can be stated in terms of known periods and schools of artists that the evidence fails to bear this out. We were able to discern specific phases of the development of the portrait in Athens, for example, because of the technical and stylistic similarity of groups of portraits of widely dissimilar individuals—Aristotle and Olympiodorus, for example. In other eras, such as that of Roman Egypt, with its startlingly vivid mummy portraits, we have evidence of strong stylistic imperatives being imposed equally sternly on male and female subjects, without distinction for age or character insofar as it is possible to infer from the paintings themselves. In most periods where it is possible to study evidence in detail, however, we find that, contrary to Alazard's implication, the same artist is rarely equally successful in making portraits of male and female subjects; he has his greatest success with one or another sex or age group. Even in the fourth century B.C. there are traces of the presence of such specialists—Demetrius of Alopece, for example. Whether this is a matter of differences in technique, temperament, or some other factor (there even seem to be whole periods distinguished for portraiture of youths, old men, lovely women, but not all types of subject at once), it surely does not indicate that the character of his subject will, in any significant way, modify an artist's way of working *as an artist*.

3. *A mediocre artist may raise himself to the ranks of the great in meeting the challenge of a particularly striking subject.* We should be happy to be supplied with a list of examples of this circumstance. There are, it is true, artists otherwise unremarkable who have created one or more fine portraits; it is equally indisputable that some of the greatest artists have been quite incapable of making a decent portrait. Specialists, after all, have their place in all fields of endeavor. We have no justification for saying, in the former case, that the artist was "painting over his head"; about the only generalization that might be offered is that this particular sort of specialist flourishes only in periods, such as republican Rome or fifteenth-century Flanders, when the most objective approach to the portrayal of the subject is dominant. Nevertheless, striking as one or two of Michael Sittow's portraits may be, no one could seriously maintain that any of them surpassed the finest by Hans Memling or that either of these painters reached the level of Van der Weyden or Van Eyck.

With regard to the ancient world, it is again the difficulty of attributing surviving images to known hands that makes a detailed analysis of this question impossible. Nevertheless, the decisive importance of Lysippus' portrait of Alexander the Great may be cited as evidence that, in whatever period, the greatest portraits with the most powerful influence will be the product of great artists.

A converse point might also be made. The numerous decidedly inferior portraits of eminent men in all fields of human activity, from poetry to politics, is not merely a demonstration of the fact that few figures in history have matched Alexander in sensitivity as a patron of the arts. It seems to indicate that a powerful personality will not necessarily evoke a significant work of art—matching his own excellence in the world of affairs—from a run-of-the-mill portraitist. It may even be that too powerful a personality can overwhelm the artist of normal capacities, so that only the very greatest artist can meet the challenge. The sort of work Alazard refers to—the startling and evocative portrait created by an otherwise obscure artist—seems invariably to portray an equally obscure subject.

Our purpose in undertaking this extended critique of this frequently encountered statement is, therefore, to reassert our basic premise that the art of portraiture does not diverge in any significant way from the general character of the art of the period in which it is created; if there are stylistic "laws" governing the nature of art at any given time and place, these laws are obeyed by the portraitist as much as by any other artist.

In the course of surveying the early history of the portrait, we have found it useful to keep in mind both the broader and the narrower answers to the question, "What is a portrait?" that we examined in Chapter I. While it must be conceded that the most workable definition is the restrictive one proposed by Schweitzer,

which can first be applied to works made by the Greeks in the postclassical period, it has proved instructive to relate such material to the larger category of images of particular individuals which do not meet all of Schweitzer's strict requirements.

Such "proto-portraits" are to be found in a wide range of pre-literate societies; when their function can be defined, it virtually always relates to funerary practices. Hence such likenesses concern the very important relationship of the living to the dead. Again, the making of funerary effigies in these pre-literate societies is almost always linked with the practice of inhumation rather than cremation—a curious by-product of the fact that there is a great division between those societies which place great stress on bodily preservation after death and those which take the contrary direction and seek to destroy all traces of the physical remains of the departed.[6] At first glance it might appear that cremation would be more closely related to the common primitive fear of the dead; yet this fear is far too universal for cremation practices to be a true index of its incidence. All funerary practices have to do with coping with this dread; we simply have different modes of doing so.

Considered functionally, a funerary image may serve a variety of purposes. It may be a *relic* of the individual commemorated, and this seems to be its earliest form; it may serve as the *double* of his body, as in the Egyptian tomb; or it may offer a *reminder* to the living, as on the Greek tomb *stelae*, where the fully naturalistic or "true" portrait never appears. In all these cases the "true" portrait has not yet come into existence, because the individual "represented" is not really the subject of the work. Only when the subject is shown "for his own sake" can we really speak, first, of the portrait as it concerns itself with the whole of the person and, second, of a work of art, not a work of magic.

It would seem that, almost by definition, the funerary effigy cannot fulfill the requirements of the "true" portrait; periods in which funerary images meeting these criteria were actually made, such as republican Rome or Ptolemaic Egypt, are ones in which the influence of the fully developed "true" portrait concept had become superimposed upon older cult practices. At the same time, the more "living" a likeness, the further it tends to be removed from the norm of simple funerary art.

The portrait "for its own sake" is the special kind which we can consider the fully developed mode of portraiture: a work of art which seeks to represent the totality of an individual, for the sake of his individuality. Once created by the Greeks, the history of this mode is continuous to our own time, although attitudes toward the most appropriate manner of portraying the individual may change from time to time.

We have seen, then, that this "true" portrait is a creation of postclassical Greek artists and that, following this period of initial flowering, it becomes a major art form in the Hellenistic world and its political successor, the Roman empire. As the art of the empire is transformed into the new style we call the Late Antique, the nature of portraiture also changes, so that with the dawn of the new Christian empire we find a new sort of conceptualization determining the form taken by the portrait likeness.

In all these transmutations of the art of portraiture—as in the prior developments, which we termed the prehistoric period of the portrait—we have found parallels between the character of the portrait image and contemporary views on the nature of the human individual and his personality. Unless we are to regard art as a completely autonomous activity with no relation to any other human occupation—a matter it should not be necessary to debate—this interaction is scarcely surprising. It is precisely because some awareness of the significance of the individual exists that the art of portraiture, which gives that awareness visible form, comes into being. The problem of portraiture as a historical phenomenon offers a particularly clear-out example of a linkage between art forms and intellectual activity, an important reason for undertaking its study from the conceptual point of view.

The fundamental problem at stake is the question of identity, faced by man throughout his history as a sentient being. It may be a question (as has often been asserted) that man first seriously confronted in the face of death.[7] Identity may be defined in a multitude of ways, and some of the most primitive concepts have survived unchanged to the present day. The problem of identity, and of its correlative, identification, is fundamental to the study of the portrait and brings us close to some of the simplest—and most unanswerable—questions of all: not just "Who am I?" but also "Who are you?"

It seems noteworthy that the self-portrait does not appear in any significant way in all the vast range of material surveyed thus far. A few putative self-portraits are mentioned in the ancient sources, but, even if these are more than legendary, they do not assume the status of a special form of the portrait, as we find it in modern times. On the basis of modern examples, it would seem that self-portraits are ordinarily quite easy to identify, not merely for such technical reasons as the customary absence of the left (sitter's actual right) hand. It may be that the self-portrait demands a kind of self-assertiveness not felt by artists except at moments of especially high self-consciousness, which were rare before the Renaissance.

The sense of identity is a tenuous one. Examined too closely, it may slip from the grasp, as happens sometimes to a "modern" individual:

For as long as I can remember it has always surprised and slightly bewildered me that other people should take it so much for granted that they each possess what is called "a character"; that is to say, a personality with its own continuous history which can be described as objectively as the life-cycle of a plant or an animal. I have never been able to find anything of that sort in myself, and in the course of my life this has been the source of many misunderstandings, since other people persist in expecting of one a kind of consistency which, in the last resort, they really have no right to demand. . . . As a child this did not worry me, and if indeed I had known at that time of *Der Mann ohne Eigenschaften*, the man without qualities, I would have greeted him as my blood brother.[8]

The presupposition of the "true" portrait is that the personality does have a continuous history that can be described as objectively as the life-cycle of any other organism. This presumption can be challenged, as can any other, and the modern era is a time when most presuppositions are in question; this is but another of the reasons why it is fascinating to compare it with late antiquity.

If the Greeks first formulated the assumption that the depiction of physical form was relevant to an understanding of the psychic life of the individual, there was also latent in Greek thought an opposed attitude, the one expressed in an apocryphal legend of St. John the Evangelist:

The portrait is like me, yet not like me but like my fleshly image, for if this painter desireth to draw the very me in a portrait, he will need more than colors and things that are seen with the eye. This that thou hast done is childish and imperfect. Thou hast drawn a dead likeness of the dead.[9]

This was the dominant opinion as the history of the ancient world drew to its close and the new world of the Middle Ages came into being. In a sense, the development of the portrait to this point may be seen as having three stages: first, when the only manner of presenting the individual was through his physical, external shell; second, when an apprehension of the individual spirit was fused with this physical representation; and third, when the portrayal of that spirit was sought without that physical resemblance.

In the nature of things, a study of this sort cannot have a conclusion; it can only come to a pause in a moment of transition, as a new order of phenomena comes into being.

Notes

ABBREVIATIONS OF SERIAL PUBLICATIONS

Act. Arch.	*Acta Archaeologica*
A.J.A.	*American Journal of Archaeology*
Arch. Anz.	*Archälogischer Anzeiger, Beiblatt zum Jahrbuch des Deutschen Archäologischen Instituts*
Ath. Mitt.	*Mitteilungen des Deutschen Archaeologischen Instituts, Athenische Abteilung*
B.M.C.	*British Museum Catalogue*
Br. Mus. Quarterly	*British Museum Quarterly*
B.S.A.	*The Annual of the British School at Athens*
C.I.A.	*Corpus Inscriptionum Athenarum*
C.I.G.	*Corpus Inscriptionum Graecarum*
Gött. Nachrichten	*Nachrichten von der Gesellschaft der Wissenschaften zu Göttingen*
J.d.I.	*Jahrbuch des Deutschen Archäologischen Instituts*
J.H.S.	*Journal of Hellenic Studies*
J.pr.K.	*Jahrbuch des preussischen Kunstsammlungen*
J.R.S.	*Journal of Roman Studies*
Mem. Pont. Acc.	*Memorie della Pontificia Accademia Romana di Archeologia*
Mon. Linc.	*Monumenti antichi pubblicati per cura dell' Accademia dei Lincei*
Mon. Piot	*Monuments et Mémoires publiés par l'Académie des Inscriptions et Belles-Lettres (Fondation Eugène Piot)*

Chapter I

1. Cf. J. D. Breckenridge, "Portraiture and the Cult of the Skulls," *Gazette des Beaux-Arts*, VI^e Période, LXIII (1964), 275 ff.

2. F. D. Martin, "On Portraiture: Some Distinctions," *Journal of Aesthetics and Art Criticism*, XX (1961), 61.

3. This is an aspect of the problem of fifteenth-century Italian portraiture somewhat slighted by J. Alazard, *The Florentine Portrait* (London, 1948), p. 14.

4. B. Schweitzer, "Griechische Porträtkunst," *Acta Congressus Madvigiani Hafniae MDMLIV* (Copenhagen, 1957), III: *Portraiture*, pp. 8 f., as translated by B. V. Bothmer, *Egyptian Sculpture of the Late Period, 700 B.C. to A.D. 100* (Brooklyn Museum, 1960), p. 118.

5. II. lxv. 8–9. On the comparison, cf. E. Stiasny-Jacobsson, *Typus und Individuum: Studien zur Typenbildung und Individualisierung der antiken Kunst* (Vienna, 1934), p. 55.

6. R. Delbrück, *Antike Porträts* (Bonn, 1912), p. vii.

7. E. Panofsky, *Tomb Sculpture* (New York, 1964), p. 15.

8. R. G. Collingwood, *The Principles of Art* (New York, 1958), pp. 76 f.

9. Cf. R. Carpenter, *Observations on Familiar Statuary in Rome* ("Memoirs of the American Academy in Rome," No. XVIII) (New York, 1941), pp. 74 ff.; the passage from Pliny is in *N.H.* XXXV. 153.

10. A. N. Zadoks–Josephus Jitta, *Ancestral Portraiture in Rome and the Art of the Last Century of the Republic* ("Allard Pierson Stichting, Universiteit van Amsterdam: Archaeologisch-historische Bijdragen," No. 1) (Amsterdam, 1932), pp. 47 f.

11. Cf. K. Schefold, *Die Bildnisse der antiken Dichter Redner und Denker* (Basel, 1943), pp. 27 f.

12. E. H. Gombrich, *Art and Illusion: A Study in the Psychology of Pictorial Representation* (New York, 1959), p. 87.

13. *Ibid.*, p. 90.

14. Collingwood, *op. cit.*, pp. 52 ff., esp. p. 53.

15. J. Wilson in H. and H. A. Frankfort (eds.), *Before Philosophy* (Harmondsworth, 1949), p. 41.

16. D. Riesman, *Individualism Reconsidered* (Glencoe, Ill., 1954), pp. 354 f.

17. G. Pasquali, "Omero, il brutto e il ritratto," *Critica d'Arte*, V, Pt. 1 (1940), 34. Cf. *ibid.*, p. 35: "Si opporrá che la bellezza è più difficile a descrivere che la deformitá?"

18. Cf. Stiasny-Jacobsson, *op. cit.*, pp. 18 ff.

19. In Xenophon *Memorabilia* III. x. 1 ff.

20. Cf. M. Bieber, "The Portraits of Alexander the Great," *Proceedings of the American Philosophical Society*, XCIII, Pt. 5 (1949), 427.

21. Panofsky, *op. cit.*, p. 16.

22. Cf. H. A. Groenewegen-Frankfort, *Arrest and Movement: An Essay on Space and Time in the Representational Art of the Ancient Near East* (London, 1951).

Chapter II

1. K. M. Kenyon, *Digging Up Jericho* (London, 1957), pp. 60 ff.

2. For Melanesian examples cf. R. W. Firth, *Art and Life in New Guinea* (London, 1936), p. 101; R. Linton and P. Wingert, *Arts of the South Seas* (New York, 1946), pp. 115, 152, 157, 189; cf. D. Newton, *Art Styles of the Papuan Gulf* (New York, 1961), pp. 17 f. For general information cf. P. Wernert, "Le culte des crânes à l'époque paléolithique," in M. Gorce and R. Mortier (eds.), *Histoire générale des religions* (Paris, 1948), I, 53 ff., with bibliography on pp. 517 f. J. D.

Breckenridge, "Portraiture and the Cult of the Skulls," *Gazette des Beaux-Arts*, VIᵉ Période, LXIII (1964), 275 ff., is a preliminary study of much of the material presented in this section.

3. E. O. James, *Prehistoric Religion: A Study in Prehistoric Archaeology* (London, 1957), p. 120; cf. pp. 118 ff. in general.

4. Cf. M. Eliade, *Yoga: Immortality and Freedom* (New York, 1958), pp. 296 ff., and *Shamanism: Archaic Techniques of Ecstasy* (New York, 1964), pp. 421 and 434 ff. B. Laufer, *Use of Human Skulls and Bones in Tibet* (Field Museum of Natural History, Leaflet No. 10) (Chicago 1923), includes an often quoted survey of comparative material.

5. Cf. Eliade, *Shamanism*, p. 245. The basic study is W. Jochelson, *The Yukaghir and the Yukaghirized Tungus* ("American Museum of Natural History, Memoirs," Vol. XIII, Nos. 2–3) (New York, 1924–26).

6. Eliade, *Shamanism*, pp. 382 and 391.

7. Cf., e.g., James, *op. cit.*, p. 20; Wernert, *op. cit.*, pp. 64 f.

8. G. R. Levy, *The Gate of Horn* (London, 1948), p. 69.

9. Cf., e.g., J. Maringer, *The Gods of Prehistoric Man* (London, 1960), pp. 53 ff.

10. *Ibid.*, pp. 20 f. Cf. the reports of A. C. Blanc, especially his *Il sacro presso i primitivi* (Rome, 1945).

11. Cf., e.g., Wernert, *op. cit.*, pp. 55 ff. Chronology in this section is based on F. E. Zeuner, *Dating the Past* (London, 1953), pp. 274 ff.; while the absolute dates continue to be subject to controversy and correction as more data are provided by natural clocks, the relative chronology seems fairly well established, and this is what matters to us here.

12. Cf. the discussion in Wernert, *op. cit.*, pp. 55 ff., as well as Maringer, *op. cit.*, pp. 22 ff. Cf. also M. Eliade, *The Sacred and the Profane: The Nature of Religion* (New York, 1959), pp. 102 f.

13. Cf. Maringer, *op. cit.*, pp. 54 f., and the examples cited by Laufer, *op. cit.*, pp. 6 ff.

14. Cf. Firth, *op. cit.*, p. 123; Newton, *op. cit.*; and also Linton and Wingert, *op. cit.*, pp. 168 and 51. Valuable on the subject in general is P. Wernert, "Les hommes de l'âge de la pierre représentaient-ils esprits des défunts et des ancêtres?" in Gorce and Mortier, *op. cit.*, I, 73 ff., as well as subsequent sections of the same volume on practices of various existing societies.

15. James, *op. cit.*, pp. 127 f.

16. Cf. for general bibliography R. L. Hoyle, *Los Mochicas* (Lima, 1941).

17. Cf. F. Willett, *Ife in the History of West African Sculpture* (London, 1967), pp. 129 ff. This is the most recent study of the Ife "bronzes" in context. On the relative degree of naturalism involved, cf. pp. 19 f. and *passim*; also it is noted that, when full-length figures are made, the total proportions are unlike those of normal human beings. This exclusive concern with naturalism of the face compares with the contrast between realistic head and antinaturalistic pot-body in the Mochica jars.

18. James, *op. cit.*, pp. 110 f. It should be evident that no attempt has been made to rationalize or reconcile the widely varying systems of transliteration of Egyptian names when using direct quotations.

19. *Ibid.*, p. 111; cf. W. S. Smith, *The Art and Architecture of Ancient Egypt* (Baltimore, 1958), p. 47.

20. C. Aldred, *Old Kingdom Art in Ancient Egypt* (London, 1949), p. 30; cf. Smith, *op. cit.*, p. 61.

21. *Mélanges Maspéro*, I ("Mémoires de l'Institut français d'archéologie orientale du Caire," Vol. LXVI, 1935–38), 103.

22. Cf. Aldred, *op. cit.*, pp. 4 and 34.

23. E. H. Gombrich, *Art and Illusion* (New York, 1959), p. 90.

24. Aldred, *op. cit.*, p. 1.

25. *Ibid.*, p. 4.

26. Cf. E. A. W. Budge, *The Book of the Opening of the Mouth* (London, 1909).

27. James, *op. cit.*, p. 245.

28. J. A. Wilson, *The Culture of Ancient Egypt* (Chicago, 1960), p. 86.

29. *Ibid.*, pp. 64 f.

30. Quoted by Gombrich, *op. cit.*, p. 143.

31. Wilson, *op. cit.*, p. 54.

32. *Ibid.*, pp. 109 f.

33. Cf. the new translation and interpretation by H. Jacobsohn, "The Dialogue of a World-Weary Man with His Ba," tr. A. R. Pope, in *Timeless Documents of the Soul* (Evanston, 1968), utilized in our discussion.

34. C. Aldred, *Middle Kingdom Art in Ancient Egypt, 2300–1590 B.C.* (London, 1950), pp. 2 f. Italics in the quotation are ours.

35. Wilson, in H. and H. A. Frankfort (eds.), *Before Philosophy* (Harmondsworth, 1949), p. 120.

36. J. B. Pritchard (ed.), *Ancient Near Eastern Texts Relating to the Old Testament* (Princeton, 1950), p. 418.

37. Aldred, *Middle Kingdom Art*, p. 27.

38. Wilson, *Culture of Ancient Egypt*, pp. 132 f.

39. *Ibid.*, p. 141.

40. *Ibid.*, pp. 142 ff.

41. *Ibid.*, p. 143.

42. Cf. Aldred, *Middle Kingdom Art*, p. 24.

43. C. Aldred, *New Kingdom Art in Ancient Egypt during the Eighteenth Dynasty, 1590 to 1315 B.C.* (London, 1951), p. 11.

44. H. Frankfort, *Ancient Egyptian Religion: An Interpretation* (New York, 1948), p. 48.

45. Wilson, in Frankfort and Frankfort (eds.), *Before Philosophy*, p. 41.

46. Aldred, *New Kingdom Art*, pp. 36 ff. Wilson (*Culture of Ancient Egypt*, pp. 193 ff.) discusses the shift in aesthetic feeling that he suspects may have begun under Thut-mose III.

47. Wilson, *Culture of Ancient Egypt*, pp. 231 ff.; Aldred, *New Kingdom Art*, pp. 28 ff.

48. Aldred, *New Kingdom Art*, pp. 28 ff.

49. Wilson, *Culture of Ancient Egypt*, pp. 216 f.

50. *Ibid.*, pp. 218 ff.

51. *Ibid.*, pp. 223 f.

52. W. S. Smith, *Art and Architecture*, p. 205.

53. Aldred, *New Kingdom Art*, pp. 73 f.

54. Smith, *op. cit.*, p. 178.

55. Wilson, *Culture of Ancient Egypt*, p. 218.

56. Cf. G. Röder, "Lebensgrosse Tonmodelle aus einer altägyptischen Bildhauerwerkstatt," *J.pr.K.*, LXII (1941), 145 ff.

57. J. E. Quibbel, *Excavations at Saqqara (1907–1908)* (Cairo, 1909), Pl. LV and p. 112.

58. Aldred, *New Kingdom Art*, p. 12.

59. H. Frankfort, *Ancient Egyptian Religion*, p. 48.

60. Wilson, *Culture of Ancient Egypt*, pp. 267 ff.

61. *Ibid.*, pp. 297 ff.

62. *Ibid.*, p. 301.

63. *Ibid.*, p. 305.

64. *Ibid.*, pp. 294 f.

65. Cf. the magnificent exhibition catalogue, B. V. Bothmer, *Egyptian Sculpture of the Late Period, 700 B.C. to A.D. 100* (Brooklyn Museum, 1960).

66. Smith, *op.cit.*, pp. 248 f.

67. Bothmer, *op. cit.*, pp. 164 ff. On the relation of Ptolemaic Egyptian portraiture to that of the Roman republic cf. below, Chapter IV.

68. Wilson, *Culture of Ancient Egypt*, pp. 152 f.

69. H. Frankfort, *The Art and Architecture of the Ancient Orient* (Baltimore, 1954), p. 23.

70. Cf. A. L. Oppenheim, *Ancient Mesopotamia: Portrait of a Dead Civilization* (Chicago, 1964), esp. pp. 172 ff.

71. *Ibid.*, p. 200.

72. *Ibid.*, p. 185.

73. *Ibid.*, pp. 201 ff.

74. Cf. T. Jacobsen in Frankfort and Frankfort (eds.), *Before Philosophy*, pp. 200 ff.

Chapter III

1. *Natural History* XXXV. 151; Athenagoras *Presbeia peri Christianon* 17.

2. Cf. G. Karo, *Die Schachtgräber von Mykenai* (Munich, 1930), Pls. XLVII–LII.

3. Identification of racial types from the masks might be feasible, but the skeletal remains were undoubtedly more useful; cf. C. W. Blegen, "Early Greek Portraits," *A.J.A.*, LXVI (1962), 245 ff. Cf. Karo, *op. cit.*, and Sp. Marinatos, "Minoische Porträts," *Festschrift für Max Wegner* (Münster, 1962), pp. 9 ff.

4. A. H. Smith, *A Catalogue of Sculpture in the Department of Greek and Roman Antiquities, British Museum* (London, 1892), I, 16 ff.; the inscribed figure is No. 14, p. 21. (Cited hereafter as "*B.M.C. Sculpture*."

5. R. M. Dawkins, *The Sanctuary of Artemis Orthia at Sparta* (*J.H.S.*, Supp. Vol. V, 1929), Pls. XLVIII–LXII and pp. 163 ff.; quotation, p. 168.

6. E.g., by G. M. A. Richter, *The Sculpture and Sculptors of the Greeks* (New Haven, 1950), p. 36. On the other hand, in *The Portraits of the Greeks* (hereafter referred to as *P.G.*) (London, 1965), I, 30 f., Miss Richter intimates beginnings of Greek portraiture as early as the seventh century B.C., without indicating what works she would place at this date.

7. Cf. W. W. Hyde, *Olympic Victor Monuments and Greek Athletic Art* (Washington, 1921).

8. Pausanias *Description of Greece* VI. xviii. 7 (trans. W. H. S. Jones, Loeb Classical Library ed., III, 109 ff.).

9. *Ibid.*, VI. xv. 8.

10. *Ibid.*, VIII. xl. 1.

11. G. M. A. Richter, *Kouroi* (New York, 1942), No. 11, pp. 78 ff., and Pls. XVIII, XIX, and XXIII.

12. Pliny *Nat. Hist.* XXXIV. 16 (trans. H. Rackham, Loeb Classical Library ed., IX, 139).

13. *Ibid.*, XXXIV. 17.

14. Cf. Richter, *Sculpture and Sculptors*, p. 200, n. 9.

15. S. Brunnsäker, *The Tyrant-Slayers of Kritios and Nesiotes* (Lund, 1955).

16. V. Poulsen, *Les Portraits grecs* ("Publications de la Glyptothèque Ny Carlsberg," No. 5) (Copenhagen, 1954), pp. 11 f.

17. K. Schefold, *Die Bildnisse der antiken Dichter Redner und Denker* (Basel, 1943), p. 25.

18. I. xxiii. 9.

19. Pliny *Nat. Hist.* XXXV. 57; cf. Pausanias I. xv. 3.

20. Implied by Pausanias I. xxi. 2.

21. Aeschines III. 186 (*Against Ctesiphon*).

22. Plutarch *Pericles* 31. 2 ff.; cf. Richter, *P.G.*, I, 150 f.

23. We would reject V. Poulsen's identification of a portrait type identifiable as Phidias: "Phidiasische Bildnisse," *Neue Beiträge zur klassischen Altertumswissenschaft: Festschrift Bernhard Schweitzer* (Stuttgart, 1954), pp. 202 ff.

24. Cf. E. Stiasny-Jacobsson, *Typus und Individuum: Studien zur Typenbildung und Individualisierung der antiken Kunst* (Vienna, 1934), pp. 52 f., and B. Schweitzer, *Studien zur Entstehung des Porträts bei den Griechen* ("Berichte über die Verhandlungen der Sächsischen Akademie der Wissenschaften zu Leipzig, Phil.-hist. Klasse," XCI, Pt. 4) (Leipzig, 1939), pp. 51 ff.

25. X. x. 2.

26. First outlined by Miss Richter in *Three Critical Periods of Greek Sculpture* (Oxford, 1951), p. 6, the thesis was further developed in her *Greek Portraits: A Study of Their Development* ("Collection Latomus," No. XX) (Brussels, 1955), pp. 15 ff. Now cf. *P.G.*, I, 31 f., 97 ff.

27. Cf. Richter, *Three Critical Periods*, Fig. 8.

28. *Ibid.*, p. 6.

29. V. Poulsen, *Les Portraits grecs*, pp. 11 f.

30. R. Calza, *I Ritratti*, I: *Ritratti greci e romani fino al 160 circa D.C.* (*Scavi di Ostia*, Vol. V, Pt. 1) (Rome, 1964), 11 ff. Cf. the article by the discoverer of the herm, G. Calza, "A proposito del ritratto di Temistocle scoperto a Ostia," *Critica d'Arte*, V, Pt. 1 (1940), 15 ff.

31. Cf. the visual argument made by Bianchi Bandinelli in *Critica d'Arte*, V, Pt. 1 (1940), Pl. XIV, in rebuttal of Calza's dating; cf. the remarks of J. M. C. Toynbee, *J.H.S.*, LXXIII (1953), 183 f., and of H. H. O. Chalk, *J.H.S.*, LXXVI (1956), 132. Discussion continues, with a recent suggestion of a late antique dating by H. Weber, *Gnomon*, XXVIII (1955), 445 f. For bibliography to date cf. R. Calza, *op. cit.*, I, 13 f., and Richter, *P.G.*, I, 97 ff.

32. Ny Carlsberg Glyptotek Cat. (hereafter "NCG") No. 450a, V. Poulsen, *Les Portraits grecs*, No. 18, pp. 12, 16 ff., and 47 f., with discussion of the relationship to the Themistocles problem. Cf. Richter, *P.G.*, III, 251.

33. Schefold, *op. cit.*, p. 63; Richter, *P.G.*, I, 99 ff.

34. H. P. L'Orange, in *Revue archéologique*, VI, Pt. 31-2 (*Mélanges Picard*, Vol. II) (1949), 668 ff., Figs. 1-3; cf. Richter, *P.G.*, I, 99 ff.

35. *C.I.A.*, IV, No. 403a, confirming Pliny *Nat. Hist.* XXXIV. 74 and Pausanias I. xxv. 1 and xxviii. 2.

36. Smith, *B.M.C. Sculpture*, I, 288 f., No. 549; cf. Richter, *P.G.*, I, 102 ff.

37. Cf. also Richter, *P.G.*, I, Fig. XVII.

38. *History* II. lxv. 8 f.

39. NCG No. 491: V. Poulsen, *Portraits grecs*, No. 1, p. 13; cf. R. Kekulé von Stradonitz, "Anakreon," *J.d.I.*, VII (1892), 119 ff. See now Richter, *P.G.*, I, 75 ff.

40. Pausanias I. xxv. 1. V. Poulsen suggests that the head in Copenhagen, NCG No. 2001, reproduces this portrait (*Portraits grecs*, No. 2, pp. 27 f.).

41. V. Poulsen, *Portraits grecs*, pp. 27 f. (with additional bibliography), following Furtwängler.

42. Pliny *Nat. Hist.* XXXIV, 82 (trans., IX, 189).

43. *Ibid.*, XXXVI. 11 (trans. K. Jex-Blake and E. Sellers [London, 1896], p. 187).

44. J. Babelon, *Le portrait dans l'antiquité d'après les monnaies* (Paris, 1942), pp. 60 f.

45. Cf. M. Bieber, *The Sculpture of the Hellenistic Age* (New York, 1955), p. 71.

46. *Ibid.*

47. [C. C. Vermeule], *Greek and Roman Portraits, 470 B.C.—A.D. 500* (Boston, 1959), No. 3.

48. Cf. V. Poulsen, *Portraits grecs*, pp. 13 f.

49. Smith, *B.M.C. Sculpture*, II, 91 ff., No. 1000. Cf. Richter, *P.G.*, II, 161 f.

50. X. ix. 7 ff. (trans. Jones, Loeb Classical Library ed., IV, 417 ff.).

51. *Ibid.*, X. x. 1 (trans., IV, 421).

52. *Against Leptines* 70 (delivered in 355 B.C.).

53. *Against Aristocrates* 196 f. (delivered in 352 B.C.).

54. Cornelius Nepos *Timotheus* II. 3; the statue is mentioned by Pausanias X. x. 1. Another monument to both father and son, in which they shared a single base, was placed on the Acropolis: Pausanias I. xxiv. 3; the base has been identified: *C.I.A.*, II, No. 1360.

55. Pliny *Nat. Hist.* XXXIV. 74.

56. Quintilian *Institutio oratoria* XII. x. 9 (trans. H. E. Butler, Loeb Classical Library ed., IV, 455).

57. *Philopseudes* 20 (trans. A. M. Harmon, Loeb Classical Library ed., III, 353).

58. *Ibid.*, 20 (trans., III, 353).

59. *Ibid.*, 20, and Pliny *Nat. Hist.* XXXIV. 76; a statue of Lysimache on the Acropolis is mentioned in Pausanias I. xxvii. 4.

60. Cf. Bieber, *op. cit.*, p. 42; J. M. C. Toynbee, *J.H.S.*, LXXVI (1956), 130; and Richter, *P.G.*, I, 155 f.

61. The relevant inscriptions are *C.I.G.*, II², Nos. 3828, 4321, 4322 (all dated *ca.* 350 B.C.), and 4895 (ca. 360). On the other hand, D. M. Lewis (*B.S.A.*, L [1955], 4) states that none of these is actually later than *ca.* 360. The recent discoveries are published by B. D. Merritt, *Hesperia*, XVII (1948), 38 f., No. 24, and A. E. Raubitschek, *Dedications from the Athenian Acropolis* (Cambridge, 1949), pp. 159 f., No. 143.

62. Cf. V. Poulsen, *Portraits grecs*, pp. 15 f., 39 ff.

63. A. Hekler, *Greek and Roman Portraits* (London, 1912), p. x. The same caution must be applied to the small portrait sketches on which Miss Richter has laid the burden of transmitting the record of individual appearances from earlier, generally idealizing artistic periods to later, naturalistically oriented ones. Certainly the examples published in her *Greek Portraits III: How Were Likenesses Transmitted in Ancient Times?* ("Collection Latomus," No. XLVIII) (Brussels, 1960), conform very well to the ideational limits of their respective periods.

64. Diogenes Laertius *Lives of the Eminent Philosophers* III. 25.

65. Cf. *Ath. Mitt.*, XXVIII (1903), 348 ff.

66. But cf. Richter, *P.G.*, II, 169 f., for a less sanguine view.

67. Cf. R. Boehringer, *Platon: Bildnisse und Nachweise* (Breslau, 1935), the definitive and generally accepted monograph. It may be noted, however, that doubts of the identification are still expressed: see, e.g., K. Kraft, "Über die Bildnisse des Aristoteles und des Platon," *Jahrbuch für Numismatik und Geldgeschichte*, XIII (1963), 7 ff. The objection starts with acceptance of the inscription "Zeno" on the Vatican herm (our Fig. 48)—although this inscription was denounced as modern over eighty years ago (W. Helbig, *J.d.I.*, I [1886], 72). Kraft, identifying this type with Zeno notwithstanding, then refers the generally accepted Aristotle (our Fig. 60) to Plato, and the pseudo-Menander (Richter, *P.G.*, II, 224 ff. and Figs. 1514–1643) to Aristotle. Kraft's visual comparisons are not persuasive; despite his claim, the existing type usually identified with Zeno is not comparable with that of the Vatican herm, nor are his reasons for assigning the pseudo-Menander to Aristotle nearly so good as those offered for the customary identification. Kraft's basic material for his revised identifications—engraved gems—is not sufficiently reliable in distinctive details (due to scale in the first place) to support so radical a thesis.

68. Diog. Laert. III. 26, 28.

69. *From the Collections of the Ny Carlsberg Glyptotek*, I (1931), 42.

70. Cf. T. B. L. Webster, *Art and Literature in Fourth Century Athens* (London, 1956), pp. 10 ff.

71. Pliny *Nat. Hist.* XXXIV. 81 f. (trans. Rackham, IX, 187 f.; italics ours). Cf. E. Schmidt, "Silanion der Meister des Platonbildes," *J.d.I.*, XLVII (1932), 239 ff., and XLIX (1934), 180 ff.

72. Pausanias IX. xxii. 3.

73. R. Kekulé von Stradonitz, "Die Bildnisse des Sokrates," *Abhandlungen der Bayerische Akademie der Wissenschaften*, I (1908). Richter, *P.G.*, I, 110 ff., inserts the questionable "pathetic"

type exemplified by the head in the Villa Albani, her No. 3, into this category; we would include only her Nos. 1, 2, 4, 5, 7, and 9. On the other hand, Diepolder's doubts concerning the Munich bronze, quoted in Richter, pp. 111 f., may also be well justified.

74. Xenophon *Symposium* iv. 19—v. 10; cf. Plato *Meno* 80A.

75. Plato *Symposium* 215A–B (trans W. R. M. Lamb, Loeb Classical Library ed., V, 219).

76. Cf. Richter, *P.G.*, I, 112.

77. *Ibid.*, II, 207 f.

78. *Ibid.*, I, 147 ff.; cf. F. Poulsen, *Greek and Roman Portraits in English Country Houses* (Oxford, 1923), pp. 27 ff., No. 1.

79. Cf. V. Poulsen, "Et berømt Filosofpar," *Meddelelser fra Ny Carlsberg Glyptotek*, VIII (1951), 33 ff.

80. Richter, *P.G.*, I, Figs. 675–77.

81. Still followed by Miss Richter, who makes of it Type III, in *P.G.*, I, 130 f., in her entry for Sophocles.

82. As in *P.G.*, I, 128 ff., Miss Richter's Type II.

83. E.g., by Hekler, *J.d.I.*, XLII (1927), 68, and by Th. Reinach, *J.H.S.*, XLII (1922), 50 ff. (repudiating the identification with Sophocles entirely).

84. Cf. Reinach, *op. cit.*

85. G. M. A. Richter, *Greek Portraits IV: Iconographic Studies: A Few Suggestions* ("Collection Latomus," No. LIV) (Brussels, 1962), Fig. 25, Pl. X; and, now, *P.G.*, I, Fig. 682.

86. Cf. Richter, *P.G.*, I, 9 f., on small-scale reproductions.

87. *Ibid.*, I, Figs. 683–88, etc.

88. Cf. K. Friis Johansen, *The Attic Grave-Reliefs of the Classical Period* (Copenhagen, 1951), p. 13 and especially note 2.

89. Aelius Aristides *Oratio* XLVI. 161. 13 ff. (ed. Dindorff, II, 215), with scholium (ed. Dindorff, III, 535 f.). Cf. Richter, *Greek Portraits IV*, 9 ff.

90. Plutarch *Vit. x orat.* (*Moralia* 841C–D, F); Diog. Laert. II. 5, 43. Pausanias I. xxi. 1 ff. includes Aeschylus in the group of statues only by implication. Cf. Richter, *P.G.*, I, 121. For the dating to 334–331 B.C. cf. G. Kleiner, in *Neue Beiträge zur klassischen Altertumswissenschaft: Festschrift Bernhard Schweitzer* (Stuttgart, 1954), p. 238.

91. Diog. Laert. II. 43.

92. Cf. Kleiner, *op. cit.*, and F. P. Johnson, *Lysippos* (Durham, N.C., 1927), pp. 321 ff.; also Richter, *P.G.*, I, 112 ff.

93. Cf. J. D. Breckenridge, "Multiple Portrait Types," *Institutum Romanum Norvegiae. Acta ad archaeologiam et artium historiam pertinentia*, II (1965), 9 ff.

94. Richter, *P.G.*, I, 125 ff.

95. W. A. Amelung, "Il ritratto di Sofocle," *Mem. Pont. Acc.*, I, Pt. 2 (1924), 119 ff., and Fig. 6; Richter, *P.G.*, I, 121 ff.

96. Cf. V. Poulsen, *Portraits grecs*, No. 11, pp. 38 f. The identification of the Rieti type with Euripides is of course rejected by Miss Richter, in *Greek Portraits II: To What Extent Were They Faithful Likenesses?* ("Collection Latomus," No. XXXVI) (Brussels, 1959), pp. 31 ff., and in *P.G.*, I, 139 f.

97. The "Farnese" type of portrait of Sophocles appears in Etruria early in the third century B.C.: R. Herbig, *Die jüngeretruskische Steinsarkophage* (Berlin, 1952), No. 148, pp. 67 ff. and Pl. 95.

98. Richter, *P.G.*, I, 94 ff.; V. Poulsen, "Poet or General, an Iconographical Puzzle," *Burlington Magazine*, XCII (1950), 194.

99. V. Poulsen, *Portraits grecs*, No. 18, pp. 12, 16 ff., and 47 f.

100. Webster, *op. cit.*, p. 5.

101. *De poetica* 1460b.

102. F. Studniczka, *Das Bildnis des Aristoteles* (Leipzig, 1908). As noted above, n. 67, this identi-

fication has recently received a fresh but unpersuasive challenge. In addition to Kraft, there is an independent attack by J. H. Jongkees, *Fulvio Orsini's Imagines and the Portrait of Aristotle* (''Archaeologica Trajectina,'' Vol. IV) (Gröningen, 1960). For a rebuttal cf. Richter, *Greek Portraits IV*, 30 ff., and *P.G.*, II, 170 ff.

103. E. Pfuhl, *Die Anfänge der Griechischen Bildniskunst: Ein Beitrag zur Geschichte der Individualität* (Munich, 1927), p. 8. Cf. W. Jaeger, *Aristotle* (Oxford, 1934), p. 322.

104. *Phaedo* 79–80 (trans. B. Jowett, *The Dialogues of Plato* [Oxford, 1953], I, 434 f.).

105. *De anima* I. 1 (403a–b) (trans. J. A. Smith, *The Works of Aristotle*, ed. W. D. Ross [Oxford, 1931], III).

106. *Ibid.*, III. 5 (430a).

107. *Ibid.*, II. 2 (414a).

108. *C.I.G.*, No. 136.

109. Diog. Laert V. 51 (*s.v.* ''Theophrastus'').

110. E.g., H. Schrader, *Die Antike*, II (1936), 124 ff.; A. Hekler, *Bildnisse berühmter Griechen* (Berlin, 1940), p. 25; G. Lippold, *Die griechische Plastik* (''Handbuch der Archäologie,'' Vol. III, Pt. 1) (Munich, 1950), pp. 213 ff.—an imposing list of authorities to find on the ''wrong'' side of of an argument!

111. Cf. V. Poulsen in *Act. Arch.*, XIII (1942), 151 ff.

112. Richter, *P.G.*, II, 210 f.

113. *Ibid.*, 212 ff.

114. *Ibid.*, 176 ff.

115. *Ibid.*, 162.

116. *Ibid.*, 215 ff., with 47 large-scale copies in addition to a large number of miniatures, statuettes, cameos, and the like.

117. Plutarch *Demosthenes* 30 f.; *Vit. x orat.* (*Moralia* 844–48); cf. Pausanias I. viii. 2.

118. Theophrastus *Characters* II. 12 (''Flattery''). Richter (*P.G.*, I, 4 ff.) gives an excellent account of evidence of public dedications but rather slights that for private ones.

119. The definitive study is by M. Bieber, ''The Portraits of Alexander the Great,'' *Proceedings of the American Philosophical Society*, LXXXIII, Pt. 5 (1949), 373 ff., reissued as *Alexander the Great in Greek and Roman Art* (Chicago, 1964).

120. Bieber, *Alexander the Great*, pp. 32 ff.; cf. Richter, *P.G.*, III, Figs. 1730–35.

121. B. Ashmole, *J.H.S.*, LXXI (1951), 15 f.

122. Cf. H. P. L'Orange, *Apotheosis in Ancient Portraiture* (''Instituttet for Sammenlignende Kultursforskning,'' Ser. B., Vol. XLIV) (Oslo, 1947).

123. Richter, *P.G.*, III, 269 f., Figs. 1867–68.

124. Bieber, *Alexander the Great*, Pls. XVII–XXIV; Richter, *P.G.*, III, Figs. 1719–22.

125. *P.G.*, III, 259 ff., Figs. 1775, 1865–66.

126. *Ibid.*, pp. 278 f.

127. *Ibid.*, pp. 273 ff.

128. *Ibid.*, II, 179 ff.

129. *Ibid.*, pp. 181 ff.

130. *Ibid.*, pp. 186 ff.

131. *Ibid.*, pp. 190 ff.

132. *Ibid.*, pp. 194 ff.

133. *Ibid.*, I, 131, based on the bronze head in the British Museum.

134. *Ibid.*, pp. 50 ff.

135. E.g. the ''Pseudo-Seneca,'' *ibid.*, pp. 58 ff. (as Hesiod, one of the more plausible identifications).

136. C. Michalowski, *Les portraits hellénistiques et romains* ("Exploration archéologique de Délos," Vol. XIII [Paris, 1932]).

137. A check of examples of regional classifications in G. Hafner, *Späthellenistische Bildnisplastik* (Berlin, 1954), reveals a high proportion of unidentified likenesses, tending in style to approach quite closely the types usually considered "Roman."

Chapter IV

1. R. Hinks, *Carolingian Art* (London, 1935), pp. 123 f.

2. G. M. A. Richter, *J.R.S.*, XLV (1955), 39.

3. R. Hinks, *J.H.S.*, LIV (1934), 232.

4. This brief account is based on the brilliant summary given by K. Schefold, *Die Bildnisse der antiken Dichter Redner und Denker* (Basel, 1943), p. 196.

5. R. Carpenter, *Hesperia*, XX (1951), 37.

6. Cf. Schefold, *op. cit.*, pp. 42 f., and especially G. M. A. Richter, *Three Critical Periods of Greek Sculpture* (Oxford, 1951), pp. 53 ff., and *J.R.S.*, XLV (1955), 46.

7. Cf. E. B. Harrison, *The Athenian Agora*, I: *Portrait Sculpture* (Princeton, 1953); C. Michalowski, *Les portraits hellénistiques et romains* ("Exploration archéologique de Délos," Vol. XIII [Paris, 1932]); and, in general, G. Hafner, *Späthellenistische Bildnisplastik* (Berlin, 1954).

8. *Nat. Hist.* XXXV. 5−8 (trans. Rackham, IX, 264 ff.).

9. R. Carpenter, *Observations on Familiar Statuary in Rome* ("Memoirs of the American Academy in Rome," No. XVIII) (New York, 1941), pp. 74 f.; cf. Rackham's translation, pp. 373 ff.

10. For this terra cotta in Boston see L. D. Caskey, *Museum of Fine Arts, Catalogue of Greek and Roman Sculpture* (Cambridge, 1925), No. 108, pp. 189 ff.

11. On the question of the likeness implied in these ancestor masks, as well as on the relationship of later republican portraiture to native Roman and Italic funerary practices, see A. N. Zadoks-Josephus Jitta, *Ancestral Portraiture in Rome and the Art of the Last Century of the Republic* ("Allard Pierson Stichting, Universiteit van Amsterdam: Archaeologisch-Historische Bijdragen," No. 1) (Amsterdam, 1932). The work of O. Vessberg, *Studien zur Kunstgeschichte der römischen Republik* ("Skrifter Utgivna av Svenska Institutet i Rom," No. VIII) (Lund, 1941), is also fundamental. Cf. A. Boëthius, "On the Ancestral Masks of the Romans," *Act. Arch.*, XIII (1942), 226 ff.

12. B. Schweitzer, *Die Bildniskunst der römischen Republik* (Leipzig, 1948), Figs. 3−10.

13. Cf. above, pp. 83−84.

14. Cf. Richter, *J.R.S.*, XLV (1955), 39.

15. *Nat. Hist.* XXXIV. 24 (trans. Rackham, IX, 145).

16. Cf., e.g., Schweitzer, *op. cit.*, p. 1 and *passim*.

17. V. Poulsen, *Les Portraits romains I: République et dynastie julienne* ("Publications de la Glyptothèque Ny Carlsberg," No. 7) (Copenhagen, 1962), pp. 9 f.

18. Vessberg, *op. cit.*, pp. 5 ff., collects source material on early republican art.

19. *Ibid.*, p. 124 and Pl. III, 1; *Br. Mus. Quarterly*, XX (1956), 11 and Pl. VI, 2.

20. A. Furtwängler, *Antike Gemmen* (Leipzig, 1900), III, 163.

21. Cf. E. S. G. Robinson in *Essays in Roman Coinage Presented to Harold Mattingly* (Oxford, 1956), pp. 41 ff.; and M.-L. Vollenweider, *Museum Helveticum*, XV (1958), 27.

22. V. Poulsen, "Eine Verkannte Berühmtheit," ΘΕΟΡΙΑ: *Festschrift für W.-H. Schuchhardt* (Baden-Baden, 1960), pp. 173 ff. The best known examples of the popular likeness are those in the Louvre, No. 919, and Vatican, Braccio Nuovo, No. 602. Schweitzer, *op. cit.*, pp. 59 f. and Figs. 53−57, seems to have gone too far in divorcing the Louvre copy from the remainder of the group;

he identifies this as A. Postumius Albinus and the others as Sp. Postumius Albinus. Both prototypes are dated by him to the beginning of the first century B.C.

23. Cf. J. Babelon, *Le portrait dans l'antiquité d'après les monnaies* (Paris, 1942), pp. 110 ff.

24. *Ibid.*

25. *Ibid.*, pp. 114 ff.

26. Schweitzer, *op. cit.*, Figs. 54, 77, etc.

27. Cf. above, p. 147, and R. G. Collingwood, *The Principles of Art* (New York, 1958), pp. 76 f.

28. Schweitzer, *op. cit.*, pp. 79 ff. and Fig. 99.

29. *Ibid.*, pp. 86 ff.; Figs. 117, 121–24; 135, 137–39, 142–43, 146–47; 152–55, 158, 161–62, and 166.

30. Cf. *Arch. Anz.* (1938), No. 3, 103.

31. Cf. V. Poulsen, *Portraits romains*, I, 13 ff.

32. An inscribed bronze bust found at Volubilis: *Mon. Piot*, XLIII (1949), 71 and Pl. 8.

33. NCG No. 600: Poulsen, *Portraits romains*, I, 41 f., No. 2. Cf. *Meddelelser fra Ny Carlsberg Glyptotek*, XIII (1956), 6 ff.

34. The number of additional identifications which have been suggested at one time or another is enormous; it would be egregious to attempt even a partial list. The most intriguing, however, remains Carpenter's attempt to identify the great bronze "Hellenistic Ruler" in the Terme Museum with Sulla; cf. his *Observations*, pp. 81 ff.

35. Schweitzer, *op. cit.*, pp. 52 ff.

36. Cf. Poulsen, *Portraits romains*, I, 15 f.

37. Cf. Richter, *J.R.S.*, XLV (1955), 39 f.

38. *Ibid.*

39. G. M. A. Richter, "Who Made the Roman Portrait Statues, Greeks or Romans?" *Proceedings of the American Philosophical Society*, XCV (1951), 184 ff.; cf. also *J.R.S.*, XLV (1955), p. 40.

40. Cf. *Acta Congressus Madvigiani Hafniae MDMLIV* (Copenhagen, 1957), III, 46 f.

41. B. V. Bothmer, *Egyptian Sculpture of the Late Period, 700 B.C. to A.D. 100* (Brooklyn Museum, 1960).

42. *Ibid.*, No. 67, pp. 81 ff. and Figs. 160–63.

43. *Ibid.*, No. 69, pp. 85 f. and Figs. 166–69. The difference of opinion as to the material of this bust between this expert and G. Steindorff, *Catalogue of the Egyptian Sculpture in the Walters Art Gallery* (Baltimore, 1946), No. 297, p. 91 and Pl. LVIII, remains unresolved even after a superficial examination of the original.

44. Bothmer, *op.cit.*, No. 83, pp. 105 f. and Figs. 205–6. In his article "A Brooklyn Head on a Cairo Statue," *Brooklyn Museum Annual*, IV (1962–63), 42 ff., Bothmer remarks (note 2, p. 51) the startling change in proportion—to a ratio close to that of Greek figures—in fourth-century Egyptian art.

45. *Ibid.*, No. 108, pp. 138 ff. and Figs. 267–69, 272.

46. *Ibid.*, pp. 164 ff. (No. 127, Figs. 317–19).

47. *Ibid.*, pp. 154 f. (No. 199, Figs. 296–97).

48. On the Isis priest as a portrait type see C. C. Vermeule III, "Oberlin's Head of an Isis Priest of the Second Century A.D.," *Allen Memorial Art Museum Bulletin*, XVII, Pt. 1 (Fall, 1959), 7 ff.

49. Bothmer, *op. cit.*, p. 166.

50. C. Blümel, *Römische Bildnisse* (Berlin, 1933), No. R 9, pp. 4 f. and Pl. 5.

51. Bothmer, *op. cit.*, pp. 166 and 197, illustrated in *A.J.A.*, LX (1956), Pl. 108, Figs. 18–19.

52. Bothmer, *op. cit.*, pp. 170 ff.

53. There is a strong possibility that humbler monuments, at least, were executed by native artists; see, e.g., V. Poulsen, *Portraits romains I*, 37 f.

54. *Tusc. Disc.* I. 24.

55. Sextus Empiricus *Against the Logicians* VII. 203.

56. C. Bailey, *Epicurus: The Extant Remains* (Oxford, 1926), p. 45.

57. Cf. H. Baker, *The Image of Man* (New York, 1961), pp. 87 f.

58. *De finibus* II. 7.

59. Marcus Aurelius *Meditationes* VI. 15.

60. Cf. Baker, *op. cit.*, pp. 71 f.

61. Marc. Aurel. VI. 36.

62. Cicero *De legibus* I. 12.

63. Cicero *De re publica* III. 22.

64. *Summa Theologica* II. 1. 91. 2.

65. Marc. Aurel. II. 16.

66. *Nat. Hist.* XXXIV. 92 (trans. Rackham, IX, 195).

67. Baker, *op. cit.*, pp. 79 f.

68. *De rerum natura* I. 419–21, 443–48 (trans. W. H. D. Rouse, Loeb Classical Library ed., pp. 31, 33).

69. *Ibid.*, III, 94–97, 128–29, 136–40, 143–44, 323–26, 331–36 (trans. Rouse, pp. 177, 179, 181, 193).

70. Schweitzer, *op. cit.*, Figs. 152, 154, 155. See now M. Borda, *Iconografia Cesariana* (Rome, 1957), for a general view of the imagery.

71. W. Amelung, *Die Skulpturen des Vaticanischen Museums*, I (Berlin, 1903), No. 107, p. 376 and Pl. 39.

72. Cf. V. Poulsen, *Portraits romains I*, 12 ff.

73. The bust at Kingston Lacy is mentioned above, p. 176; cf. the over life-sized statue from Aphroditopolis in the Museum at Cairo, *Notiziario Archeologico*, III (1922), 13 and Figs. 9–11.

74. NCG Nos. 432 and 621 = V. Poulsen, *Portraits romains I*, Nos. 5 and 6, pp. 44 ff. Cf. also V. Poulsen, *Vergil* ("Opus Nobile," No. 12) (Bremen, 1959).

75. V. Poulsen, *Portraits romains I*, 23.

76. Type "B" in the classification established by O. Brendel in his fundamental study, *Ikonographie des Kaisers Augustus* (Nürnberg, 1931).

77. Cf. E. Simon, *Der Augustus von Prima Porta* ("Opus Nobile," No. 13) (Bremen, 1959).

78. This is the thesis of H. Kähler, *Die Augustusstatue von Prima Porta* ("Monumenta Artis Romanae," Vol. I) (Cologne, 1959).

79. So W. H. Gross, "Zur Augustusstatue vom Prima Porta," *Gött. Nachrichten* (1959), No. 8; cf. V. Poulsen, *Portraits romains I*, 25 ff.

80. V. Poulsen, *Portraits romains*, p. 30.

81. L. Polacco, *Il Volto di Tiberio* (Rome, 1955).

82. Cf. G. M. A. Richter, *Roman Portraits* (New York, 1948), No. 36.

83. E.g., NCG No. 586a, the portrait of M. Vilonius Varro = V. Poulsen, *Portraits romains I*, No. 87, pp. 119 f., and, of course, the innumerable funerary reliefs.

84. See Pliny *Nat. Hist.* XXXV. 51 on the painted portrait on linen 128 feet high, and XXXIV. 45 for the $106\frac{1}{2}$-foot bronze statue of the emperor as Helios, made by Zenodorus for the Golden House. On this latter point see H. P. L'Orange, *From the Collections of the Ny Carlsberg Glyptothek*, III (1942), 247. Cf. V. Poulsen's discussion, *Portraits romains I*, 32 ff.

85. V. Poulsen, "De Tre Kejsere. Litteraere og Plastiske Portraetter," *Meddelelser fra Ny Carlsberg Glyptotek*, XVI (1959), 31 ff.

Chapter V

1. Cf. G. Mathew, "The Character of the Gallienic Renaissance," *J.R.S.*, XXXIII (1943), 65 ff. An effort to refute the Renaissance concept in reference to this period is made by E. B. Dusenbery, "Sources and Development of Style in Portraits of Gallienus," *Marsyas*, IV (1947), 1 ff., with a probably ill-advised attempt to arrange the extant portraits in single linear sequence.

2. V. Poulsen, "Den Fangne Kejser og andre Romerske Ansigter," *Meddelelser fra Ny Carlsberg Glyptotek*, XXIV (1967), 1 ff. I am indebted to Dr. Poulsen for information on these remarkable acquisitions in advance of publication and am further obliged to Mrs. L. S. B. MacCoull Shubik for the opportunity to read the manuscript of her article on them, "Two New Third-Century Imperial Portraits in the Ny Carlsberg Glyptotek," which will appear in a forthcoming volume of *Berytus*.

3. Cf. A. Alföldi, *Die Vorherrschaft der Pannonier und die Reaktion des Hellenentums unter Gallienus* ("Römisch-Germanische Kommission 25. Jahre," Mainz [1930]), pp. 11 ff., fundamental for modern understanding of the period.

4. Mathew, *op. cit.*, pp. 66 f.

5. *Ibid.*, p. 67. Venturesome indeed: Gallienus' willingness to be portrayed in feminine guise (Galliena Augusta/Ceres, an allusion to the Eleusinian Mysteries) did nothing to lessen the mistrust of his cultural interests felt among the soberer members of the senatorial class in Rome.

6. Porphyry *On the Life of Plotinus and the Arrangement of His Work* 12 (trans. S. MacKenna in Plotinus, *The Enneads* [London, 1942], p. 9).

7. E. Bréhier, *The Philosophy of Plotinus*, trans. J. Thomas (Chicago, 1958), p. 170.

8. H. Baker, *The Image of Man* (New York, 1961), pp. 95 f.

9. *Enneads* V. 8. 1 (trans. MacKenna, pp. 422 f.).

10. P. V. Pistorius, *Plotinus and Neoplatonism: An Introductory Study* (Cambridge, 1952), pp. 149 ff.

11. H. P. L'Orange, "The Antique Origin of the Medieval Portraiture," *Acta Congressus Madvigiani Hafniae MDMLIV*, III: *The Classical Pattern of Modern Western Civilization: Portraiture* (Copenhagen, 1957), pp. 53 f. Cf. now the English translation of his *Fra Principat Til Dominat*, under the title *Art Forms and Civic Life in the Late Roman Empire* (Princeton, 1965).

12. Cf. L'Orange, *Studien zur Geschichte des spätantiken Porträts* ("Instituttet for Sammenlignende Kulturforskning," Series B, Vol. XXII) (Oslo, 1933), p. 5 and Fig. 7.

13. *Ibid.*, Figs. 8–11 and pp. 5 ff.

14. H. Mattingly and E. Sydenham, *The Roman Imperial Coinage*, Vol. V, Pt. 1 (by P. H. Webb) (London, 1927), pp. 68 ff. and Pl. I, Figs. 14 and 15; II, Figs. 20–21, 24–25, and 36; III, Figs. 44, 48–50; as against Pl. II, Figs. 28–29; III, Figs. 40–43, etc. The fundamental study remains that of O. Voetter, "Die Münzen des Kaisers Gallienus und seiner Familie," *Numismatische Zeitschrift*, XXXII (1900), 117 ff., XXXIII (1901), 73 ff.

15. G. Bovini, "Gallieno: La sua iconografia ed i riflessi in essa delle vicende storiche e culturali del tempo," *Atti della reale Accademia d'Italia. Memorie della classe di scienze morali e storiche*, VII, Pt. ii, No. 2 (1941), 115 ff., and esp. 148 ff. The newly identified portrait (Fig. 109) should dispel any lingering doubts of the identification of this type.

16. Cf. Mattingly and Sydenham, *op. cit.*, V, Pt. 1, Pl. II, Fig. 21 (Rome); 24 (Lugdunum); 25 (Siscia), etc.

17. *Ibid.*, Pl. II, Figs. 30 *versus* 31 (both from Rome: p. 146, No. 177, and p. 151, No. 236). Other late examples of the "youthful" type are from Milan (Pl. II, Fig. 26), and Rome again (Pl. III, Fig. 51). The fact that important examples were issued at Rome itself eliminates the possibility that such types were continued merely through provincial ignorance of shifts in official policy.

Correspondence with R. A. G. Carson shows nothing up to the time of writing to disturb the conclusions presented here, insofar as research toward the appropriate volume of the British Museum Catalogue is concerned.

18. Mathew, *op. cit.*, p. 65.

19. Cf. in general H. P. L'Orange, *Apotheosis in Ancient Portraiture* ("Instituttet for Sammenlignende Kulturforskning," Series B, Vol. XLIV) (Oslo, 1947); but it must be understood that the portraits of Gallienus are not apotheosized in the formal sense of ordinary Roman practice.

20. Cf. *A.J.A.*, LXXI (1967), 325.

21. "We have only to compare the sorry efforts of the Athenian coin-designers with the splendid designs that were being turned out at the time by the Roman mint in order to realize that Greek artists of the first rank were now attracted to the capital of the Empire, leaving, very often, only second- and third-rate artists behind in Greece," J. M. C. Toynbee, *The Hadrianic School: A Chapter in the History of Greek Art* (Cambridge, 1934), p. xx.

22. *Ibid.*, p. xxvi.

23. *Ibid.*, pp. xxv f. and 242 f.

24. P. G. Hamberg, *Studies in Roman Imperial Art with Special Reference to the State Reliefs of the Second Century* (Uppsala, 1945), pp. 46 ff.

25. G. M. A. Hanfmann, *Observations on Roman Portraiture* ("Collection Latomus," XI) (Brussels, 1953), p. 45.

26. *Ibid.*, p. 46.

27. Cf. A. Giuliano, *Arco di Costantino* (Milan, 1955), Figs. 17–24; esp. obvious on Fig. 23.

28. Hanfmann, *op. cit.*, p. 47.

29. Mathew, *op. cit.*, p. 65.

30. *Ibid.*, p. 66. B. M. Felletti Mai, *Iconografia Romana Imperiale da Severo Alessandro a M. Aurelio Carino (222–85 d.C.)* ("Quaderni e Guide di Archeologia," II) (Rome, 1958), is a useful compendium of generally reliable attributions of imperial portraiture (with attendant documentary material) from this critical period, based largely on the numismatic evidence—which, for numerous personages, is all that is discoverable. G. Bovini, "La ritrattistica romana da Treboniano Gallo a Probo," *Mon. Linc.*, XXXIX (1943), col. 179 ff., is an attempt to correlate civil portraiture with the established imperial sequence, such as it is.

31. L'Orange, "The Antique Origin," p. 54.

32. L'Orange, *Studien*, p. 2. Cf. Felletti Mai, *op. cit.*, Pls. I–IV and IX.

33. Hanfmann, *op. cit.*, p. 48.

34. L'Orange, *Studien*, pp. 3 f.

35. Felletti Mai, *op. cit.*, p. 155, No. 161.

36. L'Orange, "The Antique Origin," p. 55.

37. L'Orange, "The Portrait of Plotinus," *Cahiers archéologiques*, V (1951), 15 ff.

38. Hanfmann, *op. cit.*, pp. 48 f.

39. Mathew, *op. cit.*, p. 67.

40. L'Orange, "The Antique Origin," p. 58.

41. Cf. Felletti Mai, *op. cit.*, pp. 251 ff. and Pls. XLVIII ff., including very few works other than coins—and those debatable. On even this evidence it is tempting to hypothesize a certain repetition of stylistic sequences found earlier in the century: an Antonine-Severan look on the coins of Postumus and Tetricus, verging toward a Gordianic-Trebonianic style as early as Claudius Gothicus, gradually taking on an almost tetrarchal crystallinity—under the influence of Gallienus' apotheosized types!—with the reign of Tacitus. It must be emphasized that such a sequence must be purely speculative.

42. Cf. L'Orange, *Studien*, pp. 35 ff. For the numismatic evidence cf. Felletti Mai, *op. cit.*, Pl. LIII, Fig. 185, and Pl. LIV, Fig. 186 (Tacitus); Pl. LIV, Fig. 189 (Florianus); and Fig. 190 (Probus); etc.

43. First published by L. Curtius, "Porträt der Tetrarchenzeit," *J.H.S.*, LXXI (1951), 48 ff., and subsequently acquired by the Ny Carlsberg Glyptotek; see V. Poulsen, in *Meddelelser fra Ny Carlsberg Glyptotek*, X (1953), 1 ff.

44. R. Delbrück, *Antike Porphyrwerke* ("Studien zur spätantiken Kunstgeschichte," No. 6) (Berlin, 1932), Pls. 31–34 and pp. 84 ff. (Venice); Pls. 35–37 and pp. 91 f. (Rome). The Roman figures are actually attached to columns, near their capitals, and are much smaller in scale; cf. Fig. 34, p. 93. Cf. L'Orange, *Studien*, pp. 16 ff.

45. Delbrück, *op. cit.*, Pls. 38–39 and pp. 92 ff.

46. L'Orange, *Studien*, p. 24; cf. Delbrück, *op. cit.*, pp. 15 ff.

47. Cf. B. V. Bothmer, *Egyptian Sculpture of the Late Period, 700 B.C. to A.D. 100* (Brooklyn Museum, 1960), p. 183. On the material and techniques used cf. Delbrück, *op. cit.*, pp. 1 ff.

48. L'Orange, *Studien*, p. 24.

49. J. Maurice, *Numismatique Constantinienne*, Vol. II (Paris, 1911), Pl. IX (Siscia); Pl. XI (Serdica); Pl. XIII (Thessalonica); Pl. XVII (Heraclea); Vol. III (Paris, 1912), Pls. I–II (Nicomedia); Pl. V (Cyzicus); Pls. VI–VIII (Antioch); Pls. IX–X (Alexandria).

50. *Ibid.*, Vol. I (Paris, 1908), Pl. XVII (Rome); Pl. XX (Aquileia); Pl. XXII (Trèves).

51. The importance of seeing the art of this period as a whole rather than in regional segments is stressed by A. Rumpf in his remarkable essay, *Stilphasen der spätantiken Kunst: Ein Versuch* ("Arbeitsgemeinschaft für Forschung des Landes Nordrhein-Westfalen," No. 44) (Cologne, 1957).

52. Maurice, *op. cit.*, has been superseded only in part by Mattingly and Sydenham, *op. cit.*, Vol. VII: *Constantine and Licinius, A.D. 312/13–337* (by P. M. Bruun), London, 1966.

53. M. R. Alföldi, *Die Constantinische Goldprägung: Untersuchungen zu ihrer Bedeutung für Kaiserpolitik und Hofkunst* (Mainz, 1963), advances the intriguing thesis that a single "Erste Graveur" was responsible for creating the finest coin dies of the Constantinian gold mint at all its locations between 306 and *ca.* 327. On the date of the Ostia mint cf. Alföldi, pp. 29 ff.

54. On the redating of this crucial battle cf. P. Bruun, *Studies in Constantinian Chronology* ("Numismatic Notes and Monographs," No. 146) (New York, 1961), pp. 3 ff., with convincing arguments for the change.

55. M. R. Alföldi, *op. cit.*, pp. 57 ff.

56. *Ibid.*, and L'Orange, *Studien*, pp. 55 ff.

57. L'Orange, *Studien*, pp. 47 ff.

58. Cf. Rumpf, *op. cit.*, pp. 7 ff.

59. Cf. C. C. Vermeule III in *Art Institute of Chicago Quarterly*, LIV, No. 4 (1960), 8 ff.

60. L'Orange, *Studien*, No. 92, pp. 64 f., and Figs. 167 and 170.

61. Cf. M. R. Alföldi, *op. cit.*, pp. 90 ff.

62. Cf. L'Orange, *Apotheosis*, pp. 90 ff.

63. Cf. now M. R. Alföldi, *op. cit.*, pp. 122 ff.

64. Ammianus Marcellinus *Res Gestae* XVI. 10. 6 ff. (trans. J. C. Rolfe, Loeb Classical Library ed., I, 245 ff.).

65. Maurice, *op. cit.*, Vol. I, Pl. VII, Figs. 9–10 (Maxentius); Pl. X, Fig. 11 (Licinius); Pl. X, Fig. 16 (Licinius II); Pl. XIV, Fig. 5 (Constantius II).

66. Marinus *Life of Proclus* XXIII (trans. L. J. Rosan, *The Philosophy of Proclus: The Final Phase of Ancient Thought* [New York, 1949], p. 26).

67. Plotinus *Enneads* VI. 7. 22 (trans. MacKenna, p. 579).

68. Rosan, *op. cit.*, p. 83.

69. *Comm. Timaeus*, in Rosan, *op. cit.*, p. 194.

70. *Comm. Parmenides*, *ibid.*, p. 197.

71. T. Whittaker, *The Neo-Platonists: A Study in the History of Hellenism* (Cambridge, 1901), pp. 169 f.

72. L'Orange, "Antique Origin," pp. 63 f.

73. L'Orange, *Studien*, Nos. 115, 116, 118, Figs. 216–20, 222; cf. the Ostia head, which helps to demonstrate once again that such "styles" cannot be classified on a regional basis. Within Asia Minor, as the Ephesus sculptures show, the style can differ more widely than between some pieces found there and others from an entirely different area.

74. Cf. E. Kitzinger, "The Cult of Images in the Age before Iconoclasm," *Dumbarton Oaks Papers*, VIII (1954), 85 ff., and *Byzantine Art in the Period between Justinian and Iconoclasm* ("Berichte zum XI. Internationalen Byzantinisten-Kongress," IV, Pt. 1) (Munich, 1958).

Chapter VI

1. Porphyry *On the Life of Plotinus and the Arrangement of His Work* I (trans. MacKenna in Plotinus, *The Enneads* [London, 1942], p. 1).

2. Marinus *Life of Proclus* III (trans. L. J. Rosan, *The Philosophy of Proclus: The Final Phase of Ancient Thought* [New York, 1949], pp. 14 f.).

3. H. Baker, *The Image of Man* (New York, 1961), p. 94.

4. J. Alazard, *The Florentine Portrait* (London, 1948), p. 17.

5. E. H. Gombrich, *Art and Illusion: A Study in the Psychology of Pictorial Representation* (New York, 1959), p. 90.

6. Cf. A. N. Zadoks–Josephus Jitta, *Ancestral Portraiture in Rome and the Art of the Last Century of the Republic* ("Allard Pierson Stichting, Universiteit van Amsterdam: Archaeologisch-historische Bijdragen," No. 1) (Amsterdam, 1932), pp. 11 ff.

7. When this writer was a child, his parents moved into a new home; while the movers were bringing in the first pieces of our furniture, the widow who was the former tenant dashed back into the house, crying, "I almost forgot my husband!" She snatched a small dust-filled urn from the mantel, put it in her purse, and rushed out, never to be seen again.

8. Goronwy Rees, *A Bundle of Sensations* (London, 1960).

9. M. R. James, *The Apocryphal New Testament* (Oxford, 1926), pp. 232 ff.

Index

THE TEXT *of this book is composed in twelve-point Perpetua, two points leaded. The Perpetua face was commissioned by the English Monotype Corporation from the notable sculptor Eric Gill and was first made commercially available in 1929. Perpetua has no true antecedent in the history of printing and type design; it was drawn by Gill in the style of lettering for which he had become famous as a carver of inscriptions, and it retains much of the quality of the stone-cut letters from which it was derived. The capitals are probably the finest example of the pure Roman majuscule to have been adapted to the purposes of printing.*

The book was composed in monotype by William Clowes & Sons, Ltd., of Beccles, Suffolk, England. It was printed by The Meriden Gravure Company, of Meriden, Connecticut, on Mohawk Superfine paper and was bound by the Russell-Rutter Company, Inc., of New York. The typography and binding design are by Paul Randall Mize.